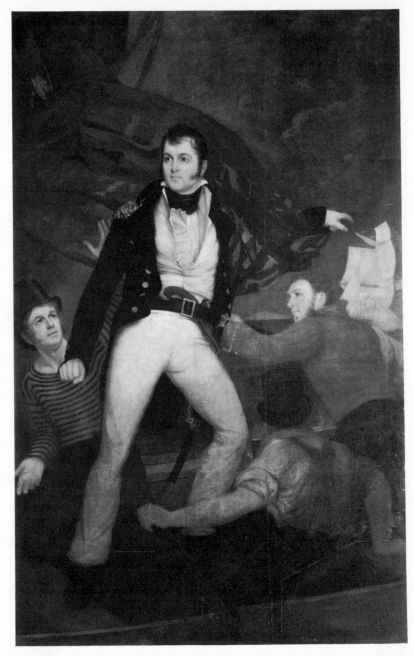

OLIVER HAZARD PERRY. Painting by John Wesley Jarvis. *Courtesy The Art Commission, City of New York.* "... he painted those full-length portraits of military and naval heroes which will keep him in public remembrance for a short-lived immortality, by their situation in the City Hall of New York and their great merit ... They are historical portraits, painted with skill and force—real representations of men and character; throwing most of the pictures painted for the City of New-York previously in the back-ground."

A HISTORY OF
THE RISE AND PROGRESS OF

The Arts of Design

in the United States

BY

WILLIAM DUNLAP

A REPRINT OF THE ORIGINAL 1834 EDITION
WITH A NEW INTRODUCTION BY
JAMES THOMAS FLEXNER

NEWLY EDITED BY RITA WEISS
WITH 394 ILLUSTRATIONS

IN TWO VOLUMES BOUND AS THREE
VOLUME 2, PART 1

DOVER PUBLICATIONS, INC.
NEW YORK

Published in Canada by General Publishing Company, Ltd.,
30 Lesmill Road, Don Mills, Toronto, Ontario.
Published in the United Kingdom by Constable and Company, Ltd.,
10 Orange Street, London WC2.

This Dover edition, first published in 1969, is an unabridged re-
publication of the first (1834) edition, as published by George P. Scott
and Company. This edition also contains a new introduction by James
Thomas Flexner, new biographical notes, new illustrations, and a new
index prepared especially for this edition, and a preface by the editor.

Standard Book Number: 486-21696-9
Library of Congress Catalog Card Number: 69-16810

Manufactured in the United States of America
Dover Publications, Inc.
180 Varick Street
New York, N.Y. 10014

List of Plates

v

CONTENTS

CHAPTER VI.

CHAPTER VII.

CHAPTER VIII.

CHAPTER IX.

CHAPTER X.

CHAPTER XI.

CHAPTER XII.

CHAPTER XIII.

CHAPTER XIV.

CHAPTER XV.

CHAPTER XVI.

CHAPTER XVII.

A HISTORY

RISE AND PROGRESS OF THE ARTS OF DESIGN

IN AMERICA.

CHAPTER I.

Alexander Anderson. History of wood engraving. Mr. Anderson the first who introduced wood engraving into the United States—his difficulties and success.

A. ANDERSON—1794.

Alexander Anderson, 1775–1870.

THE first who attempted engraving or embossing on wood in America, was born in New York: but before I proceed to a notice of his life, I will give a memoir upon

ENGRAVING ON WOOD,

furnished me by Abraham John Mason, Esq. now one of our citizens, and practising the art in New-York.

As engraving and printing unquestionably had their origin in China, it will be proper first to give a sketch of the peculiar modes practised in that empire. The design is made on a thin, transparent paper, and pasted with the face downwards on the block; it is then engraved by cutting through the paper into the wood, leaving standing only those portions of the surface which appear black in the drawing. Their tools are similar in many respects to those of other block cutters, ancient and modern, consisting of a knife for outlining, with gouges, chisels, &c. of various shapes for clearing away the wood. They use them with much celerity, especially the knife, which they guide with both hands; their facility enables them to furnish their blocks with great rapidity, and at an astonishingly cheap rate. The Chinese have never attempted the use of moveable types; all their books, illustrative or descriptive, being printed from

wooden blocks, cut in the manner described, and this mode is
to them far more economical, owing to the low price of work-
manship of every kind.

Their method of printing is simple, and peculiar to them-
selves. The block must be in a firm and level position, being
first tightly fixed in a larger piece of wood to give it stability;
in front of this the paper is placed, cut to the proper size.
The ink (which is merely a reduction without oil of that which
is known as Indian ink) being distributed on a smooth piece
of board, the workman takes a moderately stiff brush, which
he dips into it, and rubs the block carefully therewith. The
paper is next laid over, and rubbed with a second brush, which
is soft, and shaped like an oblong cushion; the paper not be-
ing sized, a gentle pressure is generally sufficient, and which
may be repeated, or regulated as occasion may offer. A third
brush, very stiff, is used for cleaning the blocks. These
brushes are curiously made of the fine fibres of the palm, or
cocoanut trees. A set of these printing materials may be
seen in the museum of the English East India Company, which
are supposed to be the only specimens in Europe. In the
manner described, without the aid of any press, have all im-
pressions been taken in China, from the earliest periods to the
present day. Their paper being so very thin, is printed on
one side only, and each leaf in their books is folded in binding,
and the edges turned inwards, and stitched with silk. There
is much neat and curious execution about some of their cuts,
but they seldom go beyond outlines, and are altogether defi-
cient in the true principles of drawing.

Much disputation has arisen as to the period when engrav-
ing was first practised in Europe. The earliest record rests
on the authority of Papillon, the French writer, who gives a
description of eight subjects, relating to Alexander the Great,
having been cut on wood by twins of the name of Cunio, at
Ravenna, as early as 1285.

During the next, or 14th century, there is clear evidence
of the practice, for printing playing cards, and figures of
saints, &c. These were without doubt first executed in the
Venetian States, and afterwards in Germany and the low coun-
tries to a great extent. The impressions appear to have been
taken by means of a hand roller, the press not being known
until the following century; in the early part of which the art
was applied to engraving larger subjects of a devotional kind,
with inscriptions. Several of these curious prints are still
extant; amongst them, in the possession of Earl Spencer, is
the celebrated one of St. Christopher carrying the infant Jesus;

this is remarkable as being the earliest print bearing a certain date, viz. 1423. The success of these gave rise to a more extensive application of the art. Scriptural designs of many figures were cut with descriptive texts on each block; they were printed on one side only of the paper, and two of the prints were frequently pasted together to form one leaf with a picture on each side; entire sets were subsequently bound up, and thus were formed into the block books so well known to antiquaries. The Apocalypse of St. John, probably the first of these works, appeared about 1420; one of the identical blocks cut for it still exists in the library of Earl Spencer. The latest and most noted of these books is the Speculum Humanæ Salvationis, produced about the year 1440, and being partly printed from moveable wooden types, became the connecting medium that gradually introduced the invaluable art of typography, which facilitating the production of books, was the means of greatly increasing the demand for wood cuts for primers, prayer books, &c. In 1457 Faust produced his Psalter, printed with metal types, and initials in colors from blocks. Of the principal letter, a highly ornamented B, an accurate fac-simile is given in Savage's Decorative Printing. Typography was introduced into England by Caxton in 1474, who published his " Game of Chesse," Esop, and other works with wood cuts, the execution of which is quite barbarous, when compared with continental engravings of the same period. All cuts consisted of little more than outline until 1493, when Michael Wolgemuth effected a great improvement in the art by the cuts for his Nuremberg Chronicle, in which he introduced a greater degree of shading, and the first attempts at cross hatching. This was carried to much higher perfection by his pupil Albert Durer, who published in 1498 his Apocalypse in sixteen folio cuts, and early in the 16th century, his Life and Passion of Christ, and other large works of high talent. In 1511, he produced the Fall of Man, with thirty-seven small cuts, and from that period until his death in 1528, he published a variety of engravings on copper and wood, besides being an eminent painter. His pupil, Burkmair, executed several rich works under the patronage of the Emperor Maximilian, many of the blocks of which still exist in Vienna, and form an ample refutation of the assertions of Mr. Landseer, and others, as to the practicability of effecting cross hatched work on wood. This 16th century was rich in able wood engravers in several parts of Continental Europe, amongst whom might be named Holbein, who published his celebrated Dance of Death, 1538, Justis Amman of Zurich, Stimmer of Schaffhausen, Cesari

Vecelli, a younger brother of Titian's; Porta, Salviati, and an innumerable host of others, whose skilful productions gave the art a high consideration with the best painters of the time. In England comparatively few works appeared, but amongst them should be noticed the first edition of the celebrated Martyrology, published in 1563, the best cuts in which were probably done by foreigners, as we have record of only a solitary name or two of worth, until within the last sixty years. In the 17th century the art visibly declined, owing to the superior cultivation of copper engravings. Some few eminent artists, however, flourished, such as Van Sichem, Eckman, and Christopher Zegher, the latter of whom engraved many very masterly specimens from the designs, and under the direction of Rubens. By the year 1700, wood engravings sunk to a very depressed state; the French family of Papillon should, however, not be omitted, the elder of whom practised about the year 1670; his son John improved upon him, and was said to be the inventor of printing paper-hangings by blocks in 1688. He was the father of Jean Baptiste Papillon, who practised with much success as a wood engraver, but is more celebrated for his well known work on the art in two volumes, published in 1766. With these and some few other exceptions, there is little worthy attention from 1650 until the era of the school of Bewick.

Mr. Thomas Bewick began wood engraving in 1768; in 1775 he produced his cut of the Old Hound, for which the Society of Arts awarded him seven guineas, it being justly deemed so very superior to any specimens then executed. In 1785 he commenced his valuable Natural Histories, and published the Quadrupeds in 1790, and the Birds in 1797. These and his other works, all of which were richly embellished with cuts, effected by their great excellence the restoration of an almost lost art. Nearly cotemporary with Bewick was Mr. Lee, of London, who produced many very neat specimens. Other artists soon arose, who effected still greater improvement in the art, by introducing a richer and more varied style of workmanship, which has led to the adoption of the art to so wide an extent as promises to be a sure prevention to its ever again sinking into neglect.

Public lectures on this art were for the first time given in London, in 1829, by Mr. Mason, who subsequently delivered the same in the United States to the National Academy of Design.

The theory and practice of this art, are in principle the

reverse of engraving on copper; in the latter the lines to be
printed, are sunk or cut in the plate; these being filled with
ink, are by means of a rolling press, transferred in effect to
the paper. In wood engraving, on the contrary, the parts
that are to appear must be raised, or rather left untouched,
and hence it is frequently termed relief engraving. In print-
ing, the surface is only charged with ink, and the impression
is taken as from types. The copper engraver rarely uses
more than three tools of the kind which are termed burins or
gravers The artist on wood requires, according to circum-
stances, from ten to fifteen or eighteen, called gravers, tools
for tinting and sculptures; the latter are used for cutting out
the broader parts which are to be left white. The earlier
artists cut on various kinds of wood, such as the apple, pear,
etc ; these being termed soft woods, are now only in request
for calico printing and other manufacturing purposes, for as
the style of work improved, these were abandoned, and box
was tried on account of its superior texture and compactness,
which have caused it to be the only kind used for every subject
that can properly be termed a work of art. The surface of the
wood to be engraved is carefully planed, scraped, etc. so as to
render it as smooth as possible, in order to receive the draw-
ing which must be put on the block itself, previously to com-
mencing the engraving. The artist in its execution, has to
arrange the strength and direction of the lines required for the
various parts and distances, so that the printed impression,
though composed of different series of interlineations, may
present the same character in effect, as the original drawing.

 Much care is requisite, on the part of the engraver, to pre-
vent a delicate design from being rubbed during the process
of cutting ; and it is usually covered with paper, which is re-
moved by degrees as required. It will be apparent also how
much depends upon the skill of the engraver, when it is con-
sidered, that, with every line cut by the tool, a portion of the
effect of his original is removed, and his recollective powers
and taste must be in constant exercise, to preserve the points
of the design ; and the block must be wholly engraved before
any impression can be taken. The copper engraver, on the
contrary, is enabled to take progressive proofs of his work,
and has his original drawing, unimpaired, constantly before
him. The latter has also another important advantage, in
what is termed tinting; inasmuch as all his skies and flat
back-grounds can be cut on the plate itself by mechanical
means ; and his various tints are thereby produced with every
required delicacy. The wood engraver can have no such fa-

cility ; all depends on the steadiness of the eye and hand, properly to effect the object, by cutting line after line individually, without any auxiliary assistance whatever.

These brief explanations may serve to show the principles on which all engravings on wood are effected. Thus, whether the design relate to landscape, the human figure, or any other species of subject, it must be composed of an infinite number and variety of projecting portions of wood, produced by those delineations which, according to the judgment of the engraver, are best calculated to convey, when printed, the desired effect.

The ancient mode of working was on the side of the grain, their wood being always cut the longitudinal way of the tree : this method continued, for all wood cuts, till about the year 1725, when the present method was commenced in England, of cutting the tree transversely, or across. This plan presenting the end of the grain, admits, from its greater tenacity, of a finer kind of workmanship, and the application of the description of tools before named. The block-cutters for paper hangings, &c. have their wood prepared in the same way as the old masters, and of course use similar tools ; the chief of which is a knife, shaped somewhat like a lancet, with which the line has to be cut on both sides, and the superfluous wood has to be removed by gouges, chissels, &c. of various shapes, as derived originally from the Chinese.

When we consider, that in this way all the finished works of the ancients were produced, it attaches a very great degree of merit to them ; for the process seems evidently to have been a more tedious one than the modern : since, if a line be cut with the knife, it is necessary it should be met by another line before any wood can be taken out; whereas, in the present mode, the graver, as it cuts the incision removes the wood at the instant of operation.

We have next to speak of the application of this branch of art to the imitation of coloured drawings ; or, as it has been sometimes termed, engraving in chiaro scuro. This is effected by cutting as many blocks as there are colours and tints in the original : and in executing subjects in this style, the first block engraved is that which embraces the outline, or most material parts of the subject, as a guide to the others ; an impression being transferred to the requisite number of blocks, and the respective tints put in, so as to fit accurately when printed.

One of the earliest known specimens of printing in colours is the letter B, in Faust's Psalter, produced in 1457. This was in two blocks, red and blue, which were very correctly ad-

justed. Towards the close of the 15th century the principle was adopted to a more finished extent, by the successful attempt at blending neutralized tints. Ugo da Carpi, of Rome, was amongst the first to effect this object; and the mode was so esteemed, that the greatest painters gave their attention to it, as a means of perpetuating their designs. Raphael, Parmegiano, Titian, Rubens, and others of note, in the 16th and 17th centuries, assisted by their designs, and in superintending their execution, in producing these works, and the many beautiful specimens extant exemplify the success of their efforts.

From the middle of the 17th century, the art of wood engraving generally declined, and of course fewer subjects in chiaro scuro were effected. In 1688, this principle was applied, in France, to the production of paper hangings; which was introduced into Great Britain, by John B. Jackson, in 1750. This artist was the first Englishman who, with any success, practised engraving in this style. At first nothing was attempted that consisted of more than two blocks; but, before the close of the 18th century, the number was increased to five; which was never exceeded till the appearance of Mr. Savage's book on Decorative Printing, in 1822. This work, which is throughout a fine specimen of art, has numerous examples in chiaro scuro, in 6, 7, and 8 blocks; and one in 14, copied from a design by John Varley. In all these, the artists' drawings are accurately represented, and the entire work is highly worthy a careful inspection.

In this general sketch it has been quite impossible to notice the various points and capabilities of wood engraving, relative to its uses, application, and durability; or to name, with any justice, its many eminent professors, either ancient or modern. Its value is becoming daily more and more apparent in both hemispheres, by the demands on the talent of those who practise it. Its prominent points and beauties will hereby, by degrees, become more universally understood: this, however, can never be properly effected, till a thorough reformation shall take place in printing. Considering the innumerable works continually issued, illustrated with wood cuts, the public have, with very few exceptions, but little chance of duly estimating their merits; since, in the greater number of them, the engravings are printed in so heedless a manner as scarcely to deserve, by their appearance, the name of embellishments. There can be no doubt that publishers will, ere long, discover it to be their true interest to give more

serious attention to this subject; which, as regards the repu-
tation of the art, is of the most vital importance."

Having prepared the reader, by Mr. Mason's excellent memoir
on the history, theory and practice of wood engraving, to appre-
ciate the difficulties of the art, I proceed to the biography of A.
Anderson, Esq., who introduced the art into our country and
almost invented it. He was born in April, 1775, three days
after the battle of Lexington, near Peck-slip in New-York.
After his school days were passed, his father placed him with
Doctor Young to study the practice of physic; but he had
from infancy devoted his play hours to drawing, and having
attempted engraving, he was so fascinated by his success that
he determined, as soon as he could, to "throw physic to the
dogs," and become professionally an engraver. He did so.

John Roberts, the universal genius, a notice of whom I
have given, at this time attracted attention. Doctor Ander-
son, (for his medical title sticks to him to this hour,) after
trying various experiments, and making himself somewhat
proficient in the art, gained an introduction to Roberts, and
was received by him as a pupil. He worked as long as he
could with Roberts, for the purpose of improving himself in
drawing, and working with the graver, but the irregularity of
the eccentric Scotchman, and his intemperance, forced him to
give up the advantages he might have derived from his in-
struction.

Mr. Anderson confirms all that has been said of the sur-
prizing versatility and cleverness of Roberts—of his engrav-
ing—miniature painting—musical taste and skill—mathema-
cal attainments—and dexterity in manufacturing tools, and
musical instruments or mechanical machinery.

In the year 1794, as a professed engraver, Mr. Anderson
was engaged by Wm. Durell, bookseller, and one of our early
publishers, to engrave cuts for an edition of "The looking-
glass," the original engravings for which were cut by Bewick
in wood. This led to the employment which distinguishes
Anderson as our first engraver on that material. He worked
through half the book on type metal and copper, and then
commenced his essays on wood without other instruction than
that derived from studying Bewick's cuts, which he was to
copy. For this new art he had to invent and make tools.
Perseverance, industry, and ingenuity overcame all difficulties,
and he established himself as an engraver in wood. Soon
after his first attempts, he cut a cameo for Sword's edition of
Darwin. From that time Mr. Anderson has had constant em-
ployment, supported and educated a family, one of whom, a

119 SUMMER, 1800. Engraving by Alexander Anderson for Robert Bloomfield's "Farmer Boy." *Courtesy Prints Division, New York Public Library.*

120 SKETCH OF LIPENARD'S MEADOWS, *c.* 1800. Wash drawing by Alexander Anderson.
Courtesy Prints Division, New York Public Library, Stokes Collection.

physician, takes the title of doctor partly from him—not entirely—for the inquirer after Doctor Anderson is sometimes asked, " Is it the engraver or the physician you would speak to ?"

Mr. Mason thus speaks of him, " Of the leading artists here, the first notice is due to Doctor Anderson of New-York, who may be termed the Bewick of America, and the father of his art in this country. This gentleman commenced in 1792 ('94) under every possible disadvantage : he at first cut on type metal, but hearing soon after that box-wood was used in England, he adopted it, and copied thereon some of Bewick's specimens. He persevered in the practice, and exhibited the highest ability, though for many years he received but little encouragement ; but like his great English cotemporary, being an enthusiast in the art, he kept steadily and perseveringly on his course, and has the similar satisfaction of having witnessed the progress of wood engraving to its present state of general adoption. It is highly gratifying to know that this amiable and talented veteran is still in full practice, and in the enjoyment of excellent health."*

Mr. Adams of this city is also highly deserving of notice in this place : he commenced the art regularly as a profession, about eight years since ; previous to which, he had merely executed a few casual specimens. He has exhibited, in his late productions especially, the most superior qualifications for the art, displaying in his engravings a near approach to the rich style of the modern English school. Although in New-York, xylography first arose in America, it has been greatly encouraged in other parts of the union, especially Boston and Philadelphia, both of which cities have produced many able artists. Of the introduction of wood engraving into Boston, the credit is due to Mr. Abel Bowen, who began there in 1812, and has continued the pursuit successfully ; he has had several pupils of ability, (Mr. Hartwell and others) who now that the art is becoming more generally understood, receive every encouragement in their professional practice. In Philadelphia wood engraving owes its origin to Mr. William Mason.

* Mr. Anderson is fully entitled to be called "Doctor." He went through a regular course of studies, and received the degree of doctor of medicine at Columbia College in 1796 : on which occasion he dilivered an interesting inaugural dissertation upon "Chronic Mania." He then for a short time entered upon the duties of a profession of which he promised to be a distinguished member. We have seen, however, that his love of the arts of design, led him to relinquish the practice of a physician, and the honourable result of his labours as an engraver, leave no reason to regret his change of profession.

CHAPTER II.

Practical instructions for the student of miniature painting—E. G. Malbone—
born at Newport—when a boy, paints a scene for the theatre—Allston—Mal-
bone practises miniature-painting—goes to London with Allston—returns—The
hours—His untimely death—Letter from Mrs. Whitehorne—Cornelius Tiebout.

PRACTICAL DIRECTIONS FOR MINIATURE PAINTING,

BY T. S. CUMMINGS, ESQ.

MINIATURE painting is governed by the same principles as
any other branch of the art, and works in miniature should pos-
sess the same beauty of composition, correctness of drawing,
breadth of light and shade, brilliancy, truth of colour, and
firmness of touch, as works executed on a larger scale ; and the
artist who paints in miniature, should possess as much theo-
retic knowledge and the same enlarged views of his art, as
if he painted in any other style.

It may be asked, what is the proper preparatory course of
study for a miniature painter ? We should unquestionably
answer, the same as for any other branch of the art. It is in
the mechanical part only that it differs.

Miniatures, as they are at present painted, are usually
executed on ivory,* and in transparent (water) colours,†
and according as the mode of application of the colours
to the ivory partakes of the line, the dot or smooth sur-

* Ivory for miniature painters' use may be purchased at most of the ivory
turners or fancy stores, sawed in thin sheets. It should be selected for the
closeness of its grain, mellowness of colour, transparency and freeness from
changeable streaks. It is then prepared for use, by first scraping out the marks
of the saw, if any appear, and afterwards grinding it with finely pulverized pumice
and water on a glass slab until all *polish* is removed ; it is then washed with clean
water, perfectly free from the pumice, and left to drain itself dry ; when dry it is
attached to white card paper, by dots of gum on the corners, and is then ready
for use.

† Colours are now manufactured in cakes ready for use, only requiring to be
diluted with more water, though some miniature painters regrind them. Those
manufactured by Newman, of London, are generally considered the best, and I
believe, if genuine, are fine enough for all purposes. Fineness of texture and
permanency are the great requisites. It is however necessary that the student
understand the qualities of the pigments made use of, both as to the tints they
form when mixed with one another, and their transparency, or opacity ; for on
this must depend their fitness for different parts of the work, even when the
same tint is procured. They may be classed under three heads, transparent,
semi-transparent, and opaque, though it is by no means my intention to enume-
rate all the varieties of colour, those generally used will be sufficient.

Opaque colours.	Semi-transparent.	Transparent.
Constant white,	Burnt ter. de sienna,	Gall stone,
Flake white,	Indian yellow,	Brown pink,
Vermilion,	Ultramarine,	Lake,
Indian red,	Cobalt,	Carmine—burnt do.

face, is the style,* technically termed hatch, stipple or wash. In the first named, the colour is laid on in lines, crossing each other in various directions, leaving spaces equal to the width of the line between each, and finally producing an evenly-lined surface. The second is similarly commenced, and when advanced to the state we have described in the line, is finished by dots placed in the interstices of the lines, until the whole has the appearance of having been stippled from the commencement. The third is an even wash of colour, without partaking of either the line or dot, and when properly managed, should present a uniform flat tint. Artists vary much in their style of execution, and even in the degree of smoothness they bestow on their pictures, some preferring a *broad*, others a minute style; though the first is decidedly the most masterly. It must, however, be governed, in a great measure, by the size of your picture and your subject.

In the mode of obtaining the desired result, and in the colours to be used for producing it, there is also a great difference of opinion. This is unessential to the student.

The following process I have found to possess many advantages, and I believe as free from errors as any that has fallen under my experience.

Having your colours and ivory prepared, and your subject selected, your next step is to procure a correct outline. If it be a head from the life, (which will perhaps best illustrate my meaning,) you will carefully examine it in all its views; both as to attitude, and light and shadow; and having selected that position which in your judgment possesses most of the likeness and character of the individual, you will proceed to outline it.† Your outline carefully drawn on your ivory, you

Opaque.	*Transparent.*
Yellow ochre,	Vandyke brown.
Burnt umber,	Sepia,
Lamp black.	Indigo,
	Pr. blue,
	Ivory black,
	Burnt madder.

To prepare a palette for a miniature painter it is only necessary to rub the colours, with the addition of water, on a glass, china or ivory palette, in spots agreeable to the requisition of the artist.

* The style or manner of execution is decided by the taste of the artist, and is after all of little consequence. There is no manner in nature. That style which gives the best imitation of nature, and conceals most the means used to obtain it, must undoubtedly be considered the best.

† It may be well if the student's hand be not firmly fixed in drawing, to make an outline on paper of the required size, and afterward transfer it, by placing the ivory over it. Its transparency will enable you to trace it very distinctly. There are many advantages in this method. You insure a clean outline on your ivory, the head of the proper size, and in the proper place in your picture, which will not always be the case if you outline directly upon the ivory.

will next lay in the dark shadows with a light and warm neutral tint,* sharp, firm, and of the right shape. Having carefully placed these, both with regard to individual form and relative, bearing to each other, you may proceed with the lighter shadows or middle tints.† They should also be laid in very lightly, colder in colour than the shadow tone, but still definite in form, however light. These effects correctly obtained, and as much depth given as you think necessary for the proper rounding of your subject, you strengthen your dark shadows, altering their forms if necessary. All being justly situated, you then lay in the general colour of the complexion,‡ and having produced the requisite depth, you will, with a sharp lancet,§ scrape off the shining lights on the face, such as the high light on the forehead, nose, &c., and again compare with your original, particularly as to general effect; this proving correct, you proceed with each feature, giving its individual parts more attention, still keeping the whole effect in view, and the work broad; endeavouring to preserve the general effect in conjunction with the completion of the detail. Having gone over all the features, corrected their drawing and colour, you next examine if the drapery and hair of your sitter suit you; if so, copy them, if not, leave them for another and more happy arrangement of forms, and then complete them, at least as to general form. Your picture then is sufficiently advanced to put in your background.

It is commenced with a round-pointed pencil‖ and faint colour, in broad lines, crossing each other at an acute angle, gradually increasing in fineness as you approach the completion; and then still further finish by stippling, constantly bearing in mind that its beauty is more dependent on preserv-

* A good neutral tint may be made with Indian red and a little blue, which will form a reddish pearl colour.

† Middle tints may be composed of the colour you use for your shadows, with the addition of a little more blue.

‡ In washing in the general colour of the face you will reverse the picture, commencing at the chin; by this means you will obtain the gradation of colour requisite for your head; the brush becoming exhausted, will naturally make the forehead the lightest part. This is of course presuming the head to be painted in the ordinary light used by painters.

§ The lancet is a very useful instrument in the hands of a skillful practitioner in augmenting the high lights; it must, however, be sparingly used by the student, and should never be considered as an eraser.

‖ Pencils used for miniature painting are the sables. They should be elastic, and drawn to a firm point when wet; if they open, they are not fit for use. The size must be governed by the kind of work, or degree of finish you want them for. Generally young miniature painters are too fond of a sharp pointed pencil; it gives dryness and hardness to their work, and will in no way contribute to the finish they vainly hope to attain by such means.

121 CARTOON ON EMBARGO. Engraving by Alexander Anderson. *Courtesy Prints Division, New York Public Library.*

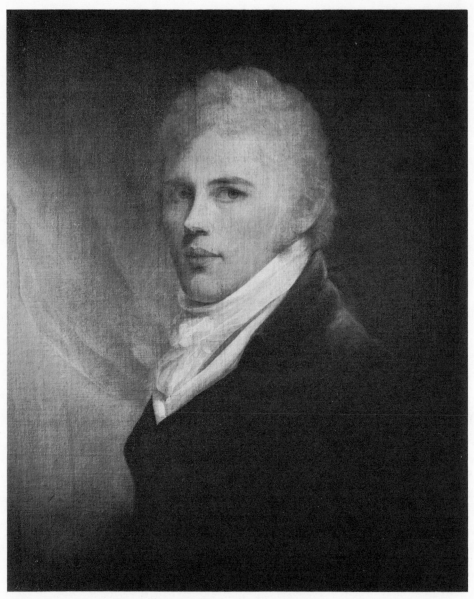

122 PORTRAIT OF THE ARTIST. Painting by Edward Greene Malbone. *Courtesy The Corcoran Gallery of Art.*

ing the masses even, and the grain open, than on the smallness of the dot, or line, which, however minute, will never produce effect, unless the general massing be attended to. Your back ground so far advanced, it is time to insert your drapery. If light, you proceed much the same as with the face; if dark, it is treated with opaque colours. The outline previously obtained, you with a full pencil float on a quantity of the colour* you wish to produce, always giving it body by the addition of white, and smoothness by laying the picture horizontally during the operation; this will allow the colour to become perfectly flat from its fluidity. When dry, it is ready to receive the lights and shadows, as indicated by your model. Your picture equally advanced to this stage, it becomes impossible to lay down rules for its further progress; it must depend altogether upon circumstances arising from the proper performance of the foregoing, as to what additions the picture may require. Generally you will find the flesh-colour deficient, and the shadows weak; these you strengthen and improve, in accordance with the original, adding such colour as in your judgment you think will render it more like the nature before you; and lastly, give brilliancy and transparency by the addition of gum† with your colours, in the dark parts, or wherever else you may deem transparency desirable.

In this we have given directions for the management of a head only; it is however easily adapted to any subject, as the leading principles must of necessity be the same.

Your success in this, as in any other mode of painting, will depend upon your knowledge of the principles of the art, combined with the study of well selected models by masters eminent in the department of art you wish to pursue.

These, with a careful study of nature, judiciously examined by a mind previously accustomed to a careful study of the antique, are the only means calculated to give promise of future excellence in this, or any other class of the arts of design.

The above is from the pen of T. S. Cummings, Esq. from whom, if I can persuade him, the public may receive a more

* The mode of mixing this opaque colour, is by grinding such colour as you desire for your use, and adding to it white, to produce the requisite opacity. Blue cloth may be obtained by mixing indigo, indian red, and white. Black cloth, by ivory black, indian red, and perhaps blue. The red is necessary to give the warmth observable in a cloth texture. In silks it is omitted, and blue substituted in greater quantities, according as the silk partakes of the blue tone. It is, however, impossible to make rules for the imitation of colour—the artist's eye is the best guide.

† Gum is used with the colours in finishing your picture. It is the ordinary gum arabic, dissolved in water.

ample treatise on the theory and practice of this beautiful branch of the art of painting.

Edward Greene Malbone,
1777–1807.

EDWARD G. MALBONE—1794,

Became by his own efforts a practitioner of portrait painting in miniature, in the year 1794. He was a native of the beautiful garden-isle of Rhode Island, which had twenty years before given to the world Gilbert Stuart, and born at Newport in 1777. He discovered a propensity for painting at a very early period of life, as is not uncommon ; but with him it grew with his growth, and strengthened with his strength, absorbing all other desires, and at length, becoming so predominant, that he neglected every amusement, and almost every employment suited to his age, for the indulgence of his wishes to acquire knowledge in an art so genial to his taste.

In the Analectic Magazine for 1815, it is truly said, " whoever writes the history of American genius, or of American arts, will have failed to do justice to his subject, if he omit the name of Malbone." From Washington Allston, Charles Fraser, and Mrs. H. Whitehorne, Malbone's sister, I have received such information, as, combined with my own knowledge of the artist and his works, enables me to give his biography with more amplitude and accuracy than any that has heretofore appeared.

When a boy it was his delight to be wherever he could gain any knowledge of the object that his mind dwelt upon ; and appeared determined to pursue any light, that might guide him in his efforts to become a painter. He frequented the theatre, and having seen the effect of the scenery by lamp-light, he anxiously sought to penetrate the mystery connected with these shifting pictures. He gained admittance behind the curtain by day-light, and the repetition of his visits, and earnestness of his examination of every thing belonging to the scenery, attracted the attention of the artist who officiated in that department, and he at length suffered the boy to assist him with the chalk and the brush. After a time Malbone felt bold enough to ask permission to paint a scene, and the request was granted. This was a great step on the ladder to fame. An entire scene, probably a landscape, was produced by the boy, and in due time and proper place exhibited.

This memorable event in the life of young Malbone, must have occurred at the period of the history of American theatricals, when the old American company was divided between Hallam and Henry on the one part, and Wignell on the other ;

leaving Harper to follow the suggestions of his great ambition, which led him to seize upon this throne of Newport, and hold his court in a palace, whose basement story furnished more vulgar food to the citizens than that dealt out by the corps above. The theatre and market-house was the same; butchers above and butchers below. But Harper was an intelligent man, and likely to be pleased by the enthusiasm of young Malbone.

The young painter thus made his *debut* in a branch of art, as dissimilar to that in which he was destined to become unrivalled, as can well be conceived ; and the hand which in manhood guided the most delicate pencil, and touched with colours of exquisite transparency, commenced by wielding the broad brush of the scene painter, redolent from the tub where whiting, yellow-oker, prussian-blue, or rose-pink, were mingled with hot and half putrefied glue.

Malbone triumphed ; and it is probable that his scene was the first thing approaching to nature, which the market for butcher's meat and poetry had ever displayed, either from the brush, the sock, or the buskin. The reward of the painter's success was a general ticket of admission, which was the more acceptable, as it gave him an opportunity of hearing in secret the commendation of his own work—a reward most delicious to authors and artists.

The young painter would doubtless visit the boxes, whenever his scene was to make its appearance ; which probably would be in tragedy, comedy, farce, and pantomime, or wherever a landscape was wanted, whether for Bosworth Field, or the island of Jamaica ; he enjoyed the praises bestowed on his work, on more occasions than he was entitled to. While his companions in the theatre might suppose that he was listening to the actors, he was listening to the compliments bestowed upon the landscape, which by its contrast to the other scenery, would long and often call the attention of the spectators to its vivid colouring. This may remind some artists, of the assiduous attention they have lavished upon the annual exhibition at Somerset House, or Clinton Hall, if they had a picture there exposed to the public ; and of the eager watchfulness of eye and ear they have bestowed upon the visiters who approached the place, where the painting on which their hopes of fame depended, had been hung by the academic hangmen—how eagerly sounds have been caught, and looks watched—and if no signs of approbation could be gathered or imagined, how the heart has sunk, and the injustice of those secretly (or loudly) accused, who placed the pic-

ture in a bad light, or too high, or too low—or destroyed its
effect, by approximation to some overpowering rival produc-
tion.　But the young scene painter had no rival to fear; and
when his picture received the full blaze of the row of foot-
lamps, there was no competitor to vie with it.

While the boy thus amused himself at the theatre, he
filled up his little intervals of leisure from school occupation,
by drawing heads at home, and at length, by attempting
likenesses; and he soon devoted himself altogether to por-
traiture.

Allston, our great historical painter, younger than Malbone
by some years, had been sent from his native state of South
Carolina, for the improvement of his health, and was placed at
school in Newport; he did not, however, become acquaint-
ed with Malbone until a short time before the young miniature
painter threw himself upon his own resources, at the age of
seventeen, and removed to Providence, then become the cen-
tre of the wealth and commerce of Rhode Island.　When
Allston was removed from school at Newport, to Cambridge
College, he found Malbone in Boston, and renewed the acquain-
tance, which soon ripened into friendship.　This was in 1796.
Many years after, Mr. Allston, in a letter to a friend, speaks
thus of the genius of Malbone. "He had the happy talent
among his many excellencies, of elevating the character with-
out impairing the likeness : this was remarkable in his male
heads ; and no woman ever lost any beauty from his hand ; nay,
the fair would often become still fairer, under his pencil.　To
this he added a grace of execution all his own."　This just
tribute to the memory of Malbone, will be found on another
page of this volume, but I could not omit it in either place,
without injuring both Allston and Malbone.　In another let-
ter Mr. Allston says of Malbone, "As a man his disposition
was amiable and generous, and wholly free from any taint of
professional jealousy."

"His rapid progress," says Mr. Fraser, speaking of Mal-
bone's youth, "convinced him that he had talents, and gave
alacrity to his endeavours.　Prospects of fame began to open
upon his mind, and that propensity which had hitherto been
nourished by the mere force of nature, derived additional
vigour from the hopes which increasing reputation and wealth
inspired."　He began now to be known and eagerly sought
after as a miniature painter.　Taste, feeling, and elegance
marked every face and figure that came from his pencil ;
but more especially the forms of females.　He visited the
principal northern cities; the western had then no existence.

New-York, Philadelphia and Boston were in their turn favoured by his residence. "In the winter of 1800, he came to Charleston, where his talents," I again quote from Mr. Fraser, who knew and appreciated him truly, "and the peculiar amenity of his manners enhanced the attentions which he received from the hospitality of its inhabitants."

Allston had returned to his native state that year, after finishing his education in the University of Cambridge, and adding stability to his constitution by passing the years of his nonage in the climate of the north. Mr. Charles Fraser, since an excellent miniature painter, was then a student at law, but his taste and inclinations were those of an artist. Allston, Malbone and Fraser, must have encouraged in each other the desire that led to their subsequent skill—Malbone, already a successful practitioner, was of course the leader.

Although Malbone delighted in conversation, and fully appreciated the frank manners and social habits of the south, the pleasures of the table never led him to neglect the more congenial occupation of his painting room. It was his regular habit to begin study before breakfast, and to occupy himself with the labour he delighted in for the greater portion of the day. Some years after he told the writer that eight hours were his average allowance in each day for his pencil. But in 1800 he painted many more hours in the day, never appearing to weary; and indeed so avaricious was he of time, that he contrived a method of painting by candle-light, making use of glasses, by the means of which he condensed the rays, and threw them upon the ivory. But this was merely an experiment, which did not answer as he wished. It serves, however, to show the ardour of his mind, and his perseverance in the pursuit of his favourite object. This ardent desire after excellence induced sedentary habits, which, although they sensibly affected his health, he could not, or would not discontinue; and the consequence was, that although his desires were pure, the inordinate gratification of them produced pain, disease and death.

In May, 1801, he sailed in company with his friend Allston for London, where he resided some months, absorbed in admiration of the paintings of celebrated masters. With a mind improved by study and observation, and animated by the enthusiasm of genius, he visited the different galleries of living painters, enlarging his ideas through the medium of their labours, and profiting by the study of those processes for the attainment of the wished-for effect, which were discoverable in their pictures.

In a letter to his friend, Charles Fraser, written at this time from London, he thus expresses his opinion of the artists whose works he saw there. " Mr. West is decidedly the greatest painter amongst them for history. Mr. Lawrence is the best portrait painter. Mr. Fuseli, from whom we expected so much, I was disappointed in." By *we*, he probably means Allston and himself. " After Lawrence, I think Sir William Beechy the next in portrait painting, and then Mr. Hopner. Some of Mr. Copley's historical pieces I think very fine. So are Mr. Trumbull's, but I do not admire his portraits. Amongst miniature painters, I think Mr. Shelly, and Mr. Cosway the best. Mr. West has complimented Mr. Allston and myself, and tells us we shall excel in the art. Yesterday was the first time he had seen a picture of my painting; to-day he condescended to walk a mile to pay me a visit, and told me that I must not look forward to any thing short of the highest excellence. He was surprised to see how far I had advanced without instruction." He writes further : " I have not painted many pictures since I left Charleston ; I am painting one now which I shall bring with me. It is ' the Hours ; the past, present, and the coming.' "*

This extremely beautiful picture is in the possession of Mrs. H. Whitehorne, of Newport, Rhode Island, the painter's sister, and although constantly hung up and exposed to the light, is as fresh and strong as when painted. I have seen it more than once, and never saw it without renewed admiration. Shelly, the miniature painter, mentioned above by Malbone as (with Cosway) the first of that day in England, paint-

* The following verses were addressed to the artist by an unknown hand, through the New-York press; and they serve to show the impression made upon his countrymen by this specimen of his study while abroad.

Whoe'er beheld thy rosy Hours,
And could unfelt their beauties see,
The mind is his where darkness lowers,
And his the heart that mine should flee.

May memory to thy mind present
The past with gentle, placid mien,
When hope, prophetic spirit sent,
Waving her golden hair was seen.

And may thy present hours be bright
As the fair angel smiling there ;
Without a cloud to dim their light—
Without a thought that sets in care.

But for the future—Oh! may they
Be crown'd with bliss, and wealth, and fame!
And may this little humble lay
Be lost 'midst songs that sound thy name.

123　THE HOURS, 1801. Painting by Edward Greene Malbone. *Courtesy Providence Atheneum.*

124A RICHARD HARRIS. Miniature by Edward Greene
Malbone. *Courtesy Mrs. Frederic R. Pratt.*

124B MAJOR SAMUEL WRAGG. Miniature by Edward
Greene Malbone. *Courtesy Amherst College.*

ed a picture of " The Hours," from which a print has been published; and as Mr. Malbone saw Shelly's picture, the merit of entire originality in the composition of his " Hours" has been disputed. Mr. Fraser says on this subject, "He informed me that the idea was suggested to him by one of Shelly's that he had seen, although I always understood the composition to be Malbone's." Mrs. Whitehorne says, in her very interesting letter in answer to my inquiries respecting her brother, " I have heard him say that he selected two figures, (and don't recollect from where they were taken) added a third, grouped them, and designed 'The Hours.' " Those who know the truth, taste, elegance, chaste drawing, and clear, strong colouring of Mr. Malbone's pictures painted from nature, and especially his female portraits, will not wish to rest his fame upon a composition even so fascinating as ' The Hours.'

" When in England," says Mr. Fraser, " he was introduced to the president of the royal academy, who, conceiving a high opinion of his talents, gave him free access to his study, and showed him those marked and friendly attentions which were more flattering than empty praises to the mind of his young countryman. He even encouraged him to remain in England, assuring him that he had nothing to fear from professional competition. But he preferred his own country, and returned to Charleston in the winter of 1801."

We have already seen how Malbone writes respecting the flattering and friendly attentions paid him by the amiable West. The American president of the English Royal Academy, some years after, when in conversation with Mr. Monroe, afterwards president of the United States, spoke thus of Mr. Malbone: " I have seen a picture painted by a young man of the name of Malbone, which no man in England could excel."

For a short time in the autumn of 1801, Malbone drew at the Royal Academy, Somerset House, and had as a fellow student a young Scotsman, who has since stood in the foremost rank of British miniature painters, Mr. Andrew Robertson, a younger brother of our fellow citizens, Archibald and Alexander Robertson. I have never seen any thing of Robertson's that equals Malbone's pictures, unless it be the portrait of a young British officer, the son of Mr. John Trumbull, and in his possession. This I have always considered as a perfect specimen of portraiture in miniature.

On Malbone's return to America, the improvement he had made during this very short absence was manifest. After fulfilling his engagements in Charleston, he visited and painted in all our principal cities on the seaboard, and his company

and his pictures were sought by all who could appreciate his conversation or his skill.

In the autumn of 1805, the writer, then endeavouring to recover the use of his pencil, after having laid it aside for near twenty years, by attempting to paint miniatures, found Mr. Malbone successfully exercising his profession in Boston. His price for a head was fifty dollars. His health was then delicate. He suffered from a pulmonary complaint, but physical suffering did not change the mild and amiable temper of his mind, or impart any asperity to his manners. Eight hours of the four-and-twenty were devoted to the pencil, and those in which he mingled in society were not clouded by gloom or complaint.

The practice of the writer in his youth had been first in crayons, then in oil, and he was at the age of forty painting miniatures for subsistence without knowing the proper mode of preparing the ivory for the reception of colours. I met Malbone at the houses of Colonel David Humphreys, one of the aids of Washington, and long ambassador to Spain, and Andrew Allen, then British consul, and I had exposed some of my work to the examination of the accomplished artist as to a master. He saw the difficulty and pointed it out. "You never can execute as you wish until your ivory is prepared to receive colour." While at a dinner party at Allen's, he made an appointment for a meeting the next morning. "They persuaded me to drink some champagne," said he, when the meeting took place, "and my head is splitting." The champagne notwithstanding, he showed me the method of preparing the ivory, and furnished me with many valuable hints in addition.

By nature of a good constitution, although of a tall and slender form, his health declined so sensibly while he continued his confinement and application to his pencil, that he at length yielded to the solicitations of his friends, and broke from his studies to take *that* exercise in the open air, so necessary to the health, without which, man can neither enjoy nor communicate happiness. He repaired to the lovely island of his nativity ; he endeavoured to become an idler and a sportsman. It was too late. He had committed the fault, without intention and without guilt, which could be only atoned for by premature death. Nature has her rights, which, if violated by intemperate study, neglect of exercise, or seclusion from atmospheric air, the violation is punished as certainly as if what is usually called intemperance inflicted the injury. His frame had become too weak. The fiend that had fastened upon his lungs could not be shaken from his hold. His phy-

sicians recommended him to try a change of climate, (a prescription which generally increases the sufferings of the patient, by removing him from the comforts of home and the care of friends,) and in the winter of 1806, he took passage in a vessel for Jamaica and visited that island, but the change not producing the hoped-for benefit, he returned to the first port he could reach in the United States, which was Savannah, where he languished until the 7th of May 1807, when death relieved him from his sufferings, in the thirty-second year of his age.

The works of the miniature painter are, comparatively, little seen ; they may be preserved for ages, but it must be as jewels of less real value are preserved, in caskets.　Their possessors ofttimes do not know their worth, but show them as curiosities or likenesses of relatives, but on such occasions they may meet an eye that can estimate them as works of art. The works of Malbone are spread throughout our country— they are impressed with the seal of genius—the grace, purity, and delicacy of his character are stamped upon them.

The following letter from his sister, in answer to my inquiries, is too honourable to her and to her brother to be withheld from the reader of this work :

" Newport, March, 26, 1834.

" Sir,—Your letter of Jan. 9th, forwarded by Mr. Boggs, did not reach me until February 27th. It would be very gratifying to me to aid your wishes, in giving to the world an accurate biography of my lamented brother, Edward G. Malbone ; but unfortunately I possess few sources of information, excepting the power of recollection. Although many years have rolled away, memory often prompts me to take a retrospective view of the interesting scenes of his early childhood.　He could not have been more than six or seven years of age before any common observer must have noticed many peculiarities wherein he differed from other children. Generally occupied in his own pursuits, he could find but little leisure for play, the intervals of his school hours being filled by indefatigable industry in making experiments, and endeavouring to make discoveries.　He took great delight in blowing bubbles, for the exquisite pleasure of admiring the fine colours they displayed; if he had a curious toy he would invariably take it to pieces, and immediately imitate it so well that the difference was scarcely perceptible ; he actually created his own amusements, and not only his, but those of his associates—being constantly engaged in various ways ;

sometimes cutting moulds and making little toys of lead, then
painting them, thereby greatly recommending himself to his
young friends, among whom he distributed them. He would
frequently raise his kites in the evening with a long appendage
of fire-works, of his own invention, attached to them, to ex-
plode for the pleasure of his companions.

" He soon turned his attention to painting, copying any little
picture that pleased him ; making his own brushes, and pre-
paring his colours, even before he could discriminate between
the different shades, having never seen a paint-box. He
would gather paint stones on the beach, and with the few
colours he could collect, labour till he could make them
answer his purpose. He was naturally very absent, appearing
to be wholly absorbed in his own reflections. I can never
forget how frequently we used to teaze him to join in our
plays, but he would remain entirely inflexible to our entreaties,
until we were induced to ridicule his stupidity and laugh at
his folly in spending all his time in ruminating over all the
old pictures he could collect ; he then would smile and reply,
" You may enjoy your mirth, but you shall one day see my
head engraved ;" always possessing such equinamity of mind
that nothing ruffled, or put him out of his course. About the
age of eleven or twelve, he commenced drawing figures of
gods and goddesses, with Indian ink, upon ivory or bone,
purchasing common handkerchief pins, and expunging the
devices to replace them with his own performances, but more
frequently sawing out the ivory or bone with his own hands,
it being an article which Newport, at that time, could not fur-
nish. When the picture answered his expectations he would
take large brass wire, bend it handsomely, and make the
setting, which would somehow find its way to the neck of the
prettiest girl in the school, as beauty was his particular
admiration. This will give some idea of his perseverance.
His genius daily developing itself, he laboured under every
disadvantage ; his friends rather damping his ardour, judging
that it might interfere with his prospects in future life, not
anticipating in the remotest degree, that he would arrive at
that excellence which he afterwards attained. But he himself
was very sanguine, calculating to go to Europe as soon as he
was old enough. His acquaintance with Mr. Allston com-
menced at an early period, growing into a friendship that
terminated but with his life, opening also a new source of
happiness. He now became much interested in drawing
heads, applying himself closely, and visiting the theatre, by
way of relaxation, listening to the rehearsals, viewing and

making remarks upon the scenery, which, attracting the attention of the scene-painter, he entered into conversation, and showing a disposition to encourage him, he asked the liberty of taking the brush, at which he discovered so much genius, that, feeling gratified by the pleasure evinced by those present, he voluntarily offered to paint a new scene. This was much applauded, and it was so novel a thing for such a boy, that it drew crowded houses. I never heard of any lessons in drawing, engagement as assistant, or any compensation, (excepting a general ticket of admission) until I met with it in the Analectic Magazine; nor were his family circumstances so humble, but that his father could at any time have placed him in a different situation, had not the object been rather to discourage than promote his natural pursuits. It is true that his family, from a combination of unhappy events, were living in retirement, and suffering an accumulation of evils, not however of a pecuniary nature, but from which resulted the operating cause of the neglect of his early education; this was the only misfortune, respecting himself, that I ever heard him lament. He was now generally engaged in his own room, taking but little interest in what was passing around him, daily experience proving that his mind was wholly bent upon perfecting himself in the art of painting. About the age of sixteen he painted upon paper, Thomas Lawrence, which was so universally admired by every person of taste, who saw it, that his father could no longer shut his eyes to his decided talent, but having neither drawing nor painting masters in Newport, he sent the picture by a friend to Philadelphia, to a French artist (with a request to receive him as a pupil) who was so much struck with the performance that he immediately replied, " De boy would take de bread out of my mouth." Requiring several years services and so exorbitant a sum of money, that his father did not think proper to comply with his terms, flattering himself that some opportunity would present of placing him to more advantage. But this spirit of procrastination not being in accordance with the youth's feelings, at seventeen he determined to throw himself upon his own resources. Communicating his plans to no one but myself, he proposed a visit to Providence, and immediately brought himself before the public as a miniature painter, and so warmly was he received, that several weeks passed away before he apprised his father of the step he had taken. He now wrote a letter to his father, and two to myself, which I regret its not being in my power to forward, having sought for them in vain; they were worth preserving,

as they expressed his hopes and views for the future so
powerfully, and at the same time so much filial obedience to
his father's wishes. Continuing pleased with his flattering
reception, daily improving, and successful in his likenesses, he
remained in Providence thirteen months, until he was recalled
by the sudden illness of his father, which terminated in death
before he reached home. After the funeral, October 1795,
he returned to Providence, continuing fully occupied until the
following spring, when, making us a visit, he received much
flattering attention from the gentlemen of the town, particu-
larly the British consul, Mr. Moore, who exercised great
hospitality towards him, losing no opportunity to introduce
him to strangers of distinction, endeavouring to promote his
interest, and being about returning to England with his
family, kindly urged his joining the party, setting before him
the advantages that must result from it—that it should cost
him nothing, and when arrived in England he would make
every exertion to forward his views among powerful friends.
It was now that his affectionate heart shone forth in all its
lustre; a youth of scarcely nineteen, to decline so favourable
an opportunity, when all his hopes and wishes would have
been so much gratified by the acceptation ; but his three sis-
ters were without a parent, young, and left in embarrassed
circumstances, requiring a protection, and no earthly good
could have tempted him to leave his country. A friend now
advised his going to Boston in 1796, to which he acceded,
and was immediately introduced to, and found friends in many
of the most distinguished characters. His natural refinement
and engaging manners being so prepossessing, that letters of
recommendation seemed hardly necessary : his Boston friends
appeared to vie with each other in the exercise of their hos-
pitality. Had he availed himself of half their politeness, he
must have had but little time to devote to his profession ; it
was, however, very gratifying to such a youth, and he ever
cherished a lasting remembrance of their kind attention.
This will show how highly he was estimated.

 " His reputation now began to make some noise in the
world, being constantly employed and always successful,
merely allowing himself time to visit us once a year, and ex-
erting all his powers to promote our happiness. In 1798 I
was married. In the course of that year several of his friends
were very urgent for him to go to Europe, offering to loan
any sum of money he might require, without interest, which
he declined, I believe, from an innate principle of self-depen-
dence, shrinking from the bare idea of obligation, being

predetermined to create his own fortune and rear his own fame. His younger sisters were now with me. The year previous, however, he visited New-York (1797) for the first time—his good fortune still preceding him—making many friends and being liberally employed. But feeling an anxious desire to visit all our cities, the succeeding spring he went to Philadelphia, with equal success. In the summer the yellow fever becoming prevalent, obliged him to go into the country; even here he found full employment. After this he passed his time alternately in the different cities until 1800, the summer of which both Mr. Allston and himself passed in Newport, and perhaps it was the happiest of his life, being surrounded by the friends he loved best. In the autumn they both went to Charleston, S. C., his reception being as flattering as his most sanguine wishes could have anticipated, and enjoying the most delightful society; his acquaintance with Mr. Charles Fraser commencing here, he soon ranked among his warmest friends. His affairs being very prosperous he determined upon going abroad, and embarked about the middle of May 1801, for London, in company with Mr. Allston. His reception by the president of the Royal Academy was so flattering, that it could not fail to give him confidence in himself, holding out every inducement for him to remain in Europe; and having free access to the school of the arts his improvement was very rapid. He now painted the "Hours" and several female heads, which were highly eulogised by the president, Mr. West, saying that no man in England could excel them, and that he had nothing to fear from professional competition; but his private affairs requiring his attention, he returned to Charleston in December of the same year.

"His reputation now standing very high, he was crowded with business. The summer of 1802 he returned to Newport. His sisters being all married, he occasionally visited the different cities, agreeably to the wishes of his numerous friends, yearly contemplating another visit to Europe; but being so fully employed, and devotedly attached to his own country, he found it difficult to put his wishes in execution until 1805, when he sailed for Charleston in December, with the intention of going to London the following spring. But alas! in March he took a violent cold, which settled upon his lungs; his sedentary mode of life contributing greatly to hasten on the disease, which proved so fatal that medical aid was vain. He returned to New-York in June, very feeble and much emaciated, and soon after to Newport, where he ap-

peared to recruit a little ; laying aside his pencil, indulging
in riding and exercise of various kinds. Being very fond of
field sports, in shooting, he ran to pick up a bird ; the act of
stooping suddenly brought on a hemorrhage, which confined
him to his bed. His physicians, anxious to save him, advised
riding ; and I travelled about the country with him for some
weeks ; but not deriving any benefit, the physicians recom-
mended a warmer climate, which he very reluctantly con-
sented to try : considering it his duty, however, while there
remained a ray of hope to submit, although against his own
judgment, he accordingly sailed for Jamaica, December 1806.
The voyage not proving of any advantage, and finding him-
self rapidly declining, he was very anxious to return, and took
passage for Savannah, hoping to be able to reach Newport as
soon as the spring opened ; but there he languished until the
7th of May, 1807, which closed his valuable life ; his passage
being taken for Newport only two days previous, so anxious
was he to end his days among his dearest friends.

" His private character was truly unexceptionable : amiable
and excellent from the first dawn of reason ; greatly beloved
by all his friends and acquaintance ; the pride and delight of
his family—but he has passed away like a bright vision, leav-
ing the sweet remembrance of his devoted affection and his
many virtues indelibly engraved upon the hearts of his few
surviving relations. He was born in August, 1777.

" I have had several applications from gentlemen wishing
to collect particulars of his early life, two within a few months ;
one from a gentleman in Albany, and one from an English
gentleman ; but have furnished nothing excepting to Colonel
Knapp, I think in 1828—sending him some newspaper bio-
graphies, and at the same time mentioning some little incidents
of his early childhood to the gentleman who forwarded the
papers. You, sir, have probably seen his Lectures upon
American Literature, wherein he speaks very handsomely of
my brother, not giving him credit for his manner of colouring
however, which was in such high repute that it has been twice
sent for from Europe since his death. Col. Knapp observes
that his colouring fades like the hues of the rainbow ; but at
the same time says that he has only seen some of his early
productions, which makes his apology. I wish he could see
his " Hours," the tints being as vivid as when his hand gave the
finishing touch, although it has hung up more than twenty
years. His mode of colouring being peculiar to himself, and
considered one of his greatest excellencies. Col. Knapp also
observes that he shall reserve what information he has gained

for a more ample page, when I trust that error will be corrected.

"A gentleman going to Europe the next year after his death, begged to be entrusted with several female heads of his; took them to the president, Mr. West, who asked the favour of retaining them a while;—when the gentleman called for them, he said he could hardly bear to give them up, as he considered them invaluable. I hope, sir, if you ever come to Newport, you will call, that I may have the pleasure of showing you the "Hours," having no other productions of his in my possession, excepting a few unfinished heads. Mrs. Cosway's "Hours" is quite new to me;* and being certain that my brother never arrogated any thing to himself, do not understand it. I have heard him say that he selected two figures, (and do not recollect from where they were taken,) added a third, grouped them, and designed the "Hours."

"Trusting that this concise statement may be useful, I now refer you to the gentlemen named, Mr. Allston and Mr. Fraser, who can furnish much information, and am, sir,

"Respectfully yours,
"H. WHITEHORNE."

I continue my notice of this gentleman by a quotation from the author of his biography in the Analectic Magazine :

"It too often happens that the biographer, after dilating with enthusiasm on the merits of the artist, is obliged with shame and mortification, to confess or to palliate the vices or grossness of the man. The biographer of Malbone is spared this painful task ; all his habits of life were decorous and gentlemanly, and his morals without reproach. His temper was naturally equable and gentle ; his affections were warm and generous.

"The profits of his profession, which, after his return from Europe, were considerable, were always shared with his mother and sisters, to whom he was strongly attached.

"In that branch of the art to which he had chiefly devoted himself, Malbone deserves to be ranked with the first painters of the present, or indeed of any age. The works of Isaby, the first living French artist in this way, are certainly not so good as his ; nor is it believed that there are many English miniatures equal to them. This is not the empty praise of an unskilful panegyrist, but the sober opinion of practical artists.

* I had mentioned Shelly's "Hours ;" or perhaps, by mistake, wrote, "Cosway."

" There is, in the European academies, a certain aris-
tocracy of taste, which has somewhat unjustly degraded minia-
ture painting to a low rank in the scale of the imitative arts ;
so that every underling designer of vignette title pages to
pocket editions of the poets, has attempted to consider himself
as belonging to a higher order of genius, than the painter who
delineates ' the mind's expression speaking in the face.'

" Yet Reynolds entertained a very different opinion of por-
traiture as a field for the exertion of genius ; and he pronounces
the power of animating and dignifying the countenance, and
impressing upon it the appearance of wisdom or virtue, to re-
quire a nobleness of conception, which, says he, ' goes beyond
any thing in the mere exhibition even of the most perfect
forms.'

" This degradation of miniature painting is, however, in no
small degree to be ascribed to the faults of its professors.
They have generally limited their ambition to a minute and
laboured finishing, and a gay and vivid, but most unnatural
brilliancy, of bright colouring. They content themselves with
painting only to the eye, without addressing the mind, and
their pictures are, therefore, portraits of Lilliputians, or, at
best, of men and women, seen in a *camera obscura*, but never
the ' pictures in little' of real and living persons. Now,
Malbone had none of these faults, and almost every excellence
which can be displayed in this kind of painting. He drew
well, correctly, yet without tameness. He had acute discern-
ment of character, and much power of expressing it. He had
taste, fancy, and grace; and in the delineation of female beauty,
or gay innocent childhood, these qualities were admirably con-
spicuous. His pre-eminent excellence was in colouring ; such
was its harmony, its delicacy, its truth. His miniatures have
most of the beauties of a fine portrait, without losing any of
their own peculiar character.

" In the arts, the miniature may be considered as holding
the same relative rank that the sonnet does in poetry, and the
peculiar merit of Malbone is precisely of the same kind with
that of the poet, who, without violating the exact rules, or the
polished elegance of the sonnet, is yet able to infuse into it
the spirit, the freedom, and the dignity of the ode, or the epic.

"To all this he added the still rarer merit of originality ; for
he was almost a self-taught painter. Though, whilst he was
in England, he doubtless improved himself very much by the
study of fine pictures, and the observation of the practice of
West, and other great painters of the day ; yet it has been said
by artists, that the style and manner of his earlier and later

works are substantially the same, and those painted after his return from Europe are only to be distinguished by their superior delicacy of taste, and greater apparent facility of execution.

" The few pieces of larger composition, which his hurry of business left him time to complete, have the same character of grace and beauty.

" He occasionally amused himself with landscape. His sketches in this way were but slight, and are valuable only as they show the extent of his powers. There is one little piece of his which is said to be a mere sport of imagination : it possesses a singularly pleasing effect of pastoral sweetness.

" In the latter years of his life, he tried his hand in oilpainting, in which he made a respectable proficiency. That he did not attain to great eminence in this branch, was owing, not to any want of talent, but to that of leisure and health ; for so much of his excellence was intellectual, and so little of it purely mechanical, that with requisite application, he could not have failed to acquire distinction in any department of the art."

The biography of Malbone appears like a studied panegyric. I can sincerely avow that I never heard ill of him ; nor do I know of an action in his short life that was not praiseworthy. If I had heard or known of his assuming a character that did not belong to him, or making any pretensions to *that*, which he was *not*, I would have exposed his turpitude unsparingly. If he had been addicted to vices, I would have recorded them. But truth and virtue were his guides ; and all testimony agrees that he was a good man, and a great artist.*

* Having received the following letter unexpectedly, I subjoin it to the previous notice.

" Newport, Sept. 9th. 1834.

" Dear Sir—I am happy to learn, through Dr. Francis, that my letter of the 20th of March was satisfactory. He has expressed a wish to know where the finest specimens of my brother's paintings are to be seen. Upon looking over some of his papers I find the following memorandum, dated April 6, 1807, a month only before his death.

' Presented to Mr. Robert Mackay, of Savannah, Georgia, a Miniature Picture representing Devotion, as a present for Mrs. Mackay, (who was then in England to Mr. Mackay, a miniature of a Scotch Lady.'

" Mrs. Mackay has also in her possession either two or three female heads, of the most exquisite finishing— some of the finest of his productions ; and a small picture of the Birth of Shakespeare, done in umber. These pictures were loaned to take out to London ; and, from some unfortunate circumstances, were never returned.

" There is a fine Miniature of Colonel Scolbay, of Boston, in possession of his daughters ; they told me that Stuart used to come, at least once a year, to see

CORNELIUS TIEBOUT—1794.

Born in New-York, probably about the year 1777, began to show his propensities for drawing and scratching on copper at an early age, and made some progress in engraving on copper in 1790, while an apprentice with J. Burger a silver-smith of New-York. In the year 1794, he engraved several heads for my German theatre then publishing; but it is believed that he received no regular instruction until he went to England about the year 1796. Mr. Rollinson, one of our oldest engravers at this time, (1834,) and still in the vigour of life, informs me that Mr. Tiebout was employed by Burger, during the latter part of his apprenticeship, in engraving, and on becoming free, immediately commenced engraver, and had as a pupil Benjamin Tanner, well known since. Mr. Tiebout engraved for an edition of Maynard's Josephus published by Mr. Durell. In 1796 went to London for instruction, and worked with Heath. He returned very much improved, for the old methods as described in the books, seems to have been previously his only guides. He engraved a head of John Jay, and the battle of Lexington, from a design by Tisdale. The latter has no claim to praise—it is feeble. Mr. Tiebout was the first American who went to London for instruction in engraving, and about the same time Alexander Lawson came to America and made himself an excellent engraver without instruction.

On his return from Europe, Mr. Tiebout chose Philadelphia as the place of his residence, and worked for Mathew Carey, and other publishers of books. After living prosperously and accumulating property, he engaged in a speculation for the manufactury of blacking, and was ruined. One among the many who leave the path they are accustomed to, and lose

it, desiring them to take great care of it, as it was decidedly the finest miniature in the world.

"Agreeably to Dr. Francis' request, I subjoin a list of some of the paintings done in Charleston, S. C. in 1803 and 1804; the memorandum for 1805 and 1806, &c. not being at hand.

"Dr. Bruilesford; Mr. R. A. Fraser; Mrs, Cockran; Mrs. Ball; Mrs. Thomas Pinckney: Mr. Sam. Sawbere; Mrs. F. Rutledge; Mrs. F. Haywood; Mr. Vaughan; Mrs. Sinkler; Mrs. Trappere; Miss Huger; Mrs. Edward Rutledge; Mrs. Loundes; Major Wrag; Mr. Manigault; Mrs. Poincet; General Pinckney; Major Hamilton; Dr. W. Allston; Mrs. Middleton; Mr. Izard's three daughters; Col. Chesnut; Mr. Bowman; Mrs. Calhoun; Miss Sarah Loadson; Miss Fenwick; Mrs Gadson; Dr. Poinsett; Miss Poinsett; Dr. Drayton; Mr. Ratcliff. He also painted a picture of Col. Trumbull, and a number of others, in New-York."

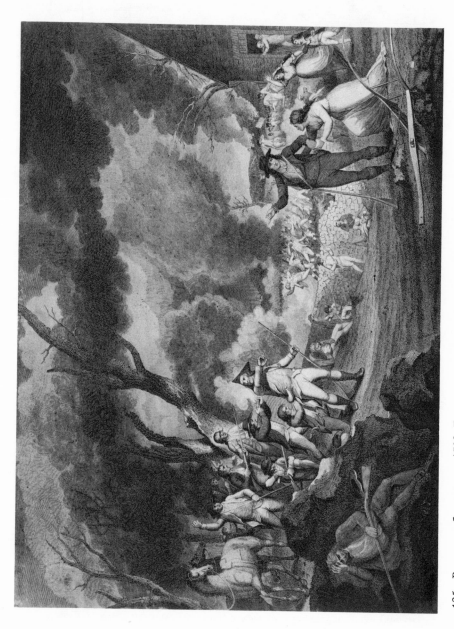

125 BATTLE OF LEXINGTON, 1798. Engraving by Cornelius Tiebout after painting by Elkanah Tisdale. *Courtesy Library of Congress.*

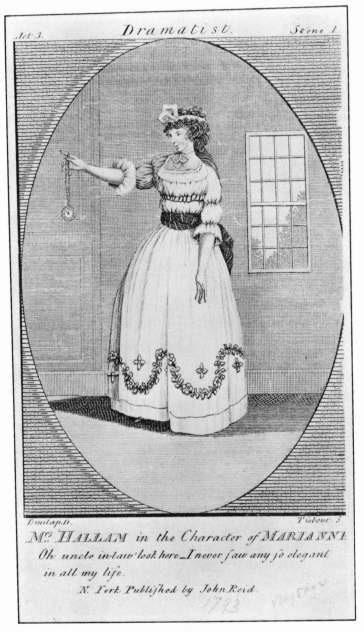

126 Mrs. Hallam as Marianne in "The Dramatist," 1793. Engraving by Cornelius Tiebout after William Dunlap. *Courtesy Harvard University Theater Collection.*

themselves. He exhibited in the Pennsylvania Academy in 1811–12 and 13. After his failure he removed to Kentucky only to die.

===

CHAPTER III.

John Vanderlyn—Born at Kingston 1776—Taught to draw by Mr. Archibald Robertson—Patronised by Colonel Burr—Sent to Paris—Returns home and again visits Europe—Two years in Paris—Studies in Rome—His picture of Marius—Ariadne—Sketches for a panorama of Versailles—Return home—De Witt Clinton's portrait—Panoramas—Corporation of New-York and rotunda—Mr. Vanderlyn's successful picture for Congress.

JOHN VANDERLYN—1795.

John Vanderlyn, 1775–1852.

In my biographical sketch of Mr. Vanderlyn I shall make use of a memoir written by a friend of the artist ; but, as it is not the intention of my work merely to praise, I shall make use of my own knowledge, and give my own opinions both of the painter and his works. Mr. Vanderlyn's friend says :

" This distinguished artist was born in Kingston, Ulster county, in the state of New-York, in October 1776. In the following year his native village was laid in ashes by the British troops, under the command of General Vaughan, and his family were among the principal sufferers ; but however reduced in property, Mr. V.'s parents were still able to afford him, at the proper age, the benefits of a liberal education, at the Kingston academy, then one of the most flourishing in the state, where he continued until the age of sixteen. His attainments at this period were such as to have qualified him for the pursuit of the liberal professions.* His eldest brother, Peter Vanderlyn was a physician of eminence in Kingston, and in the autumn of 1792, young V. accompanied him on a visit to the city of New-York, and was introduced by him to the late Mr. Thomas Barrow, well known in this city at that time as a gentleman of cultivated taste in the arts."

Mr. Barrow was an Englishman, and originally a coach-painter. He remained in New-York during the revolutionary war, and was the only dealer in good prints. His second wife was sister to Bishop B. Moore, and by this connexion with the church he gained more than by his connexion with the fine arts. He deserves a notice in this work as aiding their progress.

" Mr. B. was a large importer of engravings, and young V.

* Does the writer mean that he did not pursue a liberal profession ?

from his early predilection for the art, was easily prevailed on
to enter into the store and employ of Mr. B., and continued
there for the period of about two years; it was here that his
taste for the art developed itself more fully; from his familiar-
ity and daily contemplation of the finest specimens of engrav-
ings and inspired him with the hope of perhaps one day be-
holding, and emulating at some future day their glorious ori-
ginals. At this period he occasionally attended, at leisure
hours, the drawing school of a Mr. Robertson, who had re-
cently arrived from England."

Mr. Archibald Robertson, here affectedly styled " a Mr.
Robertson," is mentioned in this work under date 1791, at
which time he arrived in the country. Vanderlyn received
three years tuition at the school established by Mr. R. who
was well able to instruct him or any tyro in the art of drawing.

"It was also during his stay with Mr. Barrow that Stuart,
the celebrated portrait-painter, arrived from England; and it
was then young V. became acquainted with him, and was per-
mitted to copy some of his portraits, among which were those
of Colonel Burr and Judge Benson. In the autumn Mr. V.
returned to Kingston, carrying with him his two copies, and
disposed of that of Colonel B. to Major Van Gaasbeck, then
a member of congress from Ulster county. After spending the
winter in Kingston, in the occupation of painting portraits,
he again, in the spring, returned to the city and engaged in
the business of portrait painting, and it was during the summer
here that he received an anonymous letter inviting him to call
at the corner of Church and Fulton, then Fair-street, which
proved to be the office of Colonel Burr; he was there directed
by the late Judge Prevost to Richmond Hill, then the residence
of Colonel Burr. He accordingly went thither without any
loss of time, and had his first interview with Colonel B. who,
after bestowing compliments upon his early skill and attain-
ments in the arts, proffered him his aid to enable him to prose-
cute his studies at the first schools of Europe, after he had been
with Mr. Stuart for a short time. Mr. V. accordingly repair-
ed to Philadelphia, in which city Mr. S. then resided. After
spending eight or nine months with him, during which time
he copied a large picture by Van Ostade for his patron, Mr.
V. returned to New-York, and executed a few portraits for
Colonel Burr, among which were those of the French minister
Adet, Albert Gallatin, and Miss Burr, Colonel B.'s daughter.

"In the same year, the fall of 1796, he embarked for
France, arrived at Bordeaux, and without delay hastened to

Paris, furnished with letters of introduction from the French minister to several men of distinction, and Mr. V. had also the pleasure to meet there Mr. Prevost, then secretary to Mr. Monroe, the American minister. Mr. V. was soon recommended to the school of Mr. Vincent, an eminent painter, and a cotemporary of David.

" In 1801 Mr. V. returned to his native country, bringing with him also a few copies from the first masters, and studies, which he had executed while in Paris. At this period, in 1802, he painted two views of the Falls of Niagara, which were afterwards engraved and published in London, in 1804. He also painted a portrait of Colonel Burr and another of his daughter, then the wife of Governor Allston of South Carolina.

" In the spring of 1803 he returned again to Europe, and was at this time commissioned by the American Academy to purchase a collection of casts from the antique, and such pictures as he might be able to procure from time to time. This institution had been then just established, and owed its origin to Chancellor Robert Livingston, then American minister to France; and the Hon. Edward Livingston, then mayor of our city was its president.*

" After remaining two months in France, he crossed over to England in company with Mr. Monroe, from whom he received the most friendly attentions and civility in London. In November of the same year he returned to Paris by the way of Holland and Belgium, in company with his countryman and brother artist, Washington Allston. He remained in Paris, on this occasion, two years. During this time he made portraits of Col. Mercer, of Virginia, and Wm McClure, esq. of Philadelphia, whose life abounds with acts of the most disinterested liberality, the latter tendering him pecuniary aid to enable him to visit Rome. He also painted for Joel Barlow, then residing in Paris, the death of Miss McCrea, which was his first essay at historical painting. About this time he met with Washington Irving, who was on his first visit to Europe. Mr. I. was travelling for his health, and came to France from Italy. He made a small sketch in chalk of this distinguished gentleman in the summer of 1805.

" Mr. V. left Paris in August of this year for Switzerland, where he tarried some weeks. He met his friend, Mr. McClure, at Geneva, and in company with him visited Ferney,

* See the article Academies in this work; where it will be seen that Dr. Joseph Brown, the brother-in-law of Colonel Burr, was one of the directors.

Lausanne, Vevay and Clarens, classic ground, even before
they were visited by the muse of Byron. He also visited the
vale of Chamouny, at the foot of Mont Blanc, rambled amid
the sublime scenes of Savoy, and extended his excursion into
the Cantons of Switzerland as far as Altorf on the road to
Mont St. Gothard. In October of that year he crossed the
Alps, by the pass of Mont Cenis, from whose summit he had
the pleasure of his first view of the plains of Lombardy, and
the beautiful sky of Italy. At Turin he stopped a few days,
thence proceeded to Milan, where he visited the works of art
of many of the Italian masters, and among others, the original
"Last Supper," by Leonardo da Vinci, the wreck of a splen-
did painting, and one of the master-pieces of the art. From
Milan he passed through Lodi, Placencia, Parma, where he
tarried a short time, and was gratified with a sight, although too
hurried fully to enjoy it, of some of the splendid frescos of Cor-
regio in the churches. Passing through Modena and Bolog-
na, he was gratified with some more works in painting, and
then crossed the Appenines, the wild scenery of which remind-
ed him of the style of Salvator Rosa, whose genius was nur-
tured by such scenes. He spent four or five days in Florence,
a city rich in works of sculpture, architecture, and painting—
noble and immortal monuments of her former wealth and great-
ness. The Florentine gallery is one of the most celebrated in
Europe, and the churches are also adorned with splendid
paintings by the early masters, all of which he now had an
opportunity of beholding. He thence proceeded to Rome, by
the way of Sienna and the lake of Bolsina, and arrived there
in the month of November.

"He was rejoiced to meet again with his friend Mr. Allston,
who had preceded him by a twelvemonth to this seat of the
arts, with views similar to his own, and they were the only
American artists at that time in the city. He remained there
upwards of two years, and occupied himself with zeal and en-
thusiasm in his favorite study, copying from the works in the
Vatican, making sketches from nature, and visiting the nume-
rous works of art which embellish that far famed capital.

"During the second year of his residence at Rome, he paint-
ed his celebrated picture of 'Marius amid the ruins of Car-
thage,' which met the general approbation of the artists assem-
bled there, and gave him reputation.*

* Mrs. Child has published the following beautiful lines on Mr. Vanderlyn's
Marius:

> Pillars are fallen at thy feet,
> Fanes quiver in the air,
> A prostrate city is thy seat—
> And thou alone art there.

"In Rome it was customary for the foreign artists who resorted there for improvement in their profession, to meet together to draw from the living model, and Mr. V. with his friend Allston, attended an association, composed of young artists from different parts of Germany, Sweden, and Denmark. The French also had their own academy *de Rome.* While our young countrymen were studying their profession at Rome at their own expense,† and striving to obtain an art then but little cultivated at home, there were numbers of students from various parts of Europe, who had been sent there at the expense of their governments and their princes. Mr. V. was destitute of fortune, and could not have remained at Rome had it not been for the aid received from his friend Mr. McClure, already mentioned. Notwithstanding both he and Mr. Allston were without public patronage, and the eclat which always attends it, they were fully successful in contending for the honours of their art with the more favored protegés of the European monarchs. Mr. V.'s residence at Rome was, a part of the time, in a dwelling formerly occupied by Salvator Rosa, and he made a sketch of the garden, which is now in the possession of William Carter, Esq. of Virginia.

No change comes o'er thy noble brow,
 Though ruin is around thee :
Thy eye-beam burns as proudly now
 As when the laurel crown'd thee.

It cannot bend thy lofty soul,
 Though friends and fame depart ;
The car of Fate may o'er thee roll,
 Nor crush thy Roman heart.

And genius hath electric power,
 Which earth can never tame;
Bright suns may scorch, and dark clouds lower,
 Its flash is all the same.

The dreams we loved in early life,
 May melt like mist away;
High thoughts may seem 'midst passion's strife,
 Like Carthage in decay.

And proud hopes in the human heart,
 May be to ruin hurl'd,
Like mouldering monuments of art,
 Heap'd on a sleeping world.

Yet there is something will not die,
 Where life hath once been fair ;
Some towering thoughts still rear on high,
 Some Roman lingers there.

† I have omitted the words "and with no selfish views; but to add, if possible, to their country's renown," as savouring of something Mr. Allston would not join in.

"In 1808 he re-crossed the Alps, and again returned to Paris. He exhibited his Marius in that capital, and received the Napoleon gold medal, which was awarded to him by the professors of the Academy of Artists, for having produced that painting, a work of the first merit. In the gallery of the Louvre, he made a copy of Correggio's admirable picture of Antiope, as large as life. This copy, placed alongside of the original, was greatly admired by the artists of the French metropolis."

I first saw this admirable copy at the house of John R. Murray, Esq. from whom, I then understood, Mr. Vanderlyn had received a commission to copy a picture for him. Murray admired it, but he said "What can I do with it? It is altogether indecent. I cannot hang it up in my house, and my family reprobate it." The artist had consulted his own taste, and the advantage of studying such a work, more than the habits of his country, or the taste of his countrymen.

"It has since been exhibited in the Rotunda of our city. He also copied a head, with the hands and arms, after a female figure in the transfiguration of Raphael, now in the possession of Philip Hone, Esq.; also, two or three figures of reduced size from a picture representing Leda and the swan, by Correggio, which he sold in Paris to a gentleman of Salem, Mass.; also, he made a copy of Danae, of the size of life, after Titian, and which has likewise been seen and admired in the Rotunda. In 1812, he painted Ariadne, an original picture,* and also, from time to time, employed himself on portraits and minor works. At this period, when on a visit to Versailles, he formed the project of a panoramic view of its splendid palace and gardens, which was suggested by a visit which he made in 1814 to that celebrated residence of the monarchs of France. He was occupied in the sketches for some months, and these completed, he returned to the United States in 1815, having been detained for some time by the events of the war. He brought with him Danae, Ariadne, and some smaller pictures, both originals and copies. Marius and Antiope were sent home under the care of our Minister to France, General Armstrong, previous to the close of the war.

"Immediately on his return to his native country, he was employed in painting the portraits of some of our most distinguished fellow citizens, and among the rest, of President Madison and Monroe, Vice-President Calhoun, and of gover-

* This picture has been purchased and engraved by A. B. Durand, Esq. himself an excellent painter, and our first engraver. This painting proved Mr. Vanderlyn's powers even more than the Marius, and is in my estimation the finest figure of the kind I have ever seen. The engraving of Mr. Durand is worthy of it.

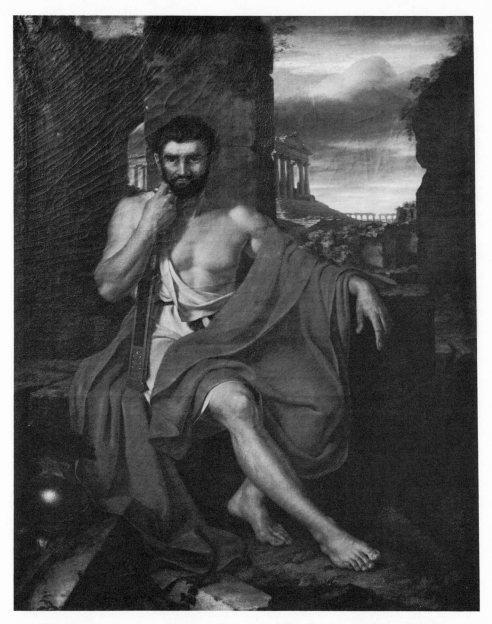

127 Marius amidst the Ruins of Carthage, 1807. Painting by John Vanderlyn. *Courtesy M. H. de Young Memorial Museum, gift of M. H. de Young.*

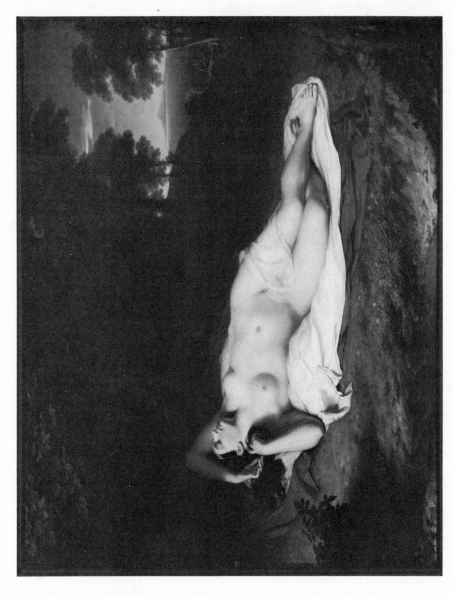

128 ARIADNE ASLEEP ON THE ISLAND OF NAXOS, 1814. Painting by John Vanderlyn. Courtesy The Pennsylvania Academy of the Fine Arts.

nors Yates and Clinton. The portrait of Governor Clinton, was painted for the Literary and Philosophical Society. He has also painted two portraits of General Jackson, one for Charleston, South Carolina, and the other for this city; also a full length portrait of President Monroe, for this city."

The word "immediately," in the preceding paragraph, gives a false gloss to the whole, and prevents the reader from forming a just estimate of Mr. Vanderlyn, and his condition as an artist and a man for a long period. That he painted the portraits mentioned, is true; but at times long distant from each other; years intervening.

The pictures were of various degrees of merit, and generally much inferior to what was expected from the author of the "Marius," and the "Ariadne."

I have elsewhere described the manner in which John R. Smith made his attack upon Mr. Vanderlyn, and his pictures, before the directors of the incipient American Academy of Fine Arts. He failed, but the instigator prevailed, and Mr. Vanderlyn's pictures were turned out. I am permitted to copy from a letter of Mr. V's, some passages which ought to be known. After noting some inferior symptoms of jealousy he proceeds: "The instance which is more deserving of being noticed, and of which there can be no doubt, he (Trumbull) was the prime mover, was, when I had my pictures in two rooms of the old alms-house, forming a part of what was allotted to the academy of arts. I had obtained permission of the president of the society, then De Witt Clinton, to have the use of these rooms, and there was then no talk or appearance that the academy would soon be resuscitated, and my friends Judge B. Provost and others, led me to believe that I should not be disturbed in their possession, for at least six months. I had these rooms fitted up as soon as they were vacated by these former tenants, and spent fifty dollars in cleaning, painting, and colouring the walls. After my exhibition was open two or three weeks, I went up the river, in July, leaving it in charge of the keeper. During my stay in the country, I received a letter from Mr. Murray, the vice-president, that they would have need of the rooms, and requesting me to remove my pictures. This appeared ungenerous, and was injurious to me. I hastened to town and found one room already cleared. I have sufficient reason for believing that it was through the influence of Trumbull, with D. Hosack and Murray, that these resolutions and measures were adopted. How far John R. Smith was instigated by Trumbull, I

do not now recollect. I am not able to affirm that he was evidently encouraged to it by Trumbull—I remember to have heard Smith say, that he heard him use such language as " damn the pictures, I wish I had never seen them." In the same letter Mr. V. says, " Trumbull made a proposition to two or three of my subscribers and trustees of the rotunda, during my absence at Washington, about two years after the existence of the rotunda, when he had eng aged in the government pictures ; he understanding that the rotunda laboured under a debt, still due to the builder, made overtures to purchase the building without consulting me ; seemingly indifferent how far my interest was affected. The trustees of course, could not listen to any such proposition. Dr. Mott ; Augustus Wynkoop ; and C. D. Colden, had all been spoken to for this purpose. When I mentioned this affair to Mr. Allston, he could scarce believe it possible."

It was this gentleman's misfortune, that Mr. Trumbull returned to New-York, after a residence of many years in England, in the year 1816 ; and *his* reputation did not rest alone upon the pictures which he brought with him, but on those he had painted in former days, and under the inspection of West ; (of which, very fine engravings were spread abroad,) and on the well known unfinished, and nearly finished historical compositions which he had shown in 1790 ; besides the beautiful miniature portraits of revolutionary men, in former times, painted by him with great perseverance and activity. The association called the American Academy of Fine Arts, was revived, and Trumbull elected president. This was followed by his obtaining a commission for four pictures, at eight thousand dollars each, from congress. Mr. Vanderlyn felt and knew that he was a better artist at this time than Trumbull ; but *he* had the start of him ; and the public knew nothing, and cared little about it. I remember well when Mr. Vanderlyn visited me at my house, and inveighed upon the injustice of giving all the government patronage to Trumbull, I answered, that he had a fair claim, as he had collected the portraits to be introduced, and no one else possessed them.

When the first exhibition was got up, Mr. Vanderlyn intended placing his noble Marius before the public, in the room fitted up in the old alms-house, but the place he wished was denied him by the president, and he exhibited nothing.

I now recur to the memoir again, and the first subject is that of panoramas. " While in Europe he had beheld panoramic exhibitions with admiration, and witnessed their success in Paris, as well as in London ; and felt confident that if they

were approved and popular in capitals, whose galleries abound in *chef d'œuvres* of art, their success would be certain in our cities, where, comparatively, no such competition as yet existed. In fact panoramic exhibitions possess so much of the magic deceptions of the art, as irresistibly to captivate all classes of spectators, which gives them a decided advantage over every other description of pictures; for no study or cultivated taste is required fully to appreciate the merits of such representations. They have the further power of conveying much practical, and topographical information, such as can in no other way be supplied, except by actually visiting the scenes which they represent, and if instruction and mental gratification be the aim and object of painting, no class of pictures have a fairer claim to the public estimation than panoramas.

" It was under these circumstances that the corporation of New-York, in 1817, was induced to grant him the privilege of erecting a building for this object upon the public ground in the north-east corner of the park; and with a liberal and laudable motive of embellishing the spot, he proceeded to erect a building worthy of the merits of the institution and the character of our city; and to which he gave the name of the New-York Rotunda. In the prosecution of his plan, he had the misfortune to involve himself in some pecuniary difficulties, arising from the excessive cost of the building. Eight thousand dollars was the estimated expense of the structure he had projected; and if ten thousand had sufficed, no difficulties would have ensued which could not easily have been surmounted. And those which did arise would probably have been surmounted, had he been present to superintend the progress of the work, which he was prevented from doing by other pressing and indispensable engagements, connected with the institution. The work, however, went on, and the building was erected at a cost of between thirteen and fourteen thousand dollars; all which was paid, with the exception of about three thousand five hundred dollars, which remained due to the builders and others who had furnished the materials; and it was this unliquidated balance which was finally the cause of his being deprived of the building, at a time when he had just begun to realize some of the hopes which he had formed at the commencement of the project.

" It was through the liberality of private individuals, some the personal friends of Mr. V., and all friends of the liberal arts, who were desirous of patronizing him, as well as of adding to the attraction and character of our city, that he was

supplied with a principal part of the funds disbursed on the building, he himself furnishing about twelve hundred dollars out of his private resources. The lease of the ground granted to him by the corporation, was for nine years, with a nominal rent; and although there was no express clause of renewal, Mr. V. had received every assurance from the then mayor, the Hon. Jacob Radcliff, and several influential members of the board, that at the expiration of the first term, an extension would undoubtedly be granted, if he should desire it, and the institution answered public expectation. Thus was he induced to erect an ornamental structure, such as the rotunda in fact was, and as was admitted on all hands.

" He commenced his exhibitions, and there were presented, in succession, the panoramas of Paris, Athens, Mexico, Versailles, (painted by himself,) Geneva, and the three battle pieces of Lodi, Waterloo, and that at the gates of Paris. In addition to those panoramas, his own pictures of Marius, Ariadne, &c. &c. were also exhibited.

" The patronage which he received from the public was satisfactory, and he deemed that the institution would become a permanent one. In this, however, he was mistaken, for, after an ineffectual effort on the part of the Philharmonic Society, of the City Dispensary, and of the National Academy of Design, to get possession of the building, the Corporation of 1829, in despite of the petitions and remonstrances of Mr. V. and of his friends and patrons, finally resorted to summary measures to remove him from the Rotunda, and which were adopted during his temporary absence from the city.

" This step having been taken, an effort was afterwards made to procure its recall; and in May, 1830, a petition, signed by Cadwallader D. Colden, Richard Varick, John Ferguson, and other gentlemen of the first respectability, who were among his patrons, was presented to the Corporation; praying that the building might again be appropriated to its original purpose, and that a new lease might be granted to trustees, to be chosen from among the petitioners, to see to the execution and fulfilment of such conditions as the board might prescribe; and also suggesting, that the creditors of the building should receive a portion of the receipts from the exhibitions, until their claims were liquidated; and that payment be guaranteed in such way as should be deemed equitable by the board.

" This petition, which protected the rights of the creditors, as well as those of Mr. V. was rejected; and the Corporation held the building, appropriating it, in the first place, to the use

129 SELF-PORTRAIT. Painting by John Vanderlyn. *Courtesy The Metropolitan Museum of Art, bequest of Ann S. Stephens in the name of her mother, Mrs. Ann S. Stephens.*

130 ABRAHAM HASBROUCK. Painting by John Vanderlyn. *Courtesy The Brook Club.*
Photograph Frick Art Reference Library.

of the Court of Sessions; and afterwards, it being found totally unfit for that purpose, it was transferred to the Marine Court, by which tribunal it continues to be occupied."

Of the merits of the case between Mr. Vanderlyn and the Corporation, I am neither competent nor willing to constitute myself a judge. Mr. Vanderlyn's recent employment by the U. S. Government, and his triumphant success, gives me sincere pleasure; and I hope that he may yet have the honour of painting one of the pictures to fill the Rotunda at Washington, and show to posterity, that, in 1817, America had a better painter than filled the first four compartments.

Mr. Vanderlyn made, I believe, several visits to the south, and more than one to New Orleans. He put up a building in that city, and had his panorama (perhaps more than one) exhibited there. He likewise visited the Havana, and attempted an exhibition of his fine pictures of Marius and Ariadne, but without profit and without employment.

During these voyages and residences, the building Mr. Vanderlyn had incurred a debt for the erection of, was generally a useless and unprofitable thing.

After several pages respecting the Rotunda and the corporation, the memoir of Mr. Vanderlyn's friend concludes thus:

* " Being deprived of the Rotunda, and, in consequence, involved in some pecuniary embarrassment, Mr. Vanderlyn was obliged to recur to his only resource, that of portrait painting, for his immediate subsistence."

That Mr. Vanderlyn has been " triumphantly successful," in his Washington for Congress, I sincerely rejoice; and *yet* hope, that the corporation of the great city of New-York will remunerate the artist and others who may be losers by the appropriation of the Rotunda to the business of the city: for, whatever may be strict, legal right, there is a feeling of justice, which, though it may not touch the heart of a corporate body, will make itself familiar in the bosoms of the electors, who contemplate the actions of the common council.

* It would appear from the wording of this memoir, that the Rotunda was constantly used by Mr. Vanderlyn. On returning from a residence in Norfolk, in 1820, I wanted a room in which to paint a large picture, and, on inquiry, was referred to the Rotunda. "But where is Mr. Vanderlyn?" I could obtain no knowledge on that point. I understood the building to be abandoned to his creditors. "Who has the key?" "Doctor Mott," I applied to him, and he put me in possession of the building for this temporary purpose. Fortunately, before I put up my large cloth to paint on, some friend of Mr. Vanderlyn let me know that he would return to New-York, and I might be considered an intruder, and I instantly abandoned the premises.

Mr. Vanderlyn's friend proceeds thus:—

" He had the good fortune to be commissioned by congress, in the spring of 1832, to paint a full-length portrait of Washington, to be placed in the Hall of Representatives, and an appropriation of $1000 was made for the purpose. That painting has now been completed, and has added to the fame of the artist, while it reflects credit upon the discrimination of those who selected him for the task. On its being exhibited in the capitol, the House of Representatives immediately and unanimously voted him an additional compensation of $1500.

" In 1833, Mr. V. presented a petition, for the second time, to the corporation of New-York, soliciting the restoration of the rotunda, and a renewal of the lease, or such remuneration for his losses, as, under all the circumstances, that body might deem reasonable and just. This petition, after a delay of many months, has been finally acted upon, and its prayer denied."

Mr. Vanderlyn published an address to his subscribers, in 1824, pamphlet form ; and another pamphlet in 1829, after the loss of the building. These efforts remain without effect.

———

CHAPTER IV.

Barralett arrives from Dublin—his eccentricities—E. Tisdale—Clark—Gilbert Fox—imported from London—Marries and goes on the stage—Tanner—Martin—Abner Reid—Marten—W. Groomrich—his landscapes—Gideon Fairman.

John James Barralet,
c. 1747–1815.

JOHN JAMES BARRALETT—-1795,

PROBABLY arrived from Dublin and took up his abode in Philadelphia about this time. He was certainly established as a painter and designer before the year 1796. He was on the wane, and appeared as an old man to Edwin when he first knew him, which was in 1797. Mr. Barralett was by birth an Irishman, but of French descent, and spoke the language of his father's country fluently, having all the volatility of France united with Hibernian prodigality and eccentricity. He was a French Irishman. He was a man of talent without discretion or any thing like common prudence ; prodigally generous, and graspingly poor. As represented to me, he had the wildest portions of the French and Irish characters whimsically united in him. Mr. Barralett had been in good employ at home in his native city of Dublin, and a teacher of drawing

in a public institution. In the earliest part of his American career, (although lame from some accident, probably in childhood) he was a beau of much pretensions, powdered to the extent of the fashion of the day, and ruffled to the finger-ends. In latter life he was a sloven to as great a degree.

His employment in Philadelphia was principally as a designer for publishers of books. Mr. Longacre (now one of our most respectable artists) when a boy and a pupil of Murray's, the engraver, was sent to assist Barralett in painting a transparency which Murray was preparing to display in honour of Perry's victory on Lake Erie. Young Longacre strove to accomplish his master's views, but in vain; the work was exhibited half unfinished, for Barralett amused himself by taking snuff and telling stories while his young assistant did all the labour.

Alexander Lawson engaged in a copartnersip with Barralett; but the union of the Scotchman, a downright matter-of-fact, industrious and warm-hearted man, with this flighty genius, was that of oil and vinegar. Barralett designed pictures and Lawson engraved them. Barralett always poor, contrived to receive payment for the work, and kept, or rather spent it. Lawson prudently withdrew from the connexion. Another cause of disagreement between the parties was, that Barralett would put a finishing touch to Lawson's work. Between them they furnished the plates for Linn's poems, and Lawson says his partner ruined several of them by re-touching them. On one occasion the poet was discontented with a design presented by Barralett, but knowing his violent temper, and the unsparing use he made of improper language, oaths, and imprecations, the young clergyman was afraid to speak to him on the subject, and persuaded Lawson to represent his wish for some alteration in the design—he did so—and the designer raved like a madman, at the indignity of being criticized by a Yankee parson.

" On my arrival in the United States in 1797, (says Mr. D. Edwin) Mr. Barralett was established in Philadelphia as a designer of picturesque drawings, &c. &c., a man of abilities, and, as I was informed, had been, at an early period of his life of much more. He was the first in the United States who invented a ruling machine for the use of engravers, he spent much of his time also in making a better black for copper-plate printers' ink than that in general use—an article then much wanted. He was the most eccentric man I ever knew—he was lame—(a dislocation of the head of the thigh bone) when he walked it was, to use the common saying, 'dot and go

one,' and the surtout coat he constantly wore in bad weather was dipt in mud on the lame side at every step he took. He took large quantities of snuff—was extremely irritable and passionate, and very dirty in his general appearance, he was also very poor, but had too much pride to complain of a poverty he could ill conceal.

" A friend of his called on business at his house, he waited in a room without fire, though the weather was very cold, till his return; when B. came home, ' By George, says he, (his usual oath) we must have some fire, come with me in the cellar and I will split some wood. Unfortunately there was but one stick, and that very knotty; the old man, who never lost his courage, made repeated strokes at the log, but in vain; grown desperate, he at last placed it on its end, stood at some distance from it, brandished his axe in a threatening posture, and to give more force to his desperate and final attempt, he ran or rather hopped (disregarding the assistance of his lame leg) at the devoted log, on which he inflicted a severe blow, but alas! still without effect; he then desisted, wiped the sweat from his face, and addressing his friend, ' By George, I believe the weather is warmer than it was, come up stairs, I think we have now no occasion for fire.'

" He once requested General Moreau, when in Philadelphia, to sit to him for his portrait; Barralett was then a widower, with two small children, living in part of a house, and having no housekeeper, things were in a very deranged and dirty state, but in expectation of the great general, every thing was put in as much order as his reduced circumstances would admit of. The general came, but before the drawing was half done, he thought he heard some low sounds of sorrow in the room, but could see nobody; the crying and sobbing became at last so audible, that Barralett could not help taking notice of them. In a rage he limped or rather flew to the closet, which he unlocked, discovering his two children, whom he had confined, to keep them out of the way of his sitter. ' What do you want, you torments?' says the father; ' A piece of bread!' cried the children. ' Look there now, look there now,' said he to the general, ' what trouble I have with these brats.' Then taking down, from an upper shelf in the same closet, a loaf of bread, he cut each a slice. They wished to make their escape, but he thrust them back, re-locking the door, with threats, in case they were not quieter; and before the drawing was finished, the crying, a slice of bread, and the scolding were repeated, to the great amusement of the general, who told the story to his friends."

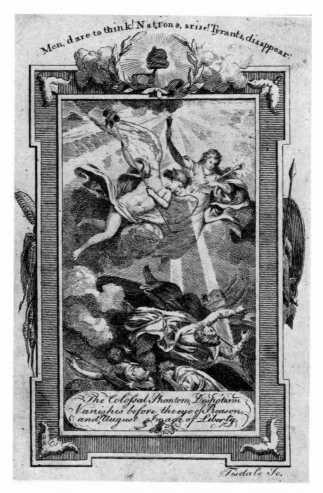

131 "THE COLOSSAL PHANTOM ..." Engraving by Elkanah Tisdale. *Courtesy Dover Archives.*

132 FAITH TRUMBULL. Drawing by Elkanah Tisdale. *Courtesy Yale University Art Gallery, gift of Miss Maria Trumbull Dana.*

Mr. Barralett exhibited a drawing of the First Landing of Columbus, which gained him applause and employment. He displayed many other original drawings in the exhibitions of the Pennsylvania Academy. I have no traces of him later than 1812.

E. TISDALE—1795,

Designer, engraver, and miniature painter. He has declined, by letter, giving me any dates or facts relative to himself; if, therefore, I err, he must excuse me—the world will care nothing about it. He was born in New-England about half a century ago. His Battle of Lexington was engraved by Tiebout in 1797, and it is a feeble affair. He designed and perhaps engraved the plates for Richard Alsop and Theodore Dwight's " Echo," in 1807. He is said to be a man of wit. Among his early designs are some for Judge Trumbull's McFingal. He was known to me in New-York as a miniature painter in 1805. He removed to Hartford and became a partner in what was called " The Graphic Company." The business of this company was principally executing plates for the banks.— Tisdale designed the vignettes, Brewster was the dye-sinker, N. Jocelyn, Willard, and Huntington the engravers.

Tisdale visited New-York in 1820, and painted miniatures, but continued attached to the Hartford Graphic Company until 1825. He not only designed but engraved one or more of their plates. He is the author of a political satire called the Gerrymander, and made designs for it. This publication was meant to lash Mr. Gerry, who, with the New-England men in congress, supported the imbecile Gates, in his opposition to Schuyler and Washington in 1778–9, but not for that is he made the butt for Tisdale's shafts ; but for not going with the New-England men in 1811–12 and 13, in their endeavours to obstruct the measures of government when it was found necessary to chastise the insolence of Great Britain by the war of 1812.

CLARK—1795.

An English engraver, who exercised his art in New-York about this time and worked in the dotted or stippling style, engraving several of the plates for David Longworth's edition of Telemachus, and for the same liberal publisher a large plate of the Resurrection of a pious Family.

Clark went south—became deranged—imagined that he was constantly pursued by a negro without a head, and finally committed suicide by cutting his own throat to get rid of his tormentor. Mr. Longworth deserves to be recorded with praise

Elkanah Tisdale,
1771–*c.* 1834.

Clark. Cannot be identified.

for being the first to introduce engravings in *belles-lettres* literature into the country. He did much with limited means.

GILBERT FOX—1795.

Was born in London about the year 1776. It so happened that an American, who practised engraving in Philadelphia without knowledge of the art, went on a voyage of discovery to London, and finding young Fox, in the year 1793, bound by an apprentice's articles to Medland, a well-known engraver of that city, conceived the design of purchasing the youth's time if he could induce him to cross the seas to Philadelphia, the place of the adventurer's abode, and teach him what he had learned from Medland. Fox's reward was to be liberty and good wages.

Trenchard, such was the American's name, succeeded: the youth wished for change of place and to be master of his own actions, before he knew how to guide them; the master was tempted by the price offered; and Gilbert was shipped to Philadelphia in 1795 by Trenchard, as an assistant to himself, and teacher of the art of etching, which was imperfectly understood among us at that time.

Mr. Alexander Lawson says, that among engravers the general impression was, " that Fox was only to impart his art to Edward Trenchard, who had bought and imported him, but it soon spread and every one became etchers." Gilbert did not like confinement and work, and being a draughtsman, when his contract with Mr. Trenchard was fulfilled, he engaged as a drawing master to teach the young ladies of a boarding school. He was a pretty young man, had a sweet voice, and an irresistible lisp, and taught " love's dream" to one of his pupils, who became Mrs. Fox.

Contrary to all rational calculation the boarding school proprietors would no longer trust the Fox among their flocks now that he was caught, and he had to seek some other mode of gaining a living for himself and family. The stage, the refuge of the idle, became his. He had some knowledge of music, a good voice, and, like Murphy's Dick, had visited the London theatres and been a member of a spouting club. This was capital enough to trade upon, and he was received with applause at the Chestnut-street, Philadelphia.

" Poor Fox," observes one of his cotemporary engravers, " he had some excellent qualities, but prudence was not one of them." He is to be considered as one who forwarded the progress of engraving in America.

133 VIEW OF THE CITY OF PHILADELPHIA, 1797. Engraving by Gilbert Fox after the drawing by John Joseph Holland. *Courtesy Prints Division, New York Public Library, Stokes Collection.*

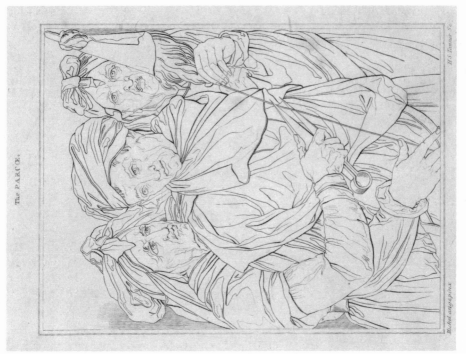

The PARCÆ.

Michel ang. pinx. H.S. Tanner Sc.

134B The Parcae. Engraving by Henry Schenck
Tanner after the painting by Michelangelo.
Courtesy Dover Archives.

Bodwel A. del. Fox N.Y.

134A Illustration. Engraving by Gilbert Fox. *Courtesy
Dover Archives.*

It is said that his father bequeathed him one thousand pounds. If so, it soon vanished. He was engaged as first singer for the New-York theatre—(there then was but one)— he played some young heroes in tragedy, and occasionally engraved. The head of Kotzebue for my German theatre is his work, and he was employed by David Longworth, our most enterprising publisher. He was always in trouble from certain symptoms of dissatisfaction among his creditors, who would not be put off with a song, or be content to wait for the yearly benefit, which experience had taught was of no benefit to them.

B. TANNER—MARTIN—1795.

B. Tanner, born, as I believe, in New-York, was a pupil of Cornelius Tiebout. He did much work for publishers, and published maps. Martin was a most wretched pretender to crayon painting. He was an Englishman ; and such was the low state of taste among the people, that he had employers. His success encouraged Jarvis to try, and he thus assisted the arts.

There were two Tanner brothers engraving at this time. Henry Schenck Tanner, 1786–1858, was the mapmaker. Benjamin Tanner, 1775–1848.

James Martin, *fl. c.* 1795–*c.* 1820.

ABNER REID—MARTEN—1796.

Reid, born in East Windsor, Connecticut ; was the teacher in engraving of W. Mason, who commenced wood engraving in Philadelphia long after the year here mentioned. Marten came from Sheffield, England, about this time, and attempted wood engraving in New-York in 1798, but soon after died of yellow fever.

Abner Reed, 1771–1866.

? Marten, *fl. c.* 1796–*c.* 1798.

W. GROOMRICH—1796.

An English landscape painter of some merit, painted in New-York about this time. I knew him personally. There was a good deal of sprightliness and oddity about him. He attempted to paint some portraits, but they could not be re-cognised. Many of his landscapes were got off by raffling. I remember a landscape in which he endeavoured, without success, to introduce the brilliant and gorgeous tints which nature displays in our autumnal scenery, but the blending of nature was not found in Groomrich's imitations, nor that harmony which she always throws over her most vivid colouring. Groomrich looked at his hard and discordant colouring, and cried, "*There* are tints ! *there* is effect ! *there* is distance !— they could not understand this colouring in England."

He painted a view from Harlem Heights, with really a good distance. " What shall I do for a foreground ?" said he ; " I

William Groombridge, 1748–1811.

will dash a watermelon to pieces, and make a foreground of it." No bad thought.

He removed to Baltimore from New-York, and Mrs. Groomrich opened a boarding school for young ladies with some success. Robert Gilmor, Esq. of Baltimore, speaking of Groomrich, says, " He painted here several good landscapes. He was a pupil of Lambert's."

GIDEON FAIRMAN—1796.

Gideon Fairman, 1774–1827.

"Gideon Fairman, a native of Newtown, Fairfield county, Connecticut, was born on the 26th day of June, 1774. At an early age he exhibited an extraordinary mechanical ingenuity and taste for the fine arts. His father having been reduced in his circumstances by twice losing his property by fire, and burthened with a large family, his son Gideon placed himself as an apprentice to a man of the name of Isaac Crane, a blacksmith and mechanic in New Mitford, a few miles distant from Newtown. Shortly after there came to the town an English engraver of no great merit, of the name of Brunton, to whom some rude specimens of young Fairman's genius were shown in the way of engraving, which, (considering that he had never witnessed the process, and worked with tools of his own construction,) were surprising indications of talent. Brunton pronounced his performances astonishing, and advised his father to encourage him in a pursuit in which he bid so fair to distinguish himself.

" After residing a short time at New Mitford with his family, he determined to leave a place where he could obtain no instruction in the art of engraving. He therefore started on foot with eighteen cents in his pocket, and walked to Hudson on the North River, where a married sister resided. From thence he found means to reach the city of Albany, where he bound himself apprentice to Messrs. Isaac & George Hutton, jewellers and engravers. He was now about eighteen years of age, and served out his time with them, after far surpassing his instructors in the beautiful art which was afterwards to gain him so high a reputation. At the age of 21 (1796) he commenced business for himself, winning the good opinion of all by a natural grace of manner, joined to great intelligence and a fine person.

" He relied on his merit alone for advancement, nor did he ever relax his efforts in a long career of usefulness, until, at the close of life, a series of misfortunes broke down suddenly the energies they could not bend.

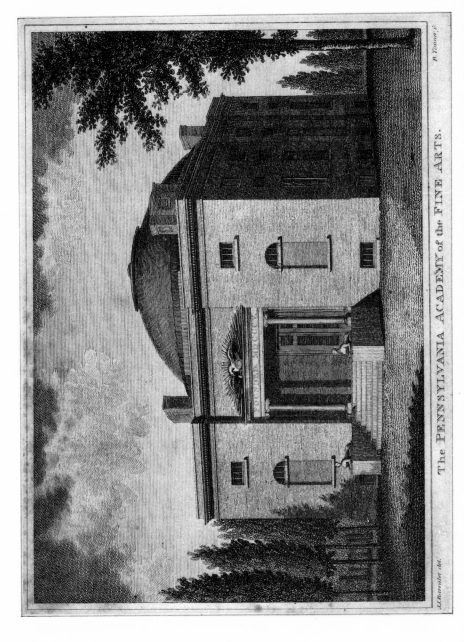

The PENNSYLVANIA ACADEMY of the FINE ARTS.

J.L.Barralet del. B.Tanner fe.

135 THE PENNSYLVANIA ACADEMY OF THE FINE ARTS. Engraving by Benjamin Tanner after the drawing by John James Barralet. *Courtesy Dover Archives.*

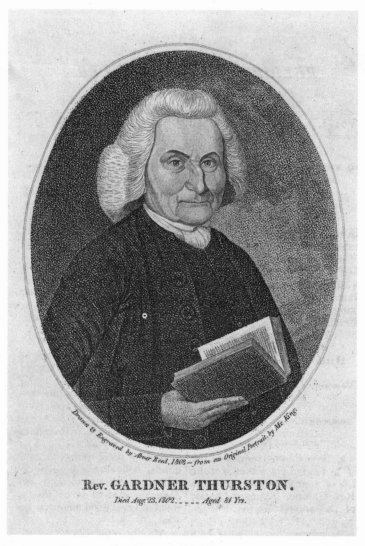

Drawn & Engraved by Abner Reed, 1808 — from an Original Portrait, by Mr. King.

Rev. GARDNER THURSTON.

Died Aug. 23, 1802 Aged 81 Yrs.

136 REVEREND GARDNER THURSTON, 1808 Engraving by Abner Reed after the painting by King. *Courtesy Dover Archives.*

" In 1798 he married, and in 1810 having lost his wife, he proceeded to the city of Philadelphia, where a company of bank note engravers was formed under the firm of Murray, Draper, Fairman & Co.

" In this city he continued; and in a few years, by his unremitting attention to business, he amassed considerable wealth. In the year 1819, he was induced to enter into another partnership with Mr. Jacob Perkins, and accompanied him to England, where he resided three years. Not long after commencing business in London, they took into partnership the celebrated engraver Charles Heath. This connection, however, proved a disastrous experiment to Mr. Fairman, who was disappointed in his anticipations by the extravagant expenditure of one of the parties in pursuing a career which has since involved every one connected with him. When at last Mr. Fairman felt the necessity of returning to his own country, he left the shores of England with a sad foreboding of impending calamity at home; and so the event proved; for within a few days' journey of the city in which he had gained so just a reputation, a friend hastened to announce his utter ruin through a spirit of insane speculation on the part of the senior partner of the concern. He was, therefore, under the necessity of stealing covertly into the city, and taking the benefit of the insolvent law to secure his personal liberty. These accumulated misfortunes depressed him not, but an unconquerable desire to retrieve, in some measure, his great losses, pay his liabilities, and provide for the wants of his family, caused him to give himself so unsparingly to his business, of all perhaps the most sedentary, and being always remarkably robust, he was suddenly struck down by paralysis and fell a victim to his exertions, on the 18th day of April, 1827, at the age of 52 years."

Such is the memoir with which I have been favoured by a friend. I first saw Mr. Fairman in Albany, apparently full of employment as an engraver, in 1805. Many years after I found him living in prosperity and splendour in Philadelphia. His small figures for bank notes were designed and executed with much taste. After his return from England I saw him snugly situated in Philadelphia, with a second wife; but it appears that his affairs had been irretrievably ruined by the unhappy conduct of Murray. He was to the last a man of uncommon physical powers, beauty of person, and elegance of deportment.

CHAPTER IV.

Some further particulars of the Peale family—Rembrandt Peale born in Bucks county, Pennsylvania—Early instruction—paints in Charleston, S. C.—goes to London; on his return renounces the name of Peale—Goes to Paris—returns and paints his Roman Daughter—residence at Baltimore—The Court of Death—The certified portrait of, Washington—Travels in Italy—returns home—another visit to London and return—Mr. Peale's lithography—Henry Sargent—first attempts at painting—Goes to London—returns home—enters the army—various appointments—" The Landing of the Pilgrims"—its destruction—" The Entrance of the Saviour into Jerusalem"—The dinner party—Woolley—Weaver—J. J. Holland—M. Pegale—D. Edwin—James Sharpless.

Rembrandt Peale, 1778–1860.

REMBRANDT PEALE—1796.*

THIS worthy man and accomplished artist, the second son and third child of Charles Wilson Peale, inherited from his ingenious father a love of the fine arts and of mechanics. He was born on the 22d of February, 1778, at a farm house in Bucks county, Pennsylvania, whither his mother had fled from Philadelphia at the approach of the hostile British army, his father being then with a volunteer company (raised by his exertions, and of which he was elected captain) with the army of Washington.

We have seen that C. W. Peale had returned from his studies with West in 1774, and although his mind was engaged by the dangers then approaching, and soon after by his services rendered to his country, he was so devoted to the art he loved that he named his son born in 1774 Raphael, his second child Angelica Kaufman, and his second son Rembrandt. These were followed by Vandyk, Titian, Rubens, Sophinisba, Linnæus, Franklin, Sybella, and Elizabeth. The last named after her mother, Mr. Peale's last wife. Mr. R. P. says, " all these children but two were named after painters, though only two

* I take this opportunity to add, from recent communications, some further particulars respecting the extraordinary family of the Peales. On Charles W. Peale's return from Europe, he promulgated a doctrine which is true to a certain extent, that " any person may learn to paint"—I say true to a certain extent. Any person with good eyes and common sense may be taught to draw and use colours, but they may fall lamentably short of the end desired, and which is the only thing to be wished in an artist. So any one may be taught to make verses; but it is only God who makes a poet. Peale persuaded two brothers to become painters. James abandoned the trade of cabinet making, and became a miniature painter in full employ. He likewise painted in oil, and even attempted historical composition. I am told of *one* on the death of Mercer at Princeton. Two of his daughters and a grand-daughter are now professional artists. Anna Peale, now Mrs. Staughton, of Philadelphia, is well known as a miniature painter. Her sister Sarah, residing in Baltimore, (says my informant) "practises the boldest branch of portrait painting in oil, and their neice, Mary Jane Simes, herself a living miniature, rivals her aunt in the same style."

137A TITLE PAGE. Engraving by Gideon Fairman. *Courtesy Dover Archives.*

137B "DELIGHTFUL TASK . . ." Engraving by Gideon Fairman after his own drawing. *Courtesy Dover Archives.*

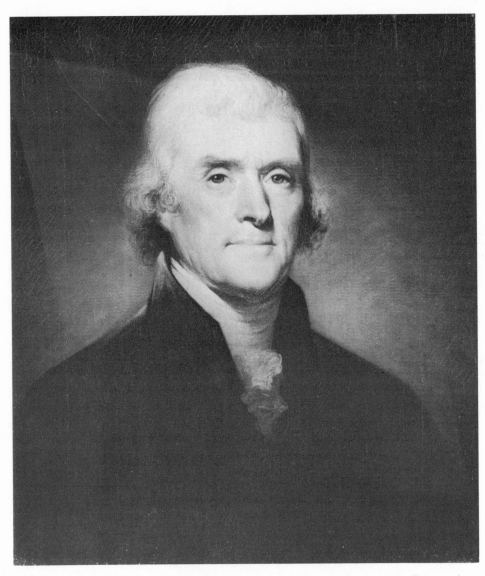

138 THOMAS JEFFERSON, 1800. Painting by Rembrandt Peale. *Courtesy Princeton University*.

of the number adopted the profession. Raphael was a painter of portraits in oil and miniature, but excelled more in compositions of still life. He may perhaps be considered the first in point of time who adopted this branch of painting in America, and many of his pictures are in the collections of men of taste and highly esteemed." He died early in life, perhaps at the age of forty, after severe affliction from gout.

Rembrandt commenced drawing at the age of eight, from the drawing book, between school hours; and I have heard him say that so great was his love of the occupation, that he injured his health by swallowing his food without chewing, and laid the foundation of illness in after life. At thirteen he left school, and devoted himself day and night to the pencil. At that age, he painted a portrait of himself, his second attempt from the life.

In the year 1796 his father relinquished portrait painting, and recommended his son to the public as his successor; but the recommendation was not successful, and Rembrandt determined to enter the world as a painter by a visit to Charleston, South Carolina. At this early period of his career as a painter, he fixes the time of Washington sitting to him for his portrait, and says, in a letter before me, that this, with the aid of one painted by his father, " gave rise to the portrait which is distinguished by its place in the Senate chamber at Washington."

At Charleston he was employed until 1801, when he went to England, accompanied by his wife and two children, to study under the direction of Mr. West. While Mr. Peale was in London he published a memoir on the Mammoth, which is honourably mentioned and quoted by Cuvier.* In London he painted a few portraits, and returned to America, thinking to abandon painting for agricultural pursuits; but success after his return to Philadelphia prevented his exchange of the pencil for the plough. In 1804 Mr. Peale issued the following advertisement :

" REMBRANDT. The names being merely to distinguish individuals—and whereas few persons discriminate between

* In the year 1802 the skeleton of the Mammoth having been completed by the ingenuity of Charles Wilson Peale, it was determined that Rembrandt should take the monster to England, and the following advertisement was issued from the press: "AMERICAN MIRACLE.—The skeleton, with which it is Mr. Rembrandt Peale's intention shortly to visit Europe, was yesterday so far put together, that previous to taking it to pieces for the purpose of packing it up, HE AND TWELVE other gentlemen partook of a collation WITHIN THE BREAST of the animal, all comfortably seated round a small table, and one of Mr. Hawkins's patent portable pianos; after which the following toasts were drank accompanied by music." I omit the toasts.

the peculiar names of my father, uncle, brother, or myself, which creates a confusion disadvantageous to the distinct merit of each as an artist, I am induced to obviate this on my part, in being known only by my first name, Rembrandt; the adjunct Peale serving only to show of whom descended. Therefore, ladies and gentlemen desirous of viewing a few specimens of my style of painting, may find me by the following direction:—REMBRANDT, PORTRAIT PAINTER IN LARGE AND SMALL, head of Mulberry Court, leading from Sixth, three doors above Market-street. Dec. 4."

How careful ought public men to be, not only of their actions, but of their words, especially words given to the world through the press! This advertisement could not be omitted in a biography of Mr. Peale without injustice to the subject, for it displays the character of the individual at the time, more than pages written by the biographer for the purpose.

In 1807 Mr. Peale visited Paris for the express purpose of painting the portraits of distinguished men of that nation, and "to feast," as he has said, "on the treasures Napoleon had assembled in the gallery of the Louvre." Mr. Peale painted a great number of French savans and military men, many of which on his return were placed in his father's museum. This not only gave him an opportunity of improvement, but introduced him to eminent men from whom he derived important information, tending to increase his store of scientific, literary, and philosophical knowledge. His style had improved, but his health had suffered, and he returned home once more determined to purchase that blessing by the abandonment of palette and esel, for the cultivation of the earth. To this determination he could not hold; and after two years more spent in portrait painting, finding it impossible to relinquish the objects of his early love and his life's pursuit, he returned to Paris in 1809, with a resolution which may be estimated by the circumstance that he carried with him a wife and five children.

The gallery of the Louvre was now completed and in its full splendour. Mr. Peale took lodgings in the vicinity, and spent all the time he could spare from completing his collection of portraits of eminent men, in studying the master pieces of eminent painters; but he could not be content from home, and "notwithstanding an offer from Denon to give him employment for the government, he returned to America after a residence of fifteen months." He again set up his esel in Philadelphia as a portrait painter, but found leisure to compose his picture of the "Roman Daughter," which possesses great merit.—This was exhibited at the Pennsylvania academy in 1812,

and elicited just encomiums; but the painter experienced wounds from the shafts of detraction, aimed by ignorance, idleness, and vanity.

A man of the name of Svemin, Russian vice consul, asserted, that the picture was a copy, and that he had seen the original in the rooms of Gerard, at Paris. A man of his standing in society was believed, and Peale considered as an impostor. He found himself treated with disrespect, without knowing the cause, and only by accident learned the accusation against him, and who was its author. He took Sully with him and called on Svemin ; who, after prevarication, was obliged to acknowledge that he thought he had seen a picture at Gerard's like Mr. Peale's, and the excellence of Mr. Peale's composition had made him conclude, it could be no other than a copy of that master's work. He avowed himself mistaken, and offered any reparation he could make. Thus is the reputation of a painter, both as artist and man, made the sport of vanity, and a sacrifice to travelled coxcombry.

The figures of this picture are the size of life, and painted carefully from nature. It is now in the possession of Mr. Savage, of Boston.

* When Mr. Peale brought this picture before the public, he published the following in the American Daily Advertiser, of Philadelphia:

" To THE PUBLIC.—After my return from France, in 1810, I designed and executed the equestrian portrait of Napoleon, my first experiment in large. The favorable reception of this, in public exhibition, induced me to venture on an historical subject—the story of the Roman Daughter, the last scene of which had often been painted, but not the first day's intercourse as I conceived it. Although my own gallery then stood in need of novelty and addition, I yielded to the request of some of the directors of the Pennsylvania Academy of Fine Arts, and sent this picture, wet from my eazle, to their exhibition in 1811. Its reception by the public was flattering to my reputation; but, being my first attempt at original composition, faults were discovered, which I was impatient to correct as soon as the exhibition closed. My friends were invited to see the alterations. I showed them the changes made successively from my first ideas. Struck with this unsuspecting display of unassisted invention, Joseph Hopkinson, Esq. gave me the first intimation of a report being in circulation that I was not the author of this composition, but had copied it in France. Perhaps with too much of the pride of conscious integrity, I would not inquire who were the propagators of this misstatement; but accident having made me acquainted with Mr. Svemin as the author, my moral character, more than my reputation as an artist, required that I should receive an explanation. For this purpose, I waited on him, accompanied by Mr. Sully, in whose presence he assured me that it was the *excellence* of my picture made him *suppose* that I had copied it—that he *thought* he had seen such a picture in *Gerard's* painting room in Paris, but did not remember the *situation*, nor the *attitudes* of the figures, by which alone a picture can be remembered. Mr. Sully was satisfied of the incorrectness of his previous assertion, and was witness to the acknowledgment of his error. I then published a few paragraphs in the papers, in which I took occasion to speak of the encouragement of the arts in America; and, in order to bring it to the test, engaged myself to make a present of the picture of the Roman Daughter to the Pennsylvania Hospital, if any person could prove (by comparison) that I had copied it in whole, or in part, from any painting, print, or drawing whatsoever. This was done with full

The establishment of a Museum, and Gallery of Paintings, in the city of Baltimore, was now a favourite object with Mr. Peale, and he accomplished it. He continued there nine years; and besides painting many portraits, composed and executed, in large, the ascent of Elijah, and other works of magnitude. Finally, he painted his " Court of Death ;" which having been exhibited throughout the United States with success, has made his name, connected with it, familiar with the public.*

Of this picture Mr. Peale says, in a letter before me, it was painted " on a canvas 24 feet long and 13 feet high, containing 23 figures of the full size. The idea of this picture was taken from Bishop Porteus's poem on Death. But instead of following the bishop, in the employment of the usual allegorical personages, I imagined a more original, impressive style of personification, at once philosophical and popular, and had the satisfaction to find, that it was equally understood and appreciated by the ignorant and the learned. It was exhibited in the principal cities during little more than a year, and produced the sum of $8,886 ; thus proving it to be a successful experiment. In New-York it was recommended from the pulpits, and by the Corporation of the city, who went in a body to visit it."

confidence, that in a composition which was strictly my own original, no part of it could, even by accident, be like any thing else. For, although historical painters from Raphael to West, have always been permitted to borrow ideas, and even figures—no such advantage was taken.

" My motive at this time for reviving the recollection of these circumstances, is, that many persons, who never read the vindication, still continue under the erroneous impressions. Now, when I present myself again before the inhabitants of my native city,* with a more important original composition, I think it necessary, and the occasion is peculiarly proper, to enforce the correction of an error, not more injurious to me than to my fellow citizens who are disposed to encourage the efforts we are making to advance the arts in our country.

"Not only the picture of the Roman Daughter, but the picture of the Court of Death, shall be given up for the same charitable purpose, should any one, actuated by such excellent considerations, detect so dishonourable an imposition. If this cannot be done, then ought every lover of the arts, and every gentleman who knows the value of character, interest himself in discountenancing a groundless aspersion against an artist, who would value no acquirements nor fame that were purchased at the expense of his integrity.

" The noble arts require a more liberal encouragement in our country. They are capable of a direction the most honourable and useful. But the state of our finances, and the recent establishment of our public institutions, do not permit the purchase of expensive works, which can only be brought forth by popular encouragement, as was practised in ancient Greece; and if they are viewed with corresponding justice, zeal and patriotism, no greater reward need stimulate the exertions of the artist.

"Witness Thomas Sully." "REMBRANDT PEALE."

* I have stated, *on the authority of Mr. Peale*, that he was born in Bucks county, and not in Philadelphia, as here asserted.

139 FRANÇOIS ANDRÉ MICHAUX. Painting by Rembrandt Peale. *Courtesy American Philosophical Society*.

140 CHRISTOPHER GADSDEN, *c.* 1795–1797. Painting by Rembrandt Peale. *Courtesy Independence National Historical Park.*

Thus far the author of the picture, who deserves praise for the experiment, and seems to be satisfied with the result. —He represents the causes and victims of Death, who is shrouded in mysterious obscurity. War and its effects are represented by the principal group. The figure of Pleasure is beautiful, and I recollect it as almost faultless. Intemperance was well conceived, if memory serves me ; and many of the figures, in half-tint, well executed.

From 1822 to 1829, Mr. Peale painted portraits in New-York, Boston, and Philadelphia, with checkered success, as to employment; and then, accompanied by his son. once more visited France, and had the satisfaction of spending sixteen months in Italy, copying some of the works of the most celebrated masters. Most of these copies were purchased by Mr. Bussy, of Boston.

Mr. Peale says, " I gratified my national and professional pride, by taking with me my Portrait of Washington ; which, in Rome, brought to my room some of the most distinguished artists, professors, and amateurs. At Florence it was exhibited, with distinction, in the Royal Academy. In London, it was visited by artists and other distinguished persons : and after my return to America, without my solicitation, it was bought by an unanimous vote of the Senate, and placed in their hall, as the picture which had united the suffrages of most of the intimate friends and relations of Washington."

Surely this distinction, these suffrages, and a good price received for this picture, may satisfy the author of it. But as I have mentioned it elsewhere, and given my opinion that it is not a likeness of Washington, and expressed my disapprobation of the manner in which I saw it exhibited in New-York, with a poor copy from Stuart's head of Washington, without frame, placed on the floor, beneath the highly decorated picture by Mr. Peale—I must here repeat that opinion and that disapprobation.

At the time of finishing this picture, it was announced as forthcoming at Washington. It was published in one or more of the journals that Mr. Peale had been for some time painting " a portrait of Washington, which was said to be, in every particular, the most admirably correct representation of the *character* and *expression* of this illustrious man that has been offered to the world."

In due time the picture is thus advertised at Washington city. After repeating the eulogies on its character and expression, it proceeds :—" The painter had the rare advantage

of having painted an original picture of the great patriot whilst living, which he has improved by subsequent study of his subject, with such aids as he could obtain from a reference to the works of contemporaneous artists. All the surviving worthies, who knew Washington intimately, speak with enthusiasm of this fine painting, as the only true likeness they have ever seen of him : and as a work of art merely, our letters from Philadelphia describe it as unsurpassed. This painting being finished, has been brought to this city by its author, with a view to submit it to the inspection of the national representatives and others, at the seat of government ; and particularly with a view to obtain the opinions upon it of those who were compatriots and personal friends of Washington, of whom so many are at this season to be found at the seat of government."

Opinions were obtained upon the portrait by presenting a certificate to those who had known Washington, and gaining their signatures. This certificate asserted every thing the painter wished.

A certificate is, in my eyes, a proof of something deficient or amiss. A certificate can be produced with signatures of many of the best men of any country to any thing. Mr. Peale, in this certificate affair, shares equally, perhaps, with those who signed it ; many of whom have since declared, that they did not think the portrait like the original.

Thus is the sacred cause of truth trifled with, and certificates obtained from " honourable men—all honourable men," to deceive mankind, mislead opinion, and often-times to destroy health and life. Why is truth so little respected, when it is the only foundation upon which human happiness rests ? I blame Mr. Peale for degrading himself by submitting to the expedient of a certificate, but I blame the signers more.

None see the anomalies of character more than the biographer ; and if he is a faithful historian of nature, he will represent them. Mr. Peale's conduct in the above-mentioned affair stands in contradiction to his general character as a man.

We have seen that it was in 1827 that Mr. Peale's father died, and I sincerely hope left property enough to place all his children in situations that, with the talent and industry of the family, has made them independent of circumstances. In 1829, the subject of this memoir visited France and Italy, as said above, and on his return published a volume on the latter country. In this publication he has shown himself an acute observer, and, in many instances, an excellent describer ; but Italy and the eternal city is such an eternal theme, that the

veteran reader feels as if he were going over pages familiar to him, although perfectly original. Mr. Peale's observations on works of art are very valuable to the artist. In the autumn of 1832, he says, "I made my last visit to England. From Liverpool proceeding to Sheffield, where I painted a number of portraits. In the spring," (of 1833,) "I established myself in London, and divided my time between my painting room and the various galleries of pictures and the rooms of artists. Here I deliberately went over a review of the whole of my preceding studies—defined, compared, and digested their various merits and defects, which I collated with the living testimony around me, and brought my judgment to a mature conclusion as to the course I should pursue in my future practice; believing that I was demonstrating, in the work I was then executing, that I had made, as a student of nature and art, a manifest advance in the art which I had loved from my infancy, and to which I had devoted all my time and means." Long may Mr. Peale continue to advance in his art—an art in which he has held a distinguished place for many years.

Besides the usual occupations of a painter, Mr. Peale applied himself to lithographic drawing, and obtained the medal from the Franklin Institute of Boston.* I have freely expressed my opinion of what I consider errors in Mr. Peale's conduct and publications; not with a view to his injury, but to his benefit and that of others. He has, in 1834, removed to New-York, where I hope his portraits will be justly appreciated, and his success answer so his wishes.

At an early age Mr. Peale was induced to make experiments on gas light, and when Doctor Kugler succeeded in purifying gas, he being then an inhabitant of Baltimore, formed a company for lighting the city with gas, which was done in 1817. Baltimore owes to him the honour of being the first of our cities that adopted this great improvement.

The ever active mind of this gentleman leads him to exer-

* Mr. Peale has furnished me the following note respecting his study of lithography:

"I was among the first of the artists who employed this admirable method of multiplying original drawings. My first attempt in New-York was a head of Lord Byron, and a female head from a work of Titian. In 1826 I went to Boston and devoted myself for some time to lithographic studies, and executed a number of portraits and other subjects, and finally a large drawing from my portrait of Washington, for which I obtained the silver medal from the Franklin Institute at Philadelphia in 1827. Unfortunately the workmen, by some neglect, destroyed this drawing on the stone when but a few impressions were taken. I instructed one of my daughters and my son in the art, and they produced some very commendable specimens."

tions honourable to himself, and beneficial to mankind. He is
now about to publish in New-York a book on the principles
of drawing, with illustrations, and he shows the connection
between drawing and writing, giving rules which I have seen.
This work will entitle him to the gratitude of the public. The
book is calculated to enable the student to instruct himself in
writing by the same process and at the same time that he
learns to draw. It will be eminently useful in schools of every
description. The author has displayed great knowledge and
much thought on the subject. The transition from drawing
to writing is finely pointed out and illustrated, and the work
must be extremely useful. I hope it may be adopted in our
schools, and thus the ingenious author remunerated.

Henry Sargent, 1770–1845.

HENRY SARGENT—1797.

Was born in the town of Gloucester, state of Massachusetts,
in the year 1770. At an early age he was instructed in the
rudiments of Latin and Greek, at the celebrated Dummer
Academy, (so named after Governor Dummer, who made
large donations to it,) near Newburyport, in which town the
father of Mr. Sargent, an eminent merchant, then lived,
during the war of the revolution: and after Boston was freed
from the British troops, Henry was removed from Dummer,
in consequence of his father's taking up his residence in the
capital of Massachusetts, and received the remainder of his
education at such schools as that town then possessed. At the
usual age, he was admitted into the counting house of Thomas
Perkins; and that gentleman going abroad, Henry was re-
ceived into his father's mercantile establishment; here he re-
mained until the age of nineteen or twenty. Up to this period
he had evinced no partiality for the study of any of the fine
arts.

This is a very remarkable circumstance in the life of Mr.
Sargent: in short it is unparalelled. In thus keeping his
hands from chalk or charcoal, and his school books uncon-
taminated by pen or pencil monsters, Mr. Sargent stands
alone in the history of art. The reader of this work will have
remarked, that from the time of West to the present day,
every painter or engraver began to scrawl, scratch, pencil, or
paint as soon as he could hold any thing wherewith he could
make a mark. There is reason to believe that Mr. Sargent,
when a boy, evinced taste for poetry and music, notwithstand-
ing which, the talent or faculty for imitating forms remained
dormant, and the craniological bump undeveloped, almost to
the age of maturity, although several fine portraits by Smy-

141 ROBERT HARE, c. 1820–1825. Painting by Rembrandt Peale. *Courtesy Independence National Historical Park.*

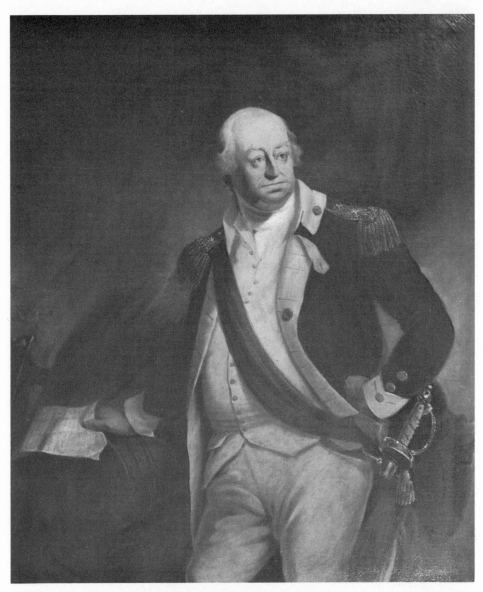

142 GENERAL BENJAMIN LINCOLN. Painting by Henry Sargent. *Courtesy Massachu-setts Historical Society.*

bert, and finer by Copley, adorned the walls of his father's house. They had been familiar objects from infancy, and "familiarity," says the proverb, "breeds contempt." Certain it is, that these familiar objects produced no effect upon the boy. He was first incited to attempt drawing by some rude sketches in common chalk, made by one of his brothers on the walls of their sleeping apartment. Success made him continue the practice. He found he could outdo his brother, and the walls were soon covered with their rival productions. Thus was the dormant desire to imitate forms aroused; but the ambition to become a painter was awakened, never to sleep again, by the following circumstance :

A house and ship painter was employed to decorate one of the ships of Henry's father, which was preparing for sea. The incipient painter, having outstripped his brother in the arts of design, determined to encounter this more formidable rival. The desire was irresistible; and seizing the opportunity of the ship painter's absence from his brushes and colours, which he had abandoned that he might gratify a more common but equally irresistible desire for dinner, young Sargent seized his tools, and produced the head of a sea nymph, to the great astonishment of the gaping sailors. The master of the paint pots "knocked under," and this essay with colours was so often repeated, and with such success, that the duties of the desk and the counting-house became uninteresting and repugnant to the student of the fine arts. Sketches of "men and things" deranged or interrupted the sober avocations of mercantile life, which it is possible the young painter's father thought were more important, and would produce more solid advantages; but after a time the old gentleman was induced to consent that Henry should try his skill with more refined and suitable materials than the paint pot and pound brush. Palette, pencil, colours, esel, and maul-stick were procured, and a room was allotted him in his father's house as an atte-lier, where he soon painted several portraits, and made copies of several pictures, among others was one from a mezzotinto print published by Copley, from his painting of Brook Watson, or the youth rescued from a shark.

Trumbull, in 1790, visiting Boston after his second sojourn in England, saw the young painter's work, and commended this copy so highly, that it was at once decided by his friends that he should be permitted to study the art for which he had not only shown a decided preference, but had given proof of being qualified to pursue with success.

This praise of the copy above mentioned decided the fate

of Henry Sargent, and he embarked for London in 1793, carrying letters from Trumbull to West, who received him with his usual urbanity; made him an offer of his services, —and placed his rooms, his pictures, and his casts at his disposal. Apartments were taken by Mr. Sargent in the vicinity of Mr. West; and during his whole residence in London, he always had free access to the great painter's house, and the benefit of his advice on all occasions relative to art. He likewise received the kindest and most courteous treatment from Mr. Copley, to whom he carried letters.

In London Mr. Sargent remained four years, during which he pursued such studies as are usually recommended by the Royal Academy. He would then have passed over to the continent, but the bloody contest, then in full violence, made his friends anxious for his return home, which he accordingly did in 1797. In Boston he remained for near two years, but such was the apathy then existing towards the arts, that he often was discouraged, and has said, that sometimes he regretted he had ever undertaken the profession. He, therefore, in 1799, was induced to accept of a commission offered him in the army then about to be raised, of which General Washington, who had retired from the presidency, accepted the command, but which, until called into actual service, was placed under the immediate direction of Major-General Alexander Hamilton. With this army Mr. Sargent remained until it was disbanded. The taste for military life thus acquired, distracted and drew off his attention from the arts. He received several commissions from successive governors of Massachusetts, which were particularly complimentary, as they were unsolicited and unexpected.

I well remember the finest body of light-infantry I ever saw out of regular service, going through their evolutions in the mall, and on the common of Boston, under the command of Captain Sargent.

During the last war with Great Britain, he received the appointment of aid-de-camp to the governor, with the rank of colonel, and was appointed assistant adjutant-general when the invasion of that part of our country was expected in 1814.

After the glorious termination of this war, which a second time vindicated our rights, and chastised the usurpations of England—a second time triumphantly proved that the free citizen has only to determine to conquer, and he will conquer in despite of monarchies, aristocracies, and their hirelings— Colonel Sargent received several military and civil commissions, equally honourable and equally unsolicited. He was

appointed, in behalf of Massachusetts, to attend to the surrender, under the treaty of Ghent, of certain islands in the Bay of Passamaquoddy, by his Britannic Majesty's government, to Brigadier-General Miller, and the authority of the United States. It was said, justly, in the papers of the day, that " the President could not have appointed a more proper person to have conducted this affair, than General Miller, or the Governor, on behalf of the commonwealth, one more suitable than Colonel Sargent."

At a later period Colonel Sargent was twice chosen to represent the town of Boston, in the General Court, or State Legislature, but at length he was induced to decline any re-election, by a deafness occasioned by too close proximity to a cannon which was suddenly discharged. His various public avocations having no charms for him, he again turned his attention to the arts, and set himself seriously to work upon his great picture of " The landing of the Pilgrims."

I never saw this picture, but I saw in the painter's room the small picture, the study for it, on one of my visits to Boston. This was about the year 1806, shortly after Mr. Gilbert Stuart's removal to Boston. Mr. Sargent says in a letter to me, " I became very intimate with him, and obtained much useful information from him. In our frequent walks together, the conversation of course often turned upon the subject of painting. It was his opinion (often expressed) that the art was on the decline. I never argued with him, for as he was a vain, proud man, and withal, quick tempered, I chose rather to preserve his friendship as an artist. He once had just painted a very fine portrait, and I ventured to ask him if it was not under-sized? He answered in a very peremptory manner, " No, not in the least." I was silent, but a few months after I saw him about to make a copy of the same picture, he held in his hand a small instrument, and I asked him what was the use of it? He said, " to enlarge the copy, as he thought the original too small." I imputed this acknowledgment to the lack of memory, and was again silent, not willing to interrupt the good feeling that existed between us.

The large picture, of the Landing, was finished after several years of severe application, and was destroyed in the following manner: After having been exhibited to the public, it was rolled upon a *fresh cut unseasoned* pole, around which, it continued for a number of months, during which time, the sap so completely rotted the picture, that it fell in pieces in unrolling. The part next the wood was like mud. The extreme interest the public took in this subject induced

the painter to undertake the arduous task of painting another of the same size. This the painter possesses. Colonel Sargent painted for exhibition, a large picture of Christ entering Jerusalem. I give from Sketches of Public Characters, the following :

" Sargent's picture of the Landing of the Pilgrims was, I speak in the past tense, for I understand that it was destroyed by some accident, much admired in its day by the descendants of the pilgrims, and spoken well of by those who did not feel any extraordinary sympathy for that race of men. The event of the landing of those few wanderers had nothing in it of very great sublimity or interest when taken by itself, unconnected with the past or the future in relation to that period. A handful of adventurers setting foot on an inhospitable shore, in an inclement season is, no doubt, a subject of sympathy, but not of wonder. The appearance of a northern sky in such a season of the year, was a fine object for the painter, and Sargent availed himself of it. He was northern-born, and had lived, for the usual months of the year, under such a sky as our forefathers first saw on their first landing, a freezing atmosphere, rocks, ground, all covered with a mantle of snow, while a low and sickly looking sun threw a few faint rays on the iron-bound, frost-bound coast. The dignity of the group was conspicuous in the picture. All they had suffered, all they were prepared to suffer, and what they hoped to effect, was well conceived and defined in the painting. The pious, providence-trusting, resigned look, was there also. A little of the soldier was still seen in Miles Standish—yea, more of it than of the saint. The females were well displayed ; not with Amazonian hardihood and fearless look ; but yet there was no timidity, no shrinking weakness, no dread of the savages, nor of a more appalling foe ; a long and dreary winter, without house or home, or any shelter for themselves or their little ones. They stood, they looked, they went forward, as those who believe that they have a God for their protector. That painter is good for nothing who cannot impress us with the moral sublimity of virtue, and give us the majesty of religion with all her sweetness. There is a spirit of prophecy in the hearts of the good in every undertaking, which, if it has no defined views, no tongue, but only speaking looks, yet it lives and dwells in every vein, and kindles in every eye, and has full possession of the soul, as certain as the soul has an existence ; and the painter of this picture had genius enough to seize the thought and make the best of it.

143 LANDING OF THE PILGRIMS, c. 1813. Painting by Henry Sargent. *Courtesy Pilgrim Hall.*

144 ASHBEL GREEN. Painting attributed to William Woolley. *Courtesy Princeton University Archives.*

" The next picture, from the same artist, was Christ enter-
ing into Jerusalem. This was also a popular picture. It
was remarkable for variety in the expression of the counte-
nance of the hosannah-crying multitude. The face of the
Saviour is wonderfully fine. An Indian chief once viewing
the picture in the presence of the author of these remarks,
looking steadfastly in the face of our Saviour, said, emphati-
cally, *that is a good man.* The last and only remaining
picture I know from Sargent, is the *Dinner Party;* a specimen
of the extraordinary power of light and shade; to exhibit
which seems the great object of the artist in this painting.
Sargent formerly took several portraits which were praised
for their spirit and exactness."

The Jerusalem was sold for $3000, and as much was
received for the exhibition. It is probably ruined by travelling
with its owner. Besides the pictures above-mentioned, Colo-
nel Sargeant has painted " The Christ Crucified," which is
in the possession of the Roman Catholic Society of Boston.
The Dinner and the Tea Party are beautiful and finished
pictures, and are in the possession of Mr. D. L. Brown, of
Boston. A large full-length of Mr. Fanneuil, belongs to the
city of Boston, and hangs in the far-famed Fanneuil Hall.
" The Tailor's News" and " Starved Apothecary," are from
the same pencil.

When the " Dinner Party" was exhibited in New-York, the
association of gentlemen, called " The American Academy of
Fine Arts," elected the painter an honorary member, and
about the same time he received the honorary degree of
Master of Arts from Harvard University.

Attention to mechanical inventions and other causes con-
nected with the study of mechanics, have, of late years, in a
great degree, diverted Colonel Sargent from application to
his favourite pursuit. It has always, and continues to be, the
highest gratification to him to indulge in the practice of paint-
ing, but his health will not now allow of so sedentary an occu-
pation, except at intervals.

WOOLLEY—1797.

William Woolley, *fl. c.* 1797*ff.*

This was an English painter, who made New-York and
Philadelphia alternately his home. He painted small portraits
in oil, the last of which I saw in Philadelphia. He was
called the Woolley painter. His best picture was Archy
Gifford's sign, at Newark, a fox hunt, doubtless copied from a
print.

WEAVER—1797,

Probably an Englishman. He painted portraits in oil, small size. He generally painted on tin, "inveterate" likenesses, hard as the tin and as cutting in the outline. He was one of those, who, by intemperance disgrace, as far as they can, a liberal and honourable profession. His portrait of Alexander Hamilton attracted attention from the strong likeness, and was the property of Dr. David Hosack, but he gave it in exchange to Mr. Trumbull, and, as I am informed, Mr. Trumbull destroyed it.

JOHN JOSEPH HOLLAND—1798.

This gentleman was born in London about the year 1776. At the early age of nine, he was apprenticed to Marinelli, the scene painter of the opera-house ; who, pleased with the boy, taught him both the theory and practice of scene-painting, made him a good water-colour draftsman, and architect. He married very young ; and Mr. Wignell found him at the opera-house as a scene-painter, shortly after the termination of his apprenticeship, and engaged him for the Philadelphia theatre.

I knew Mr. Holland for years, and ever found him a warm-hearted, generous, unsuspecting man. Of the world, at the time of his coming to America, he knew nothing, out of the sphere of his immediate existence in London. Holland has in after time, often laughed at his profound ignorance of the country to which he was emigrating. Not having an opportunity of consulting Wignell on the subject, he brought out his household and kitchen furniture with him, fully pursuaded that such articles, except of inferior quality, and at enormous prices, could not be procured in the savage country he was going to. The ship arrived at New-York, in the autumn of 1796, and was moored at a wharf in the East river, late in the evening. Holland went ashore to reconnoitre, and happened to see neither negroes nor Indians. The ship was at the foot of Wall-street; and the young cockney determining to keep on a line which he could retrace, proceeded up that avenue. All was matter of astonishment to him. He saw men who looked like Englishmen. The street was well lighted with lamps. He walked on good flag-stone pavement. He saw lofty edifices on each side of him ; and finally found in front of him a handsome gothic or half-gothic church. This

145 A VIEW OF BROAD STREET, WALL STREET AND THE CITY HALL, NEW YORK, 1797. Watercolor by John Joseph Holland. *Courtesy Prints Division, New York Public Library, Stokes Collection.*

146 MILL ROCK AND HELL GATE, 1814. Watercolor by John Joseph Holland. *Courtesy The New-York Historical Society.*

church being a land-mark, he ventured to turn a corner and walk up Broad-way, where the shops still blazed, and the broad pavements resounded with the feet of passengers ;—he arrived at another church, and saw, amazed, the lofty Roman Ionic columns of St. Paul's. He could go no further. The desire to communicate the results of this expedition into foreign parts, to his equally interested partner on ship board, caused him rapidly to retrace his way with wondering and delight; that he might congratulate his wife upon their arrival at a land of civilization.

Mr. Holland after residing several years in Philadelphia, was engaged by Mr. Thomas A. Cooper, who had leased the New-York theatre, to rebuild that edifice internally; which he did to the entire satisfaction of the proprietors. In New-York he lost his wife, and married a second time, to a woman of superior talents; the daughter of Mr. Jackson, of Staten Island. He died still a young man, and left no children. He was a man of taste in the arts; and his landscapes in water-colour had great truth and force. He never attempted oil. Two of his pupils, Mr. Hugh Reinagle, and Mr. John Evers, have been distinguished as scene-painters, and have produced many landscapes of merit both in water and oil.

Though short in stature, Mr. Holland was well formed, active, and athletic. In his personal appearance, always extremely neat. When he entered the work-shop, he uniformly changed his dress; and both by precept and example, forwarded the business of his employers with wonderful dispatch. Streets, chambers, temples or forests, grew under his hand as by magic.

During the last war with England Mr. Holland shouldered his musket, and did duty as a soldier. He likewise at that time made drawings of the fortifications which were thrown up to defend the city, both on Manhattan and Long Islands. His faults (for he had faults) were the result of accidental circumstances, his virtues were his own.

M. PIGALLE—1797.

A French artist of this name, designed and etched some plates in New-York, about this time, " particularly," says my correspondent, Alexander Anderson, Esq. the Bewick of America, " a fine emblematic eagle, for the title-page of Tiebout's American battles.' "

? Pigal (or Pigalle), *fl. c.* 1795*ff.*

DAVID EDWIN—1798.

This eminent artist was the first good engraver of the human countenance, that appeared in this country. His portraits from Stuart, in the stippling style, are unrivalled to this day.

He is an Englishman, and born at Bath, in the month of December 1776. His father, John Edwin, the celebrated comedian, was the delight of the citizens of London, in my young days; and the support of O'Keefe's comedies and farces, as Lewis was afterward of those of F. Reynolds. John Edwin was, however, I have reason to believe, a better actor than a father. David was articled to Jossi, a Dutch engraver, who went to England to study a particular branch of the art, not practised in Holland. He was a thorough bred artist, and " the most correct draughtsman of the human form," says his pupil, " I ever saw."

When David Edwin was twenty years of age, in the year 1796, Mynhere Jossi returned to Holland, and took his apprentice with him. Their place of destination was Amsterdam; but as the republican French were in possession of the country, the travellers entered Holland by the way of Embden. The Hollanders were at that time enamoured with the new system of French democracy; and John Bull was out of favour. Edwin found that his English face and English dress were insuperable obstacles to all familiarity or friendly intercourse with the Dutch. He observed that most of his fellow passengers in the boat, had taken off their hats and wigs; substituting in the place of both the Dutch striped-cap; he therefore doffed his hat, and mounted in its place a red woollen cap, which he had purchased before leaving London, as a *companion de voyage*, and a warm friend for the night. Unexpectedly it proved a most useful friend by day; for no sooner had he appeared in his new costume, than he heard from different parts of the boat the exclamation of " Bonnet rouge! Bonnet rouge!" and he was hailed as a true *sans culotte*, with the utmost cordiality by those who had before assiduously shunned him.

The young Englishman did not agree as well with his instructor after arriving at Amsterdam, as he had done in his native land; and before the term of his apprenticeship had fully arrived, they separated. Edwin at one-and-twenty years of age, found himself in a foreign country without friends or money, and looked anxiously towards the land of his birth. There was, however, no direct communication with England, and he determined to make his way from Am-

sterdam, to some port from whence he might find a passage to any part of Great Britain ; not despairing of finding some mode by which to reach London. But he was doomed never to see his native country again.

A ship bound to Philadelphia was in the harbour, and the young engraver entered himself under the American flag, to work his passage as a sailor before the mast, to the country which was destined to be his future home ; a country where at that time, 1797, the art he was master of was in its infancy. He accordingly embarked from Amsterdam, and assisted, as well as hands used to *points* and *gravers* and not to ropes could do, in navigating the American to *Havre*, and finally across the Atlantic, and up the Delaware to the place of his destination. It was in the month of December 1797, that David Edwin landed in Philadelphia, after being near five months on board ship as a fore-mast-man, and he made his entré upon this new scene in a new world, in his tarry round-a-bout, and equally tarry trowsers ; trudging after the captain through the streets of Penn's city, with the ship's let-ter-bag on his shoulder, on the way to the post-office.

The duties appertaining to the voyage having been discharged, the engraver prepared to cast his sea-skin, and appear in his proper character. His sailors dress he sold to one of his messmates, and with the aid of Delaware river water and Philadelphia soap, with a decent suit of London landsmen's-clothes from his trunk or chest, he bade adieu to the ship, to seek his fortune on the shores of a new world. He had heard that his countryman, Mr. T. B. Freeman risided in Philadelphia, and carried on his business as a publisher ; and he waited upon him—stated his circumstances—his profession—his well known name, (well known to Englishmen from his father's celebrity)—and solicited employment. He was well received ; in fact he was such a person as was wanted in America, especially in Philadelphia where the book publishing business was in greater forwardness than in the more commercial metropolis of New-York.

Mr. Benjamin Carr, mentioned by me in the History of the American Theatre, was a friend of Mr. Freeman's, who was then about publishing a collection of Scotch airs selected by Carr; and Edwin was employed to engrave a title page. This was his first work in America ; and at the time of commencing it he was destitute of the necessary tools, and could procure none in Philadelphia ; the cause is not stated by my informant, certainly there were at that time several engravers in the city, and it would appear that some of them might have

helped a brother in this state of destitution, as it regards tools. The engraver accidentally found in his seaman's chest, a graver which had been thrown into it at Amsterdam and forgotten. The shank of this tool, or that part which is inserted into the handle, he shaped as well as he could to his purpose, and commenced etching his plate therewith. As he proceeded with his work, he reversed the tool, tied a rag as a substitute for the handle, round the end he used as an etching point, and with this second contrivance finished the plate.

An engraver, at the time of Mr. Edwin's arrival in Philadelphia, had much to struggle with. He says in a letter before me, " copperplates were finished rough from the hammer ; no tools to be purchased, he (the engraver) had to depend upon his own ingenuity to fabricate them for himself, or in directing others qualified for the work ; but worse than all was the slovenly style in which printing was executed. Often have I in extreme cold weather, waited hours for a proof, till the paper, oil, and even the roller could be thawed. The work shop of the principal printer in Philadelphia, was little better than a shell, and open to the winds. I once insisted that the printer should have the plank of his press planed and leveled, as it was impossible in the state it was now in to take off a tolerable impression ; and the plate I wished printed had cost me much trouble in the execution ; the printer resisted all my arguments for a long time, being himself perfectly satisfied with the state of his press : at length, and only in consideration of my paying the expense, it was that he gave his consent."

I have transcribed Mr. Edwin's statement of the rude imperfections attendant upon engraving and copper-plate printing in Philadelphia in 1797. In New-York, before that period, there were difficulties similar, no doubt ; but as early as 1790, the writer, under the direction of Mr. Peter R. Maverick, found no difficulty in procuring tools for etching and engraving, and some prepared plates ; and etched and scratched until he was satisfied that engraving required more skill, time, and patience, than he had to bestow upon it. Mr. Maverick was the best engraver then in New-York ; his competitors were indeed few and feeble. He was his own printer, and worked off his own proofs very comfortably, at his own press, in a comfortable work-shop. In his printing he had an assistant. Mr. Edwin goes on to say, " Mr. Edward Savage, a portrait painter, was the only publisher of prints at that time. He published prints from pictures of his own painting, being sometimes painter, engraver, and printer."

Edwin engaged at one time with Savage, and came on to

Engraved by D. Edwin from the original Picture by John Neagle.

GILBERT STUART

Ætat. 72

147 GILBERT STUART. Engraving by David Edwin after the painting by John Neagle.
Courtesy Dover Archives.

G. Stuart Pinx. D. Edwin sc.

William Smith D.D. Æt: 75.

148 DR. WILLIAM SMITH. Engraving by David Edwin after the painting by Gilbert
Stuart. *Courtesy Dover Archives.*

New-York, but how long he worked for him, or when he returned to Philadelphia, I do not know ; probably he was in New-York a very short time.

Mr. Edwin says, " At the time of my arrival in Philadelphia Dobson was publishing an edition of the Encyclopedia. It was thought a rash undertaking ; and General Washington, on being asked to subscribe to the work, declared, that ' he thought Mr. Dobson a bold man.' " Now, as I was a subscriber to Dobson's work, I doubt not that Washington gave it every encouragement, being so much more able. The plates, at the time Edwin speaks of, were done by Thackara and Valence, assisted by Lawson. Edwin, for many years, had all the portrait engraving in the United States.

" About the year 1801," he says, " I had the happiness of forming an acquaintance with Mr. Gilbert Stuart." I think he might have dated his happiness some years earlier, and been within the bounds of truth. " It took place on my undertaking to engrave a portrait of Dr. Smith, (of the Pennsylvania University) from Mr. Stuart's painting. The first meeting I had with the Doctor on the subject of the plate that was to be engraved, I shall not readily forget. The Doctor had been a school-master ; and although ignorant of the art of engraving, undertook to examine me on my capabilities.— He was old, hasty, and very irritable. He began in a broad Scotch dialect, by asking me if I could draw. But when we came to the price of the plate, I thought the poor Doctor would have gone distracted. He ran out and in the room, throwing at me angry and reproachful glances ; and ended with the determination of paying me only half of my demand, which I accepted, considering the connection I should form with Mr. Stuart, by undertaking the work of more value to me than any sum the Doctor could pay me for the plate."

At the commencement of the last war between America and Great Britain, Mr. Edwin informs me that there was no town of any consequence, from Maine to Louisiana, both inclusive, whose citizens were not in his debt for work done. He says, '' I lost it nearly all; which, with a sickness, occasioned by an over-application to my business, caused in me a temporary disgust to my profession. I applied to Mr. T. B. Freeman, who, with his usual humanity, employed me as a clerk in his auction store. But, as they say, an old coachman loves the smack of the whip, so I, at most of my leisure hours, undertook small jobs in the engraving way : that of most consequence was my last—the last I ever shall engrave—the head of, I am proud to say, my friend and patron, G. Stuart, painted by Mr. John Neagle.

"Mr. T. B. Freeman meeting with difficulties in his business, I found myself, in the spring of 1831, of no further use to him, and quitted my station in his counting-house. I then made some efforts to recommence engraving, but could get no publisher to trust me with a plate. In the winter of that same year I was seized with influenza, (at that time a general complaint) which affected my head severely, and took from me the sight of one of my eyes, leaving me a prey to melancholy and distress."

Such is the account I received from this once excellent engraver; written in the month of April, 1833, at the age of 57. —A poor, broken down, and prematurely old artist. In the month of June I visited Mr. Edwin, in company with my friend, Mr. Neagle; at which time he appeared in general good health and cheerful. An attempt was made to provide for his age, by procuring for him the situation of keeper of the Pennsylvania Academy of Fine Arts, when Mr. Thackara retired from the situation, but his friends did not succeed.

Since writing the above it has given me much pleasure to learn, that by a gift from Mrs. Francis, (once of the profession of which Mr. Edwin's father was an ornament, and an old acquaintance of both Mr. and Mrs. Edwin) the old age of the engraver is amply provided for.

JAMES SHARPLESS—1798.

James Sharples, Sr., c. 1751–1811.

This gentleman was an Englishman; and being of a Roman Catholic family, was educated in France, and intended, like John Kemble, for the priesthood; but, like John, he preferred the fine arts. He married before coming to this country; and on the first attempted passage was taken by the French, and, with his wife and three children, carried to France, and there kept as prisoners for some months. When liberated he made a more successful effort, and landed in New York about 1798.

He painted in oil; and I have seen a composition of his, wherein several of Doctor Darwin's family were portrayed: but his successful practice in this country was in crayons, or pastils, which he manufactured for himself; and suited, in size, to the diminutive dimensions of his portraits, which were generally *en profile*, and, when so, strikingly like.

He visited all the cities and towns of the United States, carrying letters to persons distinguished, either military, civil, or literary, with a request to paint their portraits for his collection. This being granted, and the portrait finished in about two hours, the likeness generally induced an order for a copy,

149 THOMAS JEFFERSON, c. 1795–1800. Painting attributed to James Sharples, Sr.
Courtesy Independence National Historical Park.

150 RUFUS PUTNAM, c. 1795–1800. Painting attributed to James Sharples, Sr.
Courtesy Independence National Historical Park.

and brought as sitters all who saw it. His price for the profile was $15; and for the full-face (never so good) $20.

He painted immense numbers, and most of them very valuable, for characteristic portraiture. His head quarters was New-York; and he generally travelled in a four-wheeled carriage of his own contrivance, which carried the whole family and all his implements, and was drawn by one large horse.— He was a plain, well-disposed man, and accumulated property by honest industry, and uncommon facility with his materials.

Previous to the establishment of his safe and methodical way of travelling, I witnessed a scene connected with this gentleman's itinerary movements which made a deep impression on me. I had joined the stage waggon, the usual travelling machine of those days, and with Mr. and Mrs. Sharpless, with their three children, (two boys and a girl) rode to Middletown, Connecticut, enjoying the picturesque beauties of the route with more zest, as my adult companions were capable of appreciating them. We stopped at the inn door, in the flourishing village of Middletown, about mid-day and in summer. I jumped out of the vehicle, to inquire for my friends of the Alsop family; and I soon saw the stage, with the horses at full run and no driver, pass me with the rapidity of lightning, the little girl alone in the carriage, and the distracted parents following, with outstretched arms and unavailing screams. On dashed the frightened horses with their light load, she perhaps unconscious of her danger; and soon deviating from the road, they struck the carriage against a post, overturned it with an awful crash, and, leaving it, pursued their race. All within sight of the accident ran to the spot with the distracted father and mother, looking to draw from the ruin the lacerated corpse of the child: when, on taking out the little creature, she was found perfectly unhurt, and restored to her parents as she had been left by them and the driver of the team to the mercy of four horses without guide or governor. I have travelled a great deal since then, but never saw a driver leave his horses without due security, but I thought of Middletown and the Sharplesses.

Mr. Sharpless was a man of science and a mechanician, as well as a painter. In the first volume of the Hosack and Francis' Medical and Philosophical Register will be found a paper on steam carriages, confirming this character.

Mr. Sharpless had acquired property without meanness, and looked to the enjoyment of easy circumstances in old age, when he died suddenly, at the age of 60, in New-York, of an ossification of the heart, and was buried in the cemetery of the Roman Catholic chapel in Barclay-street. His widow, her daughter, and youngest son, returned to England, and

long resided near Bath, after selling the *distinguished heads* (among which I had the honour to be numbered) at public auction.

The two sons both practised their father's art in America: James, the younger, presented me with a copy of my friend Elihu E. Smith's portrait before leaving the country. Felix resided and died in North Carolina.

CHAPTER V.

Jarvis—born in England—brought a child to America—The boy left behind and the boy with strange names—Jarvis dabbles in paint—put apprentice to Savage, and taught engraving by Edwin—at New-York—sets up as an engraver—commences portrait painter—partnership with Wood—studies anatomy, craniology, and modelling—his kindness to Sully—Jarvis at Baltimore—Charleston, S. C.—Strange mode of living—Compares himself to Morland—A dinner party—Bishop Moore and Jarvis—Great success at New Orleans—Jarvis an inimitable story teller—Stories told of him and by him—His activity and benevolence during seasons of pestilence.

John Wesley Jarvis,
1780–1840.

JOHN WESLEY JARVIS—1798.

Was the best portrait painter in the city of New-York for many years. He was, like many of our artists who are strictly American, born in England. The nephew of the great lawgiver of Methodism, the place of his birth was South Shields, on the Tyne, and the time, the year 1780. His father emigrating to America, left him with his uncle until he was five years of age. Had he remained longer under the roof of that extraordinary man, even a few years, when the first, best impressions are made, it might have been well for the embryo painter. He might have been a preacher, and if so, one of the most popular in America. Or he might have been introduced to a guide, who would have made his talents a blessing to himself and the world. Even at the early age of five some impression must have been made upon the boy by the orderly mode of life he saw practised among those around him; an order and regularity which he in after life seemed to mock by the arrangements or disarrangements of his own ever shifting places of abode.

Jarvis's father having taken up his residence in Philadelphia, the child was conveyed to that city, and there received his second education; for even at five years of age, the first must have been impressed upon the tender mind of his infancy. Was not the boy's conduct in the following transaction guided as his mind had been moulded in early childhood? Or was it the unsophisticated workings of that inclination to good which we receive from the Creator, that prompted his tongue and his action?

While John was yet an urchin, " with shining morning face, creeping like snail unwillingly to school," and munching a huge piece of bread and butter, which he had demanded after breakfast, more to prolong the time before he must resign his liberty to the schoolmaster's despotism, than because he wanted food—on his way to the dreaded mansion, he passed an unoccupied building in Water-street, and his attention was arrested by sobs coming from the house to which he was opposite, and which had been partly torn down, and so left for the accommodation of the proprietor (until he saw the best time for re-building) and of any vagrant who wanted shelter. Having ascertained the quarter from whence the signs of distress came, John Wesley, still munching his luncheon, unconsciously overloading his stomach, (if a child's stomach can be overloaded,) entered the deserted place with feelings of curiosity, if not humanity, (perhaps mixed, as most of our motives are) but the latter soon prevailed, when he saw a little fellow, younger than himself, seated on the broken floor and crying bitterly. "What's the matter, little boy?" said the young Englishman, suspending the operation of his masticators. The tone of sympathy increased the sobs of the forlorn child. " Don't cry! tell me what's the matter?" " I've lost my father, and I'm hungry." The idea of being hungry, especially as that was the last word, had more powerful influence on the feelings of the commiserating boy than the loss of a father. " Hungry," he cried, "why have you had no breakfast?" " I have not had any thing to eat since I lost my father," sobbed the little sufferer. " When was that?" "Yesterday morning. He went to sea in the Sally while I was playing up at the head of the wharf." " Where's your mother?" " Mother's dead. I slept here last night. I'm very hungry." " Here, take this, and I'll get you more."

The little urchin fell to work upon the remains of the bread and butter, and his friend sat down by his side comforting him, and now and then asking him a question. Jarvis saw the bread and butter, seasoned with tears, demolished, and then said, " Come, I've got a father—he'll take care of you—come with me." And willingly forgetting school, he took the little fellow's hand and trudged back to his home, to place him under the protection of one he knew from experience could give him bread and butter. The father of John soon found out the owners of the ship Sally, and they received and took care of the little orphan until the return of his father.

It appeared that the father of the boy was mate of a ship bound to Europe, and intended taking this motherless child

with him. He had made every arrangement, and, that the boy might be out of "*harms way*," had ordered him to keep in his state room, where he thought him safe stowed away at the time the ship sailed; meanwhile the boy had slyly stolen on shore and joined in play, just without sight of the vessel, and when he looked to get back again, lo! she was gone.

With the father hours had passed in attending to his arduous duties before he thought of liberating his little prisoner; and we must imagine his feelings when the child was not to be found. The boy had been seen to go on shore. That quieted one of the mate's fears. The captain, a brutal man, would not put back—said the owners would take care of the boy—he would lose wind and tide—and the mate submitted. But when the ship had cleared the river and the capes of Delaware, and the pilot was about returning, the father of the lost boy threw his sea-chest and himself into the pilot boat and returned in search of his child. The owners commended his desertion, and found him another berth for himself and the little runaway.

We may imagine the feelings of the mate on his return, when he found his boy safe—and his gratitude to little John Wesley.

Such were the feelings—such the actions prompted by nature, before the world, or the miscalled pleasures of the world, perverted the heart or the instinct. Before I proceed regularly with the biography of John Wesley Jarvis, I will as a contrast to the above, repeat a story which Jarvis, when a man, often told of himself, as I am informed. Being on a party of pleasure in the neighbourhood of New-York, his attention was attracted to a sturdy boy who was playing near him, perfectly unmindful and independent of Jarvis and his companions, their wine, their cigars, or their bursts of merriment. The painter admired the boy, and with his usual playful manner and laughing eyes, addressed the child, and at the same time called the notice of the company to him. "What's your name, my man?" "My name's John, and I'm not your man." "That's a fine fellow—John? a very good name. It's my name too. Have you any other name?" "Yes, I have." "That's right! what is it?" "Wesley." "Wesley! John Wesley! that's my name too. Have you any more names?" "Yes, I have." "So much the better—the more the merrier. What's your other name?" "Jarvis." "That's odd enough—that's my name too. Who's your father?" "Jarvis, the painter—and mother says he is a very bad man."

I must go back to Philadelphia and the days of the painter's childhood. Jarvis has said, "In my schoolboy days the painters in Philadelphia were Clark, a miniature painter—Gal-

agher, a painter of portraits and signs, he was a German who, with his hat over one eye, was more *au fait* at walking Chesnut-street, than at either face or sign painting—then there was Jeremiah Paul, who painted better and would hop farther than any of them—another, who painted red lions and black bears, as well as beaux or belles, was old Mr. Pratt, and the last that I remember of that day was Rutter, an honest sign painter, who never pretended or aspired to paint the human face divine, except to hang on the outside of a house : these worthies, when work was plenty—flags and fire-buckets, engines and eagles in demand—used to work in partnership, and I, between school hours, worked for them all, delighted to have the command of a brush and a paint pot. Such was my introduction to the ' fine arts' and their professors.

" About this time I first saw Stuart, who occasionally employed Paul to letter a book—for example, the books in the portrait of Washington, which Jerry thought it no dishonour to execute : the two great men, however, quarrelled, and Paul threatened to slap Stuart's face—trusting, I presume, to being able to hop out of the way of his arm. Mr. Pratt was at this time, say 1790, an old man, and as he encouraged my visits, I frequently passed my out-of-school hours at his shop, making figures of what passed for men and things by dint of daubing on my part, and imagination on the part of the beholder.

" Dr. Rush, seeing my propensity to have a hand in the manufactory of monsters, the many-coloured offspring of this combination of genius, persuaded my father, as the time had arrived when I must learn something besides *learning*, or expect to starve with the Philadelphia market at my elbow, to make a painter of me. But I did not like the prospect of making one in a partnership of Paul, Pratt, Rutter, and Gallagher ; and as I saw in the prints displayed at the shop windows, something much more perfect, and more to my taste, I preferred being an engraver. To this my father assented, and Savage being at that time the publisher of prints, some of which with his name to them I then admired, I was bound apprentice to the most ignorant beast that ever imposed upon the public. He painted what he called fancy pieces and historical subjects, and they were published as being designed and engraved by him, though his painting was execrable, and he knew nothing of engraving. He was not qualified to teach me any art but that of deception. There he was a master— at drawing or painting I was *his* master. Fortunately, as he could neither draw nor engrave, it was necessary for him to

employ one who could, and who did not wish the honour of having his name affixed to the fancies of the Savage.

" Mr. David Edwin had arrived in America with more skill than money, and Savage engaged him to engrave for him. Not long after this my master removed to New-York, and took Edwin with him. I followed of course. From Mr. Edwin I learned to draw and to engrave, and we worked for the fame and profit of the *great Savage*. Yet I had no intention of becoming a portrait painter. Edwin returned to Philadelphia, and soon, by engraving some of Stuart's portraits, became known and extensively employed. I made all my master's pictures, engraved them, printed them, and delivered them to customers. I remained with him until my time of service expired, and, 'bating some pranks and unlucky tricks, I served him faithfully.

" I began to engrave on my own account; but Edwin visiting New-York, asked me to go and see a great portrait painter, not long since arrived, and full of employment—with of course his pockets full of money. I went to the painting room of Mr. Martin, and found him overwhelmed with business. 'This,' said Edwin, 'is the best portrait painter in New-York.' 'If that is the case,' said I, 'I will be the best portrait painter in New-York to-morrow, for I can paint better than Mr. Martin.' And I have been at it ever since."

I reminded Jarvis of a portrait of Hogg, the comedian, very like, but flat and dingy, which I had seen when honest John Hogg kept a porter house in Nassau-street. " That was one of my first," said Jarvis, " and my old friend Gallagher, being then in New-York, helped me. I was the best painter, because others were worse than bad—so *bad* was the best. There was a man of the name of Buddington, who shared in face making; but I beat him at it."

My first recollections of Mr. Jarvis, go no further back than about 1805-6. He had in conjunction with Mr. Joseph Wood for some time occupied rooms in Park-row, between the theatre and Beekman-street; here, he says, he taught Wood to draw "from the round," and as Wood applied himself particularly to miniature painting, he seized an accidental opportunity of introducing him to Malbone; and *his* instruction made Wood an artist. Malbone came into the painting-room of Jarvis with some ladies, to see the pictures, and Jarvis having before seen him, entered into conversation, and took an opportunity to call in Wood, and introduce him as one wishing instruction in miniature painting. This led to the offer on Malbone's part to impart any knowledge he possessed; and

to his instructing both Jarvis and Wood, in his mode of proceeding, from the preparation of ivory to the finishing the picture, and they both became painters of miniature.

Mr. Jarvis tells me that about this time he invented a machine for drawing profiles on glass. The outline being rapidly drawn on one side the glass, was blacked as rapidly on the other ; and for each of these, he and Wood (both worked at it, and occasionally an assistant, hired by the day) had a dollar—they likewise made the profiles on gold leaf, shadowing a little by hatching—for each of these they had five dollars, and frequently shared between them a hundred dollars a day. This was of course while the thing was a novelty. These were piping times—and what with Jarvis's humour, Wood's fiddling and fluting—and the painting executed by each, they had a busy and merry time of it. But I fear "*merry and wise*," was never the maxim which guided either.

The artists indulged in the excitements, and experienced the perplexities of *mysterious marriages ;* and it is probable that these perplexities kept both poor, and confined them to the society of young men, instead of that respectable communion with ladies, and the refined circles of the city, which Malbone enjoyed : and I have reason to think, that these mysteries and perplexities caused the dissolution of the partnership of Jarvis and Wood on no friendly terms.

I remember Mr. Jarvis in a painting-room in Broadway, nearly opposite the City Hotel, fully occupied in painting profile portraits on Bristol-board at five dollars each; very like and very pretty. Portraits in oil, or miniatures on ivory, were done if required.

Those studies which are necessary to the formation of a good painter, were not neglected by Jarvis. He studied anatomy with Dr. John Augustine Smith ; and when my friend Dr. John W. Francis returned from Europe, in the year 1816, bringing with him the splendid edition of Gall and Spurzheim, whose work my friend was warmly interested in, he showed it to Jarvis—Jarvis asked the favour of studying the book. He kept the volume many months. "When I afterwards saw him," says Dr. Francis, "he remarked, 'this book of Spurzheim's elevates our art to a science : it has principles of value to the artist. If I have any merit as a portrait-painter, so be it ; I may have depicted Lavater : but Spurzheim renders the artist the phrenological delineator. Look at even Houbraken's heads ; see the portraits in the Spectator : every forehead is of the same height—every pericranium of the same rotundity —every wig of the same form and dimensions." Jarvis may

probably be considered the first painter in this country who applied phrenological science to the principles of the art of portrait painting.

Jarvis studied Gall and Spurzheim assiduously. He thought he saw in the science great advantage to the painter, and entered into the views of the phrenologists most enthusiastically. He likewise studied modelling in clay, and a head of Thomas Paine, who wrote " Common Sense," and played the fool, is now in the library of the Historical Society, modelled by Jarvis. These men were at one time intimates and house-mates,—how much the painter profited by the precepts and example of Tom Paine, in the latter stage of his existence, the reader may judge. He could not but admire his genius; and few things are more dangerous than admiration of a misled man of uncommon talents.

Baltimore was the field in which our painter reaped a rich harvest for more than one year. He left his family in New-York. I remember that in returning from Philadelphia, I joined Jarvis in the Raritan steamboat, and he told me he came from Baltimore, and should return again; but it being late in April, he came on to New-York to see to the moving of his family on the first of May, according to the custom of the place.

Jarvis could not, or would not see the merit of Stuart. He occasionally had commissions to copy portraits by Stuart, and it appeared to me, that with all his cleverness, he could not imitate Stuart's colouring. I saw him at work upon a copy of Judge Benson, and remarked the difference of tone. " I will give the colour of nature," said Jarvis, " that's not nature," pointing to the original. I have seen a letter of his, in which, speaking of Stuart's pictures, he says, "I should like to set my name down amongst those who do not think him so great, as some say he is."

In the autumn of 1807, Mr. Sully's business in New-York had so slackened, that he offered himself to Jarvis as an assistant,—the latter having then the run. Jarvis said it was a great shame, that such a man should want to work as his assistant ; but he gave Sully employment, and paid him liberally.

Mr. Sully once told me, that calling on Jarvis, he was shown into his room, and left to wait some minutes before he entered. He saw a book on the table amidst palettes, brushes, tumblers, candlesticks and other heterogeneous affairs, and on opening it, he found a life of Morland. When Jarvis came into the room, Sully sat with his hand on the book, which lay

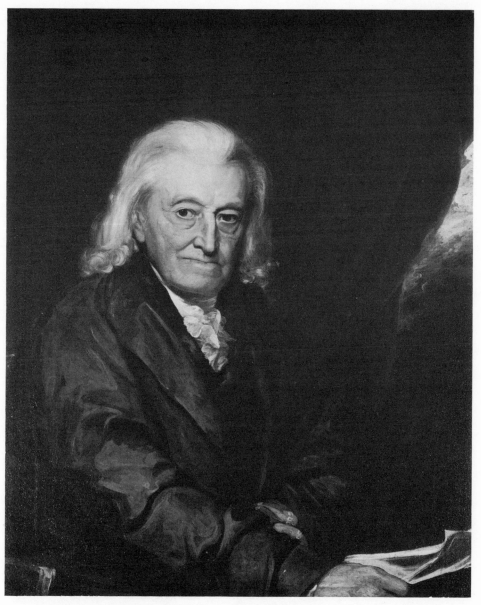

151 WILLIAM SAMUEL JOHNSON, 1814. Painting by John Wesley Jarvis. *Courtesy Columbia University.*

152 ALEXANDER ANDERSON, M.D., 1815. Painting by John Wesley Jarvis. *Courtesy The Metropolitan Museum of Art, gift of Robert Hoe, Jr.*

open on the table. " Do you know why I like that book ?"
said Jarvis. " I suppose because it is the life of a painter."
was the reply. " Not merely that," rejoined the other,
" it is because I think he was like myself."

What reflections does such a remark suggest! That a man
could possibly derive pleasure from contemplating such an
image as the life and character of Morland presents, and at
the same time considering it as a likeness of himself, is in-
comprehensible. My readers probably know that Morland
was a greater brute than the pigs he delighted to portray:
but Jarvis was a man of far superior character, both for intel-
lect and feeling, than Morland.

The last anecdote reminds me of the usual appearance of
this eccentric man's painting room. Esels, palettes, some
fresh set and others with dry paint on them, brushes, clean or
otherwise, pictures finished, or half finished, or just begun, a
table in the centre of the room with glasses, bottles, decanters,
empty or half full, chalk, and scraps of paper, with or with-
out sketches, and in the midst, perhaps, a lady's hat and
shawl. Once, in addition to all this, when I entered his room
at his request, I found his wife with her infant and a cradle,
with all the etceteras of a nursery. This was not a *mysterious
wife*, but a delicate and ladylike woman, before marriage
Miss ———, and used to those comforts which result from
order, and may be obtained at much less expense both of
money and of time, than the *discomforts* arising from confu-
sion, carelessness, waste, and extravagance. Besides the
above mentioned mass of heterogeneous materials, I saw a
side-table with a set of musical glasses, on which he gave me
a tune with great adroitness. With the utmost profusion in
lavishing money, there appeared to be in Jarvis no notion of
order or comfort, and much less of elegance ; on the contrary,
all around him evinced, if not a studied, at least an over-
whelming confusion—a chaos *hastening to destruction.*

Mr. Jarvis was fond of notoriety from almost any source,
and probably thought it aided him in his profession. His
dress was generally unique. His long coat, trimmed with
furs like a Russian prince or potentate from the north pole,
must be remembered by many; and his two enormous dogs,
which accompanied him through the streets, and often carried
home his market basket, will be remembered by all who were
children in New-York at the time.

We shall see that later in life the painter visited the cities
further south than Baltimore; and by his humour, his con-
vivial talents, his story-telling, and his untiring capability of
remaining at the table, as well as by his talents as an artist

became the favoured guest of the proverbially hospitable
south. Generally in New-York in the summer, he received
his southern friends in their annual passage to and from the
springs and the Canadas, and was happy to return, in his way,
their dinners and suppers. This was done with the same pro-
fusion and confusion as he ordered other affairs. One of these
dinners, as described to me by one of the guests, will serve to
elucidate his character, and I will attempt to repeat the de-
scription.

Some southerners having arrived, to whom he wished to
return civilities and do honour, the painter invited several
gentlemen of note to meet them. This was before his marri-
age with the lady above named. He then had his rooms in
Wall-street, and Pierre Van Wyke, the recorder of the city,
had his office below, in the same house. With Van Wyke, as
with most of the gentlemen of the city at that time, he was
intimate ; and among others Van Wyke and G. C. Verplank
were invited to meet the strangers. They sat down to a table
profusely covered with every good and costly viand the mar-
ket could afford ; venison, pheasants, and canvass-back ducks
tempted the appetite, although knives with broken handles,
and forks with one prong made the operations of carving and
eating somewhat awkward and difficult, and excited no little
surprise among the guests who were not aware of the painter's
habits. Wine was as plenty and of as great variety as the
meats, and the wine glasses of various sizes, but principally
of the largest calibre and most profound depth, such as would
not allow of the repetition of Sam Foote's pun—however old
the liquor—" Your glass of wine is very little of its age,"
would not apply here. The mode of opening a bottle (de-
canters there were none) was by breaking off the top of the
cork and thrusting the remainder down the neck with a greasy
fork—a cork-screw would have smacked too much of order.

" Jarvis," said the recorder, " I want some small drink—
here's nothing but wine." " Give the recorder the brandy
bottle !" " No, no, give me some small beer, or some water."
" We don't know such things—there is porter and ale."
" Some ale, then." " Tom ! give the recorder some ale."
After a pause, Van Wyke says, " Jarvis, where is this ale of
yours ?" " Tom ! why don't you give the recorder some ale ?"
" There's no tumbler, sir." " No tumbler !" " No, sir."
" Well, throw the soap out of my shaving cup."

In the course of Mr. Jarvis's very extensive practice, he
painted the portrait of Bishop Benjamin Moore, of New-
York ; and that eminently worthy gentleman used to tell of

one of Jarvis's quick and humorous thoughts with great glee. During one of the sittings, religion became the subject of conversation, and the bishop asked Jarvis some questions relative to his belief or his practice. The painter, with an arch look, but as if intent upon catching the likeness of the sitter, waved his hand and said, "Turn your face more that way, and *shut your mouth.*"

In the year 1808, (or 9,) Mr. Jarvis married the lady mentioned in a preceding page, and I believe about the same time raised his prices to $100 for a head, and $150 for head and hands. Some time before, I find by a letter of John Randolph, of Roanoke, that he paid Jarvis for his portrait $80. The size is not mentioned. It may be presumed that raising the price diminished the number of sitters in New-York; be that as it may, the painter, in the autumn of 1810, visited Charleston, South Carolina, where he found no objection to his prices, and a welcome reception given to his inexhaustible fund of table entertainment.

In or about the year 1814, Mr. Jarvis had possession, I presume by purchase, of Wertmuller's Danae; and exhibited it in the same house in which he painted, in Murray-street, near Broadway. Here Henry Inman became his pupil, or apprentice: but Jarvis had, soon after, better accommodations at the old Bowling-green house, built for the president of the United States at the adoption of the federal constitution— afterward assigned to the governor of the state, and for a time occupied by Governor George Clinton; but at the time of which we speak, divided between the collector of the customs, Jarvis, and the gods. The lower part of the building was the custom house, and in the upper the casts sent from Paris by Chancellor Livingston were deposited, and there Jarvis had his painting room. This was a good opportunity for the study of the antique, and no doubt was useful to the painter and his pupils. In the summer of 1813, Mr. Jarvis painted in Baltimore, and his pictures exhibited in Philadelphia are catalogued as of Jarvis of Baltimore.

When he went, for the first time, to New Orleans, he took Henry Inman with him. To use his own words—" My purse and pockets were empty. I spent 3000 dollars in six months, and brought 3000 to New-York. The next winter I did the same."

He used to receive six sitters a day. A sitting occupied an hour. The picture was then handed to Henry Inman, who painted upon the back ground and drapery under the master's directions. Thus six portraits were finished each week.

This was said in the summer of 1834, after having passed the previous winter at the same place, and returned a paralytic. The organs of speech which once kept the table in a roar, were no longer at the command of the enfeebled mind and imperfect memory, and could only by painful effort be brought to give sluggish utterance to disjointed language. He said he had not painted while at New-Orleans last winter; he could not get a room to suit him; there were none but three-story rooms to be had, and ladies would not go up in the garret. "I roomed with Hill, who plays the Yankee characters; I used to go to the theatre every night through the mud. One night I fell down in the mud, and I lamed my arm; I could not get up again; and there I lay till three watchmen picked me up; one of them gave me my knife and I walked off. 'Why he is not drunk,' says one to t'other." Mr. Jarvis has often and habitually shown his care for, and love of his fellow creatures; he now knows that it is man's duty to care for his own prosperity—to love himself, that the love to his neighbour may be efficient. To preserve the gifts bestowed upon us is a duty, which if not performed, brings repentance. In a letter before me he thus speaks of the place where a few years ago every house was open to him, and he spent his thousands in a few months, and brought away thousands in his pocket. " New-Orleans is more disagreeable than ever; I say nothing about the mud; but a lodging was not to be had. I did not know what to do. I thought I would have to cut my throat, get drunk, or sleep with a negro. But now I have a room to sleep in—they call it boarding—the weather has been decent these few days, so I went to market to see if there was any thing in it. I saw some beef, alias carrion, a few pokes, *an owl*, some crows, a few toad stools, and a smoked dog." But with a constitution of uncommon strength, and uninterrupted health, it took years to produce this wreck—years, passed, as it would appear to some, in pleasure—to others in a mad pursuit of misery.

But it was immediately after Jarvis's two *first* visits to New-Orleans that he painted those full-length portraits of military and naval heroes which will keep him in public remembrance for a short-lived immortality, by their situation in the City Hall of New-York, and their great merit. These pictures, by being the most difficult works he ever executed, tested the knowledge he had obtained by his exertions amidst apparent inattention to study and real waste of nature's gifts in dissipation. They are historical portraits, painted with skill and force—real representations of men and character; throwing

most of the pictures painted for the city of New-York previously, far in the back-ground. In the year 1812 I remember meeting Jarvis in that room, afterward enriched by his pencil, and *even then* he anticipated painting full-lengths for the corporation of the city. The pictures then in the room were the governors of the state painted by Trumbull. " One of these days," said Jarvis, " you and I will be employed in painting for this room." " You may," I replied, " but there are no miniatures wanted." This was some time before I attempted to recover my oil-brush. " We shall see," was Jarvis's rejoinder. He did see ; and performed the task he was called to very much to his credit ; although it is little to the credit of the *then* rulers of the city, that no specimen of Stuart's unrivalled pencil is to be found on the walls of its public hall.

After the war was over, and no more heroes were to be made by the cannon's mouth or the pencil's point, Jarvis continued to visit the south in the winter and return north in the summer, like the Carolinians and the snipe and woodcock. Having returned to New-York from Charleston or New-Orleans, he met an old acquaintance in the street and saluted him with the usual " How d'ye do ?" The reply was, " Very well, I'm always well ; and how are you ?" " *Well ?*" cried Jarvis ; " *Well!* I have not heard such an answer to that question for many a month. We don't talk so in the south." " Why, what do they say there to a ' how are you ?' " " Rather better to day than I was yesterday ; but not so well as I was last Wednesday."

To sing a good song is the bane of many a good fellow, and the merry story-teller frequently makes his home a house of mourning, while he sinks an object of pity to a premature grave. It is an old Joe Miller joke that the fiddle of the company is hung behind the street-door when the master visits his family ; but I am afraid it is too true to be considered a joke.

I will endeavour to give the reader a faint idea of some of the stories which made the highly-gifted man we are considering a Yorick at the convivial board. Not that I can give his words or convey any notion of his peculiar manner—a manner which gave point to a remark which, from another, might pass unnoticed.

In the year 1826 I met him in the Park on a rejoicing day. " When I see *our folks* at such times as this," said he, " it puts me in mind of the story of the young man from the interior, who, coming to New-York, went on board one of our frigates, and it happened while he was there a salute was fired

by the ship. 'By God!' he exclaimed, 'we are a great people!'"

An artist, now of high standing, told me that some years ago, as he was travelling in the stage to the seat of government, his attention was attracted to a fellow passenger by the utter want of decency in his appearance and conduct. His mouth was in a disgustingly filthy condition from his chewing a piece of a cigar, while streams of yellow saliva issued from the corners, descending upon and staining his shirt. During the ride this filthy figure took a miniature from his pocket and showed it to the young artist, asking his opinion. He praised it, but remarked something he thought wrong. "Aha! you are an artist." The young man felt that he ought not to accept the title and evaded giving an answer, but asked who painted the picture ? " I did," and after a time his dirty companion announced himself as Jarvis. After arriving at Washington he met him at a ball, and was introduced to him. He was now dressed in black, and appeared like a gentleman.— "I observed," said the young man," that he was well known to many, but always addressed with a familiarity little allied to respect."

Some of his humour was what is called manual ; not precisely that refined wit which removes the chair from the expectant sitter and displays him prostrate for the delight of an enlightened company ; but preserving so much of the character that one friend is exposed in his peculiarities or weaknesses for the amusement of other friends.

It will appear strange to many, and I confess that it appears strange to me, although the fact has been long known, that men of the first standing in our society, rich men, elderly men, with families at home, should habitually meet at a porter-house to drink beer or brandy, and seek amusement in the babble that beer and brandy generate. At a certain porter-house in New-York Jarvis frequently appeared, and met several men much older than himself, with others, and amused one part of the company by *playing off* another. Three or four of these worthies had hobbies which they delighted to ride. A cashier of a bank made astronomy his study—a rich merchant directed the movements of the European armies—an old ship-captain quoted poetry by the yard, and other prosers had nags equally unsuited for their bestriding. Jarvis's joke was to sit by the astronomer and drink and smoke until he had got him among the stars ; then steal off unperceived, and set the merchant to moving armies, and the captain to moving heaven and earth with divine poesy, and thus, having got all the talkers

involved in words and smoke, he would move to a convenient distance, and with those who were in the secret, enjoy the confusion of tongues and subjects, each smoking his cigar very seriously, and occasionally putting in a question to keep up the motion of the hobby riders.

It is said, that on seeing a tall, melancholy looking Frenchman walking very solemnly down Broadway, with a very large cigar box under his arm, Jarvis placed himself immediately behind, imitated his funereal step; and as he saw an acquaintance likely to join in the fun, he would by signs bring him to follow in the train ; until he got up a string of some length, walking in solemn procession. The bearer of the box, on turning a corner, looked round and saw that he had a suite of attendants, of whose motives he could form no notion. He stopped—the procession stopped. " Gentlemens, vat you mean ? Vat you mean, gentlemens ?" Jarvis answered, " Seeing that you were a foreigner, sir, and no friends to assist you at the burial of your child, we thought to show our respect by attending the funeral."

While residing at the hospitable mansion of a southern planter, the owner being for some days absent, the painter played the following freak. The house stood a little way from the road ; a gate being in front, and near it a large dog kennel, which had not for years had an inhabitant. Jarvis took paints and brush, and wrote on this dog-house, in front and on the sides, " Take care of the dog." It was then his amusement to see the passing neighbours or travellers approach, and suddenly stop—read the inscription, and cautiously cross to the other side of the road. If a horseman came cantering up, the speed was checked and the road crossed, or a spur given to the steed, and a quickened pace insured.— Those who wished to come to the house avoided the gate, and took a back way—" Take care of the dog," changed the course of the whole county. At length the owner of the plantation returned ; and, startled as the rest had been, avoided the gate. " Why, Jarvis, what have you got in the dog-kennel ?" " A dog, to be sure ! come and see." They went— and the painter took out of the dog-house a puppy which had not yet seen the light. " Poor little fellow !" said Jarvis, " don't you think it is necessary to *take care* of him ?"

At Charleston, South Carolina, where he long continued a great favourite, on one occasion, at a large dinner party, after the wine had circulated freely, and had banished form ; and from some of the convivialists, not only form but discretion ; it was proposed that the company should club, and make up

a sum, which should be the prize to the man who told the greatest and most palpable *lie*. This was readily agreed to, and the prize sum deposited. The president began—and the monkey's tail, of a mile in length, was nothing to what he had seen in his travels. Lie followed lie; and as it is easy to heap absurdity upon absurdity, and extravagance on enormous exaggeration; and as easy to excite laughter and command applause, where champagne has been enthroned in the seat of judgment—each lie was hailed with shouts of approbation and bursts of merriment. One of the company, who sat next to Jarvis, had exceeded all the competitors, and unanimous admiration seemed to insure to him the prize. The *lie* was so monstrous and so palpable, that it was thought wit or ingenuity could not equal it. Still something was expected from the famous story-teller, and every eye was turned on the painter. He appeared to be very serious; and placing his hand on his breast and bowing his head, he gravely said, " Gentlemen, I assure you that I fully and unequivocally believe every word the last gentleman has uttered." A burst of applause followed, and the prize was adjudged to Jarvis.

But of Jarvis's stories it is very difficult to give an idea.— He introduced them well and pointed them happily. Beside that his hearers were generally, if not excited by wine, or whiskey punch, at least divested of all worldly care for the moment, and ready for frolic and fun. Few *readers* are in this state. However, I shall endeavour to tell two or three of those stories in sober black and white, which have amused the companions of the painter at the board, or the auditors of Mathews in the theatre; for the comedian derived some of his best extravaganzas from the Yankee painter. Mathews told the following to the writer in private company, and he repeated it to Hacket at Utica, before he made the stage his profession. Hacket has since dramatized it, with what success I know not; but as the incident is very simple, I should think it was not sufficiently dramatic for the theatre.

" An old French gentleman, who resided at Charleston, as a place of refuge from the horrors of the Parisian revolution and massacres, anxiously awaited a letter from his only child, a daughter, left in Paris. This gentleman's name was *Mallet*, which, as my readers know, is by the French pronounced *Mallai*. The interest, or the humour of the story of Monsieur Mallet, rests altogether on the different modes of pronouncing the name by French or Englishmen. The emigrant is supposed to be a man of rank, with the courteous manners of a noble of the old school, and all the national vivacity, with the

irritability of the pampered aristocracy of the monarchical re-
gime. He goes to the post-office, with the anxious feelings
of a parent, who had been obliged to leave his child exposed
to dangers from which he had fled ; and he knocks at the
window where inquiries for letters are made. The clerk opens
the little door which supplies the place of a pane of glass, and
presents his face as ready to answer questions. " Sair, if you
please, sair, have you any lettaire for Monsieur Mallai ?"—
The clerk looks among the M's, and then answers respectfully,
" None, sir." " Mon Dieu ! is it possible ? It is ver strange,
sair. It is now more dan six mont dat I hear noting from my
shilde, my daughter, sair." " None, sir;" and the little door
is shut. Monsieur Mallet bows and walks away. Again and
again Monsieur Mallet appears, and knocks, and asks for a
letter for Monsieur Mallai, and receives the same answer,
" None, sir." At length, having received the usual answer,
he makes request for search, with the utmost politeness. " I
pray you, sair, be so good look again ; perhaps it is mislaid :
it is now more dan six monts since I hear noting of my daugh-
ter, who is in Paris, and exposed, sair, for my sake, for de
sake of her fader, to all de ferocity of de Jacobin regicide fac-
tion, and de fury ——" " I have looked—there is no letter
for you." " Oh! mon Dieu ! she must have been sacrificed !
My dear sair !——" The door is shut. The poor old gen-
tleman walks sorrowfully away. This goes on, with every
variation that the good teller of good stories can invent.

At length when Monsieur Mallet is sitting at the café and
reading the newspapers, he sees a long list of letters advertised
by the post-office, as uncalled for. Eagerly, though hope-
lessly, he looks over the columns, and to his astonishment he
sees a letter noticed for Monsieur Mallet, as one that had not
been asked for. His blood both natural and aristocratical
boils with rage. He seizes the newspaper and hastens to the
post-office, determined to convict the postmaster or clerk.
He has the evidence of their guilt and falsehood in his pocket.
He knocks as usual, and assumes a look of more than
usual courtesy. The clerk appears, with no very pleasant
aspect. " So, sair, I suppose dare is no lettaire for Monsieur
Mallai—ha ?" " There is no arrival since you were here this
morning." " And dare is noting for Monsieur Mallai—ha ?"
" Nothing." " No lettaire ?" " I tell you none." " A ha!
None !" His rage breaking out by degrees. " None ! You
will please to look again, sair !" " I have looked again and
again, and I tell you there is none." " Stop sair, don't you
shut dat leetle door in my face !—Dare is no lettaire for Mon-

sieur Mallai? 'Now sair," producing the newspaper, "for vat you tell me mont after mont dat dare is *none! none!* I will show you, sair, look at dis paper, sair; is dis from your post-offeece?" "To be sure it is." "Aha! It is; den look dare, dare is a lettaire for Monsieur Mallai! dare sair, dare!" striking the paper with his finger and trembling with rage. "It may be *there*, but there is none *here.*" "Vat sair, you deny your own advertisement? Look dare sair, look dare!" and he gives the paper and points to the name. "O, for Mr. Mallet; yes, here has been a letter for Mr. Mallet this three months, it has never been inquired for, there it is." The enraged noble takes the letter. "Mon Dieu! tree mont, and I suffaire, you scoundrel! you dam post-offeece! I come every day and ask for it dis tree, four mont." "You *never* asked for it!"

An altercation takes place; the enraged father forgets what it is that he holds in his hand; the insult to his dignity by the denial of his assertion, drives from his mind all other images—the daughter—the precious letter is not thought of, and as he raves he tears the document, which he had so long yearned for, into pieces, and scatters the fragments, when reduced to the smallest size, in every direction to the winds. He is brought to his senses by a demand for the postage. He looks for the letter—he feels his pocket—he is soon convinced that the intelligence from his daughter, so long and anxiously sought, has been irretrievably lost by the indulgence of rage at its detention. If there is any moral to the tale it is, that the indulgence of passion inevitably leads to misery and repentance.

This post-office story suggests another, which I will tell, though not one of Jarvis's. An English merchant, whose name was unfortunately adapted to the addition of that aspirate which causes such murder of the king of England's language, for in that country the language is the king's, although they may have imported him from Germany or Holland, where he never heard it spoken. Thus the cockney who talks of *hatmospheric hair* is said to murder the king's English. So our English trader, whose name was Ogton, always called himself by the degrading appellation of Hogtown, following the London practice of adding an *h* in speaking, when it was necessarily omitted in writing.

In the earlier times of his residence in America, and before the clerks of the post-office knew his person or he had clerks to send for his despatches, he called day after day to inquire if there were "any letters for John Hogtown?" and the inva-

153 GENERAL ANDREW JACKSON, c. 1819. Painting by John Wesley Jarvis. *Courtesy The Metropolitan Museum of Art, Dick Fund.*

154 PORTRAIT OF AN OLD LADY, c. 1815–1820. Painting by John Wesley Jarvis.
Courtesy The Metropolitan Museum of Art, bequest of Kate d'A. Bonner.

riable reply was, " None, sir." " Very strange," said he, and
he began to feel as uneasy about his goods and bills of ex-
change as Monsieur Mallet about his daughter. One day
after the usual question of " Any letters for John Hogtown ?"
His eye followed the clerk and he observed that he was look-
ing among the letters beginning with *H.* " Olloh !" cried
honest John, "what are you doing there ? I said John Hog-
town." " I know it sir, and I am looking for John Hogtown.
There is nothing for you sir." " Nay, nay !" shouted John,
" don't look among the *haitches*, look among the *hoes*." And
among the *O*'s, John Ogton's letters had been accumulating
for months. We can scarcely conceive a more efficacious
lesson to mend a merchant's cacophony.

Another story, which Mathews dressed up for John Bull,
originated with Jarvis. From a friend I have what I suppose
to be the original scene. My friend was passing the painter's
room, when he suddenly threw up the windows and called him
in, saying, " I have something for your criticism, that you
will be pleased with." He entered, expecting to see a picture,
or some other specimen of the fine arts, but nothing of the
kind was produced—he was, however, introduced with a great
deal of ceremony as Monsieur B—, " celebrated for his
accurate knowledge of the English language, and intimate
critical acquaintance with its poetry—particularly Shak-
speare." Mr. A—, as I shall call my friend, began to
understand Jarvis's object in calling him in.—After a little
preliminary conversation, Jarvis said, " I hope, Monsieur
B—, you still retain your love of the drama ?" " O cer-
tainly, sir, wid my life I renounce it." " Mr. A—, did
you ever hear Monsieur recite ?" " Never." " Your recita-
tions from Racine, Monsieur—will you oblige us ?"

The polite and vain Frenchman was easily prevailed upon
to roll out several long speeches, from Racine and Corneille
with much gesticulation and many a well-rounded *R.* This
was only to introduce the main subject of entertainment.
" Monsieur B— is not only remarkable, as you hear,
for his very extraordinary recitations from the poets of his
native land, but for his perfect conquest over the difficulties of
the English language, in the most difficult of all our poets—
Shakspeare. He has studied Hamlet and Macbeth thorough—
and if he would oblige us—do Monsieur B—, do give us
' To be, or not to be.' " " Sur, the language is too difficult—
I make great efforts to be sure, but still the foreigner is to be
detected." This gentleman's peculiarities were in extreme

precision and double efforts with the *th* and the other shibbo-
leths of English. The unsuspecting and vain man is soon in-
duced to give Hamlet's soliloquy, the *th* forced out as from a
pop-gun, and some of the words irrisistibly comic. " But,
Monsieur B—, you are particularly great in Macbeth—
that ' if it were done, when it is done,' and, ' peep through
the blanket,'—come, let us have Macbeth." Then followed
Macbeth's soliloquies in the same style. All this was ludicrous
enough, but upon this foundation Jarvis raised a superstruc-
ture, which he carried as high as the zest with which it was
received by his companions, his own feelings, or other cir-
cumstances prompted or warranted. The unfortunate Mon-
sieur B— was imitated and caricatured with most laugh-
provoking effect ; but to add to the treat, he was made not
only to recite, but to comment and criticize. " If it were
done," " peep through the blanket," and, " catch with the
sursease, success," gave a rich field for the imaginary critic's
commentaries—then he would expose, and overthrow Vol-
taire's criticisms, and give as examples of the true sublime in
tragedy, the scene of the witches in Macbeth.

" Huen shall we ththree meet aggen ?" but, " mounched,
and mounched, and mounched," was a delicious feast for the
critic—and " rrump fed rronion," gave an opportunity to
show that the English witch was a true John Bull, and fed
upon the " rrump of the beef," " thither in a sieve I'll sail
and like a rat without a tail, I'll do—I'll do—I'll do," being
recited in burlesque imitation, gives an opportunity for com-
ment and criticism, something in this manner. " You see not
only how true to nature, but to the science of navigation all
this is. If the rat had a tail, he could steer the sieve as the
sailor steer his ship by the rudder ; but if he have no tail, he
cannot command the navigation, that is the course of the sieve ;
and it will run round—and round—and round—that is what
the witch say—' I'll do—I'll do—I'll do !' "—But how can
the humour of the story-teller be represented by the writer—
or how can I dispose my reader to receive a story dressed in
cold black and white—in formal type—with the same hilarity
which attends upon the table, and the warm and warming rosy
wine ? The reader has perceived the want of these magical
auxiliaries in the above. But all Jarvis's stories did not want
the aid of the bottle to give them zest. I remember meeting
him when soberly walking in the Mall, at Boston, and he gave
as a travelling incident connected with his journey from New-
York, the following narrative, which if I mistake not, does
not require the powers of the goblet to support it.

"We had for companions in the stage four travellers like ourselves, and two of them luckily proved characters. General Q—, who is a most dignified personage, and so self-important as to be unapproachable, and a sprightly little French gentleman who had no hesitation in approaching any one. He had seen enough of the world to know how to make himself agreeable, and he had all the 'dispositions in the world' to do so. The foreign gentleman soon addressed the American general with 'Wer fine weddair, sair!' The great man drew himself to his greatest height—not less than six feet two—and answered by something like a sound you may have heard from a pig-pen, a kind of 'humph.' By and by the French gentleman took out his snuff box, gave it a lively tap, and presented this link in the social system to the military hero, who drew back without even deigning a bow of thanks. The box was handed round, and Henry and I took each a pinch and entered into conversation with the owner; who, as if he was determined not to be repulsed by the ill-breeding of the self-sufficient yankee general, (who, by the by, came from south of the Delaware, again with great suavity of manner took the opportunity which a jolt gave, to remark on the state of the roads; but he only received a still more repulsive 'humph.' The Frenchman then turned his back upon the warrior, and without appearing to notice his insolence, entered again into familiar chat with less dignified companions of the voyage, but from that time he began to show marked contempt for the general.

"At the end of the day's journey, we were all shown into the room appropriated to travellers who journey by the stage; but the general, as if his dignity had been offended by such democratic treatment, after a minute or two of surly silence, called loudly for the waiter. Instantly the Frenchmen echoed him—'Vaitaire?' The general looked at the little man and seated himself. The little man looked at the great general, and took his seat also. The waiter, an Irishman, entered and stood between the incipient belligerents, looking unutterable mis-intelligence. 'Bring me a pair of slippers!' said the man of insulted dignity. 'Bring a me *two* pair sleepaire!' shouted Monsieur. The general looked ten thousand contempts. Pat stood like Francis between fat Jack and lean Hal. 'Give me a candle, sir!' said the *militaire*. 'Bring a me, sair, *two* candaile!' shouted the foreigner. Pat was immovable—an image of confusion worse confounded. 'Quick, sir,' said the general, 'show me to a bed.' 'Queek, sair,' was the echo, 'show me to *two* beds.'

" The general kept up his dignity by retiring from the contest, and the next day proceeded in a private carriage.

" ' Now if I know the maining of this, I'll be bothered!' said Pat." It means that common courtesy when travelling smooths the road better than macadamizing.

I dramatized this story in a farce called " A trip to Niagara," and with effect. I will attempt one more of Jarvis's stories; which, as I did not hear it from him, the reader may imagine to be in Jarvis's language or in mine, as seems most agreeable to his notions of verisimilitude.

" Some years ago, when it fell out that in the fall of the year the yellow fever visited New-York before the ' yellow leaf' appeared in the country, I took refuge at a farmer's house on Long Island, where I saved *my* bacon and eat *his*. He had an empty building about half a mile off, which I hired for my painting room, and thither conveyed my unfinished pictures, my paints, brushes, oils, and varnishes, and took my seat, palette, and maul-stick in hand by my esel. No one came to see me, for I had nothing to eat or drink at this place, and the only living creature that patronized me was a cat. I thought at first that she was one of the farmer's family; but soon found that puss was a fixture in my painting establishment, and never moved any distance from the door, that is, not out of doors, generally sleeping near my esel, (as soon as she found that I was a quiet, inoffensive creature like herself,) and every day, about a certain hour, walked lazily up stairs to the garret. I say lazily, for she was too fat to move otherwise. The plump and sleek condition of this cat, caused a con*cate*nation of conjectures to pass through my mind with the force of projectiles from a *cat*apult—in short, my thoughts were like a *cat*aclysm, and overwhelmed me like a *cat*aract : to give you a *cat*alogue of them is impossible. The question was, ' how could this *cat*-creature keep up fat and flesh in a place where there was nothing to eat ?' This worried me thin. I could not paint for thinking of this fat cat. It was a secret worth the philosopher's stone. It was the *cat*holicon. If a man could live, and live fat, without eating, he might laugh at fortune and defy death. I could not make it out; and it was in vain to *cat*echize the cat. Her answers, though not *cat*echistical, were as far from the purpose as if they were. To *cat*ch the cat napping was no difficulty, for except when she took her walk up stairs, she was as stationary as a *cat*head. ' The mystery must be in the garret, and I'll dog the cat but I'll find who *cat*ers for her.' So thought I.

"Accordingly, the next time puss stretched herself after the usual nap, I put down palette, pencils, and maul stick, and prepared not only to follow the cat but the *cat*enation, (if I could but discover it) until the *cat*astrophe should be established *cat*egorically. Up went puss and up went I, as silent as *cat*gut dissevered from horse hair. I took off my new boots, for they squeaked like *cat*calls. I tried to avoid being seen. I kept out of the line of direct vision, and there was nothing that could discover me *catoptrically.*

I saw puss very deliberately sit down and lick the bottom of her feet. "If that's necessary," thinks I, "I can't do it."— Puss having performed this leading operation with as much gout as if the soles of her feet were *cat*es, or as a gourmand would lick his lips when sauced with *cat*sup, she got up and traversed the centre of the room, backwards and forwards, as if confined within a circle. Looking sharply at the spot on the floor which seemed to confine her, as a *cat*erpillar would be if surrounded by a ring of molasses, I saw that it was covered with small seed. This I knew would, with the saliva, form a *cat*aplasm. My curiosity was now intense. The cat, having satisfied herself that all was ready for the next step, approached a window, always open, because broken half out, and making one spring, vanished. There was no light, as you perceive, thrown upon the subject by the window; but I would not lose sight of my *cat*er-cousin and prospect of immortality thus. I came from the hole, as dark as a *cat*acomb, where I had been ensconced, and on tiptoe went to another broken window, all the time expecting to hear a *cat*erwauling on the house-top—but no, all was silent as *Cat*aline. I looked out and saw puss in the gutter—on her back—her legs stiff and fixed upright as if she had been struck by *cat*alepsis. In short, my teacher of a way to live forever, appeared dead and stark as a fried *cat*fish. I was not long at my window before a little chipping-bird alighted on the roof, and came hopping towards puss. The little rogue shyed for a while, then started, and was winging its flight over the cat's feet, when seeing the seed, he wheeled round, closed his wings, and descended on her forepaw. No sooner did his beak touch the bait, but the trap closed on his head—he struggled—gave a faint stream—and I saw in the *cat*astrophe a *cat*egorical answer to all my doubts, and an end to my vision of life without eating.

"Thus you see she contrived to *cat*er for herself by becoming a *cat*-erect though on her back, and every bird she made a shift to *cat*ch was an addition to the string of *cat*astrophes on

which she feasted. I found that all the difference between puss's way of living and mine, was that she killed and dressed her own tid-bits — she 'killed her own mutton.'

" My only consolation for this overthrow of all my hopes of being a second St. Leon, was to sit down and draw up a statement of this case, which I entitled *Catology.* This document is deposited among the archives of the New-York Philosophical Society; and ensures me one kind of immortality, though I have been disappointed in that which I confess is more to my way of thinking."

The habit of entertaining boon companions, and " setting the table in a roar," unfits a man for domestic comfort. Mr. Jarvis's marriage was not a happy one. A separation took place, and the mother withheld her children from their father. Legal interference made this unhappy state of things public, and made the painter more and more reckless of the world's opinion, and apparently regardless of his own welfare.

It was about four years ago, i. e. 1830, that I met Mr. Jarvis in Broadway. I had not seen him for many months. He reproached me for not having called upon him. I told him I did not know where he lived. " Come with me and I will show you." Although it was not yet noon, I perceived that it was late in the day with Jarvis.

We turned down Vesey-street, and walked towards his quarters; and by the way he expatiated largely upon a plan he had for painting two large pictures for exhibition. " In one," said he, " I show the effects of bad habits, and strong liquors. I will paint a farm-house with every thing around it going or gone to ruin: fences down—gates broken or unhinged—windows shattered, and old hats and petticoats for panes of glass— the man of the house in rags and bloated, reeling home from a tavern—his wife sallow, dispirited and sick—the children neglected, filthy, and crying for bread. In the other picture I will exhibit the effects of industry and temperance, on another farm-house and its inmates. The house and fences neat and painted white;—all serene around, and in the distance a golden harvest. The white house, shaded by luxuriant fruit trees, the man full of health and vigour, having returned from the field, has his blooming children around him, and is plucking cherries for them, while his wife, full of health and smiling with content, looks at him she loves, and invites him in to his meal. In short, such a place as the abode of temperance must be."

By this time we had arrived at the abode of the artist, who

could conceive and describe these scenes, and a commentary on the text was given. In the front room was an esel, a palette and brushes, with the paint dried upon them. Two or three bad unfinished portraits on the floor, confused furniture in scant quantity, and a little dirty boy. The painter threw open a door, and invited me into a back apartment. It was small, and on one side was a bed, and on the other a pile of wood. Opposite to the door was a kind of cupboard. The centre of the room was occupied by a table with bottles and glasses. He opened the cupboard, and took out a decanter of brandy, a pitcher of water, and two tumblers, for which he found room on the table. " Come," said he, drink?" " No," I replied, " I belong to the white house." " Well, well," said he, filling a tumbler more than half full of brandy, " if you will not drink, you shall see me drink," and adding some water, swallowed the whole. The result of such conduct has been seen. At the age of fifty-four, an age at which men, with half the vigour that he had been blessed with by nature, are strong in body, and more strong in mind than at earlier periods, his mind and body are destroyed. The excellent artist cannot paint—the tongue which delighted the hearer is paralyzed—the memory which furnished ideas for a rich imagination to combine, is no more. With a frame of iron, and constitution of steel—with a mind to contrive, and hand to execute—nature had endowed this extraordinary man; but the good gifts were misused, the blessing of health and strength counteracted by poisons, and the name of John Wesley Jarvis, a man of great talents and kind disposition, can only be used " to point a moral or adorn a tale."

Mr. Jarvis was never a hypocrite nor a sycophant. His manners were not what are styled courteous, but they were always frank. In prosperity and adversity he met the first and best of the land as an equal. He did not disparage the works of other artists, either by words or by smiles which conveyed a sneer of contempt. Stuart alone he made war on—but it was open war on one who could defend himself. I never knew him to refuse his advice or assistance to an artist. To me he was always friendly, as an artist and a man. The depreciation of his powers have been long gradually more and more apparent, and it is due to truth that the cause should be pointed out, and particularly due to every professor of the fine arts.

I shall conclude my account of Jarvis with an extract from a communication concerning him from Dr Francis:

" Dr. Syntax never with more avidity sought after the sublime and picturesque, than did Jarvis after the scenes of many-coloured life ; whether his subject was the author of

Common Sense or the notorious Baron Von Hoffman. His stories, particularly those connected with his southern tours, abounded in motley scenes and ludicrous occurrences; there was no lacking of hair-breadth escapes, whether the incidents involved the collisions of intellect, or sprung from alligators and rattlesnakes. His humour won the admiration of every hearer, and he is recognised as the master of anecdote. But he deserves to be remembered on other accounts," continues Dr. F., " his corporeal intrepidity and reckless indifference of consequences. I believe there have been not a few of the faculty who have exercised, with public advantage, their professional duties among us for a series of years, who never became as familiar with the terrific scenes of yellow fever and of malignant cholera as Jarvis did. He seemed to have a singular desire to become personally acquainted with the details connected with such occurrences; and a death-bed scene, with all its appalling circumstances, in a disorder of a formidable character, was sought after by him with the solicitude of the inquirer after fresh news. Nor was this wholly an idle curiosity. Jarvis often freely gave of his limited stores to the indigent, and he listened with a fellow feeling to the recitals of the profuse liberality with which that opulent merchant of our city, the late Thomas H. Smith,* supplied daily the wants of the afflicted and necessitous sufferer during the pestilence of 1822.

" We are indebted to Jarvis for probably the best, if not the only good drawing of the morbid effects of cholera on the human body while it existed here in 1832. During that season of dismay and danger our professional artists declined visiting the cholera hospitals, and were reluctant to delineate when the subject was brought to them. But it afforded a new topic for the consideration of Jarvis, and perhaps also for the better display of his anatomical attainments, he with promptitude discharged the task. When making a drawing from the lifeless and morbid organs of digestion, to one who inquired if he were not apprehensive of danger while thus employed, he put the interrogatory, ' Pray what part of the system is affected by the cholera ?' ' The digestive organs,' was the reply. ' Oh no, then,' said Jarvis, ' for now you see I am doubly armed—I am furnished with two sets.' "

* This distinguished merchant was proverbially known as a man of unbounded liberality in the days of his adversity as well as of prosperity. During the prevalence of the yellow fever in 1822, he almost daily visited the abodes of sickness in different parts of New-York, and he often appropriated, of his own private funds, some fifty, one hundred, or more dollars in the course of the day, to the relief of the afflicted sufferers.

155 COMMODORE THOMAS MACDONOUGH. Painting by Joseph Wood. *Courtesy The Metropolitan Museum of Art, gift of Mrs. W. Murray Crane.*

156 THOMAS SAY. Miniature by Joseph Wood. *Courtesy Yale University Art Gallery, gift of Mrs. Francis P. Garvan.*

CHAPTER VI.

Joseph Wood—works as a silversmith—paints—joins Jarvis—removes to Phila-
delphia—to Washington—death—B. H. Latrobe—Sully—birth and early life—
Difficulties in youth—Sully commences painting at Norfolk—removes to New
York—visit to Stuart at Boston.

JOSEPH WOOD—1798.

Joseph Wood, *c.* 1778–1830.

MR. WOOD was born at Clarkstown, Orange county, state of New-York. His father was a respectable farmer, and wished his son to follow in his steps.

When Joseph was fifteen years of age he had gleaned some tidings of painters and their high estate, and feeling confident in his powers with the pencil, he determined to seek his fortune in New York.

He was attracted by some miniature pictures in the window of a silversmith's shop. He offered himself to this silversmith as an apprentice, and was received. These miniatures seem to have decided his future employment; for being permitted to attempt to make a copy of one, he so far succeeded as to encourage him in the hope of becoming a miniature painter. Working as a silversmith and attempting to paint, occupied the youth for some years, at the end of which, Wood had become acquainted with the eccentric John Wesley Jarvis.

Jarvis and Wood for a time carried on business together, having rooms near the Park Theatre. Their principal occupation was in profile likenesses, but by degrees Jarvis had employment in oil portraits, and Wood having improved, got work in miniature.

Wood's biographer says, in the Portfolio, Malbone gave him instruction, and "While he (Malbone) lived, was Wood's best friend, and when he died, he left him an example in his life, and a pattern in his works."

The friends, Jarvis and Wood, separated. Wood had for a long time his painting rooms in Broadway, and executed work enough to have secured a fortune. Such was his rapidity, that he has often finished a portrait in one day.

Mr. Wood, about the year 1806-7, removed to Philadelphia, and from thence to Washington, the seat of government, where he died at the age of fifty-four.

BENJAMIN HENRY LATROBE—1796.

Benjamin Henry Latrobe, 1764–1820.

Was a native of England, the youngest son of the Reverend Benjamin Latrobe, an English Moravian clergyman, and

Anna Margaret Antes, the daughter of a gentleman of Pennsylvania. The childhood of Benjamin Henry, which was passed under the age of eleven, at school in Yorkshire, gave indications of his future eminence as a draughtsman and architect, for even then he made drawings, generally original, from buildings which attracted his attention. From Yorkshire, he was sent to a Moravian seminary in Saxony, and thence to the University at Leipsic. In 1785, after three years of intense study, Mr. Latrobe left Leipsic, for the purpose of travelling, but was tempted to enter the army of the King of Prussia, and served as an officer for one campaign. He then made the tour of Europe, and studied the works of the masters in the art which he loved. On his return to England, he studied architecture and civil engineering, and immediately distinguished himself.

In 1790 he married Miss Lydia Sellen, and was appointed surveyor of the public offices in the City of London. He lost his wife in 1793, and that event, and the part he took in the great political divisions of the day, induced him to think of the United States as the future field for the exertion of his abilities, and as the country of his choice. In November 1795 he embarked, and after a passage of nearly four months, arrived at Norfolk in March 1796. Delighted with Virginia he remained in Norfolk and Richmond, until November 1798. In this interval among other professional exercises, he planned and built the penetentiary at Richmond, and examined and reported on the dismal Swamp Canal.

In 1798, on a visit to Philadelphia, when in company with the President of the bank of Pennsylvania the conversation turned upon the banking house then proposed to be built. Mr. Latrobe made a sketch of a design, while the conversation was going on, and left it with the president, without thought of the future.

In July 1798, he received a notice that his plan for the Bank of Pennsylvania was adopted, and a request to furnish instructions for the workmen. It is needless to speak of the universal approbation which this beautiful edifice has received. To superintend its erection, Mr. Latrobe removed to Philadelphia, and soon after undertook the water works which he triumphantly executed. At this period he married Miss Mary Hazlehurst. He was, in 1799, engaged in making surveys relative to a canal for uniting the waters of the Chesapeake and Delaware Bays ; his report was adopted, and the work begun, but was not finished, as the subscribers did not pay up their shares. These waters have been united by a more expensive route. In 1803,

Mr. Latrobe was called to Washington by Mr. Jefferson, to complete the works begun under former administrations, and was appointed surveyor of the public buildings. Little had been done for the buildings, until Mr. Jefferson in 1803 by his influence, caused the determination in Congress to proceed to their completion, and by him Mr. Latrobe was selected to carry the resolution into effect. To finish upon another's plan, and in conflict with the interests of all who had preceded him, raised difficulties in the way of Latrobe, and he was met by opposition at every step, and assailed by misrepresentation from every quarter. But the President duly appreciated his merit, and gave him his undeviating support.

In 1808, Mr. Latrobe commenced the South wing of the Capitol, the exterior of which, of course, had to conform to the north wing, as designed by Dr. Thornton, but the interior was finished on Latrobe's plan. The navy yard being also under Mr. Latrobe's direction, he planned and erected the buildings and machinery connected therewith. In 1809, he surveyed and superintended a canal which passes through the city, uniting the main stream of the Potomac with the eastern branch. This construction reflects honour on Mr. Latrobe's skill and ingenuity.

In 1811, the south wing of the Capitol was finished; but the approaching war caused the suspension of the public work. Mr. Latrobe has been praised for what has been termed, a new order of architecture. In the small vestibule of the east entrance of the north wing of the Capitol, the vaulted roof is supported by columns representing the stalk of the Indian corn with its fruit. The column being the stalks bound together, and the capital, the ears of corn with the husk open. In 1813 Mr. Latrobe resigned his situation at Washington; his reasons will appear in note A, appendix. Freed from the service of the United States, Mr. Latrobe devoted his attention to the great object of supplying the city of New Orleans with water on a plan similar to that which had been so successful at Philadelphia. This work had been proposed to Latrobe in 1809 by Mr. Jefferson, and the plan matured by consultation with Governor Claiborne. The engines were to be made at Washington, and sent by sea to New Orleans, where Mr. Latrobe sent his eldest son and pupil to receive them and construct the work; the war of 1812 rendered this dangerous, and the architect removed to Pittsburg, to carry on the work, and transport the materials by river communication. With this project was combined another in conjunction with Robert Fulton; and Latrobe became agent of the Ohio

Steam Boat Company. In this undertaking he was unfortunate; misunderstandings arose between him and Fulton, afterwards amicably explained, but in the mean time Latrobe was ruined; his spirits sunk, for the first time in his life, and he abandoned himself to a state of profound despondency. Not only was he disappointed by the failure of efforts for steam navigation, but in the great project respecting New Orleans.

In this state the peace of 1814 found Mr. Latrobe, but to his mind it brought no consolation. Mrs. Latrobe, however, had seen by the papers that a law had passed for rebuilding those edifices, which a barbaric enemy, in an irruption for the purposes of destruction, had laid in ruins. Unknown to her husband she wrote to his former friends, stating his situation, and asking their influence for his reappointment to his former office. She had the gratification of carrying to her husband the answer, that the subject had been already under consideration, and there never had been a moment's hesitation as to his being appointed to rebuild the Capitol. A letter from Mr. Latrobe (Note B) in answer to one from Mr. Jefferson, will be found in the appendix, and is one of the most impressive documents relative to the destruction of Washington city, that has yet met the public eye.

In 1817, Mr. Latrobe received the intelligence of the death of his eldest son, Henry S. B. Latrobe, whose life was sacrificed to the New Orleans Water Works, as was ultimately that of his father. In 1818, Mr. Latrobe finding himself uncomfortably situated under the direction of a commissioner appointed by Congress, who was ignorant of science or art, and could not appreciate an artist, resigned and removed to Baltimore. He had, however, left specimens of his taste and skill by the erection of St. John's church, and Christ's church at Alexandria, as well as many private dwellings. In Baltimore he was employed to plan and erect the Roman Catholic cathedral, the greatest monument to his architectural fame, though not, perhaps, so perfect as the bank of Pennsylvania above mentioned. The exterior of the cathedral still wants one of its towers to lighten the dome by contrast. He likewise designed the Baltimore Exchange. Mr. Latrobe after quitting the public employ again, turned his attention to the New Orleans Water Works, and to complete them, removed to that city. He had the prospect of completing this great undertaking and making a fortune for his family, when the same cruel disease of the climate, which had deprived him of his son, robbed the world of his valuable life.

157 SKETCH OF THE WEST APPROACH OF THE U.S. CAPITOL, WASHINGTON, D.C., 1811. Plan and elevation by Benjamin Henry
Latrobe. *Courtesy Library of Congress.*

View of the east front of the President's House at the City of the 1807 as now to Public

158 VIEW OF THE EAST FRONT OF THE PRESIDENT'S HOUSE, 1807. Watercolor by Benjamin Henry Latrobe. *Courtesy Library of Congress.*

The character of Mr. Latrobe's architecture is simplicity and perfect proportion. The Grecian model had his preference, and the book he most frequently consulted was Stuart's Athens. The uncommon facility with which he used the pen and pencil gave him great advantages, and his profound knowledge, rendered his sketches perfect models for the workmen.

Mr. Latrobe was above the middle height, and his early military campaign had impressed itself upon his manner and carriage. He was a profound mathematician, and a skilful linguist, ancient and modern. He was a scientific musician, and well versed in the natural sciences of geology, entymology and botany. He never left home without his sketch-book, and his family possess drawings of scenery accumulated in his journies. His career in the United States, though a proud one for his children, was rendered painful to himself, and was finally cut short when it would have resulted in fortune for them, as well as fame to him, which was already secured. This country has felt, and must continue to feel the benefit of his exertions, not only personal, but through his pupils, Mills, Strickland and Small, and those to whom his example and instructions must *descend*.

THOMAS SULLY—1799.

Thomas Sully, 1783–1872.

This gentleman, who has long stood at the head of his profession as a portrait painter, and whose designs, in fancy subjects, all partake of the elegant correctness of his character, and the rich store of knowledge he has accumulated, was not born in America; but is one of the many artists who have been brought in childhood to a country whose institutions or manners do not place the painter in the rank of the mechanic, and among whose inhabitants is not found a class or *caste* who look down with contempt upon the man of science and taste, because he receives money for the product of his talents; a caste who call the giving of employment to such men (their superiors in knowledge) *patronage*. But he was born in a country rich in science, art, and literature, where such a *caste* does exist. In a late British Review of the first character it is said, " If the tenth son of the lowest baron were to follow painting as a profession, there would be many well meaning persons who would hold up their hands in surprise and horror at the degradation of such a step. They could scarcely be more shocked at his keeping a shop, than at the idea of his painting for money. Painting is considered as a mechanical art, and the man of rank would be considered to lose caste by following it." We all have to thank

our fathers who have rescued us from such a state; for if we had not been made independent of England, the same absurd and arrogant aristocratical caste would have been established in America.

The evil spirit exists here as elsewhere; but is kept down by our democratic institutions; and when the aspirants assume the airs of superiority, they are *put down* by the spirit of common sense.

Thomas Sully was born in Horncastle, Lincolnshire, in the month of June 1783. He has told the writer that his earliest recollections were connected with his maternal grandmother, with whom he was placed in charge at Birmingham by his parents, they being comedians, and attached to some of the provincial theatres at the time, and of course unsettled wanderers. But their merit gaining for them a permanent establishment, by an engagement at Edinburgh in Jones and Parker's theatre, little Tom was removed to the capital of Scotland; but, as he has said, never lost his attachment to the good old lady who had taken charge of his early infancy. When he revisited England, after many years absence, a man, a husband, and father, his first care was to see the guardian of his helpless years, to recall to memory the incidents of his childhood, and to employ his pencil in sketching the antique building, whose every door and window, every nook and corner, recalled some scene of that period, that link in the chain of existence when all was novelty—when every object presented to the senses a subject for inquiry, and a lesson in the most important part of man's education. " At this window," said Sully, pointing to the sketch, " I was hired to remain stationary one rainy day, for a given time, and my reward was to be sixpence. I stood, like a hero, looking straight forward at an old brewhouse, when the rain having undermined its foundations, it fell with a crash—to my great delight; for in addition to the novelty of the scene presented, the accident gave me my liberty."

In the year 1792, the painter's father was induced, by the liberal offers of Mr. West, then, and for years afterwards, manager of the Virginia and Charleston, South Carolina, theatres, to remove with his family to the United States. Mr. West was the brother-in-law of the elder Sully, who brought with him four sons, of whom Thomas was the youngest, and several daughters. The oldest son, Lawrence, was a miniature and device painter for many years in Virginia, and will be hereafter mentioned in connexion with Thomas. The second son Matthew, although an excellent draughtsman, pre-

ferred the stage and followed his father's profession, and was long the favourite comedian of the southern states. The third son, Chester, tried the stage in very early life; but not liking it, or not succeeding to his wishes, abandoned the profession, and devoted himself for a time to a less dangerous one, as practised among Americans, the sea. He went several voyages before the mast; but his companions of the forecastle did not suit him, and at the age of nineteen (his parents had been some time dead) he bound himself apprentice to a cabinet maker in Portsmouth, near Norfolk, Virginia, and obtained the power, by industry, to support himself, and become the respectable father of a well educated family. One of the daughters of the elder Sully married Monsieur Belzons, a French miniature painter settled in Charleston, who, although a very poor artist, was the first instructer of the subject of the present memoir.

From the above dates it will be seen that Thomas Sully was brought to this country a child of nine years of age. The profession of Lawrence Sully, that of miniature and device painter, created and fostered in the breasts of several of his brothers and sisters the desire to become painters. Lawrence's ability in his art was but moderate, but it appeared otherwise to the younger branches of the family. Thomas was especially desirous of becoming an artist, and has said that for years he looked up to the productions of Lawrence as the summit of perfection.

Thus it is with us all, at all times. Man, individually or in society, considers *that* as true and beautiful at one period which he sees and knows to be false and deformed at another. The childhood of an individual and the childhood of a people are in most things similar. Each commences its career in ignorance, gropes in darkness and uncertainty with tottering steps, is guided or misled by the crafty who assume the office of teachers, and can only get a glimpse of the true and the beautiful at distant intervals, when, as he gathers strength, if not perverted from that desire for truth which the Author of all good has implanted in his heart, he will eventually see the loveliness which resides in perfection, and will aim unceasingly to attain it.

The individual whose name and life has suggested these reflections, is an instance of the power of that desire, and the effect of virtuous perseverance through uncommon difficulties, to the attainment, (if not to the full accomplishment of his wishes) at least to the high and commanding eminence which may encourage thousands to follow and emulate him, not only

in his works of art, but in the suavity of his manners, the blameless tenor of his life, and his benevolent exertions to forward the views of all who apply to him for instruction.

In 1783 Thomas was sent to the same school with Charles Fraser, in Charleston, and the similar propensities of these boys caused intimacy. Fraser, though like himself, a beginner in the art of face-making and spoiling copy-books, became Sully's leader and teacher. Mr. Sully has said of Mr. Fraser, " he was the first person that ever took the pains to instruct me in the rudiments of the art, and although himself a mere tyro, his kindness, and the progress made in consequence of it, determined the course of my future life."

The desire which Thomas felt to imitate his brother Lawrence's productions, was not immediately indulged. He was placed by his father, in 1795, in the insurance broker's office of a Mr. Mayer ; but the broker complained to his father that although he was very industrious in multiplying figures, they were figures of men and women, and that if he took up a piece of paper in the office, he was sure to see a face staring at him ; in short, that Tom spoiled all the paper that fell in his way, or that he could lay his hands on ; and concluded by advising, that instead of a merchant or broker, he should be made a painter. Accordingly, the youth was placed for instruction with Mr. Belzons, a French gentleman, who had recently married into Mr. Sully's family. Mr. Belzons had emigrated from France in consequence of the revolution, and having lost his property, had made a profession of the art which had been studied as an accomplishment. Although he was enabled to support his family in Charleston very respectably by the pencil, he was neither in skill or temper the best qualified person to teach the young painter. In fact, he was a very poor artist, and like many of his lively countrymen, had not learned to control his passions.

Tom had been directed to superintend the cleaning of Belzons' gallery, and accordingly took his seat with a box of watercolours, (a present from his sister) and all the requisites for the work he was engaged upon, nothing doubting that by sitting at his table and prosecuting his studies at one end of the gallery, while the servant was scrubbing the other, that he was doing his duty and obeying his teacher. While thus innocently and properly employed Balzons entered, and either mistaking Sully's employment for neglect of his orders, or put out of humour by some previous occurrence, he in a violent rage assailed the young painter with opprobrious language, at the same time dashing the precious box of colours to pieces, and

strewing the floor with pencils, drawings, and fragments of what the youth deemed his dearest treasure. Tom looked in despair upon the wreck, and might have submitted to what appeared utter ruin; but when Belzons, his passion increased to frenzy by indulgence, roused the youth's indignation by accusations which he knew to be unjust, and finally attempted to strike him, the spirit of the land of his fathers and the land of his adoption blazed forth, and with an agility and power of muscle the assailant was not prepared for, Tom with one blow floored his master; and when in the blindness of fury he repeated his assault, again prostrated him, doubtless to the great delight, if not edification, of the black who was plying the scrubbing-brush. The French combatant seemed to gain strength, like the antagonist of Hercules, from his repeated falls, and his rage being in no wise abated, the man would probably have overpowered the boy by superior weight and power; but at this crisis Mrs. Belzons, a beautiful woman, attracted by the noise, entered and rushed between her husband and brother. Tom left the gallery—found his hat—and without further accommodation, departed with a determination never to put himself again in the power of his brother-in-law.

This event took place early in 1799, when Sully was sixteen years of age. His parents were dead. His brother Lawrence settled at Richmond. The youth was thrown upon the world, and all his previous plans dissipated. He had left Belzons' house without money, or any thing else except the clothes he had on. It was not likely that he would slacken the cords of resentment against oppression and insult, or that Belzons, while he felt Tom's blows, would seek to lure back so pugnacious a pupil. We may imagine the feelings that made him avoid all his acquaintance that day; and, for lack of other shelter, he slept the night following in the Exchange, a public building, the upper part of which was enclosed and locked against, and the lower left open to, the destitute of every description. The next day something must be done. Tom found that to be tolerably comfortable, he must eat as well as sleep; and though stomach-full when he thought of his wrongs, there was nothing in that turbulent feeling which supplied the want of food, or created sensations of pleasure.

He sallied forth from his wretched lodging and met a friend, who could enter into his feelings; to him he related his story, and asserted his determination not to return to Belzons. His conduct and resolutions were approved, and present protection afforded him.

The John Adams, United States ship, was at this time fitting for sea. Mr. Read, the navy agent, became interested for the youth, and offered his interest to procure a midshipman's berth for him. The offer was accepted: our painter was within an ace of becoming a sailor, but his brother Lawrence inviting him to come to Richmond and become his pupil, the love of art prevailed over the love of variety and wandering; and after submitting the question to the benevolent Mr. Read, it was resolved that he should go to Virginia, and pursue his studies as an artist. But Lawrence had not remitted money to transport him from Charleston to Richmond. Tom was without a cent, and was too delicate to mention the circumstance to his Charleston friends; but he had a person and address which, together with unblemished character, recommended him to strangers as well as acquaintance, and gained him friends throughout life.

He found in the harbour of Charleston a vessel belonging to Norfolk, commanded by her owner, captain Leffingwell. Sully applied to him for a passage, promising to pay at Norfolk. Leffingwell received him willingly, took him not only into his vessel, but on their arrival at Norfolk into his house; until his brother should remit money to pay the debt, and wherewithal to pass up James River, this was in due time done, and Tom was at home again.

Mr. Lawrence Sully appears to have been a man struggling with poverty, and not possessing that skill as an artist, or that energy and felicity in resources which would have enabled him to place an amiable wife, and numerous family of children, in such eligible circumstances, as a man of ordinary ambition must aspire to. The talents of his young brother were of more importance to him, than his instructions could be to the ingenious youth who now commenced miniature and device painter.

In the year 1801, Mr. Lawrence Sully removed his family to Norfolk, and of course Thomas went with him. At this time the younger brother was the better artist, and the main support of the household. But not content with ivory and water-colours, and stimulated by the sight of some portraits and other pictures by Mr. Henry Bembridge, who was then exercising his pencil in the Borough, Tom determined to try oil, and made his preparations accordingly. An original picture by Angelica Kaufman, still in the possession of Mr. Sully, strengthened this determination, as in it he had a subject to copy. He resolved as soon as possible to abandon miniature

painting in water-colours, and to become a painter in oil ; and the first effort was to make a copy* from Angelica ; but so ignorant was he of the materials he was about to use, that he ground his pigments in olive oil, and to his great surprise found that they would not dry. Fortunately there was a sign-painter in Norfolk who explained the mystery, taught him that vulgar flax-seed oil would do him better service, and put him in the way of renewing his labours with better success. The praise lavished on this effort encouraged Tom to try por-traits from life, of a small size, in imitation of Mr. Bembridge. His first sitter for an oil portrait was Mr. William Ormsted.

The young painter who looked up to an artist who had been educated at Rome, with an awe approaching to idolatry, found means to gain access to that mysterious temple, a painter's attelier ; and was received with a benignity more correspond-ing to the gentlemanly education and attainments of the being he approached, than to his own hopes. Bembridge, for it was his sanctum sanctorum he had entered, encouraged his ef-forts, instructed him by painting his portrait, and explaining his palette, its arrangement, and the application of the tints while the work was going on ; and behaved as a genuine artist, if a gentleman, (as the term implies) will always behave to those who love the art, and appear worthy of it.

In 1803 the business of Lawrence Sully, and his credit, failed in Norfolk. Richmond, the seat of the state legislature, presented hope of resource, and thither he repaired, leaving his family to the care of Thomas. This was in December, and Christmas was at hand, a festival more observed in Nor-folk, than in any other portion of the United States. Origi-nally peopled by Englishmen and Episcopalians, the custom of the parent country in celebrating this holiday was combined with the hospitable profusion of the south ; and with a custom long prevalent in the Borough of providing abundant stores on Christmas-eve, or the twenty-fourth of December, for the approaching short winter which is there known only in its milder form, never begins but with January. Christmas-eve is in Norfolk a fair ; the main street as well as the market, is one continuous exhibition of poultry, of which turkeys are the preponderating article ; wild fowl, butchers' meats, Carolina hams, venison, and more eggs than are to be seen in New-York at *poss* or Easter. Through the day and evening this portion of the ancient Borough is one thronged mart for the sale of articles of food, and the produce of all the surrounding region seems crowded into the hospitable town to promote the festivi-ties of " Merry Christmas," and provide for the few days of

cold weather, expected with the new-year. There are few in the United States who have not a turkey for Christmas dinner; but to judge by the Norfolk market at this time of preparation, one would suppose that every table would show two; and the provision of eggs for puddings and *nogg*, in the morning is always in equal proportion and profusion. But what was all this to poor Tom Sully? He could only look on, and while others anticipated the joys of the morrow, think, that in the house he had charge of there would be none of these good things to rejoice over. He had to furnish food for his brother's wife, and four infant girls, and no means to provide for the feast of the morrow, or the wants which winter brings in its train.

" Sally, what have we got in the house?" " There is some indian-meal, and some sweetmeats." "Capital!" said Tom, " we will have indian cakes, and the children shall have the sweatmeats in the bargain." Youth, hope, and purity, were the Christmas guests, and Tom, after a dinner which neither dulled his intellect nor clogged his limbs, went to see his brother Chester, who was at this time serving his late-in-life apprenticeship, with honourable perseverance at Portsmouth. Tom told Chester of the state of his family—laughed at the Christmas dinner—and pointed joyously to the pictures engaged, but yet unpainted, which were to improve his skill and supply all deficiencies in the household establishment, which he felt determined to support and improve.

The brothers were taking their afternoon's walk, when suddenly stopping at a corner, Chester said, " Tom, go you on ahead to the market-place, and wait for me—I'll soon join you," and darting off, round the corner of a street that led to the harbour of Portsmouth, left him. As directed, the young painter, no way suspecting any thing extraordinary, walked to the market-house, and there waited until his brother, heated and flushed by some unusual exertion, joined him. Tom had observed two sailors at some distance down the street Chester had turned into; but had no notion that they were connected with his brother's motives for leaving him; and his elder brother had sent him forward out of the way, that he might not be involved in the adventure which he now recounted. We have seen that the young painter had pugnacious propensities, which might be aroused to action, and the means to gratify them. Chester, stouter and inured to the gymnastic exercises of a seaman and an artisan, older, but equally active, was more qualified for combat and more than equally ready.

" When I left you," said he, " I gave chase to two fellows
who had been my messmates, and to whom I had pledged my
word, that if ever I met them on shore, I would pay them in
full for the scurvy services they rendered the boy, over whom
they had a little brief authority."

" But there were two—why did you not take me with
you ?"

" No, no—it was my own business, and I knew I could
manage it alone. I hailed them. 'Hallo my lads, bring to. I
will now quit scores with you both, and perform my promise.'
We had a crowd about us immediately. I chose the biggest
bully to begin with, and I said to the spectators, 'Gentlemen,
if you will take care of that chap, while I thrash this, I will
then thrash him for your amusement.' 'Hurrah !' they cried,
' we'll see fair play.' So, we set to. He could not hit me a
blow, and I soon found him ready to give me a receipt in
full.—' Now for t'other lubber.' But he seeing that I paid in
hard coin, sneaked from the crowd who were too eager
spectators, to be good watchmen, and had taken to his heels.
So, now let's cross over to Norfolk, and see Sally and the
children."

The talents, industry, and amiable manners of Thomas en-
abled him to support Lawrence's family, and pay his debts ; but
the accumulated house-rent he could not discharge, and the
furniture being sold by the landlord, Mrs. Sully and children
followed her husband to Richmond.

Tom now began the world for himself, remaining in Nor-
folk ; and with two persons of the names of Brown and Tay-
lor, he took a house in company, and kept bachelor's-hall. His
year's receipt from his labours, was one hundred and twenty
dollars ; but with this he lived contentedly, and relieved the
necessities of others. The house he lived in was in Church-
street. One of the joint partners in house-keeping, before the
end of the year falling in debt, was removed by his creditors to
prison. Sully attended upon him, and by his exertions pro-
cured his release. In after times when the fame of the painter
was bruited abroad, Taylor used to boast that " in early life he
was among the first *patrons* of young Sully, in the borough of
Norfolk." The man who is blessed with taste and benevo-
lence, and with riches to gratify both, cheerfully assists strug-
gling genius through the impediments poverty throws in his
way, and enjoys in conscious rectitude the reward which the
good deed assuredly brings, but he never boasts or assumes
the title of patron.

In August, 1804, Sully removed to Richmond, and joined his brother Lawrence again as a partner. The one pursued his miniature and device painting, the other painted portraits in oil. But Thomas soon felt the cravings after further knowledge, and the desire for that improvement from instruction which was not to be found in Richmond. He determined to visit the land of his fathers, and formed a rigid plan of economy, by which to accumulate sufficient to carry him to London; youthful confidence assuring him, that, once there, he could make his way, and see painters and pictures.

He began his approach to London by removing to Petersburgh; a very short step on the way, but a new field for his pencil. But while successfully painting, and acquiring property and friends, his brother Lawrence died, leaving his wife and infant children unprovided and unprotected. Inclination was sacrificed to duty; the young painter gave up all his hopes of improvement and dreams of pleasure, from travel and the treasures of art, and returned to Richmond, to become the protector of the widow and the orphan.

After faithfully acting as the brother and the uncle for more than a year after Lawrence's decease, he became the husband of his brother's widow and the legal father of his children.— This step was approved by all who knew him and his circumstances, and never repented by himself.

It happened that Mr. Thomas A. Cooper, in one of his professional visits to Richmond, sat to Sully for his portrait.— This led to a friendship for the painter, and an invitation, when Mr. Cooper became lessee and manager of the New-York Theatre, so friendly and liberal, that it induced the young painter to remove with his family to that city, and gave the impulse which has ultimately carried merit to its deserved goal—fame and fortune.

In a letter from Sully to a friend, after mentioning his first acquaintance with the tragedian, he proceeds thus:—" I should be very ungrateful not to acknowledge Cooper to have been one of my greatest benefactors. His friendship encouraged me to remove to New-York, where he thought I might learn more of the art, from the example and pictures of more experienced artists; and that I might feel a confidence in taking, for me, so adventurous a step, he pledged himself to secure me business to the amount of one thousand dollars; and, on my removing to New-York, gave me authority to draw upon the treasurer of his theatre for money, as I might require it, to that amount."

 " So shines a good deed in a naughty world."

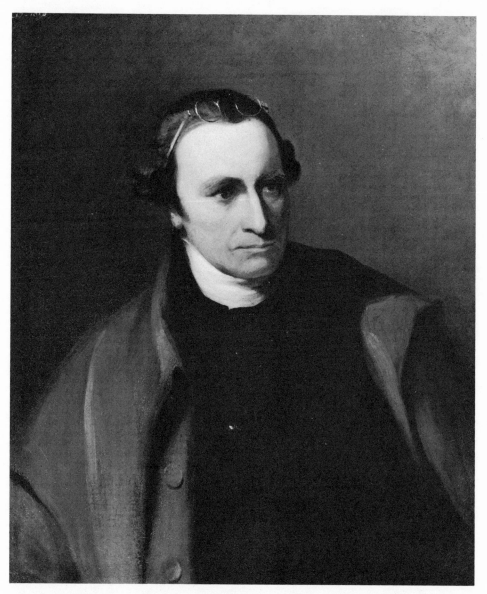

159 PATRICK HENRY, 1815. Painting by Thomas Sully. *Courtesy Colonial Williamsburg.*

160 JAMES ROSS. Painting by Thomas Sully. *Courtesy The Pennsylvania Academy of the Fine Arts.*

Our great poet has said, that the evil deeds of men are written in brass—the good they do, in sand. May this *good* deed be written in brass!

When Sully presented himself to the manager in New-York, his first words were, "Well, Mr. Cooper, here I am!"—"That's right!" said Cooper, "I am ready for you—work engaged—sitters waiting—you shall have a painting room in the front of the theatre, that will cost you nothing—and call on the treasurer for money as you want; you have a credit with him for a thousand dollars."

Mr. Sully remembers and feels this as he ought. The friends of genius, the admirers of art, ought to remember and feel it. To encourage and foster talent is conferring a benefit on mankind, and the world is indebted to the benefactor.

Thus, in 1806, Mr. Sully commenced his career anew, in a metropolitan city, aided by the friendship of the most brilliant histrionic artist the western world had seen. The writer of these memorials of the fine arts of his country was then engaged as assistant manager in the New-York Theatre, and that situation brought him in immediate contact with Mr. Sully; the acquaintance ripened into friendship, and has existed undiminished to the present day.

Mr. Sully was yet a young man and a young painter.—He had much to learn, and no one knew his deficiencies better or felt them so strongly as himself; therefore, having energy of character, he of course improved daily. Trumbull and Jarvis were both painting in New-York; and at that time the first was the best portrait painter, though he did not continue long so; his art was without feeling or nature—and Jarvis's nature was soon supported by art. What Jarvis knew was freely communicated: to derive advantage from the older artist was not so easy of attainment. Sully sacrificed one hundred dollars, (that is, one-tenth of his borrowed capital) for the purpose, and carried his wife to Trumbull's rooms, as a sitter, that he might see his mode of painting, and have a specimen from his pencil. He gained some knowledge for his money, and probably learned to imitate the neatness with which palette and pencils and oils and varnishes were used and preserved; an art Jarvis never knew or thought of: and he gained a model, which served him as a beacon, warning him of that which it was necessary to avoid.

Of many anecdotes connected with Mr. Sully's portrait painting, of this time, a few may amuse the reader. He was surrounded by men whose profession is laborious, but who in the moments of leisure indulge in the sportiveness of boys

The painter had, as one of his sitters, Mr. Jas. Hamilton, of Philadelphia, a friend of his friend the manager; who, as actor and manager, was then in the enjoyment of the flood-tide of success and unbounded animal spirits. Hamilton's portrait was nearly finished when Cooper entered the painter's room: and after looking over the artist's shoulder for some time, he said, " Sully, it is very like James, but"—and he paused.—Now, thought the poor portrait painter, here comes the usual *but*. He worked on, only saying, " Yes, I think it is like." " It has a very strange colour," said the other. " How so?" " Don't you think it looks very green?" said the manager.

This is one of the ways in which artists are civilly told that they do not know what they are about. " No," said Sully; " Green! No—rather warm, perhaps, but certainly not green." " It has a strange appearance to me," said Cooper. " I have coloured as usual—I have tried to give his complexion," said the painter. " It is very like, but there is a greenish tint—it's very like." And after some minutes chat on other subjects the critic departed, leaving the painter to rub his eyes and look in vain for green in the flesh of his picture.

By and by Harwood called on him; and, after admiring the likeness, said, in his good-natured way, " But, Sully, don't you think all your half-tints are too green?" " Green! I see no green, except a little here; as we find it in all flesh, where the yellow mingles with the blue." " But all over—somehow —I suppose I am wrong; but the whole has a greenish hue, as if I saw James through a pair of green spectacles." " Perhaps I look green too." " No, not at all—it is very like—I dare say I am wrong." The subject was changed; but the " green-eyed monster" had got possession of the poor painter; and when Harwood was gone, the picture was turned upside down, and viewed at various distances, in search of green.

A well calculated interval was suffered to elapse before Twaits made his appearance. " Good morning, Sully.— Bless me, how like James!—but he looks as if he had been at an alderman's feast, and the green fat of the turtle had tinged his skin."

It happened that one of the servants of the theatre was employed in the room putting up a stove; and hearing all this green criticism, he approached and gazed with lack-lustre eye. " Yes," said he, " it is green, sure enough."

Sully was by this time convinced that he could not see. He put down his palette—turned the face of the green picture to the wall, and with Twaits walked to the *green*-room of the

theatre : where the tragedian and two comedians reiterated their compliments on the successful likeness he had made of James Hamilton ; but it was a pity there should be such a *green* tint about it. " I dare say it will not look so green when he gets it to the woodlands, and it is surrounded by trees and green fields," said Harwood. Sully declared his determination to remedy the colour—he would re-paint it.— " I have been at work so long, that I suppose I can't see. I work no more to-day. To-morrow I will go over it again."

" Why, you pump !" said Cooper, " to let us three buck-ram men persuade you out of your senses. It is all a trick. The picture is better coloured than any you have done. Go and finish it without changing a tint ; and, Tom—here-after believe your own eyes, in preference to any other pair, let them belong to whom they will."

About this same period, Mrs. Warren, late Mrs. Merry, had come on from Philadelphia, to delight the public of New-York, as she had often done before, by the finished pictures she exhibited on the stage : she at the same time assisted Sully, by sitting for that likeness which was afterwards en-graved by Edwin for the Mirror of Taste.

She had had but one sitting, and had appointed four o'clock for the second, on a certain day, when she was to visit the theatre for her professional exertions. The painter had placed the newly begun portrait on his esel, at one o'clock, to pre-pare it for the sitting before he went to dinner ; and becoming dissatisfied with his work, determined to rub it out, and com-mence anew with another sketch, to be ready for the lady's visit. The door was carefully locked, but the key most un-wisely left in the lock—no lounger was to be admitted. But scarcely had he defaced the product of the first sitting, ere he heard the feet and voices of females on the stairs, and then a tap at his door. No answer. " Mr. Sully !" And he knew the " silver-sweet" tones of Mrs. Warren's voice. " It will never do to answer"—so communed the painter with himself. " I must work two hours before it is ready for the sitting." " Mr. Sully," was repeated in the same melodious accents.— Another was heard to say, " He is not here." " Yes, he is," said the first, " for I see the key inside of the key-hole. Mr. Sully ! Why, he certainly has locked himself in and gone to sleep." " A capital hint *that*—I'll take it. I'll be asleep"—and he leaned back in his chair and was asleep instantly. " Try if you can see him through the key-hole." " I will. Sure enough, there he sits, fast asleep be-fore his esel. Well, we will not disturb him." The ladies

laughed at the drowsy artist and went off. The ever indus-
trious painter relinquished dinner to accomplish his purpose,
and at four o'clock was ready for his sitter, who punctually
came. Women are in *this*, as in most things, more true than
men.

"Why, Mr. Sully, what a sound sleeper you are." "O no!
not very." "Yes you are, and sitting before your esel too."
"I never slept before my esel in my life." "But I saw you,
so sound too, for I knocked and called upon your name, and
made noise enough to raise any but the dead." "None so
deaf as those who won't hear," said the painter, and then told
the truth and his reason for not admitting her. "Well," said
the lady, laughing, "that is too bad, Sully; but I suppose I
must let your candour cancel the memory of your rudeness,
in refusing to let me in—there is no apology like plain truth,
so here's my hand—you are pardoned."

Anxious for improvement, Mr. Sully resolved to visit Boston,
and see the great portrait painter as soon as circumstances
would permit. In the year 1807, removing his family as far
on the way as Hartford, he proceeded to the capital of Mas-
sachusetts. He took letters to Andrew Allen, Esq., British
consul; to Mr. Perkins, and several others. Mr. Allen was
the friend of Thomas A. Cooper, whose letter of introduction
Sully carried. He was of the family of that Allen who was
the friend of West in the days of his youth. Andrew Allen
was a friend of the arts, and a frank noble spirited gentleman.
By such a man the young painter could be no otherwise than
cordially received. He inquired into his wishes and his
views, and thought how he best could gratify the one and for-
ward the other. He had an appointment with Stuart for a
sitting the next day, and it was arranged that Sully should
accompany him and then return with him to dinner.

The next person to whom Sully delivered a letter was a
rich merchant. He was in his counting-house. He read the
letter. "Mr. Sully, from New-York—extremely happy to be
of any service. Where do you put up? How long do you
remain in Boston? John, take this letter to the post-office.—
You paint portraits—dull times in Boston just now."

As soon as the artist left the presence of the commercial
magnate, he deliberately took all his remaining letters of in-
troduction from his pocket, and as he walked to his hotel, tore
them one by one, and strewed the fragments on the cold
pavement, where they were received without one expression of
desire to serve him, or any token of extreme happiness in con-
sequence of his presence.

The next day Allen introduced him to Stuart, who received him with the utmost urbanity, and ever after treated him with liberality and kindness, imparting instruction as freely as he had received it from his own great master. Allen was placed in the sitter's chair, an awfully wearisome throne when the occupant is under the hands of many operators on the humane face, but not so in the *attelier* of Gilbert Stuart. One of his patients being asked, after a sitting, if he was not tired, answered, " Yes, with laughing."

Sully, in after times, when describing his first interview with Stuart, has said, " I had the privilege of standing by the artist's chair during the sitting, a situation I valued more, at that moment, than I shall ever again appreciate any station on earth."

Before he left the painting room, Isaac P. Davis, Esq. came in, a truly liberal, friendly and excellent gentleman, to whom Sully had, by the omission of his friends in New-York, brought no letters, (which, if he had, would have been preserved from the pavement by the well known character of Mr. Davis.) He was intimate with Stuart and with Sully's friends in New-York, and on being introduced, reproached him with not bringing letters to him. Before the sitting of Allen was over, an arrangement was made that Mr. Davis should sit to Sully, and by the result Stuart was to judge of the nature of the instruction most needed by the young artist.

Accordingly Davis sat, and the picture was carried to Stuart, "He looked at it for a long time," said Sully, " and every moment of procrastination added to my torment. He deliberated, and I trembled. At length he said, ' keep what you have got, and get as much as you can.' "

There is more encouragement in this oracular sentence than at first view meets the eye. Most young artists have to get rid of " what they have got," or the greater part of it, as well as to " get as much as they can." For further encouragement, Stuart showed him his palette, his arrangement of colours, and his mode of using them. He advised him in respect to his future proceedings, and recounted his own experience. There was here no necessity for purchasing a picture by way of getting a lesson ; all was as it should be, and as it is with every liberal artist—gratuitous.

CHAPTER VII.

Jarvis assists Sully—Sully removes to Philadelphia—B. Wilcox—C. B. King—London—West's liberality—frugal living—hard study—Sully returns to America—C. R. Leslie—anecdotes.

In the autumn of 1808 Mr. Sully returned with his family to New-York, and again set up his esel. He was improved in theory and practice, but the tide had turned, or the stream had taken another course. Jarvis had improved likewise, and painted most decided likenesses. Trumbull who, as has been said of Reynolds, " gave good dinners" while in New-York, had painted up his guests and returned to England, as the discontents between us and that country multiplied, and as the merchants slackened both in dinners and portraits. New-York being essentially commercial, the embarrassments in trade no doubt affected Sully, while Jarvis, at that time the better painter and better known, had full employment. Sully was obliged to offer himself as his assistant in copying, preparing, filling up back-grounds, or laying in draperies. " It is a great shame that it should be so," said Jarvis; but he frankly accepted the offer, paid him liberally, and rendered him every assistance in his power.

At this time of ebb tide (or rather low water) at New-York, Benjamin Wilcox, of Philadelphia, invited Sully to that metropolis, and thither he removed with his large and increasing family. Mr. Trott, the miniature painter was then in full practice in Philadelphia, and conjointly with him, Sully took a house in the month of February 1809, in which they both successfully pursued their respective branches of art in harmony.

The interruption to commerce was felt by Sully after a time in Philadelphia. His business nearly ceased. He had been employed at $50 a head, and was full of work. He proposed, by advice of his friends, to paint thirty portraits at $30 each, and a list for that number was filled. Again he was in a kind of eddy of prosperity, but he felt that he had arrived at that point beyond which he could not make his way unassisted towards the perfection he aimed at, and had determined to attain. This aid he thought could only be obtained in London.

The Pennsylvania Academy of Fine Arts was then in em-

bryo. Gentlemen, many of whom were personal friends of
Mr. Sully, had associated for the purpose of erecting a build-
ing, procuring casts from the antique, and good pictures, and
thus becoming the benefactors of their country by encouraging
the advancement of the arts. It was proposed to these gentle-
men to employ Mr. Sully in the prosecution of this design;
and he agreed, for the sum of $3000, to proceed to London
and employ himself in making copies from paintings of the
best masters accessible there, for the academy. He announced
his intention of departing for Europe, and declined receiving
sitters. Happily, the scheme proved abortive, for it is evident
that the sum was not adequate to the purpose intended. Sully
was blinded by his desire for improvement; but small as the
amount was, the directors declined the project for want of
funds to make the necessary advances.

Thus disappointed and thrown out of business, the painter's
good friend Wilcox opened a subscription at $200 each signer,
to be paid to Sully, and repaid by copies of pictures to be
painted by him in London, and sent from thence to Philadel-
phia at the painter's expense, each subscriber being entitled to
one picture from a master. Sully's inexperience, or thirst for
the opportunity of studying the works of art, made him in-
sensible of the inadequacy of the price he was thus setting
upon his labours; he only saw the prospect of improvement.

Seven subscribers were obtained. Thus for $1400 a good
painter undertook to support a large family in America, while
he incurred the expense of going to England and remaining
there during the time necessary to the painting seven pictures
from the works of masters, and then transporting them with
himself back to Philadelphia.

Mr. Sully, when mentioning this period of his life in a letter
to a friend, says, " I will not dwell upon the slavery I went
through, nor the close economy used to enable me to fulfil
my engagement; but although habitually industrious, I never
passed nine months of such incessant application. Let me
never forget the disinterested kindness of Benjamin Wilcox on
this occasion. His generous offer of the use of his purse, gave
me a courage and a confidence that enabled me to complete
my engagement cheerfully."

It will be seen that the painter only called upon his liberal
friend for $500 during this experiment; two hundred, after
the nine months residence in London, for the purpose of pay-
ing his passage back; and three hundred advanced to his
family during his absence. Although Mr. Sully himself

would not dwell upon the particulars of this arduous struggle, it is doing a duty to the world to present them to the student as the honourable and interesting characteristics of a true disciple of the fine arts.

Mr. Sully having left $1000 with his wife, embarked on the Delaware the 18th of June 1809, and arrived at Liverpool the 13th of July following. Although his parents had long been dead, his aged grandmother—then ninety years old—the nurse and guardian of his infancy, still lived in Birmingham, and still in the same house in which he passed his early probationary hours, the noviciate to life's motley mysteries. Sully was not a man to forget his first duty, and he immediately repaired to Birmingham.

While on this visit, recalling the events of childhood, and wondering at the pigmy dimensions of every place around; which, being traced upon his mind's tablet when that was of its smallest size, had expanded with the growth of the material to a greatness very much beyond the reality; he made inquiry after the old lady who had petted and cherished him in days of yore. "Here she comes," was the answer. He had difficulty in making himself known; for although she remembered the child, her mind could not unite that cherished image with the appearance of the gentleman before her. Truly there was no similitude. And that this gentleman had come from America—a far-off country, of which she had no distinct notion—and that this gentleman was the identical Tom Sully she used to carry in her arms, puzzled the old lady over-much. In fact, this same business of identity has puzzled others as well as old women.

Mr. Sully carried a letter directed to Mr. West from William Rawle, Esq., of Philadelphia; but the first letter he delivered in London was to his friend and subsequently fellow student, Charles B. King. Long after Mr. Sully has been heard to say, "I resided under the same roof with him, and our painting room was in common during my stay in London: an intimacy of twenty years enables me to testify to qualities of heart and correctness of conduct rarely equalled for purity or usefulness."

When Sully first saw King in England, there was an immediate reciprocity of feeling, that produced a frank interchange of thought without hesitation or disguise. King had been some years studying in London, and could appreciate Sully's inexperience. "How long do you intend staying in England?" "Three years, if I can." "And how much money have you brought with you?" "Four hundred dollars."

" Why, my good sir, that is not enough for three months—
I'll tell you what—I am not ready to go home—my funds are
almost expended, and before I saw you I had been contriving
a plan to spin them out, and give me more time. Can you
live low ?" " All I want is bread and water." " O, then you
may live luxuriously, for we will add potatoes and milk to it.
It will do ! we will hire these rooms, they will serve us both—
we will buy a stock of potatoes—take in bread and milk
daily—keep our landlady in good humour, and (by the by)
conceal from her the motive for our mode of life by a little
present now and then, and—work away like merry fellows."
And so they did. Thus making themselves excellent artists
by a system of labour, economy, and independence as honour-
able as it was efficacious.

His friend King introduced Sully to the council chamber of
the Royal Academy, and he has thus recorded the first im-
pression made upon him in a note book, from which, by per-
mission, this extract is made. He thus remarks upon the
pictures deposited by the academicians on their election :—
" The room is well stocked with works by Reynolds, Gains-
borough, Fuseli, Stubbs, West, Lawrence, Owen, and many
others. Owen's manner pleases me much. It is cool, broad,
and firm, in some respects like Reynolds. The colour is laid
on in great body and with large brushes, so that no markings
or hatchings are visible. His colouring is cool in the lights
and warm in the shadows, beginning from almost pure white
to vermilion tints—to the cool half-tint from that graduated
to a greenish half-tint, which looks like ochre-black and ver-
milion, and which perhaps is rendered more green when
finished by glazing with asphaltum—the main shade of black
and vermilion broken with the green tint. In some places
Indian-red is used instead of vermilion.

" Gainsborough's manner struck me as being exactly as Rey-
nolds describes it. There is some resemblance to it in
Stuart's manner, only that Stuart is firmer in the handling.
His dead colourings seem cool and afterwards retouched with
warm colours, used then so as to resemble the freedom of
water-colour painting. Many light touches of greenish and
yellow tints are freely used, and although on inspection the
work looks rugged and smeared, and scratched, yet, at a dis-
tance, it appeared to me the most natural flesh in the room.
The specimens of Reynolds' pencil disappointed, and Opie's
seemed raw, crude and dirty. Copley more hard and dark
than usual. Lawrence's too much loaded with paint, and the
red and yellow overpowering. The ceiling of this room is

painted by West and Angelica Kaufman, by far the most deli-
cate colouring I have yet seen of the president's, and Angelica
has closely imitated it."

Such were the feelings of the young American painter in
1809, upon first seeing the works of the London academici-
ans, and such was his keen mode of observing and retaining
the result of his observations for comparison with subsequent
attainments.

The next thing was to deliver letters of introduction to
artists, and first to Benjamin West. His friend, King, went
with him, and the first introduction he had to this great paint-
er and benevolent man was in the gallery which leads from
his dwelling house in Newman-street, to the suite of rooms
beyond it, for painting. The two young men were standing
at the commencement of the gallery, which used to be hung
with the sketches of the master's great works. Sully heard
the steps of the great painter, but an angle of the gallery hid
him from sight. He fitted his eyes to the height of six feet to
catch the eye of the great man, but felt a momentary disap-
pointment in having to sink them to the attitude of a little old
man, by no means answering to the picture his fancy had
drawn. But all sensations, except those of pleasure, were put
to flight by the reception he met. He was conducted to the
painting rooms, and saw in its incipient state, the great pic-
ture of "Healing in the Temple," at which West (then ap-
proaching his seventieth year) was at work with all the mental
power of youth.

From that time West was, to use Mr. Sully's expression
when in conversation on the subject, "like a father" to him,
and he had "the advantage of his instruction and the free use
of his pictures."

The letters Sully bore to Lawrence, Sir William Beechy,
and Hopner, procured him a reception from those eminent
painters as courteous as could be wished. Beechy's advice
was always freely given, but in a blunt and sometimes almost
harsh manner. The young painter only saw Hopner once.
He was afflicted with the gout. Examining a picture in the
room, Sully, who had been encouraged by him to ask any
questions relative to his art, inquired *what yellow he used in
flesh?* "Yellow? None." Was the laconic reply. "Indeed!
I thought yellow was necessary to balance the blues and
reds." "There is no yellow in flesh, sir." The lesson and
the manner taken together not only prevented further ques-
tions, but forced the inquirer to conclude that there was no
further information for him in that quarter.

161 THE ARTIST'S WIFE. Painting by Thomas Sully. *Courtesy The Metropolitan Museum of Art, bequest of Francis T. S. Darley.*

162 FANNY KEMBLE AS BEATRICE, 1833. Painting by Thomas Sully. *Courtesy The Pennsylvania Academy of the Fine Arts.*

To Sir Martin Archer Shee he had brought no letters, but was introduced to him by Mr. Marshall, who had been one of Wignel and Reinagle's company in Philadelphia, and was now attached to the Haymarket theatre. Shee was at this period an experimenter in macgylps, but of too liberal a nature to keep his discoveries to himself. He gave his composition of the article as the result of his labours and experience. "Macgylp, made of mastic dissolved in spirits of turpentine, and drying oil prepared by letting good linseed oil stand in a bottle over litharge, may be used safely if used sparingly." "Mastic," said he, "will not crack if used over colours *thoroughly dry*. The litharge used in making drying oil should be granulated. Drying oil which has stood a long time should be shook before using it. 'When taken, to be shaken.'"

The painting room of Sully and King was a good one, and as above-mentioned, used in common. It is in Buckingham place, Fitzroy square, and has not only to boast of King and Sully, as occupants, but of Leslie and Allston.

As Sully had painted a head of his friend Davis, to show Stuart the point he had arrived at, so he carried to West a head of his friend King. The frank and friendly criticism showed that there was an indecision in expressing the anatomy of the head, which indicated a want of confidence in the painter of his knowledge of the internal structure, and the advice was to study osteology assiduously. This was precious advice, and was gratefully received and followed.

Having seen the lions of London, it was necessary to find the means of fulfilling his engagement by copying seven good pictures, and to do this, pictures must be found and procured. It is well known, that in England nothing of art is to be had or even seen without paying for it, and our student was to make $400 support him for as long a time as possible, and certainly until he had gained possession of seven paintings by a master or masters, and copied them. He had found in London an American, a liberal American, who was moving among the great and the rich, and of course possessed the passports to their locked up treasures. This was John Hare Powell, Esquire, of Philadelphia. Powell offered him any assistance he might want, and obtained for him access to the collections of Angerstein and others of the aristocracy with whom he was on intimate terms. But he could not fulfill his contract by merely seeing pictures. He was told that if he went to France the best pictures would not only be open to his view and examination, freely and gratuitously, but that he would

have the privilege of copying them at will. " I must go to France," said the young painter. But on consulting Mr. West, he said, " I understand that your object on your return is portrait painting." " Yes, sir," " Then stay in England. You wish to fulfil an engagement and improve yourself by copying some pictures. My collection, old and new, is at your service. There are specimens of the ancient masters and of the moderns. Take them as you want them, and come to me for my advice when you want it."

But for this offer, the young painter must have gone to France. English collections were out of his reach : he might look, by special favour and introduction, but he might not even take out a pencil and make a memorandum. He must have been thrown upon a foreign country with his scanty resources ; and have lost the instruction of the best teacher living, but for the advice and generous offer of the American patriarch of painting. " Study portraiture in England above all schools." This wise counsel determined Sully ; and the liberal permission to use his choice collection of old masters, as well as his own works, with the privilege of removing them to his own *attelier*, made every thing easy to the ardent and industrious student. Nine months he laboured, painting through the day, and drawing at the academy in the evening ; husbanding his scanty resources, which even by the limitation of his sustenance to bread, milk and potatoes, would not have lasted so long, had not John Coates of Philadelphia employed him to copy some landscapes, which were in the possession of Wm. Penn.

The money arising from this additional copying, gave him power to prolong the time to the accomplishment of the contract; but notwithstanding this salutary aid, at the end of nine months his funds were exhausted ; and for his expenses in returning home, he drew upon his good friend Wilcox for two hundred dollars.

The following letter from Mr. West shows his anxiety that Sully should have a longer time given him, to improve himself, and the high opinion he entertained of the young artist. It is from the Portfolio.

Newman-street, Nov. 3, 1809.

" Philadelphia I cannot name without being interested in all that has a connection with that city : this, my good sir, alludes to a young gentleman now studying painting under my direction as a professor of that art, whose talents only want time to mature them to excellence ; and I am apprehensive, that his means of support are too slender to admit his

stay at this seat of arts that length of time to effect what I could wish, as I understand it cannot be longer than the beginning of next summer. Could his friends unite in a way that would afford him the means of studying here another season, he would then secure the knowledge of his profession on that permanent basis, on which he would be able to build his future greatness in America—to his honour and the honour of the country.

" The young gentleman I allude to is Mr. Sully. I find him every way worthy and promising. I could not refrain from thus giving you my sentiments, when the success of Mr. Sully in his profession as a painter, is so much to be desired.

<div align="center">

" I have the honour to be, my dear sir,

" Your much obliged,

" BENJAMIN WEST."

</div>

The friends of Sully, and he, like West in his early days, found or made friends every where; such is the force of talent joined to good conduct and conciliating manners. His friends Wilcox and Powell and others would have willingly advanced funds to prolong his stay in Europe: they knew nothing of his penurious mode of subsistence, and would cheerfully have placed him at his ease in his studies; but the just dread of debt and love of independence, made him prefer the shorter period for improvement, and the lenten fare of penury to the more liberal allowance of time and rich diet. Though fond of the theatre, he never indulged himself in seeing a play. Passionately devoted to music, and himself a skilful performer, he would never have heard a concert during this time, but that he met in London a friend who had a similar taste, and private concerts at his house.

The number of Americans who had attended the Royal Academy, attracted the attention and became a theme for conversation among the native students. When Sully had entered his name in the book as usual, several of the young men satisfied their curiosity by examining the entry, and when they read the words " from Philadelphia," the exclamation from each was heard, " another American."

Beside the labour of painting, and drawing at the academy, the friends Sully and King studied from a model hired to stand in their painting-room; and the lesson Mr. West had given the young painter, when he carried his head of King to him, caused the additional labour of studying osteology by copying anatomical engravings at night, and of course

by candle-light, to the lasting injury of his eyes. Such is the enthusiasm of genius directed to the object it loves.

The friendship of Hare Powell having opened some of the galleries of the rich to Sully, he made the best use his time would allow, for profitting by this privilege. He has said that notwithstanding the works of great masters which met his eyes at Angerstein's, his attention was arrested by the " Marriage-a-la-mode," of Hogarth, and he could with difficulty tear himself away from them.* The pictures of Titian did not afford him great pleasure until Sir Wm. Beechy directed his attention to the Ariadne.

It may be supposed that he did not neglect the pleasure and profit which visits to West always afforded; who had at that time two works on hand, very dissimilar, his " Amor vincit omnia,"† in the small room at the commencement of the sketch-gallery; and the " Healing in the Temple," in one of the spacious apartments to which the gallery led. On one occasion when Sully was with him in the small room, the young man took up from a sofa the wing of a mackaw, and was examining it. " That," said West, " is the wing of one of my genii. I never paint without having the object before me, if it is to be had." An important lesson to all painters.

Sully having finished a copy from a Correggio, which had been entrusted to him by his kind benefactor, carried it to Newman-street, for his inspection. " It is very correct," said

* See Leslie's opinion on this subject in his biography. These pictures are two feet three inches high, and two feet eleven wide. Hogarth's portrait of himself, is two feet eleven by twenty-three inches. Rembrandt's " Woman taken in Adultery," is two feet nine, by two feet three, and cost Angerstein six thousand guineas. Mr. Sully preferred the " Adoration of the Magi," in this collection, to the " Woman taken in Adultery," it was painted with the greatest facility. Rembrandt's ground of preparation was like the Venetians in general, white, over which he scumbled lightly a clear transparent warm colour, over that he passed olive glazings, which became the principal ground colour of his pictures; and like Adrian Ostade, he glazed the same olive colour upon itself, so as to bring it to any depth or richness, and often produced his lights and shades by the means of one colour only—his mode of producing his lights was always by masses of different colours, having affinity to each other, laid on pure; and which when examined seemed to be laid on by chance; but which all harmonized at a short distance. Those pictures which have been painted with most facility, have been most admired. Sully saw at Angerstein's a very good portrait by Vandyke, of which he says, " It would seem that he used Naples-yellow and white for the highest light—next, venetian-red and white; the gray tints are broken into every part of the flesh, and are apparently of blue-black and white. Titian's practice of colouring is supposed by Ramsay Reinagle, to be as follows for making out the effect of his pictures. Raw-umber, burnt-umber, venetian-red, Indian-red, and black: glazing the draperies, &c., and then heightening the scale of colours as the work progresses."

† A copy of this picture by Leslie was brought to this country by one of our travelling connoisseurs.

the master, " but what ground did you paint it on ?" " A tan-colour." " That accounts for the only difference. The original is painted on a lilac." Sully begged to have the original again—took it home—and made a second copy on a lilac ground.

Thomas Sully had now been nine months in England; he had completed all the copies contracted for, and some more ; he had painted four landscapes for Mr. John Coates; studied diligently at home and at the academy; and in March 1810, he embarked for New-York on his way to his family. When he took leave of the good West, he requested him to visit, on his return to Pennsylvania, his dear native place, Springfield. " Inquire for Springfield meeting-house," said the old man, " two miles from where the road crosses you, you will find the house." It was on this road that he had refused to ride on the same horse with the boy who was content to become a tailor. Mr. Sully found the house, but not by the old gentleman's direction, for roads, as well as every thing else, had changed their course in the lapse of sixty years. The house to which West bore such filial affection was at the time of Sully's visit owned by a superannuated man of the name of Crazier, who considered the queries of his visiters so intrusive and inexplicable, that he ordered them peremptorily to leave the place. Fortunately his son came in from his agricultural labours, and comprehended the desire of Sully and his companions to make inquiries respecting the great painter, who had made the township an object of note, and understood the meaning and the motive for making a sketch of the house. Two sketches of the building which would excite so many recollections, recall so many scenes—scenes so very opposite to those in which he had been an actor through a long life—were faithfully made by his grateful pupil, and sent duly and safely to his master and friend.*

* Having brought the biography of Sully to the time of leaving England, a few of the notes made by him on painters and paintings, their manners and materials, may be of use to such of our readers as study the art.

"The best picture of Reynolds that I could see in London, was in Guildhall. The Governor of Gibraltar—Elliot. A portrait by Opie, on the same wall, pleased me exceedingly.

"Sir William Beechy uses a mixture of nut-oil, mastic varnish, and sugar of lead, well shaken and suffered to settle. This he uses in his light colours to make them dry.

"Ramsay Reinagle paints on paper which is pasted on linen ; a narrow strip is left of the linen all round to allow for the changes produced by the weather.

"I find wax is sometimes used by the English painters, which is prepared by boiling the honey-comb, and extracting the wax with care, and then it is bleached in the sun. In order to mix it with the mastic varnish it is melted alone, and then the mastic poured to it. If a small lump is put with the white, all the other colours on the palette will partake of it—but no other liquid must be used while

During the passage to New-York, and in the month of April the ship was surrounded, and more than once in danger from ice islands. They were once saved by the prompt exertions of a passenger, (a sea-captain,) who in the night happened to be on deck, and saw that the ship was running on an ice mountain, when the sleepy watch and helmsman were unconscious of the danger. He gave the alarm—took the command of the vessel—altered her course by force and autho-

painting with this. Beechy has the custom of tempering his colours with a mixture of japanner's gold-size and turpentine. He invariably declines the use of any liquid to dip his pencil into, preferring to temper the colour with the knife—should he require the colour to be more liquid, he adds turpentine. When finishing the picture, no matter how large it may be, he brushes it over with a mixture of drying oil and spirits of turpentine, and then adds upon it a mixture of turpentine and gold-size, upon this mixture he retouches the work, and it serves as a varnish. I am persuaded this practice would hasten the destruction of the picture, and at all events change the tone." Mr. Sully has said that Mr. West followed the process last mentioned in his " Healing the Sick," and the defect of it was visible in 1822.

" Mr. West sketches on paper with umber and a reed pen: the effect is also put in with umber—next it is brushed over with size, and then retouched in oil colours.

" Mr. Shee condemns the use of yellow oker in the flesh ; thinks burnt terra de sienna quite yellow enough, and for a very swarthy complexion glazing over the flesh with asphaltum is sufficient, and while the glazing is wet he touches upon it with a palette set for the purpose, which drying with the glazing, mixes and partakes of its hue. Umber he discards. Venetian-red is a favourite colour in the flesh. Blue-black, indian-red, burnt terra de sienna, blue, vandyke brown, asphaltum, vermilion and lake. He observes that as colours are liable to change from yellow to brown, some allowance should be made in the first instance.

" Mr. West observed that Correggio generally painted on a ground of a pearly tint, composed of indian-red, black and white. In copying, it was essential to paint on a ground of the same tint with the original. Correggio as an ideal colourist was excellent, his pearly tone suited the chastity of his subjects.

" Titian's grounds were mostly of burnt umber and white, which is the nearest approach to the half tint of nature. Rubens used a white ground, and his colouring, which is uncommonly rich, is like metal, compared with the purity and truth of Titian.

" The English painters generally use absorbent grounds. Lawrence paints his common sized portraits in a broad flat frame painted yellow. This preserves the edges of the canvass from injury, and helps to determine what will be the effect of the picture when framed. Lawrence oils out the ground after making the outline, which he is more exact and particular with, than any portrait painter I know of. His room is lined with dark red—so were Owen's exhibition and painting rooms.

" A macgylp is made with water saturated with sugar of lead, an equal portion of mastic varnish, and three-fourths of linseed oil. It dries well. Ramsay Reinagle approves of oiling out a picture—in painting a dark complexion—uses white lowered with asphaltum. Brown oker and Naples yellow are better for flesh than yellow oker. Drying oil is not fit for macgylp after it has stood a month, without shaking the bottle well. An absorbent ground may be prepared with weak size, whiting, and a small portion of treacle."

So far Mr. Sully's notes. It may be added that oiling out a picture is a bad practice, and that burnt terra de sienna is yellow enough for nearly all complexions, perhaps this is what Hopner meant when he said, " there is no yellow in flesh."

rity—and received the captain's thanks when he had rushed
on deck and seen the perilous situation he had been rescued
from. Another sea-captain was likewise a passenger, a rough
and boisterous son of the storm, who had conceived an affec-
tion for the painter—that is, " taken a strong liking to him."
The alarm of ice islands being given one night, and the well
known sound of confusion on the deck reaching him, he snatch-
ed Sully from his berth, and bearing him aloft in his herculean
arm, rushed upon deck, where the first thing he did after plac-
ing him on his feet was to fasten down the hatches. The alarm
being over, Sully asked him the meaning of the last act.
" There were more than enough," said the sailor, " already on
deck to fill the boat, and I meant that all under the hatches
should stay there."

Returned to Philadelphia and to his family, the painter oc-
cupied again the same house, jointly with Mr. Trott. Sully
felt that in portrait painting he had made little progress, ex-
cept that he had more of the theory, and that his general
knowledge of his art was much greater. The public how-
ever saw great improvement in his portraits, and he had the
world of fashion at his beck. That knowledge he had ob-
tained was soon, and ever after, apparent in all the productions
of his pencil.

He was enabled to offer to his friend Wilcox the $500 he
had borrowed of him. " Why what have I done," said he,
" that you will not paint for me, as well as others? I don't
want the money—I must have pictures." The painter sent
him pictures nominally to the amount of the debt, but on any
estimate except that made to induce his friend to accept them,
to the value of half as much more. The copies for masters
made for, and sent at his expense to the subscribers, are now
the ornaments of their houses, and of ten times the value of that
very moderate sum the young painter received for them: but
that well timed aid enabled him to gain the prize he aimed at.

In 1811, Charles R. Leslie's talent, since so fully developed,
manifested itself. Sully, ever ready to communicate to others
the knowledge bestowed upon him, either by the instrumen-
tality of men like himself, or by his own indefatigable exer-
tions, encouraged the efforts of Leslie in every way. He
painted a head in the manner of Rembrandt expressly for his
instruction. He thus taught the boy the use of the material,
which he has employed so conspicuously to his own honour
and the delight of the world. For this service rendered, we
have heard Sully say that Leslie has never ceased repaying him

by presents of prints, drawings and other friendly tokens of remembrance and good will.

But the effect of too close application to study began to show itself before the end of 1811, and rendered it necessary for Mr. Sully to make a journey to Richmond for the recovery of his health. This leads to a notice of an arrangement made by the painter to secure the services of an eminent physician for his family after he returned from this journey to Virginia. Dr. Dorsey very willingly agreed to attend as family physician, for the sum of $100 the year, to be paid in pictures. After a time the doctor protested against the bargain, and said "I must break off, Sully, this will not do." " How so?" " Because none of you will be sick " " Only let us remain well, doctor," said the painter, " and I am willing to paint to three times the amount for you."

A pleasant acquaintance of mine had the habit of introducing any subject whatever, by "speaking of a gun," a phrase similar to the French " apropos des bottes." We shall come nearer the mark we aim at, by saying, " speaking of a doctor," and having related one painter's anecdote of a doctor, let it introduce another. Doctor Lewis, a very old gentleman was sitting to Sully for his portrait when Dr. Abercrombie came in. "So," said the latter, " sitting for your picture, Dr. Lewis, that's right !" " Yes," said the old gentleman, " I have settled all my affairs, and have nothing to do but have my likeness taken and die." In two months from the time he was a corpse.

This did not prove a sufficient warning to Dr. Abercrombie, who perhaps had not yet settled his affairs, for he soon after sat for his portrait. When he was adjusting himself to the fatal chair, the painter inquired, " How much time can you give me, doctor." " I'll sit as long as you please," was the reply. " I can paint all day." " And I can sit all day." By and by, Trott came in, but finding a sitter, retired. After the longest time he had ever known or heard of for the operation, he returned,—found the doctor on the same spot, and withdrew. He came a third time, after a still longer interval, and there still sat the doctor, who saluted him with, " Well, Mr. Trott, don't you think I'm a good sitter ?" " Good," said Trott ; " yes indeed. You set like an old hen." This joke, may pass in common parlance, because in common parlance *sit* and *set* are frequently very improperly confounded.

Another esel anecdote, *apropos des bottes*. Monsieur Brugere, a French gentleman, who had lived in double blessedness, until his consort and himself were of a certain age, or a

little beyond, called on the painter and engaged his portrait. The transaction, by agreement, was to be a profound secret, as he meant to surprise Madame Brugere, by presenting her with a duplicate of his beloved visage, as a new-year's gift. While this affair was going on the painter received a visit from Madame Brugere. Sully, on seeing her enter, thought the secret had fared the fate of most secrets, and was preparing to bring Monsieur's physiognomy from its hiding place; but the lady did not give him time to be a Marplot. "Mr. Sully," said she, "you must paint my picture very quick; for I am determined to surprise Mr. Brugere very much by presenting to him my likeness on new-year's day, the first thing he shall see. Monsieur Brugere has long desired to possess my portrait—I have long time refused—but now I would surprise him, when he shall find it hung up before his face on new-year's morning. So you will paint my portrait, and we shall keep it very, *very* secret, from Monsieur Brugere and all the world." Thus this happy couple had hit on the same plan to increase each other's pleasure at the commencement of the year. Accordingly both portraits were painted, and both secrets remained inviolate and unsuspected. The painter contrived that the pictures should be carried to the house and placed in the parlour on new-year's eve, after the family had retired to rest—the same pretence for the secrecy of the proceeding, and the lateness of the hour, answering for each, and each plotting with the painter to deceive and surprise the other. A visit was soon received from the husband. "Aha! Monsieur Sully! *Mon Dieu!* how we have all played trick! I trick my wife—my wife trick me—you trick both. Very early on new-year morning Madame Brugere get up and go into the parlour. I listen, and I hear her exclaim very loud, and laugh immoderately. So I go to her to enjoy the joke. 'Aha! my dear!' I say, 'is it like?'—'You shall look if it is like:' and there I found her picture by the side of mine. 'Aha!' said I, 'Sully has told you my plot, and you counter-plot me!' but I found it was the same thought in two heads." "And the mutual desire to produce an agreeable surprise," said the painter.

Mr. Sully painted several full-lengths about this time. One of the celebrated George Frederick Cooke, in the character of Richard the Third, he presented to the Pennsylvania Academy of Fine Arts. A full-length portrait of Samuel Coates, an active governor of the Pennsylvania Hospital, is placed opposite to one of Doctor Rush, in the building erected for West's picture of "Healing in the Temple," but in an ante-

chamber. Coates's portrait he presented to the Pennsylvania Hospital; that of Dr. Rush he was employed to paint by the directors and paid for. This was in the year 1813.*

* To Thomas Sully, Portrait Painter, Philadelphia.

" New-York, April 16th, 1812.

" Dear Sir—I am desirous of obtaining a portrait of my friend Dr. Rush. I have an imperfect likeness of him in crayons, by Sharpless; but it contains nothing of the character of Dr. Rush, which it should be the object of the painter to delineate : in that respect yours is a *science*, not an *art*, as it is generally denominated. Believing that you duly appreciate the mind which animates the face of my friend, and that you have become familiarly conversant with his features, I have no doubt you will be enabled to furnish me with a portrait which will be gratifying to me, at the same time that it will afford me and your other friends an opportunity of seeing a specimen of the present highly improved productions of your pencil. I hope your engagements will permit you to confer upon me the favour I ask, in the course of the present season.

" I wish it to be a half-length, to correspond with that of Dr. Bard, by Vanderlyn, which you have seen in my room. Your order for the same will be honoured whenever you think proper to inform me of the amount, and to whom it shall be paid.

" Would it improve the picture by throwing into the back-ground a distant view of your City Hospital or University, to which Dr. Rush's labours have been so much and so long devoted?

" I am, Sir, with regard and respect,
" Yours,
" D. Hosack."

To Dr. Benjamin Rush.

" New-York, April 23d, 1812.

" My dear Sir—I have written to Mr. Sully, the portrait painter, of your city, requesting to know if his engagements will permit him, at this time, to execute for me a portrait of a much esteemed and respected friend. Finding that he is both ready to comply with my wish, and pleased with the subject upon which I have requested his pencil to be employed, it remains for me to ask the favour of you to oblige me by sitting to him for this purpose, whenever you may find it convenient. I am very sensible of the tax I lay upon your friendship, in asking from you this favour, incessantly occupied as you are by business. I already possess an imperfect sketch, by Sharpless, but it consists of mere features, exhibiting little or nothing of the character which I consider every thing in a portrait.

" I have applied to Mr. Sully, believing that he duly appreciates his art in this respect, and that he, at the same time, is sufficiently acquainted with your *mind* as well as your *face*, to blend them on the canvas. You see I am fully apprised of the correctness of the observation by Sir Joshua Reynolds, that ' it is not the eye, it is the mind, which the painter of genius desires to address, that it is this *intellectual* dignity that ennobles the painter's art, that lays the line between him and the mere mechanic.'

" But I hope I am not imposing upon you the task of a *five* hours' sitting, the time occupied by Sir Joshua when he painted his celebrated portrait of your friend Dr. Beattie.

" Present me affectionately to Mrs. Rush and Miss Julia; I hope we shall be favoured with a visit from them in the course of the summer. I am happy to tell you, that after the embarrassments which the delay of payment for the garden had temporarily created, my mind is once more at ease, and that my undivided attention is now given to my profession. My promised letter is only *delayed*, not forgotten. " With great respect and esteem,
" I am yours,
" David Hosack."

163 MARTHA JEFFERSON RANDOLPH. Painting by Thomas Sully. *Courtesy Peter A. Juley & Son.*

164　Dr. Benjamin Rush. Painting by Thomas Sully. *Courtesy The Pennsylvania Hospital.*

CHAPTER VIII.

Sully's yearly receipts at various periods—his business decreases in 1818—loss by a drawing from West's " Healing in the Temple"—Full-length of Commodore Decatur, for New-York—Sully's delicacy towards Stuart---Stuart's strange conduct---Unfortunate circumstances attending the painting of the great picture of " Crossing the Delaware "----is sold to Doggett---The Capuchin Chapel---Full-length of Mr. Jefferson, for West Point---intended visit to England---he is going to Boston---stopped by several artists---permanent success---person and character---Remarks on pictures and pigments---James House.

THE yearly receipts of the painter has been stated, at the time he commenced oil painter in Norfolk : it was $120. His yearly earnings now, for some years, including the first after his return from England, were, from $4,500 to $4,120. This did not last; and before the year 1818 his business had most sensibly decreased. He lost much time by undertaking to make a large drawing of West's picture of " Healing in the Temple," for the directors of the Pennsylvania Hospital.— From this an engraving was to have been made : he was to receive $500 dollars for the finished drawing. But after proceeding in the work for several weeks, he found that he should lose by the bargain, and begged to be released from it, unless an additional $200 could be added for his remuneration. The directors chose to annul the agreement, and the time employed upon the drawing was lost.

By invitation from the city of New-York, Mr. Sully repaired to that city, and painted Commodore Decatur's full-length portrait, for which he received $500. This was the first painted of that series of full-lengths which the common council of New-York ordered, to commemorate the men who distinguished themselves during the short war of 1812 : a war which, in its causes, characterized the insolence of Great Britain, and, by its events, proved that she was not the mistress of every sea, or conqueror on every shore—the latter had been before shown triumphantly on the same soil. Mr. Sully's Decatur is not the happiest effort of his genius or pencil.

The voices of all in America who understood or loved the fine arts, would have called upon Gilbert Stuart to have fulfilled the views of the city of New-York, by perpetuating the resemblances, in form and character, of the defenders of the country ; and he had already commenced the full-length of the first who began the career of victory, the conqueror of the

Guerriere; but, from some misunderstanding with the officer, or with the corporation of New-York, or from some caprice of the eccentric painter, the work was discontinued, and the collection in the city hall of New-York cannot boast a picture from the hand of Stuart.

Mr. Sully was applied to by the common council of New-York to go on to Boston and paint the portrait of the officer whose likeness Stuart had begun and left unfinished; and the assurance was given, that the portraits of the other victorious commanders, naval and military, would be ordered in succession. This was a glorious and golden opportunity for the painter. But to go to the place where Stuart resided,—his friend and early instructer—his elder, and undoubtedly, at that time, his better as an artist, and paint a subject which he had commenced——" O no!" said Sully, " it cannot be!" However, as the journey was pressed upon him, and thinking that he might find some means of serving Stuart, connected with this project, he asked a little time before giving his final answer. He therefore wrote to Mr. Stuart, reminding him " that he had heard him often express his aversion to painting back-grounds in their details, the draperies of portraits, and the subordinate accessories of pictures; telling him that the corporation of New-York were determined to have a gallery of portraits of distinguished men, for which he might be employed if he chose, and offering to be his assistant in the subordinate parts of the plan, and the whole should be under his direction." Stuart never answered the letter. Sully declined going to Boston, as required, and another was employed to paint the pictures. Mr. Jarvis, who had not the same scruples in respect to Stuart, went on to Boston, and achieved the work which Stuart had neglected or refused: and in consequence of the satisfactory likeness produced, was employed for a long time in decorating the city hall of New-York with full-lengths of successful commanders.

Some years after, Mr. Sully being in company with Mr. Stuart at Boston, the latter proposed painting in conjunction, and almost in the words of Sully's former proposition, concluding with, " We can carry all the continent." Mr. Sully replied that he should be delighted with such a company-scheme, and then asked him if he remembered his letter to him in 1814. He denied all knowledge of it. Upon which Sully remarked, " If we had undertaken that business at that time, sir, we should have painted"—Stuart interrupted him by exclaiming, " All those full-lengths which that blackguard painted !"

The affair of the drawing commenced for the Pennsylvania hospital mentioned above, took place in July 1818, and in October of that year he had another order, which produced still more unfortunate results. He was applied to by the legislature of North Carolina for two full-length portraits of Washington. In reply, he proposed the painting of one historical picture, in which some prominent action of the hero should be represented, and mentioned the crossing of the Delaware at Trenton. This was agreed upon. He wrote for the dimensions of the place the picture was destined to occupy; and not receiving an answer, proceeded with the work on a canvas of great dimensions: years were expended in the completion; applications for portraits almost ceased; money was borrowed to carry on the work, and when it was finished he was informed that there was no place fitted to receive it, and the picture was thrown upon his hands.

To paint a great picture, and this was such both in size and subject, the artist requires a lofty apartment, and many expensive adjuncts which may be dispensed with in the composition of smaller works. The time exhausted in studies and labour, especially where all is done by one person, as has heretofore frequently been the case in our country, probably amounts to years; and the expenses of the artist and his family, if he lives in that becoming style which his professional standing in society entitles him to, and even his interest may require, must be serious in the amount. Thus his picture costs him (without charging it with any of the capital expended on his education as an artist) some thousands of dollars, which, if paid by a purchaser, is thought a great price, although it merely suffices to repay the painter for the expense incurred while painting the work—and his talents and labour go for nothing.

Stuart used to say no man would paint history if he could find full employment in portrait. If mere gain is to be considered, he was right. Sully had committed two errors in this business: first, his ambition prompted him to put aside the painting of two full-lengths which were offered to his pencil, for the sake of painting history. Here " vaulting ambition did o'erleap itself;" and secondly, prudence should have dictated to wait until he received an official answer respecting the size of the historical picture.

Mr. Sully had produced a fine historical picture, representing perhaps the most brilliant achievement of Washington, and in many respects in the most perfect style of art; but he found no purchaser for it, nor any profit from its exhibition.

Unfortunately, Washington's portrait was not acknowledged as a likeness. The generation, who were its judges, generally formed their opinion from the vile print published by Heath of London, and called Gabriel Stuart's Washington, (certainly it was not Gilbert Stuart's) and from Trumbull's pictures of the general. This unfortunate picture was at length sold to Mr. John Doggett, a wealthy and worthy frame maker of Boston, for $500, and he sold it to Mr. Greenwood, the keeper of the Boston Museum; and it there remains rolled up, awaiting the time when it shall be justly appreciated. If it was an old instead of a modern picture, the winter landscape would alone stamp it as a jewel; but in the old pictures one good part redeems—in the modern, one part faulty condemns. When the painter hears this picture mentioned, he sometimes says, "I wish it was burnt." A small finished study, four feet by three, painted previous to the large picture, was purchased by Sir James Wright, and is now in Edinburgh, and another of the same size was purchased by Col. I. Ash, of Georgetown, South Carolina.

In July 1821, Mr. Sully first became personally acquainted with Washington Allston. Among the many projects suggested by the lack of regular professional business as a portrait painter, the noise which Granet's picture of the "Capuchin Chapel" made at this time, was the cause of one which Sully carried into execution with success. It was justly thought that a good copy would be a profitable exhibition picture, especially as the original was the property of a man of fortune, and not visited with the same freedom as one feels when paying twenty-five cents for admission—a kind of ease similar to one's enjoyment "in mine own inn." Thus thinking, Sully, having obtained permission of Mr. Wiggins of Boston to make the copy, (a permission for which he was in part indebted to the suggestion of Mrs. Wiggins, that it would diminish the number of visiters who came to see the original painting—ladies do not like to have their carpets trodden by unhallowed feet,) the painter repaired to the famous tri-mount town, and prepared for the task. When Sully spoke of the time necessary to make a copy of this very highly finished picture among his brother artists, Sargent gave him four months, Allston said five, Stuart six, but the indefatigable painter finished it in less than three. When he told Allston it was finished, he said, "You have made a sketch." "No; a carefully finished copy —come and see." It was acknowledged to be such. But the artist had worked ten hours every day; and such was his absorption in the labour he had undertaken, that, neglecting his

premonitory feelings, he one day on leaving off, after having extended the time of labour, while preparing to clean his palette, fainted away from exhaustion.

M. Granet, the painter of the original which Sully copied as above, had been commissioned from Naples to paint a picture while he was in Rome, and took for his subject the choir of the Capuchin church in the Piazzi Barberini, during divine worship. He was admirably successful. He had orders for, and executed ten copies of this picture. One of these was made for Mr. Wiggins, who brought it to the United States. The other copies by Granet are distributed all over Europe.

In this same year, 1821, Mr. Sully painted his fine full-length portrait of Mr. Jefferson for the Military Academy at West Point. For this purpose he visited the sage at Monticello, and in his house made a painting, head size, of the venerable ex-president. The painter was an inmate of Monticello twelve days, and left the place with the greatest reluctance.

Many are the vicissitudes which a portrait painter has to undergo even after he has attained eminence. How necessary is it for him to catch and hold fast a portion of the product of the flood tide, that when the ebb comes he may not be left stranded and destitute like a ship-wrecked mariner. Perhaps no painter of Mr. Sully's acknowledged merit has experienced the fluctuations of fashion, or the caprices of the public, in so great a degree. At one time overwhelmed with applications for portraits, at another literally deserted, not because he deteriorated, as some have done, for all acknowledge progressive improvement to the present hour. In 1824 Mr. Sully's business had decreased fearfully, and his embarrassments increasing in proportion, had become so onerous that he had determined to leave America. He had pressing invitations to come to Edinburgh, and there take up his permanent residence. While he hesitated, a plan was proposed by some of his friends for a second visit to England, instead of a removal of his family. It was thought he might leave his family at home while he went to London and painted the portraits of eminent men, originals, and copies from good pictures by artists of known talents, of deceased worthies, the Lockes, the Newtons, the Miltons, the Cromwells, the Hampdens, and others that we claim as our countrymen, and revere as our benefactors. He was to be supported by sums subscribed for the purpose by those who wished such pictures, and who wished to encourage the art and the artist.

This plan was so far matured that the painter carried it in the form of a subscription paper to a wealthy, and professing friend for his signature. He was coldly received, and time asked for deliberation. Sully took his leave with his subscription paper in his hand; and if the patron looked from his window upon the man whose expectations he had raised but to disappoint, whose manly spirit rose as his hopes were crushed, he might have seen the heart-stricken husband and father tear the paper to pieces, and dash it in the kennel before his door.

He now thought of accepting invitations from Boston promising him employment, and having made known his intentions, packed up and made all ready for the journey, he was waited upon by Messrs. Fairman, Fox, and Childs, engravers, who were determined to prevent what they justly considered a loss to the city. "You must not leave us," they said. "I have no employment here." "If you had gone to England, you would have returned. If you go to Boston, and take your family, you will stay there. Will you paint our portraits?" "Certainly." It was agreed upon. The painter unpacked his materials, and from that time to this he has had uninterrupted success—full employment, increased prices, increased reputation, and increasing skill.

Mr. Sully is, as we believe and sincerely hope, anchored safely in port for life. He has portraits engaged in succession for years to come at liberal prices. His fellow-citizens of Philadelphia justly appreciate him as an artist and a man. The late wealthy, eccentric, benevolent, and munificent Stephen Girard caused to be built in addition to one of his houses, purposely for the artist, an exhibition and painting room, and in that house he resides surrounded by his numerous family, and by all those conveniences which are so dear and necessary to a painter.

With a frame apparently slight, but in reality strong, muscular, athletic, and uncommonly active, Mr. Sully does not stand over five feet eight inches in height, but he walks with the stride of a man of six feet. His complexion is pale, hair brown, eyes grey, approaching to blue, and ornamented with uncommonly long eye-lashes, and his whole physiognomy marked with the wish to make others happy. At the age of fifty-one, he enjoys the cheerfulness and activity of youth. Two of his daughters are married, one to Mr. John Neagle, a first-rate portrait painter, another, herself a painter, to Mr. Darley. The oldest son of the artist has followed the example of his father in rejecting the counting-house for the painter's attelier, and we doubt not will follow his example in industry and virtue.

NOTES ON PICTURES AND PAINTING,

BY THOMAS SULLY, ESQ.

CHARLES R. LESLIE, Esq., soon after he went to London, copied Hogarth's "Gate of Calais," and sent it to this country. Sully copied it, and says in one of his notes, " that he painted the figures in front at each side with colour tempered with wax; especially the figure of the Scotchman, which, except a slight effect of burnt umber in the commencement, was wholly painted with wax colours, which is prepared as follows: to a desert spoon full of mastic (varnish) add a piece of bleached wax, melted by fire ; when this mixture is cold it will form a thin jelly, which may be either used as a magylp by tempering it with oil, or by adding it to the colours when ground in oil." Sully's copy from Leslie is in Sully and Earle's gallery, Philadelphia. The fate of Leslie's copy from Hogarth is singular. It was purchased at auction by a boy for two dollars, who did not know its worth, and willingly sold it to his master for a trifling advance. It is now in New-York.

In April, 1826, Mr. Sully visited the collection of Joseph Bonaparte, at Bordentown, New-Jersey. The remarks of the painter at this period of matured knowledge and judgment, are worthy the attention of the student. "Titian's plan does not appear to me to produce splendour of colouring by employing the brightest colours, but by the judicious and artful use of sober tints, and the practice of toning and glazing them. I am now speaking of the impression made upon me by an inspection of those examined on this occasion. Indian red appears to have been the principal red used in the flesh—in the fairest flesh a little improved with vermilion. I have little doubt that the dead colouring made with Indian red, or even colcotha in the flesh, then toned with raw umber and white in the lights, and glazed with asphaltum or mummy in the shadows, would be near the general preparation. But if in the dead colour black were used in the gradations, perhaps toning with brown ochre and Indian red might be better. It is remarkable how much glazing has been used in the Lucretia, which I examined closely. Even the whole drapery has been glazed or toned down. The effect is a subdued splendour, far preferable to the oily smoothness of the opposite system. Absorbent canvas seems to have been used ; the colours much loaded. I again had occasion to remark that in large pictures very sober colours may be employed to produce richness of effect. A picture by Velasquez (a deer-chase) has very much the aspect of a Titian, but there is not so much display of

glazing and process; the unity of the tone seemed effected by beginning the whole picture with one colour for the shade, and one for the light, which are afterwards finished upon. Murillo looks dirty and clouded in the tone and in the flesh; except in small pictures of a portrait size, *there* the flesh was rich and natural. Guido looked hard and liny near Titian, and very cold and weak. The large pictures of Rubens have much of Titian's good colour in them, although generally of a higher scale."

In 1828, Mr. Sully, though standing so high in his profession, copied a head painted by Raeburn, for study. He says of it, " I found much use made of glazing colours of green, purple, asphaltum, and lake. The green made of prussian blue and asphaltum; the purple, of prussian blue and lake. After dead-colouring near life, I tinted the flesh, white drapery, and back-ground with yellow, red and blue tints : when dry, glazed and improved the shadows, and scumbled the lights, on which I improved the tinting and finished the picture."

In 1827, Mr. Sully says, " I have resorted to my first method in laying in the flesh, by dead-colouring with Indian red and black—two tints with white and light red, and two tints of white, making out a broad effect of the head—including hair —a portion of the drapery and a portion of the back-ground. I follow upon that with the following tints, in the order they are set down, beginning with the madder lake and so on ;— using a light touch with a long-haired pencil.

Madder lake	Brown oker	Cobalt & white
Vermilion	Do. & white	More white
Do. & white	More white	Black & brown oker
More white	More white	Do. and do. & white
More white	Cobalt	Asphaltum or Vandyke for the hair.

Yellow oker, or Naples yellow, may be substituted for the brown oker, or blue-black for the cobalt, or raw umber for the black and brown oker tint. The back-ground and drapery tinted in the same way; that is, with the Indian red, black and white ; and, while wet, the colours broken in—except in masses of coloured or dark drapery ; these may be put in of the tone or depth of colour, and glazed and retouched afterwards. The subsequent sittings are to glaze the shadows of the flesh, scumble the lights with light red and white, or any other fit tone, and retouch the complexion. I have painted, in this way, Dr. Abercrombie, and two copies of Guy Bryan, Esq."

Mr. Sully was incessantly making experiments, but not los-

ing his time in search of nostrums and secrets. He made notes of the palettes of eminent men—he tried their practice, and finally came back to the above. He thus gives Raeburn's palette. After ivory black and white lead, follow the tints.—

1. Indian red	6. No. 5 and white	12. Black & Indian red
2. Add white	7. More white	13. Add white
3. More white	8. Raw umber	14. More white
4. More white	9. Add white	15. More white
5. Brown oker & Indian red	10. More white	16. More White
	11. More white	

Finishing palette :—

1. Indian red & vermilion	7. No. 6. & more white	13. No. 12. & white
2. No. 1. and white	8. No. 7. and white	14. More white
3. More white	9. Raw umber	15. Ivory black &wh.
4. More white	10. Do. and white	16. More white
5. No. 1. and brown oker	11. More white	17. Madder lake
6. No. 5. and white	12. Indian red & black	18. Asphaltum

" The foregoing memorandum, from Sir Henry Raeburn's portrait of Dugald Stewart, presented by Dr. P. Tilghman to our Academy, has induced me to remark, that it is a list of colours applicable to most complexions, varying, as occasion demands the tints No. 5, 6, and 7. In very florid complexions, as those of red-haired persons, or of very fair, a different scale is requisite ; for such, perhaps, burnt terra de sienna and vermilion. Light red and Naples yellow, with vermilion and white tints would be better. In glazing, I found he had incidentally employed cobalt with the tint No. 12, (Indian red and black) ; cobalt with asphaltum ; also asphaltum with No. 12. It is well to paint with daring boldness and strength in determining the head. In finishing with the different tints, more circumspection must be used."

In another note he gives the proportion of light and shade for large pictures. " The half, demi-tint ; one-fourth, dark shade ; and one-fourth, light. For small pictures, more dark shade, and less bright light."

Speaking of one of his pictures, he says, " By taking too much pains with the detail, I have lost breadth—by muddling the colours, I have lost clearness. I must give more local tint to the flesh ; the cold tints bordering the shadows trench too much on the light—the face looks muddy."

In May, 1830, Mr. Sully writes thus :—" On careful inspection of several good pictures of the old masters in Abraham's collection, at New-York, I find that the practice of touching the whole picture with a warm colour, like terra de sienna, and, in some instances, with a dark colour like asphal-

tum, was common to their practice. A fine copy of Corregio's Magdalene, and a portrait by Velasquez, (rather doubtful) were much toned. In the landscape by Hobbima, asphaltum has been used over all the surface, sky and all. In a landscape, said to be by Claude, I found much scumbling, of a lilac neutral tint, over the distance and middle ground—perhaps also the sky; and finally, the whole picture, sky also, was toned with raw sienna, or a colour like it. The best picture in this collection is a Murillo: the colours are subdued, simple, little discrimination of tint: brown oker, Indian red, and raw umber chiefly: the whole much toned: a very full pencil has been used: the colours, at least in the beginning, were stiff, the marks of the brush left—no softening tool employed."

In June, 1831, Sully visited Boston. Ever in search of improvement, not only by industrious application, but by the examination of the works of others, and the lessons received in conversation with the masters of the art, he has made a note of the remarks of Allston, whom he always designates as " number one." " Allston says that Stuart condemned vermilion, but could not relieve himself by a substitute. (He) was of the same opinion, and had used Venetian red ; which, if of good quality and well washed, will answer every purpose if a glazing of madder lake be resorted to. In Italy they have a superior kind of madder lake, called *terra rosa*. The walls of Allston's painting room are coloured with Spanish brown. Allston recommends emphatically, solid tinting in painting flesh, especially for large pictures that are to be seen at a distance. " Paint pure, decided tints : if too raw, you may correct them by scumbling—glaze at pleasure." Again, " never use brown drapery to a dark or yellow complexion ; it will look like a snuff-bag." He recommends the use of a very slight glazing of asphaltum to a portrait, face and all."

In 1832, he has this note. " Inman observes that his practice is to measure the face from the eyebrow to the chin. That as a general rule, to the end of the nose is one half of the face from the brow to the chin. He observes carefully the distance of the eye from the brow and from the nose, as on these points much of the identity of the face depends. Stuart Newton in conversation told me " he thought Lawrence's portraits over embellished—too theatrical—so that locality was sacrificed. (He) would prefer to see the individual with his exact and leading characteristic expression, but treated with an improved view. Reynolds, far the best portrait painter— he too had to contend with the complaint of want of likeness —

Lawrence's portraits of females rather loose. (He) would like to see all portraits of women made beautiful, and *like* if possible. On account of their costume, &c., they are the best subjects for a painter of portraits."

It may be seen by these notes how attentive Mr. Sully always was to every opinion that might improve him; and it is hoped that by publishing these memoranda, made only for private use (but given by permission), many students may find hints for their colouring and for their conduct. I think them invaluable.

JAMES HOUSE—1799.

James House, *c.* 1775–1834.

This gentleman had in early life chosen painting for his profession, and practised taking likenesses in Philadelphia about this time. What changed his views I know not, but he entered the army of the United States, and I remember him long as Colonel House, and in 1814 commanding as fine a regiment as I ever beheld.

CHAPTER IX.

I. Simond—Maras, the Grand Signor's painter—No great difference, in his eye, between a horse and an ass—Gallagher—portrait painter—sign painter—scene painter—his kitchen and the manager's discontent—Miles—George Murray —engraves lions remarkably well—great prosperity—improvidence and death —Raphael West—oldest son of Benjamin—sent out to settle wild lands in Genesee—finds himself too near neighbour to a bear, and returns home—the West family picture—Raphael West a fine draughtsman—painters' criticisms—Eckstein—Natural painting—F. Guy—Tuthill—Charles Fraser—teaches Sully to draw—studies law—becomes a first rate miniature painter—Stewart—Hutchins.

LOUIS SIMOND—1799.

Louis Simond, 1767–1831.

THIS gentleman, although not professionally an artist, had been so well taught in the course of a liberal education, and practised in this country for his amusement with so much skill, that he must be considered as one who contributed to the progress of the arts of design.

L. Simond was a native of Switzerland, who visited this country as a merchant; married in New-York, and resided with us many years. On his return to Europe, he passed some time in England, and published a work on that country, particularly noticing artists and arts. Unfortunately for his reputation as a critic of painting, he had become intimate in New-York with John Trumbull, who was, at the time of his visit to London, painting his unsuccessful historical large pic-

tures in that city, and *then* the enemy of B. West. Simond uniformly condemns the works of West, except the "Death of Wolfe," and that, he hints, was stolen from a previous picture. Trumbull's pictures, then painting, are praised in the comparison. Without this clue, Mr. Simond's strictures on West would be unintelligible to those who know his taste.

His description of a night and early morning in London is very fine. He afterwards published travels in Switzerland and Italy.

M. MARAS—1800.

Probably John Marras, *fl. c.* 1801–*c.* 1808.

A Frenchman by birth, M. Maras visited America about this time. In 1801–2 he painted poor miniatures in New-York. A poor or bad artist flourishes best where the people are most ignorant; and M. Maras, with great judgment, transferred himself from New-York to Constantinople, where he is at the head of affairs in the department of the fine arts, and painter to the sublime sultan. Charles Rhind, Esq., who negotiated our commercial treaty with the porte, recognised in the sultan's portrait painter, M. Maras from New-York. The present sultan, among his many reforms, patronizes the fine arts, (at least so far as to despise what the Mahometans consider a religious prohibition,) and, in imitation of more civilized monarchs, makes presents of his portrait in miniature to the ambassadors of other courts. This gives Maras full employment. The sultan puzzled the painter by requiring him to paint his sublimity on horseback, and the Frenchman was mounting him on a creature more like an ass than a horse, when my friend Rhind visited his rooms. He had possession of the grand signor's magnificent sword and jewels, enough to make him a nabob—if he could keep them.

GALLAGHER—1800.

Christian Gullager (or Guldager), 1795–1826.

A foreign artist, who painted portraits in Philadelphia at this time, and perhaps earlier. When there was a lack of portraits to do, he painted signs. He had a dashy, sketchy manner, and had been well instructed in the rudiments of drawing. In 1807, Thomas A. Cooper employed him in New-York as scene painter; but however great Gallagher's taste for the arts might be, his taste for lounging was greater, and, unfortunately for him, Cooper had been used to the rapid and effective manner of John J. Holland. He began a kitchen scene very beautifully, and might have made it rival a Dutch picture, but week after week passed, and the scene was not ready for the stage. "Some time next year," said the ma-

165 CAPTAIN DAVID COATS. Painting by Christian Gullager. *Courtesy City Art Museum of St. Louis.*

166 MRS. DAVID COATS (Mehitabel Thurston Coats). Painting by Christian Gullager.
Courtesy City Art Museum of St. Louis.

nager, "I may have *one* scene from Mr. Gallagher, and it will cost more than a Vandyke or a Titian."

Gallagher used to come every Saturday with the accounts of the scene department in his hand, and walk the stage during rehearsal to Cooper's great annoyance. "What does that man do *here?* I will not pay him $30 a week to walk with his hat on one side, and his hands in his pockets!" Gallagher was dismissed, and I lost sight of him.

E. MILES—1800.

Edward Miles, 1752–1828.

All I know of this gentleman is, that he painted miniatures in Philadelphia for many years, and (as I am informed by J. R. Lambdin, Esq., who was his pupil in 1823,) was once miniature painter to the Emperor Paul of Russia, the mad autocrat.

GEORGE MURRAY—1800.

George Murray, ?–1822.

Was a native of Scotland and went up to London (certainly no rare case) a destitute lad. How he *got on* there my informant saith not, but he was taught engraving by Anker Smith. Entangled with the liberty boys, he found it prudent to leave England, and took refuge in our southern states, where he commenced trader and married. He failed in his mercantile business and removed with his family to Philadelphia, where he resumed his professional employment, probably in 1800. His talents and knowledge as an engraver soon brought him into notice, and his necessities were relieved by employment for the plates of the Encyclopedia. He was particularly skilful in engraving animals, and the lions of the Encyclopedia are a fair specimen and a proof of his talents.

When bank-notes became the currency of the country, Murray engaged in that branch of engraving and associated with Fairman, Draper and others; they formed the well-known company of Murray, Draper, Fairman and Co. in 1811. The company was prosperous, became rich, and Murray was the financier and apparent leader of the business. He at this time is said to have kept his carriage, and wore a breast-pin of the cost of $700. Not content with thriving in business, he engaged in purchasing houses and lots—their value fell, and he was ruined by the fall and his own prodigality.

He was a great agitator in the controversies between the artists of Philadelphia and the proprietors of the building and statuary called the Pennsylvania Academy of Fine Arts. Mr. Sully, who had been elected a director of the academy, and endeavoured by every means in his power to make it useful,

was a particular object for Murray's enmity, and he was finally obliged to call upon him and charge him with asserting falsehoods in respect to him. It is said to be painful even now to Mr. Sully to hear the name of Murray.

This reckless and improvident man died poor, about the year 1824. "I have seen," says a correspondent, "his widow keeping a small huckster's shop where gingerbread and apples were sold." He is one of the men of genius who set themselves up as beacons to warn others from the rocks of folly.

Raphael Lamarr West,
1769–1850.

RAPHAEL WEST—1800.

In the year 1800 this gentleman, my old and intimate companion in London, most unexpectedly appeared in New-York with his wife. Benjamin West and John Trumbull had made purchases from Mr. Wadsworth, of Genesee, of tracts of land on that paradise, the Genesee flatts, near the bend which the Genesee River makes after coming from the higher lands to the west, (and turning north flows through luxuriant meadows, which always reminded me of the poetical Elysium) and finally falls into Lake Ontario, near Rochester. The elder West wished his son to visit his purchase, and as we Yankees say, improve it. But of all creatures my friend Raphael was the least fitted for the task of a pioneer in America. Born and educated in London, he had never been out of its neighbourhood; and though he had studied the noble oaks of Windsor forest, which he used to draw with anatomical precision united to all the beauties of the picturesque, he was a stranger to the appearance of the untamed forest, where only the Indian footpath gave token of the presence of man, and where instead of the deer, who in conscious safety approached and gazed at his drawings, he found the bear, the wolf and all those free rovers of the woods who at that time were the prey of the Iroquois, or preyed upon the flocks and herds of the settler—for then (not only the spot to which the London painter was destined but) all that country of the west, now thronging with human life and replete with human happiness, was a wilderness, uncultivated except where the Onondaga, the Oneida, the Seneca, or some other individual of the Six Nations had pitched a wigwam by the side of a stream; where the fertile and inexhaustible soil gave maize without labour as a coarse condiment to his venison. I do not mean that in 1800 there were literally no settlements commenced in this great country, but they were principally the squatters and pioneers of

167A ALEXANDER I OF RUSSIA. Miniature by Edward Miles. *Courtesy Philadelphia Museum of Art.*

167B EMPRESS MARIA LOUISA OF RUSSIA. Miniature by Edward Miles. *Courtesy Philadelphia Museum of Art.*

So long have we been mated, fell Despair! &c.

168 "So Long Have We Been . . ." Engraving by George Murray after Thomas Sully. *Courtesy Dover Archives.*

Yankee population, and Raphael had the house of Wadsworth, at Big-tree, to receive him, although the owner was still in Europe. This place is now a paradise.

Raphael West was born in the year 1769, the oldest son of the great historical painter. His portrait as a boy is introduced by his father in the beautiful small picture of the family, leaning on the arm of his mother's chair, who is look ing at the second son, Benjamin, an infant on her lap. His school education was entrusted to one of the numerous academies that surrounded London, and it seems to have been a favourite with the Americans of that day, as Mather Brown, John Singleton Copley, (the son of the painter, and now Lord Lyndhurst,) and Raphael West, were schoolmates and playmates, when, as Mather Brown told Leslie, " he and Raefe had often, while bathing, given the chancellor in embryo a ducking in the Serpentine River.*

Having mentioned the West family picture, I will repeat what Mr. Charles R. Leslie has said repecting it, as connected with my friend Raphael. " Of all Mr. West's pictures, *great* or *small*, I prefer (perhaps you will laugh at me) the little one representing his own family. Sir Joshua Reynolds used to say, ' no man ever painted more than half a dozen perfectly original pictures in his life.' Certainly this one stands pre-eminent among Mr. West's half dozen. It is well known by an indifferent engraving, as large, I believe, as the picture, and represents a young mother (Mrs. West) soon after the birth of her second child. I know of nothing in the art more lovely than the mother and the sleeping babe. Near her stands, half reclining, a boy of nine or ten years of age (your old friend Raphael West) and on the other side sit two quakers with their hats on, the father and brother of the artist, who leans on the back of one of their chairs." Does he not lean on his wife's chair ? By the by, had Allan Cunningham ever seen this picture, or even seen Mr. West, he could not, one would suppose, constantly speak of him as a quaker. To return to Leslie. " I believe the picture represents the first visit paid by the father and brother-in-law to the lady, after the birth of the second son, and the silence

* Let it be remembered to the credit of Lord Lyndhurst, that he did not forget his early friend Raphael West, while chancellor, and when Raphael, after the death of his father, was rather in straitened circumstances. Lyndhurst exerted himself with the government, but in vain, to induce them to purchase some of the large pictures left by Benjamin West. Lyndhurst offered Raphael a place, but it was not a sufficiently eligible one, and was declined ; and unluckily, for the places he could have given him, of more consequence, Raphael was not qualified.

which reigns over the whole is that of religious meditation.
When Mr. West's pictures were sold, Mr. Newton and I
agreed, if it should come at all within our means, to buy this
one between us. But Raphael West, to whom it belongs,
would not part with it. It was therefore not included in the
sale. I did not know the reason at the time; but Raphael
since told me, and added, with a feeling which does him
honour, that as long as he could keep any thing, he would
not part with that picture. It is well known that when Ben-
jamin West, a young man, left home for Italy, he had formed
an attachment to a young lady of Philadelphia, of the name
of Shewell. On his arrival in England from Italy, his pros-
pects as an artist soon assumed so promising an aspect, that
he determined to remain there, and wrote to his affianced
bride, asking her to undertake the voyage to England, under
the care of his venerable father. The lady and her intended
father-in-law complied with the request, and in London, for
the first time, the old gentleman met his eldest son, who was
a watch-maker, settled in Reading, and at that time forty
years of age. This son was born after old Mr. West went to
America, and the mother dying, the child was retained by her
relatives. West married and remained in America until he
came to bring a bride to his son Benjamin, one of the many
children given him by his American wife."

Both the parents of Raphael West were Americans. Edu-
cated in the midst of artists and pictures, he was, when I
became acquainted with him in 1784, one of the best designers,
of the academy figure from life, that England possessed. He
did not apply himself with the necessary industry to painting
which ensures success, but seems to have been discouraged by
the overshadowing merit and fame of his father. " If I should
attain the skill and excellence of my father," thought (perhaps
said) the youth, " I shall not find another George the Third to
be my employer and friend." Raefe helped me to do noth-
ing; and I very frequently was a hindrance to his little appli-
cation, by visiting the little room, in Newman-street, at the
head of the gallery. After I left England he painted one of
the pictures for Alderman Boydell's Shakspeare Gallery. This
picture, " Orlando and Oliver," from " As you like it," was
purchased and brought to this country by Robert Fulton, and
is now in the possession of James Rosevelt, counsellor at law
of New-York.

In 1800 Raphael, as has been said, visited America, to im-
prove wild lands, and although he did not exert his talents as
a painter for the public, or exhibit any pictures during his

stay, his taste had influence on the arts of the country, (for the leaven cannot be mingled with the lump and produce no effect) and the drawings he brought with him, and those executed during his residence at Big-tree, and communicated or presented to his friends, must be considered as swelling the tide of western art by a copious though transient shower.

Disappointed, discouraged, and home-sick, Raphael gladly broke from the Big-tree prison, to return to the paternal home in Newman-street. On his way he visited me in New-York. His anger was kindled against Wadsworth, who, like a true American, saw in the wilderness the paradise which was to grow up and bloom there, but which was invisible to the London painter, and if possible, still more so to his London wife. " Would you believe it, Dunlap, as I sat drawing by a lower window, up marched a bear, as if to take a lesson !"

The last time I saw my friend Raphael, was in the winter of 1802. His wife and himself were on a cold day surrounded by snow in a sleigh, and going to embark when I bade them adieu. Even the prospect of England in the distance, could not cheer his English wife; and I felt at the moment that for a husband to bring a wife from London to America, a lady used to London life, was as certain a source of misery to both husband and wife as ingenuity could contrive.

Thirty-two years have passed since my friends departed from these shores; and I am certain from what I know of Raphael West, that whether fortune has smiled or frowned, his good principles and excellent temper have insured him many a day of happiness.

I will here quote a passage from a letter of Mr. Leslie's in answer to my inquiries. " You know our friend Raphael possessed more talent than industry. His best picture, Orlando rescuing his brother from the lioness, is, or was, in America. There is an old tree in it, drawn in a very masterly style. I have seen other drawings and etchings by him of some of the old oaks in Windsor park, in a very grand manner. He also drew the human figure with a masterly and anatomical precision equal to his father, and I believe he often assisted him in his large works. He drew the whole of the outline of the " Death on the Pale Horse," upon the large canvas, having no other guide than a small sketch by his father, and he executed this in a style that left the old gentleman nothing to correct. I have seen a *satan* painted by him. Bold and picturesque, but more grotesque than grand. It was like every thing else he did, too much in the taste of Salvator Rosa. Peter Pindar, I am told, said of it, that " It was a *damned*

thing, but not the devil." Doctor Wolcott was not content with endeavouring in vain to decry the father, but visited the son with his malice in hopes of better success. Leslie continues, " I do not remember the line among Peter's works, but it reminds me of a criticism of Fuseli on the picture of the Resurrection, by Mr. West. The Saviour (rather a heavy figure) was issuing from the tomb. There were angels above, one of them in an attitude of surprise.—In the exhibition, Sir William Beechy (who told me the story,) asked Fuseli if he thought such an expression was proper to an angel on such an occasion.—" Yes," said Fuseli, " the angel is very much in the right—he has expected to see the Messiah come forth, instead of whom he sees that great lubberly fellow, and is very much surprised." Thus painters talk of each other—*some painters*. I have had occasion to show Fuseli's bitter envy towards West. Leslie proceeds:

" Allston will remember that he and I were one day waiting in Mr. West's large painting-room to see him, when the door opened, and a young girl of about fifteen came bounding in, but stopped suddenly on seeing strangers, blushed and ran out. We both thought we had never beheld any thing so lovely. Mr. West entered soon after, and we asked him who the beautiful creature we had just seen was. He told us, she was his granddaughter, and added, ' *She is a little Psyche.*' She is the only child of Raphael West. With features of Grecian regularity, blue eyes and light brown hair, her complexion ' Nature's pure red and white,' and a form, perfect as her face, that first glimpse I had of her almost seemed like the momentary visit of an angel to the earth. This lady is now a wife and mother. She sat to me, since her marriage, for Anne Page, in a picture I painted of Falstaff and others at dinner, at Mr. Page's house. Her grandfather often painted her."

On the death of Benjamin West, his property was divided between his two sons—his only children, and the great picture of " Death on the Pale Horse," is the property of Raphael. The younger brother has the " Christ Rejected," and by coming with it to America realized a large sum of money from its exhibition. I believe a larger might be accumulated by the exhibition of the " Death on the Pale Horse" in this country. As it is, this property lies useless to its owner, whose principle revenue is derived, as I am informed, from his portion of the rent of the buildings in Newman-street.

169 BALTIMORE IN 1802. Painting by Francis Guy. Courtesy The Brooklyn Museum.

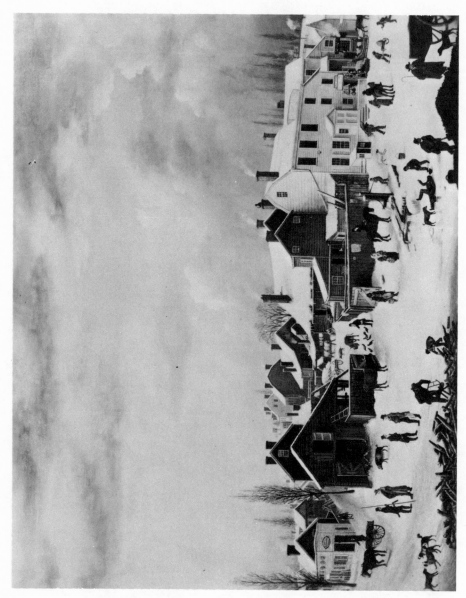

170 WINTER SCENE IN BROOKLYN, 1816–1817. Painting by Francis Guy. *Courtesy The Brooklyn Museum.*

JOHN ECKSTEIN—1801.

Johann Eckstein, *c.* 1736–1817.

" Eckstein," says my friend Sully, " was a thorough-going drudge in the arts. He could do you a picture in still life—history—landscape—portrait—he could model—cut a head in marble—or any thing you please.

" I once visited his *attelier* with Washington Irving—it was lucky that I cautioned him not to express any emotion at the odd things we might encounter, or he would perhaps have been taken by surprise. Amongst the many strange versions of classic history was one, " The Roman and Sabine combatants separated by the Sabine women." One of the females had her infant clinging to her shoulder—the terrified brat was represented screaming with affright, and the artist had anxiously added a very usual circumstance with children when they cry, and no handkerchief convenient—a large bubble was appended to its nose—a most graphic symptom of grief.

" I know nothing of his dates. I found him when I removed to Philadelphia," (1800) " an old man, and he has been dead many years."

In 1812, he exhibited a model of an equestrian statue of Washington in Roman costume, and many drawings on historical subjects.

FRANCIS GUY—1801.

Francis Guy, *c.* 1760–1820.

Was originally a tailor of Baltimore. He attracted some attention by his attempts at landscape painting, and finally made it his profession and found employers.

Robert Gilmor, Esq., of Baltimore in a letter to me, says, " He began by copying my pictures and drawings, which are his best works. I have several of them. His blue he made of common coal-cinder."

Coal-cinder makes a blue-black, but is not sufficient for the blue of the painter. His style was crude and harsh, with little to recommend his efforts, which now would not be tolerated. He exhibited several landscapes in the gallery of the Pennsylvania Academy as late as 1811.

TUTHILL—1801.

Abraham G. D. Tuthill, 1776–1843.

In the year 1812, as far as memory serves me, I saw for the first time this artist. He was then painting in Chatham-street, New-York, was a married man, and had several portraits in his room. He told me that he had been to London to study the art; but his works bore little indication of that school. He likewise claimed to be a pupil of Mr. West's. I lost sight

of him for many years, but met him again in Utica, much improved in manner, appearance and painting. He had been successful as an itinerant ; and by presenting smooth and well varnished pictures, with some resemblance to his sitters, he was accumulating property.

Charles Fraser, 1782–1860:

CHARLES FRASER—1801.

The love which this gentleman felt for the art, which he eventually pursues as a profession, was in early life controlled by those who had charge of his education and patrimony ; for he had the misfortune to lose his father before he was nine years of age.

He is a native of Charleston, South Carolina ; and from his earliest days, like most who have devoted themselves to painting, or any of the arts of design, was observed to use every substance which came in his way to make a mark, in endeavouring to imitate some of the forms presented to his sight. His wish was to become a painter, but those on whom the care of his education devolved, did not yield to his desire for instruction in that art. They perhaps did not feel authorized to sacrifice any portion of his patrimony, to qualify him for a pursuit whose results they might deem less certain, than those of (one of what are called the learned professions) the law; and had him educated accordingly.

Mr. Fraser has expressed his regret at their choice. In a letter to a friend, he says, " It was to this timid and home-bred feeling, (if so I may call it) that I owe the circumstance of not having been educated as an artist. This unfortunate error by which the destiny of my life was directed, or rather *misdirected* will ever be, as it has always been, a source of regret to me."

In 1793 he met, in a school-mate, a congenial mind, and having more skill than his companion, a boy recently from England, he became his instructor, and encouraged him in that, which, undoubtedly their schoolmaster considered a career of idleness. This English boy was Thomas Sully, who says, in a letter to me, Mr. Fraser was " the first person who took the pains to instruct me in the rudiments of the art." Mr. Fraser has done much for the progress of the arts of design, by his own pencil, and by his conduct as a man, and a gentleman; but if he had only been an agent in the good work of instructing and encouraging Thomas Sully, the world of art would have been incalculably indebted to him.

In the year 1798, Mr. Fraser, in accordance with the wishes of his guardians, entered a lawyer's office, but left it again in

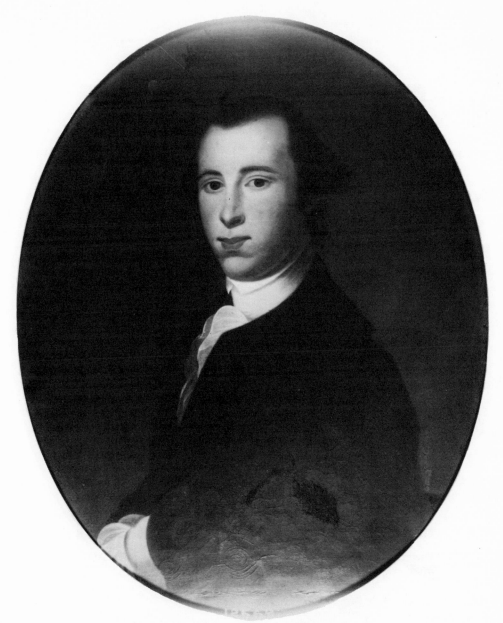

171 THOMAS HEYWARD, JR., *c.* 1851. Painting by Charles Fraser after a painting by
Jeremiah Theüs. *Courtesy Independence National Historical Park.*

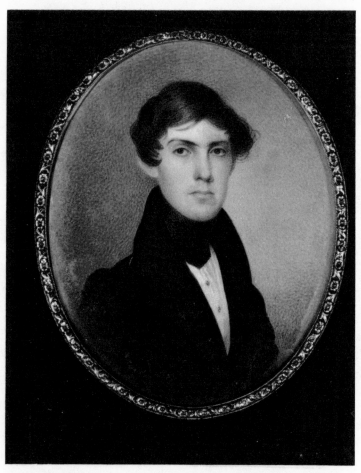

172 POWELL MACRAE. Miniature by Charles Fraser. *Courtesy The Metropolitan Museum of Art, gift of Mrs. Jacqueline L. Hammond.*

1801, for the much more attractive study of his favourite art ; but after three years he became discouraged, and resumed his legal studies in 1804. In 1807 he was admitted to the practice of the bar, and continued therein until 1818 ; doubtless during that time stealing an hour from the court of contention, to devote to the court of the muses.

Having by eleven years practice as a lawyer, by diligence, punctuality, and the most conciliating manners, joined to probity above all suspicion, made himself in a great measure independent of the contingencies attending any failure or disappointment, in the pursuit he most loved ; he commenced painting professionally in miniature, and has from that time found that his pencil has been in request so fully and constantly, in his native city of Charleston, that with the exception of two months passed in the exercise of his profession at Hartford, Connecticut, in the summer of 1831, his fellow citizens of South Carolina, and their visiters, have amply occupied his time. Those who have seen Mr. Fraser's miniature portraits will not be surprised that they have been in constant demand in one city.

Mr. Fraser is a gentleman of polished manners and fine feelings ; with a person to attract attention and command respect. The friend and associate of Sully, Malbone, and Allston, he is of that class of artists, happily become common in this country, who receive and confer honour on the arts of design.

STEWART—1802.

Mr. Stewart painted wretched portraits about and before this time in Hartford, Connecticut. This gentleman had been, (as I was informed at the time I saw him and his pictures) a clergyman. What turned him from the cure of men's souls, to the caricaturing of their bodies, I never learned. He was the first instructor in painting of S. L. Waldo, Esq.

Joseph Steward, 1753–1822.

HUTCHINS—1802.

Mr. Hutchins has occasionally painted portraits in New-York, but has attended to other pursuits which, perhaps, has prevented that progress he might otherwise have made. He has had a friendly instructor of late, in one of our first artists, A. B. Durand, Esq.

Stephen B. Hutchings (or Hutchins), *fl. c.* 1811–*c.* 1846.

CHAPTER X.

"Number one"—Born in Charleston, S. C.—Early education at Newport—Amusements of childhood and boyhood—Mr. S. King—Removed to Harvard College—Malbone—Allston's early pictures at college—Studies Pine and Smybert—Returns to Charleston—Charles Fraser—A little philosophy and poetry—Mr. Bowman—Allston and Malbone visit London—West—Reynolds—Wilson—Fuseli and the Milton Gallery—Beechy—Allston at the Louvre—Colourists—Theory of painting—Pictures painted by Allston in Paris, 1804.

Washington Allston, 1779–1843.

WASHINGTON ALLSTON—1802.

THIS name stands, to use Sully's expression, "number one" in the catalogue of American painters, or at least can only be placed second to that of his great master West, to whom, if inferior in facility of composition, he is superior in colour, and equal in drawing. Not only does Washington Allston stand proudly pre-eminent in the eyes of his countrymen as an artist, but they see in him the virtues of the man, and the accomplishments of the scholar and the gentleman. If he surpasses, in any of the attributes of a painter, the great man with whom we have associated his name, and compared his attainments, none more readily than himself will allow that the glorious distinction was achieved by help of circumstances even happier than those which attended upon the ambition of West; and that the aid of his precursor was not among the least. The mantle of Elijah has fallen upon the shoulders of Elisha.

Washington Allston was born in the year 1779, in the state of South Carolina. The climate not agreeing with his constitution, he was sent, by the advice of physicians, at a very early age, (between six and seven,) to Newport, Rhode Island, and was there continued at school until 1796, when he was transferred to Harvard College, Cambridge, Massachusetts.

Mr. Allston, on being questioned respecting his early efforts at designing, answered his correspondent thus : "To go back as far as I can—I remember that I used to draw before I left Carolina, at six years of age, (by the way no *uncommon* thing,) and still earlier, that my favourite amusement, much akin to it, was making little landscapes about the roots of an old tree in the country—meagre enough, no doubt; the only particulars of which I can call to mind, were a cottage built of sticks, shaded by little trees, which were composed of the small suckers, (I think so called,) resembling miniature trees, which I gathered in the woods. Another employment was the converting the forked stalks of the wild ferns into little men and women, by winding about them different coloured yarn.

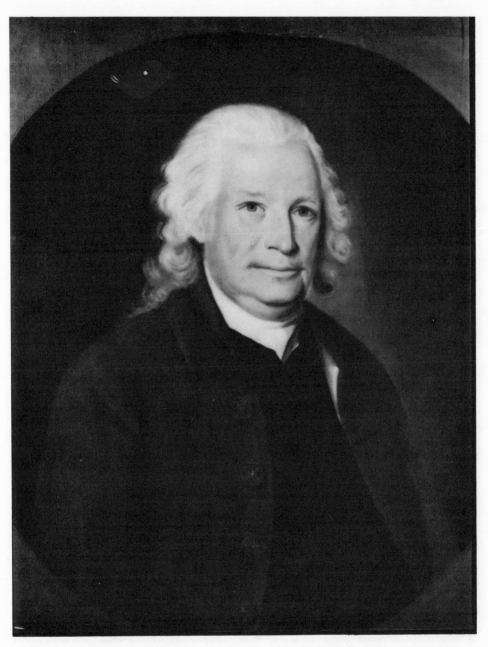

173 JOHN PHILLIPS. Painting by Joseph Steward. *Courtesy Connecticut Historical Society and Phillips Exeter Academy.*

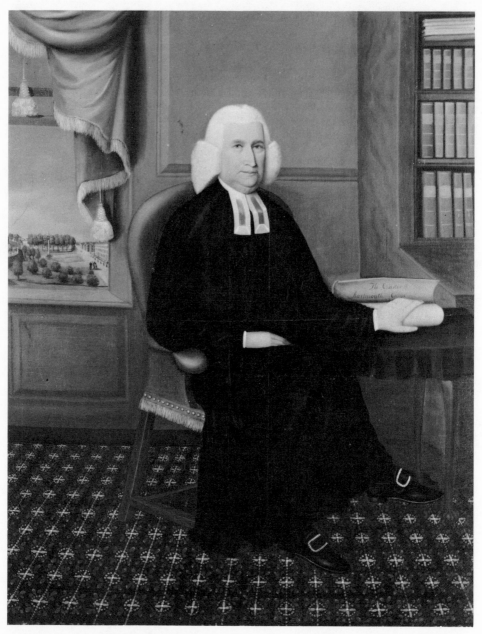

174 Eleazer Wheelock. Painting by Joseph Steward. *Courtesy Dartmouth College.*

These were sometimes presented with pitchers made of the pomegranate flower. These childish fancies were the straws by which, perhaps, an observer might then have guessed which way the current was setting for after life. And yet, after all, this love of imitation may be common to childhood. General imitation certainly is : but whether adherence to particular kinds may not indicate a permanent propensity, I leave to those who have studied the subject more than I have, to decide."

Without assuming to be deeper studied in the subject, the reader will remark, that in these delights of Allston's childhood appear the germs of landscape gardening, landscape painting, sculpture, and scenic composition. Less intellectual children are content to make mud pies, and form ovens with clay and clam-shells as if to bake them in. Even when at play they are haunted by the ghosts of cakes, pies, and puddings.

Allston continued : " But even these delights would sometimes give way to a stronger love for the wild and the marvellous. I delighted in being terrified by the tales of witches and hags, which the negroes used to tell me ; and I well remember with how much pleasure I recalled these feelings on my return to Carolina ; especially on revisiting a gigantic wild grapevine in the woods, which had been the favourite swing for one of these witches." Here may be perceived the germ of that poetic talent which afterward opened and was displayed both by the pen and the pencil of Mr. Allston.

The European—or even the inhabitant of the eastern or middle states who has been born since the effects of our revolution banished slavery from those portions of our country—cannot conceive of that species of education which is the lot of those who are surrounded in their childhood by swarms of slaves of all ages ; some born in the country, some recently brought from Africa, scored with the marks perhaps of their high barbaric origin, but all ignorant of the duties, or even the decencies of life. All who have been born where negro slavery existed, can realize the picture drawn by Allston of his childhood, of the tales of terror instilled into his eager ear by those who wished to please the young lord of the land, and whose servility would make a deep impression upon young master; cherishing self-love and self-importance if continued beyond a very early age. Mr. Allston was peculiarly happy in being removed from the place of his birth, before lessons more pernicious than could flow from witch stories were taught by the negroes of the household or the plantation.

The writer can vividly recall the words and actions of his father's negroes, whose companion he was doomed to be until their words and actions made impressions never to be erased.

Allston, in another letter to the same correspondent says, " I concluded my last with the amusement of my childhood : my next step will be to my boyhood. My chief pleasure now was in drawing from prints—of all kinds of figures, landscape and animals. But I soon began to make pictures of my own ; at what age, however, I cannot say. The earliest compositions that I remember were the storming of Count Roderick's castle, from a poor (though to me delightful) romance of that day, and the siege of Toulon ; the first in Indian ink, the other in water colours. I cannot recall the year in which they were done. To these succeeded many others, which have likewise passed into oblivion. Though I never had any regular instructer in the art, (a circumstance I would here observe both idle and absurd to boast of,) I had much incidental instruction ; which I have always through life been glad to receive from every one in advance of myself. And, I may add, there is no such thing as a self-taught artist in the ignorant acceptation of the word ; for the greatest genius that ever lived must be indebted to others, if not by direct teaching, yet indirectly through their works. I had, in my school days, some of this latter kind of instruction from a very worthy and amiable man, a Mr. King of Newport, who made quadrants and compasses, and occasionally painted portraits. I believe he was originally bred a painter, but obliged, from the rare calls upon his pencil, to call in the aid of another craft. I used at first to make frequent excuses for visiting his shop to look at his pictures, but finding that he always received me kindly, I went at last without any, or rather with the avowed purpose of making him a visit. Sometimes I would take with me a drawing, and was sure to get a kind word of encouragement. It was a pleasant thing to me, some twenty years after this, to remind the old man of these little kindnesses."

We may imagine that two such youths as Allston and Malbone—one a native of the beautiful island which gives name to a state, the other preserved from disease by its salubrious atmosphere, both full of love for the beauties of nature and art, would, while thus thrown together, have an interchange of thoughts on themes so dear to both ; but these beings, so similar in their taste, did not become intimate at this time. On this subject Mr. Allston, in a letter to a friend, has said, " I became acquainted with Malbone but a short time before he quitted Newport, a circumstance which I remember then

regretting exceedingly, for I looked up to him with great admiration. Our not meeting earlier was owing, I suppose, to his going to another school, and being some years older than myself. I recollect borrowing some of his pictures on oiled paper to copy. Our intimacy, however, did not begin till I entered college, when I found him established at Boston. He had then (for the interval was of several years) reached the maturity of his powers, and was deservedly ranked the first miniature painter in the country. Malbone's merits as an artist are too well known to need setting forth by me: I shall therefore say but a few words on that head. He had the happy talent, among his many excellencies, of elevating the character without impairing the likeness: this was remarkable in his male heads; and no woman ever lost any beauty from his hand; nay, the fair would often become still fairer under his pencil. To this he added a grace of execution all his own. My admiration of Malbone induced me at this time (in my freshman year at College) to try my hand at miniature, but it was without success. I could *make no hand of it;* all my attempts in that line being so far inferior to what I could *then* do in oil, that I became disgusted with my abortive efforts, and gave it up. One of these miniatures, or rather attempts at miniature, was shown me several years after, and I pronounced it "*without promise,*" (this anecdote has found its way into Blackwood's Magazine) not knowing it to be my work. I may add, I would have said the same had I known it. I may observe, however, (for I know not why I should not be as just to myself as to another person,) that I should not have expressed a similar opinion respecting its contemporaries in oil; for a landscape with figures on horseback, painted about this time, was afterwards exhibited at Somerset house.*

"My leisure hours at college were chiefly devoted to the pencil, to the composition equally of figures and landscapes; I do not remember that I preferred one to the other; my only guide in the choice was the inclination of the moment. There was an old landscape at the house of a friend in Cambridge (whether Italian or Spanish I know not) that gave me my first hints in colour in that branch; it was of a rich and deep tone, though not by the hands of a master; the work, perhaps, of a moderate artist, but of one who lived in a *good age,* when he could not help catching something of the good that was abroad.

* Doctor Waterhouse claims to have the first oil picture painted by Mr. Allston. In a letter dated Nov. 16, 1833, the doctor says of Allston, "for whom I have always had the strong partiality of a friendship partaking of paternal; for he was under my special care during his college life, and I have in my possession his first essay in oil, being the portrait of my eldest son when a child."

In the colouring of figures, the pictures of Pine in the Columbian museum, in Boston, were my first masters. Pine had certainly, as far as I can recollect, considerable merit in colour. But I had a higher master in the head of Cardinal Bentivoglio, from Vandyke, in the college library, which I obtained permission to copy one winter vacation. This copy from Vandyke, was by Smybert, an English painter, who came to this country with Dean, afterwards Bishop, Berkeley. At that time it seemed to me perfection ; but when I saw the original some years afterwards, I found I had to alter my notions of perfection. However, I am grateful to Smybert for the instruction he gave me—his work rather. Deliver me from kicking down even the weakest step of an early ladder."

Having gone through the four years course of collegiate studies, Allston was graduated A. B. in 1800, and returned to his native state, South Carolina. In a letter to a friend he says, " On quitting college I returned to Charleston, where I had the pleasure to meet Malbone, and another friend and artist, Charles Fraser, who, by the by, now paints an admirable miniature. My picture manufactory still went on in Charleston until I embarked for London. Up to this time my favorite subjects, with an occasional comic intermission, were banditti. —I well remember one of these, where I thought I had happily succeeded in cutting a throat! The subject of this precious performance was, robbers fighting with each other for the spoils, over the body of a murdered traveller. And clever ruffians I thought them. I did not get rid of this banditti mania until I had been over a year in England. It seems that a fondness for subjects of violence is common with young artists. One might suppose that the youthful mind would delight in scenes of an opposite character. Perhaps the reason of the contrary may be found in this: that the natural condition of youth being one incessant excitement, from the continuous influx of novelty—for all about us must *at one time be new*—it must needs have something fierce, terrible, or unusual to force it above its wonted tone. But the time must come to every man who lives beyond the middle age, when ' there is nothing new under the sun.' His novelties then are the *rifacimenti* of his former life. The gentler emotions are then as early friends who revisit him in dreams, and who, recalling the past, give a grace and beauty, nay, a rapture even, to what in the hey-day of youth had seemed to him spiritless and flat. And how beautiful is this law of nature—perfuming, as it were, our very graves with the unheeded flowers of childhood.

" One of my favourite haunts when a child in Carolina, was a forest spring where I used to catch minnows, and I dare say, with all the callousness of a fisherman ; at this moment I can see that spring, and the pleasant conjuror Memory has brought again those little creatures before me ; but how un-like to what they were ! They seem to me like the spirits of the woods, which a flash from their little diamond eyes lights up afresh in all their gorgeous garniture of leaves and flowers. But where am I going ?"

The answer will be " Not out of your path. The painter and the poet are alike, ' of imagination all compact !' You are both."

At the period of his return to South Carolina from col-lege in 1800, Mr. Allston painted a head of St. Peter when he hears the cock crow, and one of Judas Iscariot. In May, 1801, at the age of twenty-two, he embarked with his friend Malbone for England. Malbone had passed the previous win-ter at Charleston ; and whatever intimacy subsisted between these young painters at Newport and at Boston, a congenial-ity of taste must have increased when Allston met his matured friend in the place of his nativity. We have heard that All-ston sacrificed his paternal inheritance to his love of the arts to which he had devoted *himself*. The product of the sale of his hereditary property was appropriated to the support of the student in Europe, and the furtherance of his enlightened am-bition. He had generous offers from friends in Charleston, who, it would appear, wished to prevent any sacrifice of this kind, but the painter preferred independence and a reliance on his own resources.

In one of his letters to his friend, on the subject of his early life and prospects, he says, " There was an early friend, long since dead, whom I have omitted to mention, and I cannot but wonder at the omission, since he is one whose memory is still most dear to me. The name of this gentleman was Bowman ; he was a native of Scotland, but had been long settled in Ca-rolina. I believe I was indebted for the uncommon interest he was pleased to take in me to some of my college verses, and to a head of St. Peter (when he hears the cock crow) which I had painted about that time. Be this as it may, his partial-ity was not of an every-day kind ; for when I was about to embark for Europe, he proposed to allow me—nay, almost in-sisted on my accepting—a hundred pounds a year during my stay abroad. This generous offer, however, I declined, for having at that time a small income sufficient for my immediate wants, it would have been sordid to have accepted it. He

then proposed to ship for me a few tierces of rice! That too I declined. Yet he would not let me go without a present; so I was obliged to limit it to Hume's History of England, and a novel by Dr. Moore, whom he personally knew, and to whom he gave me a letter of introduction; the letter however was never delivered, as the Doctor died within a few days of my arrival in London. Such an instance of generosity speaks for itself. But the kindness of manner that accompanied it can only be known to me who saw it. I can see the very expression now. Mr. Bowman was an excellent scholar, and one of the most agreeable talkers I have known. Malbone, Frazer, and myself were frequent guests at his table, and delightful parties we always found there. With youth, health, the kindest friends, and ever before me buoyant hope, what a time to look back on! I cannot but think that the life of an artist, whether painter or poet, depends much on a happy youth; I do not mean as to outward circumstances, but as to his inward being: in my own case, at least, I feel the dependence; for I seldom step into the ideal world but I find myself going back to the age of first impressions. The germs of our best thoughts are certainly often to be found there; sometimes, indeed, (though rarely) we find them in full flower; and when so, how beautiful seem to us these flowers through an atmosphere of thirty years! 'Tis in this way that poets and painters keep their minds young. How else could an old man make the page or the canvas palpitate with the hopes, and fears, and joys, the impetuous, impassioned, emotions of youthful lovers, or reckless heroes? There is a period of life when the ocean of time seems to force upon the mind a barrier against itself, forming, as it were, a permanent beach, on which the advancing years successively break, only to be carried back by a returning current to that furthest deep whence they first flowed. Upon this beach the *poetry of life* may be said to have its birth; where the *real* ends and the *ideal* begins."

Within a few weeks after Allston's arrival in London, he became a student of the Royal Academy. The first drawing he made from plaster, the Gladiator, obtained him permission to draw at Somerset House; the third procured him the ticket of an entered student. He was immediately introduced to Mr. West; and in one of the valuable letters from which extracts have been made, he thus speaks of him :—" Mr. West, to whom I was soon introduced, received me with the greatest kindness. I shall never forget his benevolent smile when he took me by the hand: it is still fresh in my memory, linked with the last of like kind which accompanied the last shake of

his hand, when I took a final leave of him in 1818. His gallery was open to me at all times, and his advice always ready and kindly given. He was a man overflowing with the milk of human kindness. If he had enemies, I doubt if he owed them to any other cause than his rare virtue ; which, alas for human nature! is too often deemed cause sufficient."

Those feelings, which induced Mr. Altston to exclaim, " Alas for human nature !" are feelings similar to West's, and the *true* feelings *of nature;* that enmity which is generated by the contemplation of virtue, is foreign to man's nature. It is the child of his ignorance—the offspring of evil education, of jealousy, envy, malice, and all uncharitableness. The proof that it is foreign to man's nature is, that it makes him unhappy. Our benevolent Creator has implanted nothing in our nature but *that* which, with due culture, would produce fruit conducive to well-being.

Of other artists established in London, when Allston visited that city, he thus speaks :—" Of Sir Joshua Reynolds, whose lectures I imported and read before I went to Europe, I have always had a very high opinion. There is a fascination about his pictures which makes it almost ungrateful to think of their defects. They never produced in me any thing like *hesitation*, from the first moment I saw them. His taste was exquisite.— Had he been a learned designer, his Infant Hercules, and his Puck, or Robin Goodfellow, show what he might have done in history. I scarcely know, in the whole compass of art, two purer examples of poetic invention.

" It is very remarkable, that the three men whose works may be said to have laid the foundation for a new era in art, or, at least, to have revived a good one, should, though contemporaries, have had little or no intercourse with each other ; I mean, Sir Joshua, Wilson, and Gainsborough : they were scarcely acquainted, and never companions ; yet they seem to have emerged, as by consent, with the same power and purpose, from an age of lead.

" The following characteristic anecdote of Wilson was told me by Mr. West. Before the Royal Academy was formed, the Society of Painters, (as I think they were then called) held their annual exhibition in Spring Gardens. On a certain year Mr. West and Mr. Wilson happened to be appointed joint *hangers*. It was a memorable year for the crudeness of the performances ; in consequence, I suppose, of the unusual number of new adventurers. When the pictures were all up, Wilson, with an expressive grin, began to rub his eyes, as if to clear them of something painful. " I'll tell you what,

West," said he, after a while, " this will never do, we shall
lose the little credit we have ; the public can never stand such
a shower of chalk and brick-bats." " Well, what's to be
done? We can't reject any pictures now." " Since that's
the case, then, we must mend their manners." " What do
you mean ?" " You shall see," said Wilson, after a pause—
" what Indian ink and Spanish liquorice can do." He ac-
cordingly despatched the porter to the colour-man and drug-
gist for these *reformers;* and, dissolving them in water, actu-
ally washed nearly half the pictures in the exhibition with this
original glaze. " There," said he, " 'tis as good as asphal-
tum ; with this advantage, that if the artists don't like it they
can wash it off when they get the pictures home." And Mr.
West acknowledged that " they were all the better for it."

In one of his letters he has said, " I arrived in London
about the middle of June, 1801, near the close of the annual
exhibition. The next year, 1802, was the first of my adven-
turing before the public, when I exhibited three pictures at
Somerset House. The principal one, a French Soldier tell-
ing a story, (a comic attempt)—a Rocky Coast, (half-length)
with Banditti ; and a Landscape, with Horsemen, which I
had painted at College, as before alluded to. I received two
applications for the French Soldier; which I sold to Mr.
Wilson, of the European Museum ; for whom I afterwards
painted a companion to it, also comic—The Poet's Ordinary,
where the lean fare was enriched by an incidental arrest.

Malbone returned to America after a short stay—I believe
five months—on account of his engagements in Charleston.—
I little thought, when we parted, that it was for the last time :
he died before my return.

Amongst the artists we called upon was Fuseli, to whom we
introduced ourselves as Americans. He received us with
great courtesy, and invited us into his painting room. Upon
my regretting that we had arrived too late to see his Milton
Gallery, (it had closed but a few months before) he inquired
if I was an artist? I answered, " Not yet; but that I had
come to London with the hope of becoming one." He then
asked, " In what branch of the art?" I replied, " History."
" Then," said he, " you have come *a great way* to starve,
sir. There," he added, " is the Milton Gallery," pointing to
some rolls of canvas, that reached from the floor nearly to the
ceiling. There were three or four, however, belonging to the
series still on their stretching frames, which he showed us, and
he seemed gratified that we were pleased. But he would not
suffer us to like every thing ; for when I stopped before one,

and expressed the pleasure I felt, (and it was sincere) he said abruptly, " No, sir, you don't like that—you can't like it— 'tis bad." As he found, from my quoting Milton, that I was not unacquainted, at least with the subjects of his gallery, he good-naturedly presented me with one of his catalogues. I do not remember the strain in which I talked to Fuseli, but if at all in accordance with the enthusiasm that I felt, I think he could not have been displeased with our visit. I then thought Fuseli the greatest painter living. I am still his admirer, but in a more qualified degree."

Fuseli found a purchaser for a part of the Milton Gallery in Mr. Angerstein. On another occasion, and in another letter, Mr. Allston gives the following opinion of Fuseli. " It was, a few years ago, with many criticizing people (not critics, except those can be called so *who make their own ignorance the measure of excellence*) to laugh at Fuseli. But Fuseli, **even** when most extravagant, was not a man to be laughed at ; for his very extravagancies (even when we felt them as such) had *that* in them which carried us along with them. All he asked of the spectator was but a *particle* of *imagination*, and his wildest freaks would then defy the reason. Only a true genius can do this. But he was far from being always extravagant : he was often sublime, and has left no equal in the *visionary;* his spectres and witches were born and died with him. As a critic on the art, I know no one so *inspiring.* Having, as you know, no gallery of the old masters to visit here, I often refresh my memory of them with some of his articles in Pilkington's Dictionary ; and he brings them before me in a way that no other man's *words* could : he even gives me a distinct apprehension of the style and colour of some whose works I have never seen. I often read one or two of his articles before I go into my painting room ; they form indeed almost a regular course at breakfast.

" Before I leave Fuseli I must tell you a whimsical anecdote, which I had from Stuart. He was one day at Raphael Smith's, the engraver, when Fuseli, to whom Stuart was then unknown, came in ; who having some private business, was taken into another room. ' I know that you are a great physiognomist, Mr. Fuseli,' said Smith. ' Well, what if I am ?' ' Pray did you observe the gentleman I was talking with just now ?' ' I saw the man. What then ?' ' Why I wish to know if you think he can paint.' ' Umph !—I don't know but he might—*he has a coot leg.*' Poor Stuart ! that same leg— which I well remember to have been a finely formed one, became the subject of a characteristic joke with him but a few

weeks before he died. I asked ' how he was ?' He was then very much emaciated. 'Ah!' said he, 'you can judge;' and he drew up his pantaloons. 'You see how much I am out of drawing.'

"Now I have got into anecdote, I will relate another, though not at all relevant to this communication, of Sir Wm. Beechy. A young artist one day brought a picture, for the benefit of Sir William's criticism. 'Very well, C.' said Beechy ;— ' very well indeed. You have improved, C. But C. why did you make the coat and the back-ground of the same colour ?' 'For harmony, sir.' 'Oh, no! C. that's not harmony, that's monotony.' I have often thought this anecdote would have *told* for the latter in Lord Byron's perverse controversy with Mr. Bowles.

"I will add another, as little to my purpose, of Fuseli, after he became keeper to the Royal Academy. 'Well, Sam,' said Fuseli to Strouzer, the academy porter, " what do you think of this picture?' 'Law! Mr. Fuseli, I don't know any thing of pictures.' 'But you know a horse, Sam; you have been in the Guards, you can tell if that is like a horse?' 'Yes, sir.' 'Well ?' 'Why it seems to me, then, Mr. Fuseli, that—that five men could ride on him.' 'Then you think his back too long.' 'A bit, sir.' "

After three years residence in England, Mr. Allston passed over to France in company with Mr. John Vanderlyn, of New-York, who was then pursuing the same coy mistress, and encouraged by her smiles. In the year 1804 Mr. Allston first saw the glories of the Louvre. The Louvre gallery was at that time in its full splendour. The great robber of Europe, who loved the fine arts as he loved the liberty and happiness of mankind, had collected in Paris the treasures of art which were scattered over the continent, as one mean by which to dazzle France, and gratify his inordinate selfishness. The artist profited by the success of the spoiler's labour, and had an opportunity of studying without the expense of money, time, and labour in travelling, the *chef d'ouvres* of every school and of every master, from the north of Germany to the south of Italy.

Mr. Allston, in the letter before mentioned, thus expresses his feelings on visiting this splendid accumulation of plunder : " Titian, Tintoret, and Paul Veronese, absolutely enchanted me, for they took away all sense of subject. When I stood before the Peter Martyr, the Miracle of the Slave, and the marriage of Cana, I thought of nothing but of the *gorgeous concert of colours*, or rather of the indefinite forms (I cannot

call them sensations) of pleasure with which they filled the
imagination. It was the poetry of colour which I felt; pro-
creative in its nature, giving birth to a thousand things which
the eye cannot see, and distinct from their cause. I did not,
however stop to analyze my feelings—perhaps at that time I
could not have done it. I was content with my pleasure with-
out seeking the cause. But I now understand it, and *think* I
understand *why* so many great colourists, especially Tintoret
and Paul Veronese gave so little heed to the ostensible
stories of their compositions. In some of them, the Marriage
of Cana for instance, there is not the slightest clue given by
which the spectator can guess at the subject. They addressed
themselves not to the senses merely, as some have supposed,
but rather through them to that region (if I may so speak) of
the imagination which is supposed to be under the exclusive
dominion of music, and which, by similar excitement, they
caused to teem with visions that 'lap the soul in Elysium.'
In other words, they leave the subject to be made by the spec-
tator, provided he possesses the imaginative faculty—otherwise
they will have little more meaning to him than a calico coun-
terpane."

The reader will perceive that Mr. Allston is far from being
devoid of the imaginative faculty which he here speaks of, and
that he saw objects with a poet's as well as a painter's eye—
indeed they are the same. His own pictures are replete with
this magic of colour, at the same time that he is strictly atten-
tive to the story in all its parts, character, actions, and cos-
tume. It certainly is not fair to leave the spectator to make
out the story of a picture, and to be puzzled by finding Pope
Gregory alongside of Saint Peter, and both dressed in costume
as far from truth as they were from similarity of opinion. All
the charm of colour may be attained without sacrificing truth.

In pursuing the subject, Allston says, "I am by nature, as
it respects the arts, a *wide liker*. I cannot honestly turn up
my nose even at a piece of still life, since, if well done, it gives
me pleasure. This remark will account for otherwise strange
transitions. I will mention here a picture of a totally different
kind, which then took great hold of me, by Lodovico Car-
racci. I do not remember the title, but the subject was the
body of the virgin borne for interment by four apostles. The
figures are colossal; the tone dark, and of tremendous depth
of colour. "It seemed as I looked at it as if the ground shook
under their tread, and the air were darkened by their grief."

How delighted would the spirit of Carracci have been, if,
hovering near this work, he had heard a kindred spirit utter-

ing such words, or evincing such feelings. This picture, with
many others, the spoil of nations, has been restored to its
home. " Even-handed justice" " here, even here upon this
bank and shoal of time," brought the poisoned chalice to the
inventor's lips, and made him drink the potion to the very
dregs. So be it with all who usurp the rights of their
fellow men ! The work of Lodovico Carracci, which had so
powerful an effect upon his brother painter, has been carried
back to Italy : in what place it is deposited I do not know ; but
if any American traveller, after reading the above passage,
should stand before the picture, how will his pleasure be en-
hanced by recollecting these words of Allston. The painter-
poet goes on thus : " I may here notice a false notion which
is current among artists, in the interpretation they put on the
axiom that ' something should always be left to the imagina-
tion,' viz : that some parts of a picture should be left *unfinish-
ed*. The very statement betrays its unsoundness : for that
which is unfinished must necessarily be *imperfect ;* so that ac-
cording to this rule *imperfection* is made essential to *perfection*.
The error lies in the phrase, 'left to the imagination,' and it
has filled modern art with random flourishes of no meaning.
If the axiom be intended to prevent the impertinent obtrusion
of subordinate objects, (the fault certainly of a mean practice)
I may observe that the remedy is no remedy, but rather a less
fault substituted for a greater. Works of a high order, as-
piring to the poetical, cannot make good their pretensions,
unless they *do affect* the imagination ; and *this* should be the
test—that they set to work, not to finish what is less incom-
plete, but to awaken images *congenial* to the compositions, but
not *in* them expressed ; an effect that never was yet realized
by misrepresenting any thing. If the objects introduced into
a picture *keep their several places* as well in the deepest shadow
as in light, the general effect will suffer nothing by their truth ;
but to give the *whole* truth in the midnight as well as the day-
light, belongs to a master."

It may be added that it will gain—as is indeed implied by
the words of Mr. Allston. Such remarks from such a painter,
and such a thinker, are invaluable to the student. May it not
be added that this eulogium on necessity for truth in painting,
is a proof of the value of that quality, in all the relations and
transactions of life. Falsehood causes deformity in the moral
picture ; and when mystery is called in to hide it, the scumbling
causes a blot, and creates suspicion of even greater faults than
those it was intended to veil.

CHAPTER XI.

Allston in Italy—Italian scenery—Turner—Rome—Vanderlyn—A great painter's opinion of great painters—Studies modelling—Coleridge—Returns to America in 1809—Impression left by him upon Italian artists—Returns to England a married man—Picture of the Dead man revived—Severe illness at Clifton—Returns to London—Severe calamity—Biography of the living—Allston's poems—Extracts—Morse and Leslie—James Mc Murtrie—Design for Christ healing in the temple relinquished—The Dead man revived, put up in the Pennsylvania Academy.

MR. ALLSTON remained but a few months in Paris, at the time of his visit in 1804 : long enough, however, to paint four original pictures, and make a copy from Rubens, in the Luxemburgh gallery. He then proceeded to Italy, passing leisurely through Switzerland, crossing the lake of the Four Cantons, and then over St. Gothard to Belanzona, on the Italian side of the Alps. The traveller in one of his letters, says, " the impressions left by the sublime scenery of Switzerland, are still fresh to this day. A new world had been opened to me—nor have I met with any thing like it since. The scenery of the Appenines is quite of a different character. By the by, I was particularly struck in this journey with the truth of Turner's Swiss scenes—the poetic truth—which none before or since have given ; with the exception of my friend Brokedon's magnificent work, on the passes of the Alps.* I passed at night and saw the sun rise on the Lake Maggiore. Such a sunrise ! The giant Alps seemed literally to rise from their purple beds, and putting on their crowns of gold, to send up a hallelujah almost audible."

He remained in Italy about four years ; the principal part of that time in Rome. Among his fellow students at a private academy, or association, were Mr. Vanderlyn of New-York ; since known so well as an artist, and the Danish sculptor

* The great success of Mr. Turner is mentioned in an English journal, of the year 1833, as being beyond that of any other. " It is said that he has realized upwards of a hundred thousand pounds, by his pencil." They speak of his industry as " astonishing," and his prices great.—" The stores of prints from his works in the finest possible state, which will some day or other deluge the print-market, will be beyond all precedent." They tell us an anecdote of a ragged, dirty looking lad, " bidding at a guinea a bid at an auction sale, for one of this artist's pictures, to the astonishment of all competitors ; and when it was knocked down to him, he proved an agent of Mr. Turner's, who, after retouching, sold it for three times the amount " Thus we see united great talents and a just appreciation of the good gifts of fortune.

Thorwalsden, whose fame has spread over the civilized world—the only modern who has yet seized the spirit of ancient sculptors, and associated himself with the sculptors of Greece.

Of the effects produced by the great masters of the by-gone days of Italy, on such a mind as Allston's, some idea may be formed from the following effusion of his pen. " It is needless to say how I was affected by Raffaele, the greatest master of the affections in our art. In beauty he has often been surpassed, but in grace—the native grace of character—in the expression of intellect, and above all, sanctity, he has no equal. What particularly struck me in his works was, the *genuine* life (if I may so call it) that seemed, without impairing the distinctive character, to pervade them all; for even his humblest figures have a *something* either in look, air, or gesture, akin to the *venustas* of his own nature, as if like living beings under the influence of a master-spirit, they had partaken, in spite of themselves, a portion of the charm which swayed them. This power of infusing one's *own life*, as it were, into that which is feigned, appears to me the sole prerogative of genius. In a work of art, this is what a man may well call *his own ;* for it cannot be borrowed or imitated. Of Michael Angelo, I know not how to speak in adequate terms of reverence. With all his faults (but who is without them) even Raffaele bows before him. As I stood beneath his colossal prophets and sybils, still more colossal in spirit—I felt as if in the presence of messengers from the other world, with the destiny of man in their breath, in repose even terrible. I cannot agree with Sir Joshua that the " Vision of Ezekiel," of Raffaele, or the Moses of Parmegiano, have any thing in common with Michael Angelo. Their admiration of Michael Angelo may have elevated their forms into a more dignified and majestic race; but still left them *men,* whose feet had never trod other than this earth. The supernatural was beyond the reach of both. But no one would mistake the prophets of Michael Angelo for inhabitants of our world; yet they are true to the imagination, as the beings about us are to the senses. I am not undervaluing these great artists, when I deny them a kindred genius with Michael Angelo ; they had both a genius of their own, and high qualities which nature had denied the other."

The studies of Allston when in Italy, were not confined to drawing and painting. He made modelling in clay, a separate branch of study, and devoted much time to it. He has said of this study, in after life, " I would recommend modelling to all young painters as one of the best means of acquiring an ac-

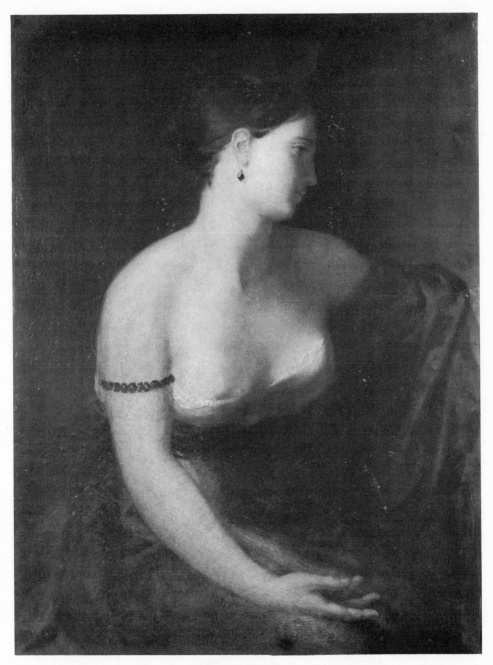

175 A STUDY FROM LIFE, c. 1802–1803. Painting by Washington Allston. *Courtesy The Metropolitan Museum of Art, gift of the Allston Trust.*

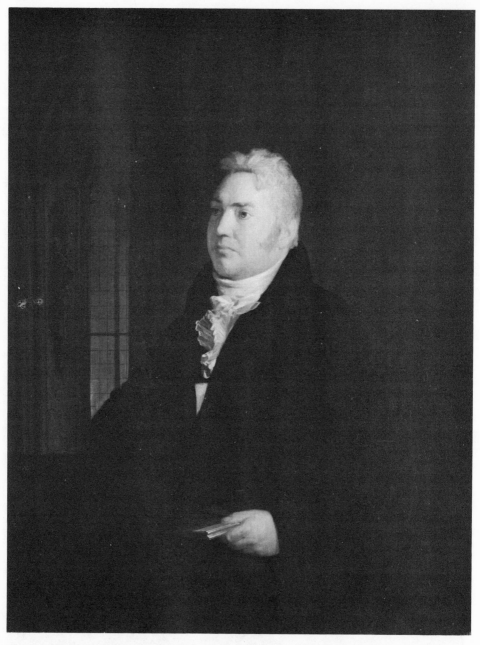

176 SAMUEL TAYLOR COLERIDGE, 1814. Painting by Washington Allston. *Courtesy National Portrait Gallery, London.*

curate knowledge of the joints : I have occasionally practised it ever since."

Another acquisition was made by the painter in Rome. He there became acquainted with Mr. Coleridge. It is only his own words that can do justice to his estimation of this gentleman. In one of his letters, after mentioning a friend, he proceeds, " I have had occasion in former letters more than once to mention the name of another most valued friend, of whom I would gladly say more, did I not feel that it is not for me to do justice to his extraordinary powers. I would observe, however, that to no other man whom I have known, do I owe so much *intellectually*, as to Mr. Coleridge, with whom I became acquainted in Rome, and who has honoured me with his friendship for more than five and twenty years. He used to call Rome the *silent* city ; but I never could think of it as such, while with him ; for, meet him when, or where I would, the fountain of his mind was never dry, but like the far-reaching aqueducts that once supplied this mistress of the world, its living stream seemed specially to flow for every classic ruin over which we wandered. And when I recall some of our walks under the pines of the Villa Borghese, I am almost tempted to dream that I had once listened to Plato, in the groves of the Academy. It was there he taught me this golden rule : *never to judge of any work of art by its defects ;* a rule as wise as benevolent ; and one that while it has spared me much pain, has widened my sphere of pleasure."

Mr. Allston returned to America in 1809. When Robert W. Weir, Esq. of New-York, was studying his profession in Rome, many years after Allston left it, the artists of Rome asked him after an American painter, for whom they had no other name than the American Titian. When Weir mentioned the name of Allston, they exclaimed " that's the man !" Sully and others say that Mr. Allston's colouring is more like Titian than that of any modern artist. He remained in his native country three years, in the early part of which time he married Miss Channing, the sister of the celebrated writer and divine, the reverend Dr. Channing, the ornament of American literature. In 1811 he returned to England, taking with him his wife, and as a pupil Samuel Finley Breeze Morse, confided to his care by his father, the reverend Dr. Jedediah Morse, celebrated for his works on geography.

The first labour in which Mr. Allston engaged on his return to England, was his great picture of the " Dead man revived by touching Elisha's bones." He says to his correspondent, " My first work after returning to London—with the exception of

two small pictures, (if they can be called exceptions, which were carried on at the same time with the larger one) was the " Dead man revived by Elisha's bones," which is now in Philadelphia. My progress in this picture was interrupted by a dangerous illness, which after some months of great suffering, compelled me to remove to Clifton, near Bristol. My re-covery, for which I was indebted under providence, to one of the best friends, and most skilfull of the faculty, was slow and painful, leaving me still an invalid when I returned to London—and indeed as my medical friend predicted, in some degree so to this day.* The "Dead man," was first exhibited at the British Institution, commonly called the British Gallery—an institution patronized by the principal nobility and gen-try—the Prince Regent then president : it there obtained the first prize of two hundred guineas. As I returned to London, chiefly to finish this picture, that done, I went back to Bristol where I painted and left a number of pictures ; among these were half-length portraits of my friend Mr. Coleridge, and my medical friend Mr. King, of Clifton. I have painted but few portraits, and these I think are my best. My second journey to London was followed by a calamity of which I can-not speak—the death of my wife—leaving me nothing but my art—which then seemed to me as nothing. But of my domes-tic concerns I shall avoid speaking, as I do not consider them proper subjects for *living* biography."

The propriety of a man's avoiding a detail of his own do-mestic concerns, as subjects for his biography while he is liv-ing, cannot be questioned ; but that which restrains him does not bear upon the ordinary biographer. When a man has made himself a conspicuous object before the world, either as a poet, a painter, a sculptor, an architect, an engraver or an actor, the world has a right to inquire into every thing respecting him. If an author we have a desire to know if his conduct squares with the lessons he teaches; if an artist, we wish to know how art has affected his character, and whether the con-templation of the sublime productions of human genius has

* The medical friend here mentioned, was Mr. King, of Clifton, a surgeon who was introduced to Mr. Allston by Mr. Southey. Mr. King is married to a sister of the celebrated Miss Edgeworth, whose novels and tales have mended more hearts, and guided more minds, than all the professed moral writers of England. With these friends, and Coleridge and Southey, aided by the delights which nature and art have bestowed upon Clifton, and around Bristol, when looking down from the terraces of Clifton upon the city below, in company with such congenial minds, though slow, the recovery of the American painter must have been made certain, by the physical and intellectual enjoyments that sur-rounded him.

raised and purified mind, or the contrary. The good artist who is not a good man, is a traitor to the arts, and an enemy to society; and it is the duty of his biographer to expose him in his true colours as a warning to others. If the biography of the living is useful, and that it is, (of every person who appears before the public voluntarily and attracts admiration,) few can doubt, then it follows that the biographer shall truly point out the causes of his celebrity ; and if he fails or falters in his high career, the cause of such deterioration. The artist's happiness, as well as that of other men, depends upon his domestic concerns. He is supported in the paths of virtue, and encouraged to strenuous exertions for the benefit of mankind by the beloved ones around him—or if disappointed in his hopes, he may sink in character, or fail in his efforts of art—or, if living for himself alone, become a cynic, a miser or a misanthrope. If a man is worth the world's attention, let the world know the truth of him, and as far as possible the true cause of his actions.

While happy in his domestic concerns and surrounded by literary friends, or when recovering from a dangerous and painful illness by the aid of such society, Mr. Allston composed, it may be presumed, those poems, which he gave to the world in the year 1813, for in that year was published in London a duodecimo volume of poetry from his pen.

A critic has observed on this work, "Poetry and painting are kindred arts. A refined sensibility to beauty and deformity, a voluptuous relish for the luxury of nature, and an exquisite perception of the shades of character and sentiment, are essential to the attainment of excellence in either. The same fervour of fancy is requisite to both.

"The resemblance between the professions, holds, too, in another point,—mere enthusiasm is incompetent to portray its own conceptions, however vivid,—a great painter and a great poet must alike be formed by study and instruction. The elementary course of their education is parallel. Expansion is given to the same powers of mind ;—the same models are held up to their admiration ;—similar passions are to be delineated by each, and both are intent to catch the living features. It is only in the application of principles to practice, that their paths diverge. Versification and colouring, plot and perspective, are the mechanical branches which constitute the difference of their arts." This is true, and these qualities, with study and instruction, were united in the subject of this memoir.*

* The reader of this unpoetical book shall be indulged with a description of autumn, from "The Sylphs of the Seasons."

Mr. Allston has only said of his return to London after his second sojourn with his friends at Clifton, " My second journey to London was followed, &c." This was not merely a " journey to London," but an attempt for the first time to establish himself in the independent character of a house-keeper.

And now, in accents deep and low,
Like voice of fondly-cherish'd wo,
　　The Sylph of Autumn said :
Though I may not of raptures sing,
That grac'd the gentle song of Spring,
Like Summer, playful pleasures bring,
　　Thy youthful heart to glad ;

Yet still may I in hope aspire
Thy heart to touch with chaster fire,
　　And purifying love :
For I with vision high and holy,
And spell of quick'ning melancholy,
Thy soul from sublunary folly
　　First rais'd to worlds above.

What though be mine the treasures fair
Of purple grape and yellow pear,
　　And fruits of various hue,
And harvests rich of golden grain,
That dance in waves along the plain
To merry song of reaping swain,
　　Beneath the welkin blue ;

With these I may not urge my suit,
Of Summer's patient toil the fruit,
　　For mortal purpose given :
Nor may it fit my sober mood
To sing of sweetly murmuring flood,
Or dies of many-colour'd wood,
　　That mock the bow of heaven.

But know, 'twas mine the secret power
That wak'd thee at the midnight hour,
　　In bleak November's reign :
'Twas I the spell around thee cast,
When thou didst hear the hollow blast
In murmurs tell of pleasures past,
　　That ne'er would come again :

And led thee, when the storm was o'er,
To hear the sullen ocean roar,
　　By dreadful calm opprest ;
Which still, though not a breeze was there,
Its mountain-billows heav'd in air,
As if a living thing it were,
　　That strove in vain for rest.

'Twas I ; when thou, subdu'd by wo,
Didst watch the leaves descending slow,
　　To each a moral gave ;
And as they mov'd in mournful train,
With rustling sound, along the plain,
Taught them to sing a seraph's strain
　　Of peace within the grave.

On this return to London he had, for the first time, taken a house and furnished it. He might, with the confidence which happily attends upon his fellow mortals, look forward to the comforts of a domestic establishment with the chosen friend who had accompanied him from his native home, and attend-

> And then uprais'd thy streaming eye,
> I met thee in the western sky
> In pomp of evening cloud;
> That, while with varying from it roll'd,
> Some wizard's castle seem'd of gold,
> And now a crimson'd knight of old,
> Or king in purple proud.
>
> And last, as sunk the setting sun,
> And Evening with her shadows dun,
> The gorgeous pageant past,
> 'Twas then of life a mimic show,
> Of human grandeur here below,
> Which thus beneath the fatal blow
> Of Death must fall at last.
>
> Oh, then with what aspiring gaze
> Didst thou thy tranced vision raise
> To yonder orbs on high,
> And think how wondrous, how sublime
> 'Twere upwards to their spheres to climb,
> And live, beyond the reach of Time,
> Child of Eternity!

And as the "Paint King" belongs to our subject, the reader may, if he pleases be amused with this playful balled in imitation, and in burlesque of Scott's "Fire King," Lewis's "Cloud King," and other sportive effusions much read at that time.

> Fair Ellen was long the delight of the young,
> No damsel could with her compare;
> Her charms were the theme of the heart and the tongue,
> And bards without number in ecstasies sung,
> The beauties of Ellen the fair.
>
> Yet cold was the maid; and though legions advanc'd
> All drill'd by Ovidean art,
> And languish'd, and ogled, protested and danced,
> Like shadows they came, and like shadows they glanced
> From the hard polish'd ice of her heart.
>
> Yet still did the heart of fair Ellen implore
> A something that could not be found;
> Like a sailor she seem'd on a desolate shore,
> With nor house, nor a tree, nor a sound but the roar
> Of breakers high dashing around.
>
> From object to object still, still would she veer,
> Though nothing, alas, could she find;
> Like the moon, without atmosphere, brilliant and clear,
> Yet doom'd, like the moon, with no being to cheer
> The bright barren waste of her mind.
>
> But rather than sit like a statue so still
> When the rain made her mansion a *pound*,

ed him in a foreign land through pain and sickness. During
the first week of their residence in Tinney-street, Mrs. Allston
fell sick, and in less than a week died. The shock produced
a temporary derangement or prostration of the artist's intellect.

Up and down would she go, like the sails of a mill,
And pat every stair, like a woodpecker's bill,
From the tiles of the roof to the ground.

One morn, as the maid from her casement inclin'd,
Pass'd a youth, with a frame in his hand.
The casement she clos'd—not the eye of her mind ;
For, do all she could, no, she could not be blind ;
Still before her she saw the youth stand.

"Ah, what can he do," said the languishing maid,
"Ah, what with that frame can he do !"
And she knelt to the Goddess of Secrets, and prayed,
When the youth pass'd again, and again he displayed
The frame and a picture to view.

"Oh, beautiful picture !" the fair Ellen cried,
" I must see thee again or I die."
Then under her white chin her bonnet she tied,
And after the youth and the picture she hied,
When the youth, looking back, met her eye.

"Fair damsel," said he, (and he chuckled the while)
"This picture I see you admire :
Then take it, I pray you, perhaps 'twill beguile
Some moments of sorrow ; (nay, pardon my smile)
Or, at least, keep you home by the fire."

Then Ellen the gift with delight and surprise
From the cunning young stripling receiv'd
But she knew not the poison that enter'd her eyes,
When sparkling with rapture they gaz'd on her prize—
Thus, alas, are fair maidens deceiv'd !

'Twas a youth o'er the form of a statue inclined,
And the sculptor he seem'd of the stone ;
Yet he languish'd as though for its beauty he pined
And gaz'd as the eyes of the statue so blind
Reflected the beams of his own.

'Twas the tale of the sculptor Pygmalion of old ;
Fair Ellen remember'd and sigh'd ;
"Ah, couldst thou but lift from that marble so cold,
Thine eyes too imploring, thy arms should enfold,
And press me this day as thy bride."

She said : when, behold, from the canvas arose
The youth, and he stepped from the frame ;
With a furious transport his arms did enclose
The love-plighted Ellen : and, clasping, he froze
The blood of the maid with his flame !

She turn'd and beheld on each shoulder a wing,
"Oh, heaven !" cried she, "who art thou !"
From the roof to the ground did his fierce answer ring,
As frowning, he thunder'd "I am the PAINT-KING !
"And mine, lovely maid, thou art now !"

He took refuge with his friends Morse and Leslie, at their
abode. They had been with him through the dreadful trial,
and now superintended the last sad offices required by human-
ity. The only persons present at the funeral of the wife of

Then high from the ground did the grim monster lift
 The loud-screaming maid like a blast;
And he sped through the air like a meteor swift,
While the clouds, wand'ring by him, did fearfully drift
 To the right and the left as he pass'd.

Now suddenly sloping his hurricane flight,
 With an eddying whirl he descends;
The air all below him becomes black as night,
And the ground where he treads, as if moved with affright
 Like the surge of the Caspian bends.

"I am here!" said the Fiend, and he thundering knock'd
 At the gates of a mountainous cave;
The gates open flew, as by magic unlock'd,
While the peaks of the mount, reeling to and fro, rock'd
 Like an island of ice on the wave.

"Oh, mercy!" cried Ellen, and swoon'd in his arms,
 But the Paint-King, he scoff'd at her pain.
"Prithee, love," said the monster, "what mean these alarms?"
She hears not, she sees not the terrible charms,
 That work her to horror again.

She opens her lids, but no longer her eyes
 Behold the fair youth she would woo;
Now appears the Paint-King in his natural guise:
His face, like a palette of villanous dies,
 Black and white, red and yellow, and blue.

On the skull of a Titan, that Heaven defied,
 Sat the fiend, like the grim giant Gog,
While aloft to his mouth a large pipe he applied,
Twice as big as the Eddystone Lighthouse, descried
 As it looms through an easterly fog.

And anon. as he puff'd the vast volumes, were seen
 In horrid festoons an the wall,
Legs and arms, heads and bodies emerging between,
Like the drawing-room grim of the Scotch Sawney Beane,
 By the Devil dress'd out for a ball.

"Ah me!" cried the damsel, and fell at his feet
 "Must I hang on these walls to be dried?"
"Oh, no!" said the fiend, while he sprung from his seat,
"A far nobler fortune thy person shall meet;
 Into paint will I grind thee, my bride!"

Then, seizing the maid by her dark auburn hair,
 An oil jug he plung'd her within.
Seven days, seven nights, with the shrieks of despair,
Did Ellen in torment convulse the dun air,
 All cover'd with oil to the chin.

On the morn of the eighth on a huge sable stone
 Then Ellen, all reeking, he laid;
With a rock for his muller he crush'd every bone,
But, though ground to jelly, still, still did she groan;
 For life had forsook not the maid.

Allston and sister of Channing were, Samuel F. B. Morse, Charles R. Leslie, and John Howard Payne, three of her countrymen.

If the biographer may not record the events which influenced

Now reaching his palette, with masterly care
Each tint on its surface he spread ;
The blue of her eyes, and the brown of her hair,
And the pearl and the white of her forehead so fair,
And her lips' and her cheeks' rosy red.

Then, stamping his foot, did the monster exclaim,
" Now I brave, cruel Fairy thy scorn !"
When lo ! from a chasm wide-yawning there came
A light tiny chariot of rose-colour'd flame,
By a team of ten glow-worms upborne.

Enthron'd in the midst of an emerald bright,
Fair Geraldine sat without peer ;
Her robe was a gleam of the first blush of light,
And her mantle the fleece of a noon-cloud white,
And a beam of the moon was her spear.

In an accent that stole on the still charmed air
Like the first gentle language of Eve,
Thus spake from her chariot the Fairy so fair :
"I come at thy call, but, Oh Paint-King, beware,
Beware if again you deceive.'

' 'Tis true," said the monster, "thou queen of my heart,
Thy portrait I oft have essay'd ;
Yet ne'er to the canvas could I with my art
The least of thy wonderful beauties impart ;
And my failure with scorn you repaid.

" Now I swear by the light of the Comet-King's tail !"
And he tower'd with pride as he spoke,
"If again with these magical colours I fail,
The crater of Etna shall hence be my jail,
And my food shall be sulphur and smoke.

" But if I succeed, then, oh, fair Geraldine !
Thy promise with justice I claim,
And thou, queen of Fairies, shall ever be mine,
The bride of my bed ; and thy portrait divine
Shall fill all the earth with my fame."

He spake ; when, behold, the fair Geraldine's form
On the canvas enchantingly glowed ;
His touches—they flew like the leaves in a storm
And the pure pearly white and the carnation warm
Contending in harmony flow'd.

And now did the portrait a twin-sister seem
To the figure of Geraldine fair :
With the same sweet expression did faithfully teem
Each muscle, each feature ; in short not a gleam
Was lost of her beautiful hair.

'Twas the Fairy herself ! but, alas, her blue eyes
Still a pupil did ruefully lack ;
And who shall describe the terrific surprise
That seiz'd the Paint-King, when, behold, he descries
Not a speck on his palette of black !

a man in the days of his gladness or those of his mourning, he may record effects, but is denied the privilege of tracing them to their causes, perhaps the most essential part of his work.

It has been well said, " say nothing of the living but what is true," and most stupidly, " say nothing of the dead but what is good." " Biography of living persons has some exceptions to it. It has the air of adulation when you praise, and of envy or malice when you condemn." Truth is the object of this book, and good or evil shall be recorded of dead or living, as truth shall dictate.

While Mr. Allston was engaged in painting the great picture of the " Dead man touching the bones of the prophet," he likewise painted " The Mother and Child," and a landscape. The three are in this country. To Mr. James McMurtie, of Philadelphia, America owes the possession of the great picture first mentioned. That gentleman being in London persuaded Mr. Allston to put the painting in his charge to convey to Philadelphia, feeling assured that the Pennsylvania Academy of Fine Arts would purchase it. Mr. Allston had entrusted the sale of the picture to Messrs. Sully & McMurtrie, and the first intimation he had of the transaction was through a Boston correspondent, who informed him that " The Dead Man" was sold to the Pennsylvania Academy for the sum of $3,500." A price very inadequate, but probably as much as that institution could afford to give.

In a letter from London, dated 13th June, 1816, to James McMurtie, Esquire, of Philadelphia, Mr. Allston writes : " When you first made me the generous offer of taking out my

"I am lost !" said the Fiend, and he shook like a leaf;
 When, casting his eyes to the ground,
He saw the lost pupils of Ellen with grief
In the jaws of a mouse, and the sly little thief
 Whisk away from his sight with a bound.

"I am lost !" said the Fiend, and he fell like a stone;
 Then rising the Fairy in ire,
With a touch of her finger she loosen'd her zone,
(While the limbs on the wall gave a terrible groan,)
 And she swelled to a column of fire.

Her spear now a thunder-bolt flash'd in the air,
 And sulphur the vault fill'd around :
She smote the grim monster ; and now by the hair
High-lifting, she hurl'd him in speechless despair
 Down the depths of the chasm profound.

Then over the picture thrice waving her spear,
 "Come forth !" said the good Geraldine ;
When, behold, from the canvas descending appear
Fair Ellen, in person more lovely than e'er,
 With grace more than ever divine ?

picture, you may remember with what implicit confidence I submitted the entire management and disposal of it to yourself and Mr. Sully. I would not have done this if I had not been fully assured that, whatever might be the event, I should have every reason to be grateful, for even if it had wholly failed of profit, I should still have felt myself indebted for every exertion that kindness and liberality would make. If such would have been my feelings in the event of a total failure (an event too, which I had suffered myself almost to anticipate) you may well judge what I now feel at the account of this most agreeable and unexpected result. I beg you both to accept my warmest and most grateful acknowledgments. The sale is in every respect highly gratifying, both as affording a very seasonable pecuniary supply, and on account of the flattering circumstances attending it. As necessary and acceptable as the money is to me, I assure you I think more of the honour conferred by the academy becoming purchasers of my work."

We here see that the highest mental powers, united to the keenest physical perceptions of the good and the beautiful, are consistent with, and perhaps produce the most delicate sensibility, diffidence in self, and confidence in the acts and opinions of others. How different from that irritable, and at the same time dogmatical character who considers all the praises bestowed upon others, or the gifts of fortune not falling to himself, as so many injuries inflicted on him. Such an one is as blind to his own defects as to the merits of others, and in self-confidence pronounces by words, or acts, or both, his own superiority. This conduct sometimes succeeds for a time, for the world will take a man's word for his worth rather than take the trouble to inquire into a subject that does not immediately touch their interests. But the truth will appear; and the pretender is generally the victim of disappointment and morbid irritability—shunned by those who can best appreciate his worth, and finally sinking into private imbecility and public contempt. A contrast between such a character (and such characters exist) and that of the subject of this biographical sketch, is as complete as the imagination can. conceive.

It appears that Mr. Allston had conceived the design, and partly executed it, of a great picture on the subject of Christ's healing in the temple. In the letter above quoted from, written in 1816 to Mr. McMurtrie, is the following passage: " If I am constrained, from various circumstances, to disappoint you as to your proposal respecting a picture from my sketch of ' Christ healing,' I yet trust you will believe me not insensible to the kindness that dictated it; and also hope that the

proposal which I in my turn make will be as agreeable to you, as if it had been in my power to comply with the first. Upon reconsidering the sketch some months since, though still pleased with the general arrangement, I found the principal incident so faulty and inefficient, and myself so unable to suggest a better, that I was forced to the resolution of relinquishing the subject altogether—or lay it by for some future period, in the hopes that my imagination might then supply a more suitable incident. It is of the first importance to a large work that the principal incident should be striking and obvious; leaving no doubt on any one of its meaning. Now in the incident alluded to, I have attempted to express the miracle of *restored health* to a sick man, and that I have failed in it is certain: because not one who has seen it has been able to guess my intention. I could easily express disease in any stage of languor or emaciation; there would then be no incident but only a sick man waiting to be healed, which is but repeating what West has already done, and very finely done. My object was not to treat the subject thus, but in a very different way; that is, to show both the *operation* and the *effect* of a miracle. The blind boy, or rather the boy that *was* blind, (which you may recollect on the sketch,) is, I think, a very happy incident; for the miracle there is obvious, and clearly explains itself: but it is a miracle that has been *already* wrought, and therefore forms a subordinate part of the picture. Had I been equally successful in the principal object, who is supposed to be under the *immediate influence* of the Saviour's word, I should not only be satisfied with the composition, but have reason to think I had achieved something *great.* I still like all the rest of the sketch; but this great and radical defect in it has long since compelled me to give it up. But were I even perfectly satisfied with it, I do not think it would be in my power to paint it on a large scale (as it would employ me full eighteen months or two years) for less than nine hundred or a thousand guineas without loss; for, in addition to my present expenses, I should be obliged to hire another large room. But though it is not in my power, for the reasons above stated, to engage in a large picture from this sketch, I should be most happy to undertake another subject for you, of five or six figures, size of life; which would make a picture about the dimensions of the St. Peter in prison; (the St. Peter, by the by, employed me more than six months after you left London, instead of two, as I had calculated;)—and this I would do for the sum you mentioned, say five hundred guineas. Such a picture I could paint in

my present room, and could finish, I should hope, in some-
what less than a year. Should this be agreeable to you, you
will please to say what kind of a subject you would prefer : I
think scripture subjects, as being most known and interesting
to the world, are the best. Should this proposal meet your
views, you have the best reasons for depending on my very
best efforts. Perhaps some splendid subject, uniting brilliancy
of colouring with character and expression." In another let-
ter, dated October 25, 1816, he says, on the subject of the
" Christ healing,"—" I may here observe that the universal
failure of all painters, ancient and modern, in their attempts
to give even a tolerable idea of the Saviour, has now deter-
mined me never to attempt it. Besides, I think his character
too holy and sacred to be attempted by the pencil."

To go back to the letter of June, the whole is so interest-
ing and instructive to students and artists, that not to con-
tinue it here would be injustice to them. " Whenever you
send the portfolio of drawings, I will with pleasure attend to
your wishes respecting them. Mr. West, who is, as I believe,
one of the most learned in Europe in these matters, will, I
doubt not, be happy to assist me in assigning to them the
names of their proper authors. I know that he has a great
esteem for you. Since you still encourage me with the hope
of selling the landscape, I will send it out in the course of the
summer. I think I gave you a memorandum of the price : I
do not recollect whether it was 200 or 150 guineas. If it is
worth any thing it is worth 200, having cost me four months
hard labour. At the same time I shall send you the little
picture of the Virgin and Child, which, as I know it is a great
favourite with you, I beg you to accept, as a small testimony
of my esteem. I have lately improved it very much ; having
repainted the mother's head, and the whole of the infant, as
well as retouched the back-ground."

It is probable that these are the two small pictures which he
painted while the great picture of the " Dead Man" was in
progress. In October he wrote, " I have shipped and ad-
dressed to you the two pictures mentioned to you in my letter
of June last, viz. the Landscape and the Mother and Child.—
I wish you not to consider it now as the " Virgin and Child,"
but simply as a mother watching her sleeping offspring. A
Madnona should be *youthful;* but my mother is a matron. Be-
sides, there are other reasons, which I have not room to state,
that would fix the propriety of the change not made in the
title. The first, the Landscape, to be exhibited and disposed
of in any way that shall seem best to you : of the other I beg

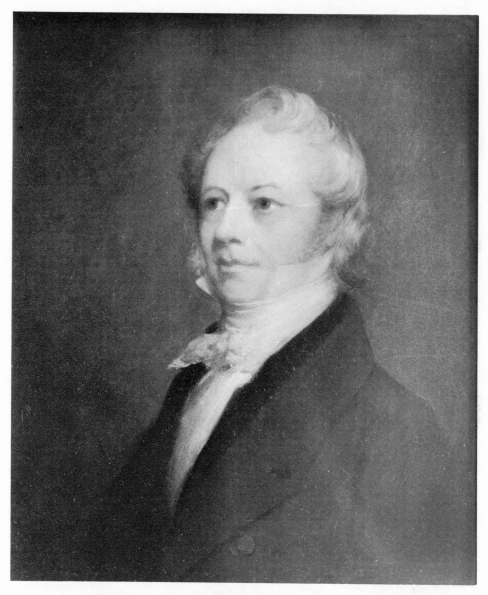

177　SELF-PORTRAIT. Painting by Washington Allston. *Courtesy The Brook Club.*
Photograph The Frick Art Reference Library.

178　Dead Man Restored by Touching the Bones of Elisha, 1811–1813. Painting by Washington Allston. *Courtesy The Pennsylvania Academy of the Fine Arts.*

your acceptance, as a small testimony of my esteem and gratitude. I have a double pleasure in offering this little present, inasmuch as, since the retouching, I think it one of my best works ; and as I know it will be possessed by one who can *truly* appreciate whatever merit it may have. It does not always happen that the possessors of pictures are also possessed of taste ; and therefore it is a source of no small gratification to an artist to know that his works are cherished by those who will neither mistake nor overlook their excellencies, however subordinate." *

* The great picture of the " Dead Man restored to Life, by touching the Bones of the Prophet Elisha," was put up in the Pennsylvania Academy of Fine Arts in April, 1816, in a good light and situation for its display, and has been a source of delight and instruction to the public and to artists. The size of this picture is 13 feet by 11. The passage on which this composition is founded is as follows :—" And the bands of the Moabites invaded the land at the coming in of the year. And it came to pass as they were burying a man, that, behold, they spied a band of men, and they cast the man into the sepulchre of Elisha ; and when the man was let down, and touched the bones of Elisha, he revived." 2d Kings, chap. xiii. ver. 20, 21.

The following description is taken from the pen of Mr. Allston:—

" The sepulchre of Elisha is supposed to be in a cavern among the mountains, such places, in those early ages, being used for the interment of the dead. In the fore-ground is the man at the moment of re-animation ; in which the artist has attempted, both in the action and colour, to express the gradual recoiling of life upon death Behind him, in a dark recess, are the bones of the Prophet. the skull of which is *peculiarized* by a preternatural light. At his head and feet are two slaves, bearers of the body ; the ropes still in their hands, by which they have let it down, indicating the act that moment performed : the emotion attempted in the figure at the feet is that of astonishment and fear, modified by doubt, as if still requiring further confirmation of the miracle before him ; while, in the figure at the head, is that of unqualified, immovable terror. In the most prominent group above is a soldier, in the act of rushing from the scene. The violent and terrified action of this figure was chosen to illustrate the miracle, by the contrast which it exhibits to that habitual firmness supposed to belong to the military character, showing his emotion to proceed from no *mortal* cause. The figure grasping the soldier's arm, and pressing forward to look at the body, is expressive of terror, overcome by curiosity. The group on the left or rather behind the soldier, is composed of two men of different ages, earnestly listening to the explanation of a priest, who is directing their thoughts to heaven, as the source of the miraculous change : the boy clinging to the old man is too young to comprehend the nature of the miracle, but, like children of his age, unconsciously partakes of the general impulse. The group on the right forms an episode, consisting of the wife and daughter of the reviving man. The wife, unable to withstand the conflicting emotions of the past and the present, has fainted ; and whatever joy and astonishment may have been excited in the daughter by the sudden revival of her father, they are wholly absorbed in distress and solicitude for her mother. The young man, with outstretched arms, actuated by impulse, [*not motive*] announces to the wife, by a sudden exclamation, the revival of her husband ; the other youth, of a mild and devotional character, is still in the attitude of one conversing—the conversation being abruptly broken off by his impetuous companion. The sentinels in the distance, at the entrance of the cavern, mark the depth of the picture, and indicate the alarm which had occasioned this tumultuary burial."

CHAPTER XII.

Visit to Paris with C. R. Leslie—Jacob's Dream—Uriel in the Sun—Martin—Allston home-sick—Opinion of England and Englishmen—No distinction made between their own artists and Americans—Allston returns home—Patriotism—Belshazzar's Feast—second Marriage—Notice of some of Mr. Allston's Pictures.

In the year 1817 Mr. Allston visited Paris, in company with his friend C. R. Leslie. The same year he writes from London, acknowledging the receipt of the first instalment for his picture of the "Dead Man;" and then goes on to say, "I am now engaged on 'Jacob's Dream,' a subject I have long had in contemplation. It has been often painted before, but I have treated it in a very different way from any picture I have ever seen; for, instead of two or three angels I have introduced a vast multitude: and instead of a ladder, or narrow steps, I have endeavoured to give the idea of unmeasurable flights of steps, with platform above platform, rising and extending into space immeasurable. Whether this conception will please the matter of fact critics I doubt; nay I am certain that men without imagination will call it stuff! But if I succeed at all, it will be with those whom it will be an honour to please. The picture is of the same size with the landscape I sent out." Mr. Allston's prize picture, "Uriel in the Sun," is in England, in the collection of the Marquis of Stafford.

In a letter from Martin to the editor of the London Athenæum, I find an account of his first introduction to Leslie and Allston, and an acknowledgment, that to a conversation with Allston, who told him that he intended to paint "Belshazzar's Feast," he owes the suggestion of the subject which he shortly after painted and engraved—with a great deal of perspective and architectural effect, much poetic imagination and more false drawing, outré attitude, and exaggerated or unnatural expression. I publish one extract, as connected with my subject, in the year 1814:

"My next painting, 'Clytie,' 1814, was sent to Mr. West, the president, for his inspection; and it was on this occasion that I first met Leslie, now so deservedly celebrated.

"I shall never forget the urbane manner with which West introduced us, saying, 'that we must become acquainted, as young artists, who, he prophesied, would reflect honour on their respective countries.' Leslie immediately informed Allston, who resided in the same house with him, that he had met me. Allston requested to be introduced, as he had felt a

strong desire to know me, from the time he had seen my ' Sa-
dak ;' but a sort of reserve had prevented his introducing
himself, although he had several times taken up his pen to do
so. Thus, twenty years ago, commenced a friendship which
caused me deeply to regret Allston's departure for his native
country ; for I have rarely met a man whose cultivated and
refined taste, combined with a mild yet enthusiastic temper,
and honourable mind, more excited my admiration and esteem.
 " It is somewhat singular, that my picture of ' Belshazzar's
Feast,' originated in an argument with Allston. He was him-
self going to paint the subject, and was explaining his ideas,
which appeared to me altogether wrong, and I gave him my
conception. He then told me, that there was a prize poem at
Cambridge, written by T. S. Hughes, which exactly tallied
with my notions, and advised me to read it. I did so, and
determined on painting the picture. I was strongly dissuaded
from this by many ; among others, Leslie, who so entirely
differed from my notions of the treatment, that he called on
purpose, and spent part of a morning, in the vain endeavour
of preventing my committing myself, and so injuring the re-
putation I was obtaining. This opposition only confirmed
my intentions, and in 1821 I exhibited my picture. Allston
has never seen it ; but he sent from America to say, ' that he
would not mind a walk of ten miles, over a quickset hedge,
before breakfast, to see it.' This is something from a bad
walker and a worse riser. His own ' Belshazzar' was not
completed for many years, not till very lately, I think." Of
that more will be said hereafter.
 The reader has seen, that this distinguished American art-
ist was in England during the last war between America and
Great Britain. He went thither in 1811; when insult, op-
probrium, and injury were heaped upon his country by the
government and the writers of the United Kingdoms ; and he
remained until the character of the United States had been
vindicated, and the pride of England mortified, both on the
land and sea. He was among men who felt irritated by the
defeat of their vessels of war (hitherto triumphant in every
encounter) by the despised Yankee seamen, and of their in-
vincible soldiers before the militia of America ; yet he was be-
loved and his talents appreciated as though he were a native
of Britain. The poet-painter became "home-sick," as he
says, and, on the return of peace, when his engagements per-
mitted, he left his English friends.
 He thus speaks of the land of his forefathers, that glorious
land, whose brightest ornaments we claim as belonging to us

as much as to our transatlantic brethren—men from whose example and instruction we derive our greatest blessings.

"Next to my own country," says Allston, "I love England, the land of my ancestors. I should indeed be ungrateful if I did not love a country from which I have never received other than kindness : in which, even during the late war, I was never made to feel that I was a foreigner. By the English artists, among whom I number some of my most valued friends, I was uniformly treated with openness and liberality. Out of the art too I found many fast and generous friends.— And here—though I record a compliment to myself, I cannot deny myself the satisfaction of repeating the kind words of Lord Egremont, a few weeks before I left England. 'I hear you are going to America,' he said. 'I am sorry for it.— Well, if you do not meet with the encouragement which you deserve, in your own country, we shall all be very glad to see you back again.' This munificent nobleman had done me the honour to introduce himself to me, and is the possessor of one of my best pictures, "Jacob's Dream."

"I have ventured to allow myself this piece of egotism, for the sake of my countrymen, who, I hope, will never let any deserving British artist, who should come among us, feel that he is not welcome. England has never made any distinction between our artists and her own—never may America. In reference to Lord E.'s kind speech, I must stop here to say, that I have received from my countrymen the kindest treatment and the most liberal encouragement—far indeed from what I ever expected, for which I cannot be too grateful."

Thus it is that the good and the grateful spirit, united to talent and intelligence, finds friends every where; and while this great artist felt himself indebted to Lord Egremont, that enlightened nobleman felt himself proud of, and honoured by the society of the man of genius, and rich in the possession of the emanations of his mind, as displayed upon the glowing canvas.

"Among the many persons," says Allston, "from whom I received attentions, during my residence in London, I must not omit Col. Trumbull, who always treated me with the utmost courtesy. Among my English friends it is no disparagement to any to place at their head Sir George Beaumont. It is pleasant to think of my obligations to such a man—*a gentleman in his very nature.* Gentle, brilliant, generous—I was going to attempt his character, but I will not; it was so peculiar and finely textured, that I know but one man who could

draw it, and that's Coleridge, who knew him well—to know whom was to honour."

After thus expressing himself respecting his English friends, Mr. Allston continues. " A home-sickness which (in spite of some of the best and kindest friends, and every encouragement that I could wish as an artist) I could not overcome, brought me back to my own country in 1818. We made Boston Harbour on a clear evening in October. It was an evening to remember! The wind fell and left our ship almost stationary on a long low swell, as smoothe as glass and undulating under one of our gorgeous autumnal skies like a prairie of amber. The moon looked down upon us like a living thing, as if to bid us welcome, and the fanciful thought is still in my memory that she broke her image on the water to make partners for a dance of fire-flies—and they *did* dance, if I ever saw dancing. Another thought recurs: that I had returned to a mighty empire—that I was in the very waters, which the gallant Constitution had first broken, whose building I saw when at college, and whose " slaughter-breaking brass," to use a quotation from worthy Cotton Mather's magnalia, *but now* 'grew hot and spoke' *her name* among the nations!" This patriotic feeling is not a thing for which any credit is claimed, it would only have been discreditable to have been without it."

Let knaves and fools laugh at patriotism; it is only knaves and fools who can make jest of the most holy feelings of man's breast! The American returning from Europe who does not feel the glow of patriotism at the recollections of the free institutions of his country, the unparalleled diffusion of enjoyment among the *people*, and the improvement of every kind flowing from the establishment of a Democracy—is a wretch to pity or abhor. " The public virtue," says Gibbon, " which among the ancients was denominated patriotism, is derived from a strong sense of our own interest in the preservation and prosperity of the free government of which we are members." The slaves of their own vices and the vices of a corrupt government will always mock at patriotism.

It was in this year, 1818, that Mr. Allston was elected an associate of the Royal Academy of England. On this subject, he has said in a letter of recent date, " my friends wrote me that I should have been made an academician some years ago had I been in London, on the occurrence of a certain vacancy; but by the original laws of the academy (for which the present members are not accountable) no one is eligible as an academician who is not a resident of the United

Kingdom. This law is peculiar to the English academy, and I cannot but think it a narrow one."

On the 17th of November, 1818, Mr. Allston writes to his friend McMurtrie, from Boston : " As I propose to remain here during the winter, I must beg you to remit the balance due me, of which you speak, to this place, directed for me to care of Timothy Williams, Esquire, Boston. With respect to the interest due from the Pennsylvania Academy, I beg you to state to them that the delay of the payment of the purchase money not having occasioned me any inconvenience, I with pleasure relinquish it. I am sufficiently rewarded both by the honour they have done me in the purchase of the picture and in the sum paid. The success I have lately met with in England left me but one finished picture to bring with me, " Elijah in the wilderness," and which, had I remained a few weeks longer, I had the prospect of transferring to another proprietor.* I have brought, however, several others *on the stocks*, some of which are considerably advanced, particularly " Belshazzar's Feast, or the Hand-writing on the Wall," sixteen by twelve in size, which, I believe, is by several feet larger than the " Raising of the Dead Man." I purpose finishing it here. All the laborious part is over, but there still remains about six or eight months' more work to do to it. As I get on with it and other smaller works, which I may probably proceed with at the same time, I will take the liberty occasionally to drop you a line. In the spring or summer I may not unlikely pay you a visit. I have a great desire to see your city, and the state of the arts there. Though I have not the pleasure of a personal acquaintance with Mr. Sully, I yet so well know him through his friends and the friendly services he in conjunction with yourselves has rendered me, that I must, in a particular manner, beg you to present him my respects. I left Leslie well. He intends embarking for America in the spring. He has lately finished a beautiful little picture of Ann Page inviting Master Slender in to dinner, from the Merry Wives of Windsor. It is finely composed and (here the letter is torn) I thought it his happiest" (torn again.)

* This picture was soon after purchased by an English traveller and sent to England. Titian and other Venetians are supposed to have painted their skies and other distances in distemper, and then having varnished them wirh strong size, finished their pictures in oil colours Allston painted his "Elijah in the wilderness" with colours ground in milk, and having perfected the work as far as he could in this manner, he varnished with copal, and finished or re-touched it in oil colours.

From the above we see that the great work, not yet finished in 1834, was considered by the painter as only wanting six or eight months' labour to be completed in 1818, fifteen years ago. "All the labour is over." How little do we know of ourselves, our works, or our futurity! This great picture was valued at $10,000, and divided into ten shares, some of which, it is understood, was paid in advance. Of the circumstances which have delayed the finishing Mr. Allston has spoken in a letter to be laid before the reader. Allston once said to Sully, " O, do not undertake any thing that cannot be accomplished by your own means." Sully before had had the burnt child's experience on that score in his picture of " Crossing the Delaware."

May 27, 1831, Mr. Allston writes thus to Mr. M'Murtrie: "I have but a few weeks since been established in my new painting room, which I have built in this place, (Cambridgeport, near Boston.) Belshazzar has been rolled up and reposing in a packing case for more than three years, in consequence of my former large room in Boston passing into the hands of a new owner, who has converted it into a livery stable; since which I have been compelled to work in a small chamber, where I have been employed altogether on small pictures. Belshazzer will still remain some time in his case—some embarrassing debts and my immediate necessities being the cause. I must be free in mind before I venture to finish it. I trust, however, that the time will not be very long. Your room which you mention must be a noble one. I wish there were such a one in each of our large cities. It is a great desideratum with me, as I mean hereafter, that is, when I once more become *free*, and should Providence grant me life, to confine myself chiefly to large works. I suppose that you know that I have become a Benedict.* I have been married about a year, and this village is now my home. It is but two miles from Boston, where I can be at any time, by means of an hourly stage, in twenty minutes. I am in better health, and certainly in better spirits, than I have been these ten years."

In a letter to a friend, Mr. Allston had said that it was not his wish to give a catalogue of all his pictures. He was afterward prevailed upon to give the following brief notice of a part of his works. " I will mention only a few of the principal which I painted during my first visit to England, viz: ' The Dead Man restored to life by the bones of Elisha.' The ' Angel liberating St. Peter from Prison.' This picture was

* He married in 1830, a relative of his first wife.

painted for Sir George Beaumont, (the figures larger than
life) and is now in a church at Ashby de la Zouch. 'Jacob's
Dream,' in the possession of the Earl of Egremont. There
are many figures in this picture, which I have always consid-
ered one of my happiest efforts. 'Elijah in the Desert.' This
I brought to America, but it has gone back, having been pur-
chased here by Mr. Labouchere, M. P. The 'Angel Uriel
in the Sun,' in possession of the Marquis of Stafford. This is
a colossal fore-shortened figure, that, if standing *upright* would
be fourteen feet high, but being fore-shortened, occupies a
space but of nine feet. The directors of the British gallery
presented me with a hundred and fifty guineas, as a token of
their approbation of Uriel.* Since my return to America, I
have painted a number of pictures, but chiefly small ones.
These pictures being pretty well known here, I shall mention
only a few of the larger ones, viz : 'Jeremiah dictating his
prophecy to Baruch, the scribe ;' the figures as large as life.
'Saul and the Witch of Endor,' and 'Spalatro's vision of the
bloody hand.' This last is a small picture, but I mention it
because it is perhaps more extensively known, and because,
too, I consider it one of my best. The others which I have
omitted are landscapes, and, with three or four exceptions,
small figures. Although my large picture (Belshazzar's Feast)
is still unfinished, yet I ought perhaps to say something about
it, as many inquiries have been made respecting my progress
in it, and the probable time of its being completed. In assign-
ing this reason for speaking of it in this place, I do not mean
to admit any *right* in the public to be made acquainted with
it ; for so far, it is wholly a matter between the subscribers
and myself. Still I am not disposed to withhold all informa-
tion from a very natural curiosity. On some accounts I can-
not but feel gratified with the general interest that has been
manifested in relation to it. All, however, that I can now say,
is, that so soon as it is in my power to apply myself without
interruption to the completion of the picture, I shall do it with
the utmost alacrity ; and that when circumstances will admit
of this, it will not take a long time to finish it. If the subscri-
bers to it have been anxious for its completion, many and
many-fold greater has been my desire to see it done : and
great indeed would be the relief to my mind. I could long
ago have finished this and other pictures as large, had my
mind been free : for indeed I have *already* bestowed upon it
as much mental and manual labour as, under another state of

* They had before presented him with 200 guineas as the first prize for "The
Dead Man revived."

mind, would have completed several such pictures. But to go into the subject of all the obstacles, and the hindrances upon my spirit, would hardly be consistent with delicacy and self-respect. Nor could I be far enough understood if I should do it, to answer by it any essential purpose. Those feelings which are most intimately blended with one's nature, and which most powerfully and continuously influence us, are the very feelings which it is most difficult to give any distinct apprehension of to another. For this reason then, as well as for the others assigned by me, I will be silent respecting them. I may add, however, in conclusion, that I have the prospect of a time, not very far distant, when I expect to be in a condition to complete this picture; an event which it is not possible for any one to desire more than myself."

Mr. Allston says, " I had a delightful visit from Morse. Its only fault was being too short. The same from my old friend Fraser." Samuel F. B. Morse, president of the National Academy of Design, the worthy pupil of Allston, after returning from this visit, exclaimed, "I go to Allston as a comet goes to the sun, not to add to his material, but to imbibe light from him." After having passed some years in Italy and France, surrounded by, and studying the masters of Europe, Mr. Morse finds his former instructor even greater than before. He has a large painting room, built under his direction, at Cambridgeport, but still the great picture is in prison. He expressed his strong desire to work on it; but by this building he is involved in debt, which prevents his mind (as he expresses) from being free. This is, however, on the point of being removed. It was thus that Benjamin West, being under the necessity of building his house and galleries in Newman-street, was, although constantly employed, obliged to live with rigid economy that he might pay the debt contracted, and support those appearances required in the associate of men overwhelmed with wealth, and after a life, a long life of virtue, frugality, and extreme industry, leave to his children less than a merchant would consider a fair gain upon a cargo of cotton. Mr. Allston's prospects are brightened—he soon will give to the world his great picture, the size of which has been so great an obstacle to its accomplishment, and in the mean time several pictures on a smaller scale are partly finished, which his pupil thinks will rank him by the side of Raffaele; among them is " Gabriel setting the guard of the Heavenly Host." Retired from the world, and engrossed by his delightful studies and assiduous labours, there can be no doubt that Mr. Allston will be free to realize his wishes by devoting him-

self to that grand style, both in size and composition, which
has placed him at the head of living artists. As in West, so
in Allston, the choice of subject for his pictures, indicates
the character of the man. Does not the warmth or coldness
of a painter's colouring depend upon his character likewise?
—and perhaps the freedom of his handling. Can a warm
hearted, benevolent man paint cold, purply, hard pictures
habitually? Be this as it may, the choice of subject is a sure
indication of the mind of the artist. When Mr. Allston
was consulted on the subject of painting for the government,
and was asked whether he would undertake to fill the vacant
pannels in the rotunda, if it was determined by Congress so
to do. His reply was, "I will undertake one only, and I
choose my own subject. No battle piece."

It has been said of Mr. Allston that when, in London, he
had by a great picture produced a great effect, he did not fol-
low it up. The public heard no more of him for years. That
the time he threw away in smoking his cigar, and delighting
his friends with conversation and delightful stories, of which
he was a most prolific inventor and unrivaled *teller*, should
have been employed in keeping up, by a succession of efforts,
the name he had obtained. But the robust and untiring man
can make no allowance for the man of more delicate frame,
and for the lassitude and disease which follow in some men the
extraordinary exertion of mind and body. I would not be the
excuser of late hours at night even with temperance, and the
waste of heaven's light by appropriating the day to sleep;
but I can feel for a mind and frame like Allston's, and though
I regret that much of his time has been spent without the pen-
cil in hand, I do not believe that time wasted which appeared
to be spent in idleness—such minds are never idle.

Washington Irving tells me that he first met Allston in
Rome. That under his guidance he visited the works of art,
and was taught by him to profit by a visit to a picture gallery:
"Select two or three pictures and look at no others until you
come again, then take two or three more, and your mind will
be free from the confusion caused by the multiplicity of
objects; you may study those you select and make yourself mas-
ter of their merits and defects." Delighted with the society of
Allston, and having all his love for art renewed and increased,
Irving says that he was at one time resolved to study the art,
encouraged by Allston. If so what might we not have gain-
ed? What must we not have lost!

179 SPANISH GIRL IN REVERIE, 1831. Painting by Washington Allston. *Courtesy The Metropolitan Museum of Art, gift of Lyman G. Bloomingdale.*

Drawn from Nature by A. Wilson. Engraved by A. Lawson.

Mocking Bird. 2. Egg. 3. 4. Male and Female Humming Bird. nest and eggs. 5. Towhe Bunting. 6. Egg.

180 BIRDS. Drawing by Alexander Wilson; engraving by Alexander Lawson for "American Ornithology," Volume Two, Plate One. *Courtesy New York Public Library*.

CHAPTER XIII.

A. Wilson—Born at Paisley—Apprenticed to a weaver—His poems—Arrives in America 1794—Extreme poverty—Works as a copper-plate printer—A weaver —Travels as a pedler—Teaches a school—Studies—Bartram—Wilson's despondency—Is taught drawing by Lawson—Studies ornithology and conceives the project of his great work—Publishes in C. B. Brown's Magazine and Denny's Port Folio—Letters to Bartram—Travels—Liberality of Samuel F. Bradford—First volume of his Ornithology published—He travels to seek subscribers —Second volume published—Letters to Alexander Lawson—Arduous journey through the wilderness---The Ornithology reaches the seventh volume---Death and character of Wilson---Letter from Dr. John W. Francis.

ALEXANDER WILSON—1803. Alexander Wilson, 1766–1813.

I shall give the biography of this extraordinary man principally by making an abstract from Ord's life of him, published in Philadelphia by Hall.

*Alexander Wilson was born in the town of Paisley, Scotland, on the 6th of July 1766. The rudiments of literature were attained in his native place before the age of thirteen; and he was bound apprentice to a weaver, in whose service he continued until eighteen years of age, and acquired the nickname of the "lazy weaver," from his love of reading in preference to the labours of the loom. He derived from his mother a taste for music, and showed a decided preference to weaving verses rather than cloth.

Freed from his bonds, he indulged his propensity for rural scenery and rambling, by shouldering a pack and commencing trade as a pedler; but aspiring to the immortality of a poet,

* It seems proper that earlier students of the natural history of our country, who had some title to be called artists, should not be passed over; and first, Mark Catesby, F. R. S., who was born in England in 1679, and visited America in 1712. He remained seven years studying the botany of the country. He then returned home; but, being encouraged by the friends of science, made a second visit to the colonies, and took up his head quarters at Charleston, S. C.: from which place he made excursions to the interior, through Georgia and Florida. An Indian was generally his companion, who carried his materials for drawing and painting, and such specimens of natural history as he collected. He returned to England in 1726, and studied the art of etching, that he might engrave the plates of his intended publication, which he did from his own paintings. His work is entitled "The Natural History of Carolina, Florida, and the Bahama Islands, in French and English, containing the Figures of Birds, Beasts, Fishes, &c." This estimable and ingenious man died in 1749, aged seventy, leaving a widow and two children dependent upon the profits of his work. Kalm, the Swede, whose name was given to one of our most beautiful flower-bearing shrubs, the Kalmia or laurel, was, I believe, no artist, but Wangenheim, whose book on our forest trees was published in Germany after his return, designed the pictures himself, if I recollect aright, for it is many years since I read the work. He was an officer in the Hessian army of our revolutionary war. William Bartram designed, and is mentioned in Wilson's memoirs. Dr. Barton drew subjects of natural history correctly, and very neatly.

he unfortunately published his poems, and endeavoured to unite the pedler and the poet, his pack and his poems, to the disadvantage of both. Though disappointed, he still continued his love for literature, and shared the poverty which such an attachment generally causes. He returned to Paisley and to weaving, but the revolutionary spirit of America and France having spread among the weavers, he of course joined the democracy, and took the liberty to publish a satire upon a wealthy knave of the aristocracy; but though published annonymously, it was traced to Wilson, and he was sentenced "to a short imprisonment, and to burn, with his own hands, the poem at the public cross of Paisley." The shouts and applauses of the weavers accompanied him; he was looked upon as a martyr to truth, but the circumstance weighed upon his spirit, and was a cause of his determination to migrate to America.

To raise funds for this purpose he became industrious and economical, living for less than a shilling a week, and hoarding the proceeds of his labour. He had read the advertisement of a shipmaster who was to sail from Belfast; and on foot he left Paisley, embarked at Port Patrick, and reached the desired ship : but her complement of passengers was filled, and Wilson, with a companion who left Paisley in company, consented to sleep upon the deck. With such accommodations the hardy poet crossed the Atlantic, and landed at Newcastle, Delaware, on the 14th of July, 1794, in the 28th year of his age.

He was now in a strange land, with not a shilling in his pocket. To enable him to reach Philadelphia, he borrowed a small sum from a fellow-passenger of the name of Oliver, and feeling that he was free, shouldered his fowling piece, and walked, light as air, thirty-three miles to the capital of Pennsylvania. His love for American ornithology was kindled by a redheaded woodpecker, the first bird he saw in the western world.

After working as a copper-plate printer, and at his old trade of weaving in Philadelphia, he tried Shepherdstown in Virginia; but only finding employment as a weaver, he returned, and in 1795 travelled through the north part of New-Jersey as a pedler, keeping a journal, full of interesting observations, and not only increasing his knowledge but his cash. He now opened a school, and for several years followed the honourable profession of a teacher, assiduously studying those branches of learning in which he was deficient; and making himself a

mathematician, to the business of a teacher he was enabled to add that of a surveyor.

The companion of his journey of emigration was his nephew, William Duncan, whose mother had been compelled by poverty to follow her son, bringing with her a family of small children. To find an asylum for these, Wilson combined with Duncan, and, by the aid of a loan, purchased a farm in Ovid, Cayuga county, New-York, where the son resided with his widowed parent.

After changing his place of residence several times, Wilson's good fortune placed him in a school house on the banks of the beautiful Schuylkill, and but a short distance from the residence of the philosopher, philanthropist, and naturalist, William Bartram, and within four miles of Philadelphia.

At a former period of my life, when the study of botany filled a portion of my time, I made a delightful pedestrian excursion from Philadelphia to Bartram's botanic garden, in company with Doctor Elihu H. Smith, my fellow student in the science, and Charles Brockden Brown, now so well known as a novelist. Although this has no connexion with Wilson, the reader may forgive the feeling which dictates it. We found the botanist in his garden, dressed, as an European would say, like a peasant, and spade in hand; but we found the simplicity of a lover of nature and the courtesy of a gentlemen under the homely garb. Such was the man into whose vicinity, and within the sphere of whose instruction, Wilson was now thrown. Bartram was pleased to find in Wilson a lover of nature, and an observer of the manners of birds, a subject dear to himself, and they soon became intimate and ardent friends.

Mr. Alexander Lawson told me that he often accompanied Wilson in his visits to Bartram, but the drudgery of a school, the confinement and the poverty that still haunted Wilson, rendered him melancholy, and instead of the exercise which might have cheered his mind, he played the flute and wrote verses, only tending to increase the evil by dwelling on it. He sometimes, in conversation, dwelt on his fruitless efforts and disappointed hopes, and hinted at suicide. Lawson suggested drawing to him—he thought it impossible—" if he could only draw as well as Bartram, he should be delighted." "You shall draw better, if you will follow my advice." Bartram had not devoted much time, or shown much talent for delineating the objects he loved to study and cultivate. Wilson consented to try drawing; but on endeavouring to copy some small human figures, he saw the imperfection of his work, and was confirmed in his opinion that he could never draw. His

friend suggested flowers as subjects for his imitation : this was approaching the goal at which he was destined to arrive. He was encouraged, and persevered. He then tried to draw a bird, from nature—delighted himself and surprised his friend. He now approached his home—his resting-place. Reeves's colours were bought, and he painted, from nature, a bird he had shot. Thus was he, as far as a man can be at this time of day in civilized society, self-taught.

The study of ornithology went hand in hand with his progress in the art of designing the objects most interesting him. He read, and was dissatisfied—he sought the meadows, the rivers, and the woods, and found all he wished—he described—he painted—and found himself a draughtsman and an ornithologist. Then arose the desire to communicate to others. He formed the plan of publishing, and communicated with Bartram, who cautiously discouraged an undertaking that might involve him in difficulties ; but his mind had received its impulse, and he had an answer for every objection.

Lawson approved of Wilson's scheme of making a collection of all the birds of the middle states, or even of the union, but saw more difficulties in bringing such a work to perfection, and before the public, than the schemer did. However, Wilson went on ; and the time he had devoted, when not employed in teaching, to flute playing, verse making, solitude, and despondency, was now employed in increasing his collection of birds, of drawings, and knowledge of the nature, manners, and history of the subjects.

Wilson's letters to Bartram exhibit him in a most amiable point of light, and show that his studies at the school house had not failed to improve his style : these letters are before the public. Hoping that by some literary effort he might relieve himself from the confinement and the drudgery of a school, he sent some essays to my friend Charles Brockden Brown, who then wrote for and conducted "The Literary Magazine" for the proprietor, Conrad ; and he contributed to Denny's Port Folio, but these efforts produced no change in his situation.

In the month of October, 1804, Wilson, with two companions, made a pedestrian tour to the falls of Niagara. This produced on his return "The Foresters," published in the Port Folio. In 1805, Wilson was, like an honest man, inflicting privations on himself to pay his debt to his friend : " I associate with nobody, spend my leisure hours in drawing, wandering through the woods, or playing on the violin." He was now seriously employed in making a collection of all the

birds of Pennsylvania, and with all the ardour of genius conceived that he might etch them himself, and then colour them. Lawson instructed him in etching, but he soon found not only that much time must elapse before he could etch, but that the graver must finish the work. Full of his project of publication, he wished Lawson to join with him in it; but he saw objections which Wilson could not, and declined. "I will proceed alone then in the publication, if it costs me my life!"

The enthusiastic Wilson conceived hopes of visiting the Mississippi under the auspicies of Mr. Jefferson, but was disappointed; but as a literary man he had better fortune in 1806, being engaged at a liberal salary by Mr. Samuel F. Bradford as assistant editor. Mr. Bradford, six years after, not only released Charles R. Leslie from the bonds of apprenticeship, but actively promoted that subscription which wafted him to Europe, being himself a liberal subscriber, and thus smoothed the path by which a truly virtuous man has attained the highest rank in the arts. Mr. Bradford thus opened the way for Wilson to prosecute his favourite object, and shortly after agreed to become the publisher of Wilson's Ornithology, and furnish the requisite funds. Lawson was engaged as the engraver, and admirably he acquitted himself.

In the month of September 1808, the first volume of the American Ornithology made its appearance; and although the prospectus had been before the public for two years, the surprise and delight was as great as if it had never been announced; for no one could conceive that America could produce a splendid work on science that vied with the proudest productions of the old world.

The author now set out on a journey to the eastward, in search of subscribers. He went as far as Maine, and returned through Vermont to Albany and Philadelphia, better freighted with compliments than subscriptions. Almost immediately on his return, he commenced a journey on the same errand to the south, through Virginia, the Carolinas, and Georgia. When at Charleston he had obtained a hundred and twenty-five subscribers; at Savannah they had amounted to two hundred and fifty, he says, "obtained at a price worth five times their amount."

The second volume of the Ornithology was published in January 1810, and in February the artist and author proceeded to Pittsburg, and thence alone in a skiff down the Ohio. His letters to Alexander Lawson, his friend and the engraver of his birds, have been repeatedly published, and can alone give a true idea of the man. He visited the numerous

towns which had even then sprung up in the wilderness, and every object of interest he could hear of and approach. Near Louisville he sold his skiff, and performed the journey to Natchez partly on foot and partly on horseback. In his diary he says, " This journey, four hundred and seventy-eight miles from Nashville, I have performed alone, through difficulties which those who never have passed the road could not have a conception of." He proceeded to New Orleans, and thence to New-York and Philadelphia.

Seven volumes of the Ornithology were published by the extreme exertion of Wilson, the unremunerated expenditures of S. F. Bradford, and the friendly labours of Lawson. The United States were proud that such a work should originate and be thus far perfected in the country—Philadelphia, still more delighted, claimed the honour of being its birth place, yet among all her learned and rich, the literati, the men of benevolence, and the men of wealth—among her thousands of high minded men, and well minded men, only seventy became subscribers for Wilson's Ornithology, "more than half of whom," says his biographer, "were persons of the middle class of society."

In 1812, Wilson was chosen a member of the " Society of artists of the United States." In 1813, Mr. West sent him a proof impression of his " Death of Nelson." The same year he completed the letter-press of his eighth volume ; but before the plates were ready, on the 23d of August, 1813, a dysentery put a period to his days, in the forty-seventh year of his age.

The admirable trait in Wilson's character is his undeviating adherence to, and innate love of truth. He was strictly honourable in his dealings, and in all trials through life rigidly a virtuous man. His fault, and I learn but of one, was irritability ; which perhaps counteracted, in some measure, the good effect which his high moral character produced.

In person he was of the middle size, of a thin habit, his features coarse, and a " dash of vulgarity in his physiognomy," which was forgotten when the intelligence of his eye was called forth, or the charms of his intellect displayed in conversation.

Of his poetical and other essays I shall not speak ; and I hope my readers are too well acquainted with the merit of his composition, in his descriptions of the subjects of his study and his work, to need my eulogium.

His remains are deposited in the cemetery of the Swedish church, Southwark, Philadelphia.

The following is from a Scotch paper: "July 13, 1833, Wilson's anniversary. On Monday night the anniversary of this celebrated ornithologist and poet was honoured by a number of his townsmen at Paisley. Thomas Crichton in the chair, Robert Lang, croupier." Crichton was the intimate friend and correspondent of Wilson. The memory of the deceased American ornithologist was "drank in solemn silence" after a speech from the chair. It is gratifying to record this testimony paid to the worth of a man of virtue and talent by his townsmen twenty years after his death.

My readers will be gratified by the perusal of a letter from my friend Dr. Francis, just received, which (as well as other matters relative to the arts) has so much original information respecting Wilson, as to make it a most valuable appendix to the foregoing memoir.

"Newport, September 8, 1834.

"Dear sir,—You will perceive that I breathe a new atmosphere, and I now purpose enjoying myself for some three or four days at Newport, renowned for its salutiferous air—as the birth place of Stuart and of Malbone, and the scene of some of the most active and laudable operations of the celebrated Bishop of Cloyne. I have again visited Mrs. W——, where we had the gratification of seeing once more *the Hours*, that exquisite work of genius and art by Malbone, which commands unmeasured praise from untold visiters at this place, who seek the opportunity of admiring this production of the pencil, not surpassed, in all probability, by the work of any foreign artist. We were also shown a number of unfinished heads, in miniature, by the same extraordinary master; a portrait of Mr. W. in crayons, done by Malbone, and his own portrait, a superior performance, kit-cat, in oil colours. From this an indifferent copy was taken by Gimbrede and subsequently engraved. There are other works of value by the same great artist to be seen in a distant part of the country; among them one entitled Devotion, and another the birth of Shakspeare, of peculiar merits, *in umbra.* Malbone's life, though short, was sufficiently long to secure to him a permanent reputation. Miss Hall seems to me the only artist who has made a close approximation to his best efforts. His " Hours" has awakened the powers of many a worthy poet. Among others, his personal friend, the late Dr. Farmer, wrote some clever verses on it; tinged, however, rather too deeply with his own sombre associations as well as with deep grief at the premature death of the painter.

" We rode to the house where the Bishop of Cloyne once
resided. Somewhat more than a century has elapsed since
he occupied it ; it was once a substantial wooden frame
farm house of two stories, and the room which we considered
as the bishop's library, still retains its old Holland ornaments
of earthen figures round the mantel and fire-jambs. It is con-
templated soon to take down this venerated building, in which
case I have made an engagement to be supplied with a relic
to make two or three snuff-boxes, one of which shall certainly
be reserved for you. And why not as well have a box of the
residence of the good bishop, as of the tree so famous for the
Indian treaty by Penn? The memorable line of the poet for
Berkeley, will apply with like verity to both these exalted
characters. At no great distance from the bishop's house are
the Paradise Rocks, seen projecting near the margin of the
sea ; they are called by the people the Bishop's study. Here
he used to retire and write, and few places are more romantic,
or better calculated for health and inspiration. With your
present bodily ailings, you would do well to come hither for
a short time and finish your projected volumes. We shall have
fine green tea and flap-jacks for your breakfast, water of the
spring of Dr. Franklin's temperature as your *medicina mentis*,
and coppices of verdant beauty for your eyes to gaze upon,
equal to any Humphrey Repton ever formed. It is affirm-
ed, as you probably will recollect, that the bishop wrote his
Minute Philosopher in America ; and this sequestered spot,
with its paradise rocks before us, is fitted for the contempla-
tion of the most ardent votary of Plato.

" If it were not too professional I might also dwell upon
the fact, that Newport is known in our medical annals as the
first place on the American continent where a public course
of anatomical lectures was given. They were delivered by
Dr. William Hunter so early as 1754. Dr. Hunter was by
birth a Scotchman, born in 1729, and like many others,
engaged in the cause of the pretender in 1745. After the
fight of Culloden he repaired to this country and settled at
Newport, where he died in 1777. He had received the ear-
lier part of his education under the elder Monro, and acted as
surgeon's mate in the contest just stated, his principal being
Middleton ; that Middleton who was afterwards the eminent
professor of medicine in King's College, New-York. There
is an admirable portrait of Hunter in the family mansion,
done by Cosmo Alexander in 1769 ; and also one by the
same artist, of rather inferior merits, of Mrs. Hunter and
her daughter. The curious who visit Newport sometimes

carry away with them some fragment of the renowned ship Endeavour ; a portion of whose hull is still to be seen at Wilkham's wharf. This vessel is associated with the discoveries of Captain Cook, who, with Banks and Solander, made in her their first circumnavigation round the world, about, I believe, 1769. I possibly may err a little in the date, but I am too far off to consult the Redwood library. The Endeavour was afterwards purchased as a whaler, and used some time in that capacity, but being pronounced not seaworthy, has been suffered to lie here and decay.

" I cannot, however, permit the present opportunity to pass without addressing you a few lines relative to your History of the Arts of Design in America. Your laborious and minute researches will probably leave little to be gleaned by your successors, in those inquiries in which you have so long been employed. The subject is of deep interest to all who feel a becoming pride in the talents which our native artists have so amply displayed, and on the reflection that Stuart, West, and Trumbull ; Allston and Newton are of American origin. It seems to me that *Wilson*, the ornithologist, will have claims to your notice, and if he falls within the scope of your work, you will probably find it in conformity to your plan to precede your account of him by some slight sketch of his predecessor, in our natural history, the celebrated Catesby. Like Wilson, Catesby was an artist ; his zeal and industry were scarcely surpassed by Wilson, and his honesty and integrity in preserving faithful memorials of the objects of his attention, have been such as to secure the strongest approbation of experienced and qualified observers. A copy of his Natural History may be seen in the library of the Rev. Dr. Hawks ; it is in two volumes, large folio ; the edition by Edwards. The figures of this work were originally etched by himself, and the colours were done either by him or under his inspection. As the reputation of this amiable, unassuming and excellent man has been somewhat impugned by Gordon and others, I hope you will allow me to give you the testimony of one of the best judges now living, on his merits. Wilson often refers to Catesby with suitable consideration, and with the ardour of a true worshipper. We are to remember that Catesby's plates do not afford specific distinctions of all he saw ; it was not his object ; his delineations of the various parts of a flower are imperfect, but for the best of reasons ; botanical science among us had not yet received the aids of the Linnean classification, though Colden, on the banks of the Hudson, about that period, took up with increased delight

his investigation of plants, excited by new feelings the inspiration of his Swedish master. According then to the testimony of the best judges and most eminent naturalists, no delineator of the works of the Creator has excelled in merits Catesby, considering the time when he published, and the circumstances in which he was placed. Audubon, in speaking of him, remarked to me distinctly that the utmost confidence might be placed in all his statements. I have examined, him, he added, with the closest severity, and I have scarcely seen in his descriptions, so far as they go, a single error. I confide in all he says. Others since his time have enlarged upon certain parts of him with the additional advantages of modern and more precise science. After the triumphant declaration of Audubon let us no longer hear it asserted that Catesby defaced nature, and that his magnificent volumes cannot be consulted without regret and indignation.

"It was my happiness to be personally acquainted with *Alexander Wilson.* The first time I saw him was in the latter part of October, 1808 : he had just completed the first volume of his Ornithology, and had come to New-York to solicit subscribers. The slender countenance he received to aid him in his vast undertaking, was somewhat depressing to his feelings. He stated briefly the great efforts he had made, the better to justify his application for subscriptions. 'I determined,' said he, ' to let the public see a perfect specimen of my work, before I sought their pecuniary support, and I carry my volume with me. I shall not abandon my design, however lukewarm it may be looked upon : but cherish the hope that there is in this widely extended and affluent country, a number of the admirers of nature sufficient to sustain me in my enterprise.' What pains me, he further remarked, is the indifference with which works in natural history are often regarded, by men of cultivated understanding and rank in life. I have just returned to your city, after a visit to Staten Island, to submit my volume to your governor. He turned over a few pages, looked at a picture or two ; asked me my price ; and while in the act of closing the book, added, ' I would not give a hundred dollars for all the birds you intend to describe, even had I them alive.' ' Occurrences such as these distress me ; but I shall not lack ardour in my efforts.'—This little incident I confess to you it was sufficiently mortifying to hear. Moreover, the governor of the state of New-York is always presumed to be an enlightened character : by charter he is a member of the board of regents, a body constitutionally created, who direct and control the intellectual pursuits of an empire state.

"Wilson on his subsequent visits to New-York, seemed to be in better spirits, both on account of the patronage he had received, and the progress he had made in his work. He seized the moments of leisure he had, in closely examining books in natural science, in different libraries to which he could obtain a ready access. The American Museum, which had now been well fitted up, was, however, his most gratifying resort. Scudder, the founder of this institution was indeed a rough diamond; but few could surpass his enthusiasm in studying the volume of nature, as he termed every subject in natural history. Wilson was loud in his praises of the *preservative* talents of this *artiste*, of materials in natural science: but at that day we had not the experience and results of Waterton before us. Few greetings could be more joyous, than that of these men; great as was the disparity in their scientific knowledge and intellectual culture. Scudder remarked, ' I have many curiosities here, Mr. Wilson, but I myself am the greatest one in the collection!' Scudder continued, and stated the trials he had passed amidst rocks and glens, referred to the time when he carried his museum on his back, and exulted at the success which thus far crowned him. He believed that a taste for nature's works was more diffused : he said he had travelled thousands of miles, in order to bring various objects of natural science together, worthy of study. All this was listened to by Wilson with feelings of great gratification : but when the museum-man added, 'Yet, notwithstanding all, and my success so far, I still find that the Witch of Endor, and Potiphar's wife, bring me ten dollars where my natural history does one;' the Ornithological Biographer, filled with emotion and changing countenance, gave utterance to a vehement expression on the listlessness of man in contemplating the harmony of nature ; and while recounting his pedestrian excursions through our extensive country, gave vent in a philippic against closet naturalists and sedentary travellers. He seemed to have as great dislike to this last named class of beings, as ever our old friend Dr. Williamson cherished.

"It was during one of these, his later excursions to the city, that Wilson waited upon our mutual friend Dr. Mitchill, whose fame had now extended far beyond the " Grampian Hills, or the chalky cliffs of Dover." Wilson found the doctor in his study : he had about this time commenced his investigations of the qualities and numbers of the fishes of the waters of New-York. Surrounded by his cabinets of conchology and mineralogy, and with his room still further enriched with collections of Indian tomahawks and antiquities, and the dresses of

the inhabitants of the south seas, the doctor poured out of the immense treasures of his prompt memory, and gave ingenious illustrations on divers topics for the mental gratification of Wilson. The meeting was highly satisfactory to both : the ornithologist found the amiable and benevolent philosopher the most accessible of mortals, expert in disquisition, whatever the subject,—a monad or the Niagara ; and no less ready at the composition of songs for the nursery, than in expounding his beautiful theory of the heavens. 'You have sojourned largely through our country, Mr. Wilson, (says Dr. Mitchill,)—I no longer travel—travellers come to me.' The result of this interview was a promise on the part of the doctor to furnish Wilson with the history of the pennated grouse of Long Island, in relation to which such a mass of foreign ignorance has been displayed. How well he complied therewith, is known to all who have read his admirable letter in the Ornithology.

 " We have strong reasons to infer, that Wilson was greatly disappointed at the state of society, and the condition of literature in America, so far at least as they might be associated with the encouragement of his designs. He had abruptly left his own country, the victim of indiscretion if not of persecution. He was tinctured with the political excitements of the times of 1790-4, and sought abroad what he deemed not within his reach at home. His whole life from its early dawn, to its unexpected close, was a perpetual struggle. Bradford was indeed his friend, and the venerable horticulturist near Philadelphia, William Bartram, delighted to speak of him to the passing traveller. His firmest resolves were often suddenly abandoned, and as often re-resolved. He was of the *genus irritabile*, and suffered at times from what is occasionally termed a constitutional morbidness. But this itself, doubtless, added to the intensity of his devotion to his sublime pursuits. When men of power and place were indifferent to his glorious plans of natural science, he sometimes betrayed a consciousness of the supremacy of his studies, and of his own mental superiority. Hence, republican as he was, he could not brook the frigid apathy of our republican governor.

 "An instructive parallel might be drawn between Wilson and Michaux the younger. All who knew the latter, remember with admiration his personal intrepidity and hardihood. Like Wilson he had in reality abided the pelting of the pitiless storm. Nothing but unintermitting efforts, under the most discouraging circumstances, enabled him to complete his History of American Forest Trees. Michaux, like Wilson, sustained himself under every social privation, and became

a tenant of the woods ; scarcely for weeks, months, nay, seasons, participating of the shelter of the domestic roof and the comforts of the culinary fire. He was, moreover, often so outré in his appearance, from necessity and habit, as rarely perhaps to command the civilities of refined life : the metamorphoses of Naso, were at times almost outdone by the peculiarities of his outward attire. But the materials of his Sylva having at length been brought together, from every quarter of our widely spread country, he repaired with them to Paris, and there, under the patronage of the savans of that metropolis, gave to the world his elegant volumes. He still lives near the Sorbonne, blessed with the remnant of a good constitution, at comfortable ease, enjoying the national bounty willingly granted him for his services ; and the students of nature greet him as one of their choicest associates. All who visit the Jardin des Plantes, will learn how much he has enriched it, and behold the platanus and the bignonia associated as neighbours, though of distant climes, in amicable rivalry with the lordly Adansonia. —He has effectively benefited the arts and rural affairs ; he points to the furniture around his dwelling, as examples of the beautiful adaptation of the products of our native woods, to the elegancies of the dining-room and the boudoir. He loves America—it was the theatre of his reputation—and her forests yield the loveliest and the loftiest trees. Poor Wilson on the contrary, with all his high and ennobling aspirations, was ever subjected to the caprices of indigence and want. With the contemplative eye of philosophy, he enjoyed the luxury of interrogating nature, in the most attractive of her forms of animated existence ; and he saw in prospective, the accomplishment of his disinterested designs. But sickness invades him with his unfinished labours before him, and in his premature death, we have a striking illustration of the uncertainty of all human things.

" Exalted as all will pronounce the contributions of Michaux the younger, I think that you should view the subject in another bearing, when considering the relative merits of the author of the Forest Trees, and of the American Ornithology.—Michaux cannot fairly be looked upon as a pioneer in his vocation. Not a few eminent arboriculturists had long ago given some account of the riches of our forests. Since the time of the Swede, Kalm, Wangenheim had penetrated into various parts of our country, the better to understand aright the capabilities of the North American tree, for transplanting and propagation in Germany, and had dedicated to his sovereign, the king of Prussia, his large folio with numerous plates. His drawings, I

understand, were made by himself; and when we consider the
professional capacity to which he was restricted during our re-
volutionary war, it is almost marvellous what he effected. The
ingenious Masson and the unfortunate Dombey, had also touch-
ed our shores, and Michaux the father having explored the
North American regions for a period of more than twelve years,
had illustrated in folio, in a manner corresponding to his
subject, the Oaks of North America. These then with John
and William Bartram and others had somewhat opened the field
for subsequent and better qualified observers, and Michaux has
deservedly secured the triumph.

How different is the fact as regards that department
in which Wilson excelled : excluding the labours of Cates-
by, in a limited district, with the exception of a casual
notice here and there, and the imperfect catalogue of
birds by Mr. Jefferson, hardly a correct observation in
ornithology is to be found, prior to the appearance of Wilson.
The most improved works in our natural history abounded in
narratives of the incantations of the serpent, the sub-terrene
hybernation of the swallow, and a thousand other absurd
stories touching the economy of animals, which, from the
plausibility with which they were sustained, caused philosophy
itself to be debased by its credence in such asinine hypotheses.
Our birds were songless and without plumage, and the for-
bodings of the raven was our only melody. In this state of
doubt and ignorance, like the dauntless mariner on unknown
seas, without chart or compass, Wilson appears. With the force
of genius he becomes an original explorer of untrodden wilds
of vast extent and peril ; shade and sunshine are alike to him ;
his pursuit is his happiness : with a diligence surpassing com-
mendation, he enlarges the boundaries of human knowledge,
and with the simplicity of truth, elevates American Ornitho-
logy to the certainty of a science, and worthy the cultivation of
the highest intellect.

" You will pardon me, if, before I conclude, I record one or
two circumstances concerning Wilson's reputation abroad.
I allude to the popular and exalted renown he attained
almost immediately after the completion of the Ornithology,
by Mr. Ord his estimable friend who published his bio-
graphy. The work of Wilson had indeed received from
the American press, a few literary notices during the progress
of its publication. Governor Clinton had written one or two
friendly critiques, with his wonted earnestness for the promo-
tion of the science, and Wilson was gratified that he enjoyed
the consideration of a character so conspicuous. But with his

181 JULIE GRIFFITH (Julie François Gabriel d'Anterroches). Painting by John Paradise.
Courtesy Metropolitan Museum of Art, bequest of Kate d'A. Bonner.

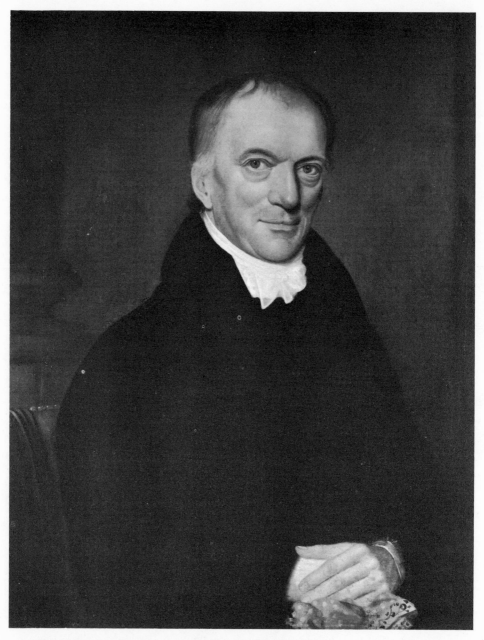

182 HENRY TEN BROECK. Painting by John Paradise. *Courtesy The New-York His-torical Society.*

transatlantic countrymen, his memory became an object of deep interest. Paisley, his birth-place, had long known him as the author of Watty and Meg, a popular ballad, which I recollect in my earliest school-boy days, to have been echoed in our streets. I believe he was also the writer of some pathetic verses on the loss of a lovely boy by drowning, entitled, " Pale wanderer of the silent night," a production not alluded to in any notice of his muse that I have seen. Within a year or two after his work was finished, his countrymen at Paisley were urgent in their inquiries of American travellers concerning him and his great production. You must allow, after all, said they, that you are indebted to a Scotchman for the true account of the birds of America. He was our townsman, and it gratifies us to learn any particulars of him. Near this place, he was once a faithful weaver among us ; and Watty and Meg please us e'en now. Perhaps these expressions of popular feeling struck me with the greater force, inasmuch as an occurrence of a somewhat different complexion took place a day or two before. Encountering a highland lad, who was discoursing sweet music to a song of Burns, I expressed my pleasure by remarking, we had no such poetry by American bards. ' You have not produced Burns,' replied he, ' but you have produced a greater man than all Scotland has,—Doctor Franklin,—he taught the way to make money.'

" When the Dukes John and Charles of Austria attended a converzatione at Sir Joseph Banks in 1816, the royal visiters expressed a desire to examine the library and vast collections in natural science of the venerable president of the Royal Society. ' I have nothing worthy of your special examination,' said Sir Joseph, ' except the American Ornithology of Wilson :' and further inquiries were dropt upon the inspection of this extraordinary work. ' Our Radcliff library is deficient,' observed Dr. Williams, the Regius Professor of Botany: we have had no opportunity of procuring the American Ornithology by Wilson: we learn the work is terminated; and it is remarkable that no Edinburgh or Quarterly has taken notice of it : in what way can we soonest obtain a copy from your country?

" Thus the sod has scarcely covered the grave of the lamented Wilson, ere his matchless efforts as nature's historian, were the theme of popular and scientific admirers in regions far remote and distant from each other. While therefore his earthly remains have commingled with their kindred dust, like the delightful solo of that chief * of song among the feathered tribe, whose vocal powers amidst the fragrant magnolia, he

* The mocking-bird,

has so eloquently described as unrivalled, his own surpassing labours will ever command the admiration of the disciples of nature in every part of the habitable globe.

"But I am fearful of enlarging this epistle, and hasten to assure you of my sincere esteem and regard.

"JOHN W. FRANCIS."

" Wm. Dunlap, Esq."

CHAPTER XIV.

John Paradise—Samuel L. Waldo—instructed in letters by General Eaton; in painting, by Mr. Stewart, of Hartford—goes to Litchfield—finds two patrons and is in despair; but finds a friend and prospers—Goes to Charleston—Visits London—returns home---Waldo and Jewett---Mr. Catton's father—Charles the son studies animal painting and landscape—paints a horse for his friend Beechy, to mount the king on—Francis Kearney---James Frothingham---a builder of chaise-bodies------attempts to paint a portrait---makes approaches to Stuart, and succeeds in gaining instruction---removes to Salem---tries Boston---removes to New-York---Anson Dickinson---Peter Maverick.

John Paradise, 1783–1833.

JOHN PARADISE—1803.

THIS very worthy citizen and pious man was born in Hunterton county, New-Jersey, Oct. 24th, 1783. His ancestors were English, his grandfather having emigrated to Maryland. The father of the artist was a saddler in Pennington village; and John, after a country school education, was taken by him into the work-shop. He, however, preferred printing to saddle-making; but, on trial, was not found strong enough, and returned to his father's. He had a taste for music, and learned to practise both on the flute and violin; but his great delight was in attempts at drawing, and after copying from prints, he even attempted faces from the life. As usual, there were admirers to encourage, and at the age of eighteen he took himself to portrait painting. He soon after became acquainted with Elizabeth Stout, and in a short time after married her. To this circumstance my informant attributes the future good of his life. He became a pious as well as a moral man, and pursued his chosen avocation with additional industry and perseverance. He went to Philadelphia, and for a very short time put himself under the tuition of Volozan; and in 1803 he commenced professionally as an artist. In 1810 he removed to New-York, and was actively engaged in his profession for many years: but his health declined, and he had affections of the head, which at times rendered him incapable of business.

The sect to which Mr. Paradise was attached contributed to his success and employment as a portrait painter. Most of the engravings in the Methodist Magazine are from paintings by

him. He died as he had lived, relying upon the mercy of his God. According to his wish, he had been removed to the house of his brother-in-law, Philemon Dickinson, near Springfield, New Jersey, that he might die in presence of his sister. His decease took place on the 26th of November, 1833.

SAMUEL L. WALDO—1803.

Samuel Lovett Waldo, 1783–1861.

This gentleman was born in the town of Windham, Connecticut. His father was repeatedly elected, by his townsmen, to represent them in the state legislature; but, being of that honourable class of citizens, yeomen cultivating their own soil, young Waldo was early accustomed to habits of laborious industry. His education was that of a good country school, but had a circumstance connected with it worthy of notice—his first teacher was afterwards the well-known Gen. Eaton.

The usual fate of writing books belonging to boys, who as men become painters, attended those of Waldo; and the desire to become an artist induced him, at the age of sixteen, to request his father to place him with a portrait painter of Hartford; assuring him, that if he would pay for his tuition, he would never ask another dollar from him. His father indulged him, and paid one hundred dollars to a Mr. Stewart, whose skill and knowledge were not worth as many cents.

Waldo made the best of such instruction; and at the age of twenty, with (as he has said) fifteen dollars in his pocket, the price paid by a British commodore for the first portrait the young painter attempted from the life, he took a painting room, and set up his esel in the city of Hartford. Success did not attend his efforts, and even his moderate expenses exceeded his income. Happily he boarded at the same table with a young lawyer, who, although just starting in life's race himself, could feel for one who appeared to be lagging and heavily laden. This was Thomas Day, Esq. since secretary of state for Connecticut. Mr. Day advised Waldo to try Litchfield, and gave him a letter to a friend in that place.— He did more—he furnished credit for a new suit of clothes, to make a suitable appearance among strangers. Theodore Dwight, Esq. gave him a letter likewise to a person of wealth and official rank. The persons to whom these letters were addressed had both invited the young painter to visit Litchfield and promised him employment.

On arriving at Litchfield, with little else in his pockets but these letters, he, with fluttering heart, proceeded to deliver them. One of the patrons by promises was very glad to see him, but extremely sorry that the friend whose portrait he

wanted was sick and could not sit. He called on the other, who bowed him out with assurances that he should at all times be exceedingly happy to see him at his house. But there are friends as well as patrons in the world, and Mr. Waldo's conduct through life entitled him to expect friendship—and he found it. It so happened that a gentleman of Litchfield, at the time unknown to him, witnessed the cold reception and formal bow with which he had been received, or rather, dismissed; and being a warm-hearted man, benevolence dictated measures which he immediately put in practice, to counteract the effects of politeness. As he took leave of the last patron with heavy heart, and was proceeding to his inn, a gentleman followed him, and calling him by name, said, "My name is Gould—I saw your pictures at Hartford—I am happy to see you in Litchfield. Will you go with me to my house? it is but a few steps." The invitation was accepted; and the young artist introduced to Mr. Gould's family, and persuaded to stay and take dinner. Before dinner was ready Waldo observed a man entering the court-yard of the house, with his baggage and professional apparatus; which, by order of Mr. Gould, was carried up stairs into a spacious and well-furnished room, to which he led the painter, saying, "This is your chamber, and my house is your home: you may commence painting my wife's portrait as soon as you please, and then my face is at your service." There certainly are two kinds of people in this world of ours.

What a sudden revolution must have taken place in the feelings of a youth, who the moment before had in a strange place seen all his hopes blasted, and had not money enough to carry him back—and now found himself surrounded by friends—the employment he sought, offered spontaneously—free quarters provided for him, and a bright prospect for futurity opened before him. Day started him—Gould sped him on, and from that moment, though sometimes among shoals and shallows, he has sailed with the flood-tide to the haven he has found.

Mr. Gould introduced him to his friends—portraits were engaged—and the empty pocket was filled with $160. At Litchfield, Mr. Waldo met the Hon. John Rutledge, of South Carolina, who employed his pencil and invited him to accompany him to Charleston. The offer was accepted, and having discharged debts and visited his parents, the young artist sailed before the wind to the south.

At Charleston he was employed constantly; but feeling as he advanced in his profession the want of instruction, he, after a visit to Connecticut, and a second voyage to Charleston, by

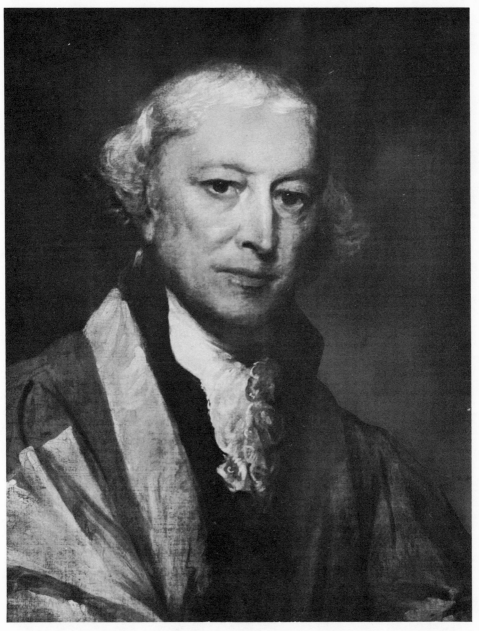

183 WILLIAM SAMUEL JOHNSON. Painting by Samuel Lovett Waldo after the painting
by Gilbert Stuart. *Courtesy Columbiana Collection, Columbia University.*

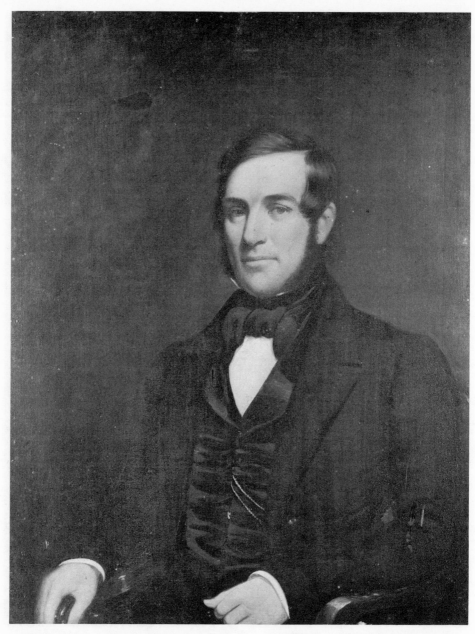

184 CAPTAIN NATHANIEL BROWN PALMER. Painting by Samuel Lovett Waldo. *Courtesy Storington Historical Society. Photograph The Frick Art Reference Library.*

aid of the warm sons of the south, was enabled to visit London with letters to West and Copley. In 1806, he was received with friendship by Mr. West, and civility by Mr. Copley— and Charles B. King arriving about the same time, they took a room jointly in Titchfield-street. Mr. Copley introduced Waldo to the Royal Academy, the advantages of which he enjoyed for more than two years. Among those who had induced Mr. Waldo to visit London, some had done it by promises, and he found himself more than once placed in embarrassing circumstances. Mr. Elihu White of New-York, and Mr. Charles W. Green, of Boston, relieved him by loans which he has repaid by cash and gratitude.

Mr. Waldo painted a few portraits at five guineas each, in London, but had not employment enough to pay expenses.— Robert Fulton was in London, and did him essential service by his advice. After passing nearly three years in England, Mr. Waldo returned home, and landed in New-York on the 24th of January, 1809, (as he has said) "With two guineas in my pocket, and indebted to my friends six or seven hundred dollars." In addition to this burthen, (for all debt is a burthen to an honest man,) he had made the dangerous experiment of bringing a wife from her native country, and had an increasing family depending upon his exertions. It is to his honour, that by industry and economy this gentleman has discharged all pecuniary obligations, and remains to this time, (1834,) a prosperous and popular portrait painter, who can talk of his bank shares and stock like a merchant, while his children are a joy to his increasing years.

About the year 1812, William Jewett came to him for instruction, and was to give his services for three years, but in the second, he proved so useful as to induce his teacher to give him a salary in addition to his board and lodging; and in a short time to take him into a partnership, which continues to this day with increasing friendship. They paint jointly as Waldo and Jewett, and most of their pictures have the labour of both on them.

Mr. Waldo being a director of the American Academy of Fine Arts, proposed opening a subscription for employing Lawrence to paint a full-length of West, as he has said, "That artists might see what constituted a work of art in that branch of painting." To this scheme the president and directors assented, and Waldo beginning the subscription with $100, *most* present followed the example. The list was filled up promptly by citizens of New-York, and the $2000 raised and paid in due time to Lawrence by Mr. Rush, then our ambassador at London. On seeing this picture, George the Fourth

ordered a copy of it. This is the full-length of West, which Williams and Cunningham, the biographers of Lawrence, say that he presented to the American Academy on being elected an honorary member, and one of these historians tells us, that in consequence of Lawrence's generosity, and in hope to share it, an Italian Academy sent him notice of like honours.

It may be seen by this sketch, that industry and perseverance can raise a prudent man from poverty and debt to independence in fortune; and from a very middling standing, as an artist, (even after his return from England) to a decided degree of merit and popularity.

Charles Catton, Jr.,
1756–1819.

CHARLES CATTON—1804.

This intelligent and pleasant old gentleman (for he was old when I knew him, in 1813) was the son of Charles Catton, R. A. of London; a celebrated painter of heraldry, and Elizabeth his wife: the younger Charles was born in London on the 30th of Decemher, 1756. Having become a widower, and being possessed of property which he supposed would render him independent in the New World, the republican institutions of which were congenial to him, he emigrated in 1804, bringing with him, to New-York, two daughters and a son.

To one of these daughters, (Mrs. Gill, of New-York) I am indebted for particulars relative to her father, which appear to me highly interesting, and eminently worthy of being rescued from that oblivion which must soon have enveloped them with impenetrable darkness.

The father of our subject had, in the pursuit of his art of blazonry, studied animal painting assiduously, and rendered the monsters of ancient heraldry beautiful and picturesque representations of nature, as far as the absurdities of the mystery would permit. He published a volume, with plates, on his favourite study. He died in 1798, having enjoyed the well-earned reputation of being the first artist in his branch of painting in Great Britain. Herald painters were in his time, ranked with artists in other departments of painting; and Mr. Catton's skill in animal painting, and knowledge of the human figure, gained him the rank of Royal Academician. Such was the instructor of young Charles; who, under so able a teacher, imbibed a love for his father's branch of art, and derived from him his intimate knowledge of animal painting—strengthened and confirmed by his own studies. He was a pupil likewise of the Royal Academy.

His father and grandfather having been victims to the gout, and Charles fearing the same inexorable tyrant, he was told

that the only probable means of escape was travel. He accordingly visited most parts of England and Scotland, making drawings ; from which, on his return home, he selected those he most approved, and painted them in oil. Many of these views are engraved and published, and some of the prints may be found in this country.

On the very respectable authority of Mr. Catton's daughter, Mrs. Gill, I give the following anecdote :—Mr. Catton, her father, was intimate with Mr. Beechy, since known as Sir Wm. Beechy. Mr. Beechy was a favourite painter with George the Third, and the king gave him an order for his portrait on horseback. Beechy proceeded to execute his Majesty's order, and had frequent sittings of the king, with opportunities of studying the horse intended to be commemorated. He, however, felt that he was not sufficiently *au fait* with the larger animal of the two, and applied to his friend Catton for assistance. Catton undertook to paint the living throne of the king; but expressly stipulated that the affair should be kept secret, and of course that no one should see him when at work. He had proceeded with his usual skill and knowledge in this branch of painting, nearly to a close ; when one day some one entered the apartment while he was at work, and thinking it was Beechy, he went on painting, and the intruder took his stand behind him, and looked on, as his friend frequently did.—" Well," said Catton, " how do you like your horse ?" And looking up as he spoke, he was astonished to see the king ; who answered, " Very well—very well indeed—I like my horse very well—sit still, sir—don't put down your palette—I will look on a little while—go on—go on—go on—you are doing very well, sir—go on."

The painter went on, and the monarch entered into conversation with him in his usual rapid and peculiar manner, asking questions particularly respecting horses; which Catton readily and promptly answered, much to the king's satisfaction.—Beechy came in, and found that the secret was discovered —the doors had opened of themselves on the approach of royalty—every precaution had been in vain. The king laughed at his painter, and expressed his satisfaction with Catton. Several other interviews took place between the king and the painter of his horse, during which the amiable monarch became very much pleased with Catton's conversation, as well as skill : and while sitting to Beechy, he expressed his approbation of his friend in very strong terms ; concluding with, " I like him very much, Beechy—Beechy, I'll knight him—I'll knight him—tell him so."

This is the cheap way in which monarchs can pay debts and confer favours ; and by a nick-name and a piece of ribbon tickle the vanity of the silly creatures who support them by their labour.

Beechy of course communicated " his majesty's gracious intention" to the astonished Catton ; who (probably after laughing at the proposal) begged his friend to make the proper apologies to the king, and decline the favour. Accordingly, when the portrait painter had the next sitting, he made excuses for his friend Catton, and announced his having declined the title and the intended honour. George took it all in good part ; but, as he determined to get rid of a portion of his knight-making power, he said, " Well, well, well, Beechy —if he will not be knighted I will knight you, Beechy—you must not refuse — ha ? I will knight you." Such is my informant's version of the story of Sir William Beechy's knighthood.

Mr. Catton, on his arrival in this country, purchased a farm up the Hudson, in Ulster county, and resided there many years, occasionally painting landscapes and animals. In 1813 he visited New-York, and I became acquainted with him. He painted a drop-scene for a theatre my friend John Joseph Holland opened in Anthony-street ; and he represented all the prominent characters of Shakespeare in appropriate costume, with good expression, and well managed throughout. I was at this time taking up the pencil for oil painting, after an interval of twenty years ; and the old gentleman frequently called upon me and encouraged me. " You shall be the portrait painter and I will be the historical painter," he has frequently said : but I never saw any historical composition from his pencil, or any grouping of human figures, except the Shakspeare characters, and two pictures mentioned below. My friend Elias Hicks, Esq. has a landscape of Mr. Catton's painting, with animals introduced.

The last picture he painted was Noah's Ark, and the animals entering and congregated for the purpose. This is in the possession of Colonel Bomford ; and a copy of it was shown to me by Charles W. Peale, painted for his Ark in Philadelphia. Mr. Catton died on the 24th of April, 1819, aged 63.

Some time after his death two pictures were shown in New-York, said to be painted by Hogarth, and brought to this country by Mr. Catton. It is said they were sent to this city for sale by Mr. Catton's son, and were in the possession of Mr. Samuel Maverick, the son of Peter R. Maverick, one

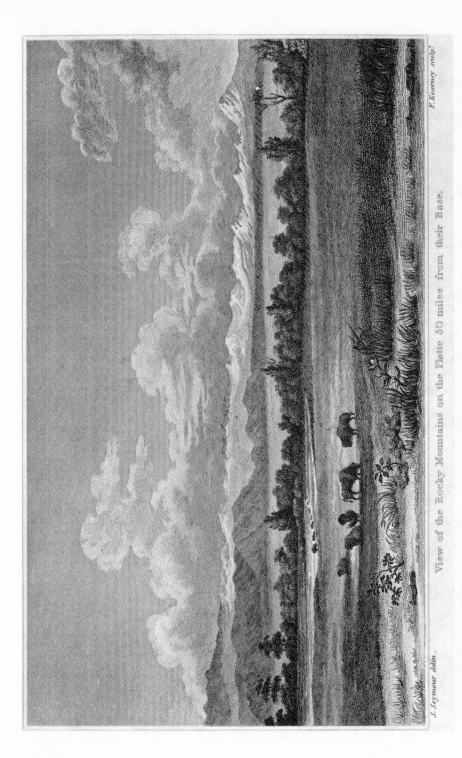

J. Seymour delin.

View of the Rocky Mountains on the Platte 50 miles from their Base.

F. Kearney sculp!

185 VIEW OF THE ROCKY MOUNTAINS ON THE PLATTE. Engraving by Francis Kearney after Samuel Seymour. *Courtesy Library of Congress.*

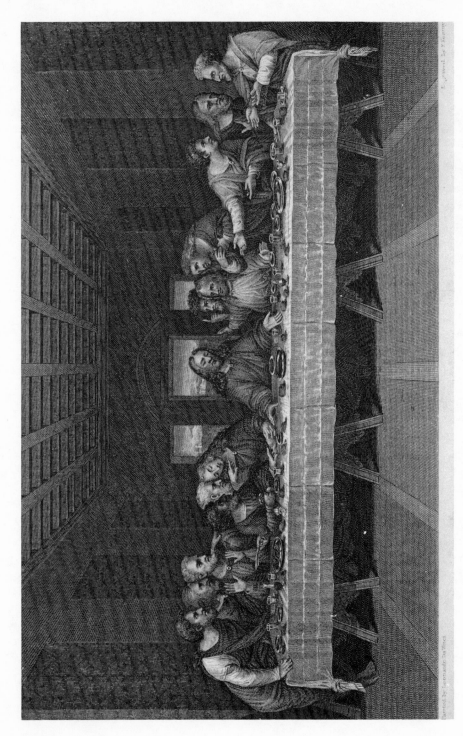

186　THE LAST SUPPER. Engraving by Francis Kearney after Leonardo Da Vinci. *Courtesy Dover Archives.*

of the earliest engravers. I had no hesitation in saying, that one of them had no mark of Hogarth's pencil upon it, or of his genius in the design : the other, (a Recruiting Sergeant enlisting a Clown) was so good, and reminded me so forcibly of " The March of the Guards to Finchley," that I said,— "this may be Hogarth's, though I doubt it." The Drummer sitting at his porter potations was particularly good. A friend of mine asked Mrs. Gill if she knew any thing of two pictures by Hogarth, brought to this country by her father, and in his possession to the time of his death. She replied, that she had never heard of his having any picture by that master in his possession at any time. My friend described the Recruiting Scene ; when the lady stepped to one of her father's portfolios and produced the original coloured drawing ; saying, she remembered perfectly the time he painted it, and all the circumstances attending it ; particularly her delight, as a child, when she saw the monkey in the corner of the picture.

FRANCIS KEARNEY—1804.

Francis Kearney, 1785–1837.

This gentleman was born in the city of Perth Amboy, New Jersey, about the year 1780. His father, at one time a merchant in New-York, was likewise a native of Perth, and his grandfather, an eminent lawyer, long resided there, if not a native. The mother of Francis Kearney was the daughter of Judge Lawrence, of Burlington, New Jersey, and sister of the gallant Captain Lawrence, of the United States navy, whose flag he graced with one of its many victories, and afterwards fell, uttering the well known cry of "Don't give up the ship."

At the age of eighteen Francis, having a predilection for drawing and engraving, was placed with Peter R. Maverick, the best engraver, at that time, in New-York, but miserably deficient, as he had no education in the art, and owed all his attainment to his own persevering industry.

Maverick demanded and received $250 for the instruction of this youth for three years, besides the advantage of his ingenuity and labour. The attention of young Kearney was principally directed to the human figure, and to such compositions as raise engraving from the mechanical arts to the arts of design. His first plate of any account was done for an Encyclopedia, published by Mr. John Law, of New-York.

Drawing he studied under Mr. Archibald Robertson and his brother Alexander. Line engraving, etching, acquatinto, stippling, and soft ground etching were all studied by the young engraver, principally by the aid of books.

At the end of the term agreed for, he commenced business as an engraver for himself, with the usual discouraging circumstances which attend the unknown; but some time after Mr. Collins, a publisher, commenced a quarto bible with plates, which was considered at the time as a great undertaking. Leney, an engraver of merit, who arrived in this country about 1808 or 9, Peter Maverick, the son of Peter R. Scoles, Anderson, and Kearney, engravers of New-York, with Tiebout, and Boyd of Philadelphia, were engaged on the plates for this work.

Philadelphia was at this time far before New-York in the business of publishing books, re-prints of English works, and the decorations of such works gave the principal employment to our engravers. In 1810 Mr. Kearney removed to the capital of Pennsylvania, and immediately found himself in full and constant employment, which continued for twenty-one years that he resided there.

In 1820 he entered into a partnership under the firm of "Tanner, Vallance, Kearney & Co.," for the term of three years. The object was bank-note and other engraving. This proved an unfortunate connection for him, and, as I am informed, at the end of three years he lost the amount of his labour for the whole time. Mr. Henry S. Tanner managed the financial concerns. The publication of the large North American Atlas was commenced; and at the winding up of the business, the financier took the plates, as the other partners complain, and, by finishing them, realized a great profit. However this may be, Mr. Kearney lost the labour of three years of his life.

Since this unsuccessful copartnership Mr. Kearney has been employed on various works for souvenirs and other publications, principally religious subjects, and in 1830 commenced engraving a large plate of the Last Supper of Da Vinci, from Raphael Morgan's celebrated plate. This has been successful, and added to his reputation as an artist. During the progress of this work he returned to his native place, on business relative to his father's estate, but continued his application to his great work of the Last Supper.

In June 1833 he returned to New-York, and there finished this plate, which he sold to Mr. Carpenter, who has already disposed of 1500 impressions at $5 each, and the demand continues.

James Frothingham, 1786–1864.

JAMES FROTHINGHAM—1805.

Mr. Frothingham, at this time (1834) one of our best portrait painters, commenced the working business of life as a

builder of chaise bodies, the trade his father followed and intended for him. He was born in Charlestown, Massachusetts, near Boston, in the year 1786. James early commenced attempts at drawing, and as he succeeded, to the admiration of his schoolmates, applause excited ambition. In due time he gained the art and mystery of chaise building under his father's tuition; but his attempts at drawing having led him to dabble in colours, his first step towards the painting art was to colour the chaise bodies made by himself and his father. This was, at the time, one of those mysteries only imparted by masters to their apprentices under seal of secrecy, and the youth had to devise means by which to compel the colours to adhere to the wood, and make one layer of paint keep its place over another. Many unsuccessful experiments did not discourage him, and he finally, notwithstanding the extreme closeness of the coach and chaise painters in the neighbourhood, obtained the art.

In the mean time his experiments in drawing had been in progress; and from copying a print from a child's book, line by line, he had attained to the representation of a bowl, a hat, and other objects technically called still-life, with an encouraging degree of truth. At this period of his progress, towards his destined profession, some one suggested that portraits might be made with black and white chalk on grey paper. He tried with charcoal and chalk, and prevailed upon a relation to sit to him. This was pronounced a monstrous likeness. He next sat to himself, and produced a portrait in indian ink. The portrait of his grandfather, in oil colours, was the next experiment. He had never seen a painter's palette but contrived a machine for himself, such as he thought proper for the purpose—it was a piece of board, in which he made holes to receive as many *thimbles* as he had colours, which diluted with oil, were thus disposed of, every colour to its thimble and every thimble to its hole in the board, ready to receive the brush. Of tints or mingling of colours he knew nothing. With this original apparatus and without instruction, he commenced portrait painting, while yet applying himself to the discovery of some mode by which to accomplish chaise painting, at the same time working at his trade. His mode of making out a likeness was as unusual as his palette was original. He painted first the forehead and finished it, then one eye and afterwards the other, finishing each as he went, and so feature by feature to the chin. The hair was then put on, the drapery followed, and last a background. Even thus

working in the dark, he made such pictures as called forth the applause of his father's neighbours and his own associates.

That the lad should have been in the neighbourhood of Boston all his life, and striving to paint from childhood, and yet have remained in total ignorance of the mode of operation adopted by others, is a curious fact. Of the fact I am assured by Mr. Frothingham himself. It marks a degree of seclusion from that portion of society to which all these matters are familiar, which at first sight appears very strange; but perhaps we should find in the occupation of the father, and the associates of the young man, a sufficient explanation. So far Frothingham had been almost self-taught.

Having been sent on business to Lancaster, Massachusetts, he there first met with a portrait painter. Mr. Whiting was the son of General Whiting, an old revolutionary soldier. This gentleman did not continue long in the profession, but entered the army of the United States. At this time, however, he had the power and the will to show young Frothingham what kind of an instrument a painter's palette is, and how painters use it. Mr. Whiting had sought and received instruction from Stuart. He communicated freely what he had freely received, and Frothingham was told with what colours the great painter set his palette, how he mingled his tints, and in some measure how he used them.

The youth returned home elated with his acquired knowledge, and eager to put in practice the lessons he had received. He procured a palette—dismissed his thimbles, procured colours and oils as directed, and began a portrait in the usual manner as he had been instructed by Whiting. About this time likewise, he obtained the privilege of reading Reynold's Discourses—the first book he had seen on the subject of painting. This again marks the seclusion to which a young man may be confined, although within the precincts of a dense and enlightened population.

His success in the mode of painting now adopted by him was so great, that at the age of twenty he found sufficient employment as a portrait painter at low prices, to induce him to abandon the painting of carriages, just as he had mastered the mystery by his own efforts. He was likewise induced to marry, while yet he had to obtain a profession or property to support a family.

Stuart, as we have seen, took up his residence in Boston in 1805, and his name had previously reached Frothingham; but although desiring above all things to see the great painter, and obtain his instruction, it was far from his thought that

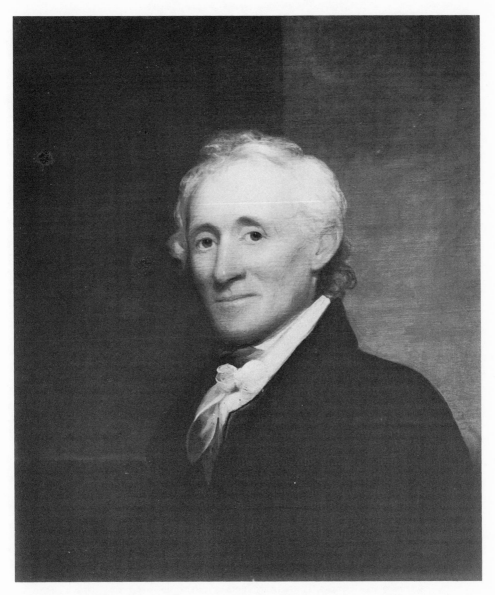

187　JONATHAN BROOKS. Painting by James Frothingham. *Courtesy Worcester Art Museum.*

188 CHRISTOPHER COLLES. Painting by James Frothingham after a painting by John Wesley Jarvis. *Courtesy The Metropolitan Museum of Art, gift of Dr. Christopher J. Colles.*

such good was attainable. He had found that coach painters
had secrets, which could only be obtained by a long service as
an apprentice, and he concluded that a great portrait painter
would require still longer servitude or payment of money far be-
yond his means, before communication of his higher mysteries.
At length, after Stuart had removed to Roxbury, and was
surrounded by his family, after much debate the young man
determined to approach the awful presence of the first portrait
painter in the country. There was at this time, an ingenious
painter of signs and ornaments in Boston of the name of Penny-
man. This man had talents which had attracted the notice of
Stuart. Pennyman accidentally saw the portrait of a Mr.
Foster, painted by Frothingham, and advised him to see Mr.
Stuart. The young man with great trepidation walked to
Roxbury, determined to gain admittance within the lion's den.
He thought he would present himself as one wanting his pic-
ture painted, and make inquiry respecting Mr. Stuart's prices.
He was admitted without difficulty, but Stuart was not at
home. His son Charles received him, answered his questions,
and showed him the works of his father.

Encouraged by Pennyman, he soon after determined to
show one of his own heads to Stuart, and again walked from
Charlestown, through Boston and over the neck to Roxbury;
this time carrying the portrait of Foster. He knocked and
Mrs. Stuart opened the door. He presented himself without
showing in the first instance that he had brought a picture,—
leaving it out of sight of whoever might come to the door.
"Your name, Sir, and I will announce you." This appeared
as an awful ceremony to the young painter—but he must go
on. He gave his name, and was ushered into the old gentle-
man's painting room. He mustered courage to communicate
his business. "I will tell you any thing I know—have you
brought any specimen of your present skill?" "I have brought
a portrait, sir—it is out-o'-doors." "Bring it in, sir, we don't
turn pictures out of doors here—bring it in."

On the great painter's esel was a portrait of Judge Jones,
thought by Mr. Frothingham, one of his best. Stuart placed
the young man's work by the side of it. He asked him what
his present business was. "Coach painting, sir." "Stick to
it. You had better be a tea-waterman's horse in New-York,
than a portrait-painter any where."

Notwithstanding this damper, Frothingham saw and heard
enough to encourage him; and he obtained permission to
come again. On his next visit he did not see the painter, who
was engaged with a sitter, but his son Charles told him that

his father had said, "That young man's colouring reminds one of Titian's." This was fixing Frothingham in the pursuit fated for him. He from this time forward carried his portraits to Roxbury, and never went without receiving a lesson of importance. The sixth picture he carried for criticism, he was amply repaid for his long and fatiguing walk by the remark, after due examination, "You do not know how well you have done this."

In the year 1810, Stuart said to his pupil, for such Frothingham must now be called, after looking at a recently painted portrait, "There is no man in Boston, but myself, can paint so good a head." And not long after, went further by saying, "Except myself, there is no man in the United States can paint a better head than that," pointing to the last his pupil had brought to him.

Mr. Frothingham removed from Charlestown to Salem,— it was there I first saw him. He was full of employment, but I remember nothing in his rooms at that time that would justify the high eulogium above given, or that could compare with portraits from his pencil since painted in New-York. He was induced to remove to Boston, but Chester Harding had gained the public favour, and even Stuart was left unemployed! In 1826, Mr. Frothingham removed to New-York, where he remains painting heads with great truth, freedom and excellence, but not with that undeviating employment which popular painters of far inferior talents at the same time find. He has, as he says, been made to remember Stuart's first characteristic advice and remark, "Stick to coach-painting. You had better be a tea-waterman's horse in New-York, than a portrait-painter any where."

But this is not a fair estimate of the profession. It will be found by every candid examiner of the disappointments and vexations attending upon the portrait-painter, that like all other troubles which befall man, much is owing to himself. It is hard to bear the supercilious conduct of the rich and ignorant who assume the patronizing tone, but it is best to smile in the confidence of superior knowledge. It is hard to have appointments broken which have caused hours of preparation ; but it is best to receive a sitter so as to give token of the injury done you, but without ill-humour. When a well informed person engages a portrait, the engagement is held sacred, but with the vulgar a contract of that nature is not thought binding, although one for a hogshead of tobacco or pipe of rum, would be considered as not to be violated. The painter is injured in his feelings, and through the preparations he makes, and the

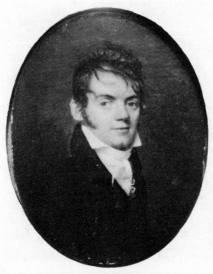

189 J. W. GALE. Miniature by Anson Dickinson. *Courtesy The Metropolitan Museum of Art, bequest of Mary Anna Palmer Draper.*

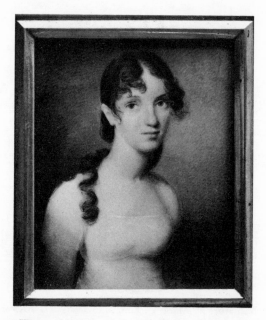

190 MRS. ROBERT WATTS. Miniature by Anson Dickinson. *Courtesy The Metropolitan Museum of Art, Lazarus Fund.*

reliance he places on the faithless individual—but he has no redress, and had better smile than scold. I have heard of painters, who if a sitter came a few minutes beyond the time appointed, would turn him or her away—this is churlish and injures his practice.

ANSON DICKINSON—1805.

Anson Dickinson, 1779–1852.

Was born at Litchfield, Connecticut, in 1780. He was apprenticed to a silversmith, and worked as such. He commenced miniature painting in 1804, or before. I first saw him at Albany in 1805, and his painting was then indicative of talent. He became a very good colourist. He was a very handsome, promising young man, but the promise of his youth has not been realized. In 1811 he was the best miniature painter in New-York. He has led a wandering, irregular life, without credit to himself or his profession.

PETER MAVERICK—1805.

Peter Maverick, 1780–1831.

The son of Peter R. Maverick above noticed. Taught by his father, but far excelling him as an artist, Mr. Maverick was, for a time, in most prosperous circumstances, his emoluments principally accruing from bank-note engraving. Some misfortunes connected with a partnership business, left him late in life to commence anew, with a very large family to support. A. B. Durand was his pupil, and in him the arts owe to Mr. Maverick unbounded gratitude—for however great the talents of the pupil, much is due to the master. Mr. Maverick died when still in the prime of life at New-York, the place of his birth.

CHAPTER XV.

John S. Cogdell of Charleston, S. C.—Educated for the bar—Early visit to Italy in search of health—Returns and paints as an amateur—By Allston's advice applies himself to modelling and the study of anatomy—Models several busts of distinguished men—Prepares to visit Europe for study, but is cruelly disappointed, owing to loss of his property, by a bank failing in New-York—Mr. Cogdell's public employments and present eligible situation—Otis Hovey—Moritz Fürst—Robert Mills—Education as an architect—The buildings designed and executed by him.

JOHN STEPHANO COGDELL—1805.

John Stephano (or Stevens) Cogdell, 1778–1847.

THIS gentleman was born in the city of Charleston, South Carolina, on the 19th of September, 1778; and at about seventeen years of age left the Charleston college, and was

placed in the office of a distinguished member of the bar; this gentleman, Judge Johnson, being promoted to the state judiciary, Mr. Cogdell, having charge in part of the business he left, found his health so much injured by application to it, that he seized the opportunity of a friend's visiting the Mediterranean and its shores, embarked with him in June 1800, and visited Gibraltar, Leghorn, Pisa, Florence, Sienna, and Rome. Previous to this he had felt no great passion for the arts, and only amused himself with water coloured copies from prints; but the pictures of Italy and a visit to Canova called forth latent powers and excited ardent aspirations, which were counteracted by continued ill health. With little bodily amendment, he returned home in about eight months and resumed his professional labours.

The desire to become an artist, however, increased, and he solaced himself for the hours devoted to legal duties by procuring materials and attempting painting in oil, and at the same time imported casts and applied himself to drawing from the round: from the plaster he advanced to the living head for his study, and painted many of his friends' likenesses as presents.

His preceptor, Judge Johnson, having been removed to the federal court, invited him to visit Washington city, which he did in 1806. On his return he received from Mr. Jefferson, then president, an appointment as consul at Rome, no doubt with a view to gratify his taste, and facilitate his study of the arts of design; but Mr. Cogdell could not avail himself of this kind intention, as his circumstances were not equal to the expense of the visit, and the appointment conveyed no emoluments.

After a happy marriage with Miss Gilchrist, Mr. Cogdell's business as a lawyer increased; and although his study of art was diminished, he found time to paint a crucifixion as a present to his former instructor at college, the Rev. Simon Flex Gallagher, which was placed as an altar-piece in his church. He likewise painted a picture for the Orphan House, and many others, heads and landscapes, as presents to his friends.

Mr. Cogdell made frequent visits to the cities of the north, and found pleasure, encouragement, and instruction from his intimacy with their artists. In the year 1825, Mr. Cogdell visited Boston for the second time, and met his friend and fellow townsman Washington Allston, whom he had not seen for twenty years. Mr. Allston strenuously advised him to model in clay, and he promised that he would make the attempt.

In 1826 Mr. Cogdell very wisely applied himself to the study

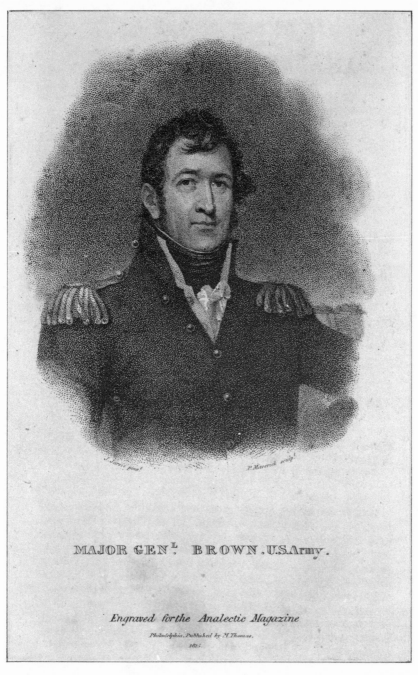

MAJOR GEN^L. BROWN. U.S.Army.

Engraved for the Analectic Magazine

Philadelphia. Published by M.Thomas.
1815.

191 MAJOR GENERAL BROWN, 1815. Engraving by Peter Maverick after the painting by John Wesley Jarvis. *Courtesy Dover Archives.*

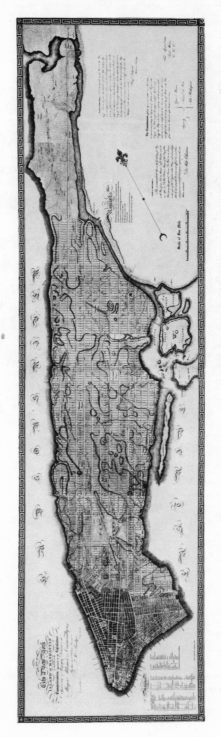

192 PLAN OF THE CITY OF NEW YORK, 1810. Engraving by Peter Maverick. *Courtesy Prints Division, New York Public Library, Stokes Collection.*

of anatomy, and on one occasion mentioned to the professor, the promise he had made to his friend Allston : this led to an agreement with the professor, by which he submitted his head for a study, and Cogdell, although only verbally instructed in the use of clay, modelled his first bust. This year he again visited Boston, and was encouraged by Allston to proceed, and the result was, on his return home, a bust of General Moultrie, a cast of which was presented to congress, placed in their library, and occasioned very flattering compliments on the floor of the House of Representatives.

While pursuing his profession with industry, Mr. Cogdell found time to design and model not only busts, but figures. But he had one favourite object in view, which was to visit England, France, and Italy, and taking with him a wife, whose attachment and congenial taste would aid and encourage him to devote himself to the arts in the latter country. Steadily pursuing this object, he had accumulated a capital nearly amounting to what might support him in Italy, by its interest, when circumstances threw in his way a citizen of New-York— a member of the bar—a former president, and then solicitor and director of a bank in that city. By the recommendation of this gentleman, he was induced to sell out stocks in Charleston, and send the proceeds subject to his proffered friendly investment.

In a letter before me, communicated by the friend of Mr. Cogdell, from whom I derive my knowledge of the above particulars relating to him, he says, " My fancy had almost numbered the months in which I should be enabled to plume my wings, and revel in the works of art in England, France, and again in Italy ; but in the spring of 1828 I received in about ten lines from the gentleman, a picture of my ruin in the bank's failure, in which he had invested my funds." He says in another passage : " I have never heard since from the gentleman."

Thus were his liberal and favourite hopes blasted. Happily he had a profession, and held an office under the general government in the customs, and summoning philosophy to his aid, he pursued his studies in art in unison, with attention to his immediate occupation as a man of business.

Mr. Cogdell has served in the legislature of his native state, and has held the office of comptroller general. In 1821 he was appointed by president Monro, naval officer of the customs of Charleston, re-appointed by John Q Adams, and afterwards by Andrew Jackson. From this situation he

was taken in July 1832, to superintend the business and interests of the bank of South Carolina, as president.

Mr. Cogdell has distinguished himself as a painter, and without having even seen any one model, he has modelled busts, figures, and groups, and without seeing any one chisel in marble, has executed several works in that material, particularly a tablet with three figures, which forms part of a monument erected in St. Phillip's church by himself and brothers, to the memory of his mother.

Thus happily situated, (notwithstanding his disappointment) with ample competency, honoured and intrusted by his country, Mr. Cogdell enjoys the blessings attendant upon a virtuous and industrious life.

Otis Hovey, 1788–?.

OTIS HOVEY—1805.

It is questionable whether this name should be entered as that of an artist, or of one who furthered the progress of the arts of design in America; but as his pictures, though merely copies, were, as such, extraordinary for one in his circumstances, here he is. He was born in Massachusetts in 1788, and his father removing to Oxford, state of New-York, the boy's genius (as we call it) was first discovered there as usual, by his attempts to draw familiar objects. Samuel Miles Hopkins, Esq., of the city of New-York, saw the boy's attempts, and wishing to aid talent, invited him to the city in 1805, and supported him there. At this period he made several copies in oil, which are with Mr. Hopkins, and possess merit as such; and as the productions of an ignorant youth, much merit. An attempt was made by Mr. Hopkins to interest our rich merchants in the lad's fate, so far as to raise money to send him to Europe, but the plan failed—the money was not forthcoming. In the meantime, Hovey showed a vulgar disposition for vulgar enjoyment, and his friend was obliged to send him home. He there painted portraits of the neighbours for a time, and then sunk to oblivion.

Moritz Fürst, 1782–?.

MORITZ FÜRST—1807.

This gentleman is a die-sinker, well instructed in his art, which is in many respects so distinct from the other arts of design, that I hoped to give a sketch of its history, and an account of the process by which such beautiful works are produced. I had promises given me by Mr. Moore, the Director of the mint of the United States, and by a practical die-sinker of New-York, but they have proved—promises.

Mr. Fürst, in answer to my inquiries respecting himself, says that he was born at Boesing, near the well known city of Presburg, in Slavonia, a province of Hungary, in the month of March, 1782. His principal instructor was Mr. Würt, die-sinker in the Mint of Vienna. Under this gentleman, Mr. Fürst was taught the art of sinking dies for coins and medallions. He had a second instructor in Mr. Megole, at Mancheneries, who had pursued his profession at Vienna in his youth, but was afterwards superintendant of the mint of Lombardy.

In the year 1807 Mr. Fürst was engaged by the American consul at Leghorn to be die-sinker to the mint of the United States, and arrived in America in September of that year. Mr. Fürst says, " I was installed in that capacity by Joseph Clay, Esq. in the spring of 1808."

I have heard from others that Mr. Fürst has experienced injustice. That he is a good artist I know. He resided in New-York many years ago, and in 1816 executed some work under my direction for the swords presented by the state to military and naval officers who had distinguished themselves.

Mr. Fürst has again resided in New-York for the last four years, but I fear his emoluments from his profession have not been equal to his skill or deserts.

ROBERT MILLS—1807.

Robert Mills, 1781-1855.

This gentleman is a native of Charleston, South Carolina, and was educated at the college of that city under the charge of Bishop Smith and Dr. Gallagher.

In the year 1800, Mr. Mills was sent by his father to the city of Washington, and placed in the office of James Hoban, Esq. architect of the public buildings then erecting in that city. Here he prosecuted his studies about two years, when he made a professional visit to all the principal cities and towns in the United States; and on his return to Washington was introduced to Mr. Jefferson, President of the United States, under whose patronage Mr. Mills resumed his studies, being furnished from Mr. Jefferson's library with such architectural works as he had, (principally Palladio's.) Mr. Jefferson was a great admirer of architecture, and was highly pleased to find an American directing his attention to the acquisition of this useful branch of science with a view to pursue it as a profession, and therefore gave Mr. Mills every encouragement to persevere. The president was then erecting a mansion at Monticello, which he afterwards occupied, and engaged Mr. Mills to make out the drawings of the general plan and elevaion of the building; the drawings of the details Mr. Jefferson

reserved to himself; and it is surprising with what minuteness he entered into these, every moulding was designated, and its dimensions, in figures, noted, so that nothing was left for the workmen to conjecture. He introduced every order of architecture in the finish of the various rooms, all true to the rules of Palladio. Mr. Jefferson was altogether Roman in his taste in architecture, and continued so to the day of his death, as may be seen on examining the University buildings in Virginia, designed by him, and carried into execution under his supervision.

Mr. Mills soon after visited his native city, and while there, designed the Congregational church of that place, a building of a novel form, a complete circle internally, ninety feet in diameter, and covered with a dome of equal span, the first attempt in this country to execute such an immense spread of roof without any intermediate support. He also laid before the governor of that state designs for a penitentiary institution, accompanied by an examination of its principles. He shared, sometime before this, in the premium given by the legislature of South Carolina for the best design for the new college, since built at the seat of government of that state, (Columbia.)

On his return to Washington, Mr. Mills was introduced by the president to Mr. Latrobe, then recently appointed architect of the capitol, and advised to enter as a pupil into that gentleman's office, which he did. His studies were now directed to engineering, and he was soon transferred to the seat of operation, in the state of Delaware, where the work of examination and location of the canal between the two bays began, of which Mr. Latrobe had been appointed engineer. This important survey was completed, and the work begun, when it had to be abandoned for want of funds. Mr. Mills removed to Philadelphia, where he was employed in designing and executing several buildings; among which was the Bank of Philadelphia, a Gothic structure, (the first attempt of this style of architecture in the United States) a work of the most intricate and difficult character to execute, from the curious forms of the vaultings, and great span of the centre arch, all of which were built of solid masonry.

He likewise designed and executed the Washington Hall, afterwards destroyed by fire in consequence of omitting that part of the plan which recommended making the first story fire proof. He designed, also, the Baptist church in Sansom-street, a building planned and constructed upon accoustic principles, expressly to insure a good hearing and speaking room

193 GENERAL POST OFFICE, WASHINGTON. Architecture by Robert Mills. *Courtesy Library of Congress.*

194 WASHINGTON'S MONUMENT IN BALTIMORE. Architecture by Robert Mills. Courtesy Library of Congress.

capable of containing four thousand persons. The result proved the correctness of the principles advocated by Mr. Mills : it is, perhaps, the most perfect speaking and hearing room, for its size, in the United States.

The fire proof wings of the State House in Philadelphia, for the public records, were also designed and executed under Mr. Mills's superintendence. The bridge near the Water-works, Philadelphia, which spans with a single arch the Schuyl-kill river, and which has the largest chord of arch in the world, is the design of Mr. Mills.

The company had fortunately engaged in its service a man well skilled in the business of bridge building, and who had both enterprise and nerve to carry the plan proposed for a single arch into execution, and he effected it greatly to the honour and advantage of the bridge company, creditable to the builder, Mr. Lewis Wernwag, and gratifying to the archi-tect ; it was besides an atchievement in the arts which the city of Philadelphia may justly be proud of. The chord-line of this bridge exceeds 340 feet.

All the timbers are sawn through the heart, and no two pieces touch each other, being separated by iron plates, secur-ing by this means the works from the attack of the dry-rot. It is upwards of twenty years since its erection, and it is now as firm and sound in its main timbers as when first raised.

Mr. Mills was one of the first promoters of the Society of Artists in Philadelphia, and acted as the secretary of that institution while he remained there.

The court house at Richmond was designed by Mr. Mills, as well as several private buildings in that city.

The Burlington county prison, New Jersey, constructed upon the fire-proof plan, was also designed by Mr. Mills.

After the close of the late war a premium of $500 was offered for the most approved design of a monument to Washington, to be erected in the city of Baltimore, which was adjudged to Mr. Mills ; being an important work, he was invited to remove to that city and take the charge of its exe-cution, which he accepted, and accordingly in 1817 took up his residence in Baltimore, and prosecuted this great work to its present state. He was soon after appointed president and engineer to the water company of Baltimore, and pro-jected and executed many works of improvement connected with that city.

Among the public buildings designed and executed by him in Baltimore are the Baptist Church, a circular building, eighty

feet in diameter, surmounted by a dome, also the St. John's Church. Mr. Mills, while a resident of Baltimore, presented designs for the State house, then about to be erected at Harrisburg, Pennsylvania, and obtained one of the premiums. During the pecuniary pressure of 1819, when property was at a low stand in Baltimore, and there was a great falling off in the trade of the West, which was diverted down the Mississippi to New Orleans, Mr. Mills published a work on the internal improvements of Maryland, urging upon its citizens the importance of opening a permanent intercourse and trade with the Western country, by means of a continuous canal from Baltimore to Ohio river, with a branch to the Susquehannah. While this subject was under examination he was invited to his native state to enter into her service, in proseculing a system of internal improvement there. Operations being suspended for the present on the Washington monument, he was at liberty to accept the invitation, and in 1820 removed to South Carolina, and was appointed one of the acting commissioners of the board of public works, and engineer and architect of the state. Here he designed, and had executed a number of public buildings for court houses, prisons, record offices, &c., all upon the fire proof plan. He designed also the Lunatic Asylum at Columbia, a very spacious and costly building, constructed entirely fire proof. During this period a premium was offered of $500 by the legislature of Louisiana, for the best plan of a penitentiary, to be built at New Orleans, and Mr. Mills' design was approved of. The principle upon which this design was founded has been adopted in other penitentiaries, since erected. Aware of the importance of a more efficient system of internal improvement than was pursued by his native state, Mr. Mills published a work on the practicability and advantages of a continuous canal from Columbia to Charleston, to render effective what had been done, pointing out, at the same time, the all important object of opening an intercourse as speedily as possible with the western country, to secure the rich boon here freely offered, and to secure which, all the great atlantic cities were striving. Mr. Mills sent a copy of this work to Mr. Jefferson, and received in reply a very flattering reply.

He also called the attention of the citizens of South Carolina, to the improvement of their rich swamp lands, the mines of the state, as promising not only wealth, but health to the people of that state.

Among the buildings designed by Mr. Mills in Charleston, are the fire proof offices, for the public records; a fire proof

195 FALLS OF THE POTOMAC. Painting by George Beck. *Courtesy Mount Vernon Ladies' Association.*

196 VIEW AT HARPER'S FERRY, WEST VIRGINIA. Painting by George Beck. *Courtesy Mount Vernon Ladies' Association.*

magazine, upon a new plan of dividing the powder among several buildings, (so that in the event of any accident happening to one, the other might be safe from explosion,) and a fire proof prison wing. The Baptist church in that city, was designed also by Mr. Mills. While in South Carolina, he undertook and completed a great work, " The Atlas of the state of South Carolina, from actual survey," embracing twenty-eight copper engraved maps of the districts of the state, on a scale of two miles to the inch : he also published as an appendix to the atlas, the statistics of the state, a voluminous work.

During the visit of General Lafayette to South Carolina, Mr. Mills assisted as architect, to lay the corner stone of the monuments dedicated to De Kalb, erected in the city of Camden, near the Presbyterian church, (which was also designed by him.)

During a visit which Mr. Mills made to Baltimore, about this period, he published a series of papers addressed to the citizens of that city, upon the importance of securing and facilitating the trade with the Susquehannah river, by the construction of a rail-road between Baltimore and York haven, which is now in considerable progress; and would have been long since completed, but that a charter had not yet been granted by the state of Pennsylvania, to take it through its territory. On his return to South Carolina, he drew the attention of the citizens of that state, and particularly of Charleston, to the propriety and expediency of making a rail-road from that city, to Hamburg and Columbia, which has resulted in the accomplishments of the work, at least to Hamburg, much to the advantage of commerce and the travelling.

The Bunker Hill monument committee, having invited plans to be offered for the monument, Mr. Mills forwarded drawings of an Obelisk design for their approval, and it is now under execution, differing only from his design, by the omission of some decorations which he considered essential to the beauty and utility of the structure. In one of Mr. Jefferson's letters to Mr Mills, who had mentioned the character of the design he had made for this monument, Mr. Jefferson remarks, " Your idea of the Obelisk monument is a very fine one. I think small temples would also furnish good monumental designs, and would admit of great variety, on a particular occasion, I recommended for General Washington that, commonly called the lanthern of Demosthenes, of which you once sent me a drawing handsomely done by yourself."

Great complaints being made, from time to time, by the

members of congress, of the difficulty of hearing and speaking in the Hall of Representatives; and no satisfactory plan being settled upon, to remedy the defect, Mr. Mills took an opportunity, when on a visit to Washington, to lay before the House a plan of alteration and improvement of this hall, which would remedy, in a great degree, the evil complained of. He went into a scientific examination, at the same time, of the causes of the existing difficulties, grounded upon well-established principles in acoustics; and showed what the effect would be were these causes removed. The subject being referred to a select committee, they reported in favour of the plan proposed by Mr. Mills, and recommended an appropriation to be made to carry it into execution; which has since been effected under his supervision; and the present congress are now deriving the advantages of the alterations made, which have not disappointed public expectation, being acknowledged to be a decided improvement. Mr. M. is now engaged in the service of the general government, and resides at Washington.

CHAPTER XVI.

Beck—Dearborn—M. Bourdon—William West—William S. Leney—Bass Otis—William Mason, the first wood engraver in Philadelphia—Jacob Eichholtz—his birth place and early occupation—Sully instructs him—he visits Stuart—Sully's surprise at his great improvement—Successful practice and independent retirement—Eliab Metcalf—descended from the pilgrims—ill health—attempts painting—settles in New-York—obliged by feeble health to reside in the West Indies—great success—death—character---John Crawley—Thompson---John Lewis Krimmel---a native of Wirtemberg---invited to this country as a merchant---previously taught painting, and prefers the profession---revisits his native land---returns to Philadelphia---extraordinary talent for design---extraordinary love of truth---His election picture---untimely death by accidental drowning---moral character---Tilyard---his genius---misfortunes---madness---death.

BECK—DEARBORN—BOURDON—WM. WEST—1807.

George Beck, 1748 or 1750–1812.

Samuel H. Dearborn, *fl. c.* 1804–*c.* 1823.

Probably David Bourdon, *fl. c.* 1810–*c.* 1813.

George William West, 1770–1795.

MR. BECK is, as far as I am informed, only entitled to notice as the first painter who penetrated beyond the Alleghanies.

Mr. Lambdin says, in a letter to me, " Beck may be justly considered the pioneer of art in the West. His landscapes are scattered over the entire union. He was for many years engaged in teaching a seminary of young ladies in Lexington, Kentucky, and died in 1814. His widow survived until 1833, and painted many clever pictures from his sketches."

The same obliging correspondent says, " Dearborn is the first portrait painter of whom I can gain any knowledge as

197 GEORGE W. LOVE. Painting by Samuel H. Dearborn. *Courtesy The Filson Club. Photograph Frick Art Reference Library.*

198　Elizabeth Young Love. Painting by Samuel H. Dearborn. *Courtesy The Filson Club. Photograph Frick Art Reference Library.*

having practised in the West. There are several of his por-
traits in Pittsburgh, painted from 1807 to 1810."

" About the same time," says Mr. Lambdin, " appeared at
Pittsburgh a French refugee, who painted small portraits in
an indifferent style. He figured in the triple capacity of pain-
ter, musician, and dancing-master." His name was Bourdon.

My friend, R. Gilmor, Esq. of Baltimore, says, that "Wm.
West was the son of the rector of St. Paul's, Baltimore; and
showing, by attempts at painting, that he had incipient talent,
was sent, in 1789 or 90 to England, to his name-sake, Benj.
West, and studied under his instruction." I am led to believe
that this gentleman, after returning home, married and settled
in Lexington, Kentucky, and became the father of W.E.West,
who will occupy another page of this work.

WM. S. LENEY—1808.

William Satchwill Leney,
1769–1831.

An English engraver, and born in London. He served his
time with Tomkins, of London, and before he emigrated had
established a reputation in stipple engraving by several plates
of magnitude. I remember particularly that from Rubens's
" Descent from the Cross." He entered into a partnership
with Mr. Rollinson of New-York, in bank-note engraving.

Leney was a prudent man, made money and kept it. His
manners were remarkably simple, and yet the cockney was
thoroughly impressed upon them. He retired from business
and purchased a farm on the river St. Lawrence, a little below
Montreal; where I passed a day with him, and went out on
the river with him in pursuit of plover. His eldest son was
the farmer; and he, having renounced his occupation to enjoy
life—died.

BASS OTIS—1808.

Bass Otis, 1784–1861.

Mr. Otis was born in the New England states, and appren-
ticed to a maker of sythes. As a portrait painter he appeared
in New-York about the year 1808. He removed to Phila-
delphia, and exhibited portraits at the Academy in 1812. He
painted a view of his master the sythe-maker's shop, and
presented it to the Pennsylvania Academy. His painting be-
gan, as I am informed, by working with a coach painter.

Mr. Otis, as a portrait painter, has strong natural talents,
and a good perception of character. Many of his heads are
well coloured. At one period he painted many portraits
in Philadelphia, but they were all of one class; if not so ori-
ginally, he made them so.

Mr. Otis has occasionally returned to New-York and set up
his esel with temporary success.

William Mason,
fl. c. 1808–*c.* 1844.

WM. MASON—1808.

This gentleman, one of our early engravers on wood, was born in Connecticut in the year 1804. He was apprenticed to Abner Reid, copper-plate engraver, of Hartford; who, at the same time, painted signs, and occasionally executed a wood cut, in what his apprentice calls "the old type metal style." The beautiful effects produced in wood, by Doctor Anderson, of New-York, excited the admiration and ambition of Mr. Mason; and in 1808 he made his first essays in wood engraving on ornaments for toy-books. Want of proper tools and want of experience impeded his efforts, and stimulated his ingenuity to supply deficiencies in both. His success determined him to persist in wood engraving. Learning that there was no engraver on wood in Philadelphia, he proceeded thither as soon as out of his apprenticeship, (1810) and was well received and amply employed.

During the last war with Great Britain Mr. Mason entered into other employments, and relinquished his wood engraving to his pupil, Mr. George Gilbert.

Jacob Eichholtz, 1776–1842.

JACOB EICHHOLTZ—1809.

I cannot do better than to let this gentleman tell his own story.

"I was born in the town of Lancaster, Penn., in the year 1776, an eventful year it was to Americans, and I often bless my stars that I was born some time after the declaration of independence, not wishing to have been a British subject, this smacks of democracy you will say, but so it is, I can't help it, I took in the fresh air of independence; but I digress—my parents were both descendants of Germans, and reared a large family of children,—I must digress again, and state that my father and three brothers, all carried arms in our struggle for independence. My parents being in moderate circumstances, could ill afford to give their children more than a plain English education. The first impulse I remember to have felt for drawing, was when a child not more than seven years of age, generally confining myself in the garret, when I should have been at school, to delineating objects that struck my fancy, on the wall with red chalk. My father not knowing the full value of the arts, felt little inclined to foster my first rude efforts. 'Tis true, a common sign painter was at length called in to give me the first rudiments of drawing. This painter being a man of strong passions, in a fit of unrequited love, committed suicide by shooting himself. I shall ever remember the pang I felt on first hearing of the destruction of my teacher, I

199 GENERAL THOMAS MIFFLIN. Painting by George William West after the painting by John Trumbull. *Courtesy Sidney W. Rumsey. Photograph Frick Art Reference Library.*

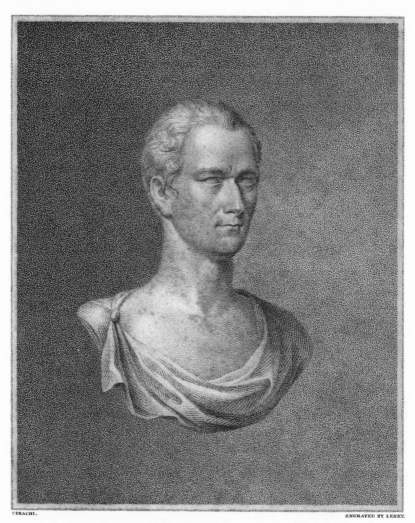

CERACHI. ENGRAVED BY LENEY.

PUBLISHED BY JOSEPH DELAPLAINE.

ALEXᴿ. HAMILTON.

200 BUST OF ALEXANDER HAMILTON BY GIUSEPPE CERACCHI. Engraving by William
Satchwill Leney. *Courtesy Dover Archives.*

considered myself forever cut off from a favourite pursuit. The
instruction I received from this source was little better than
nothing, yet the seeds were sown. At the proper time I was
put apprentice to a coppersmith, (a wretched contrast with a
picture maker,) when still my predilection for drawing showed
itself in the rude sketches of my fellow apprentices pictured on
the walls of the shop with a charcoal. After the expiration of
my apprenticeship, I commenced the coppersmith business on
my own account, with pretty good luck; still the more agree-
able love of painting continually haunted me. Chance about
this time threw a painter into the town of my residence. This
in a moment decided my fate as to the arts. Previous to the
arrival of this painter, I had made some rude efforts with tole-
rable success, having nothing more than a boot-jack for a
palette, and any thing in the shape of a brush, for at that time
brushes were not be had, not even in Philadilphia. At length
I was fortunate enough to get a few half-worn brushes from
Mr. Sully, being on the eve of his departure for England, this
was a great feast to me, and enabled me to go on until others
were to be had, (1809.) About this time I had a family with
three or four children, and yet had not courage to relinquish
the coppersmith and become painter. To support my family
as a painter, was out of the question. I divided my attention
between both. Part of the day I wrought as coppersmith, the
other part as painter. It was not unusual to be called out of
the shop, and see a fair lady who wanted her picture painted.
The coppersmith was instantly transferred to the face painter.
The encouragement I received finally induced me to relinquish
the copper business entirely. About this time a Mr. Barton,
whose memory I will ever gratefully cherish, strongly urged
me to visit the celebrated Stuart at Boston. I went, and was
fortunate enough to meet with a handsome reception from that
gentleman, through the co-operation of the late Alexander J.
Dallas and his son George, who were at Boston at the time,
and who felt a lively interest in my success. Previous to
visiting Boston, I had painted a portrait of Mr. Nicholas Bid-
dle, President of the United States Bank, and as it required, in
visiting Stuart, that I should have a specimen of skill with me,
in order to know whether I was an impostor or not, Mr. Bid-
dle very politely offered me the picture I had painted for him,
and which was well received by the great artist. Here I had a
fiery trial to undergo. My picture was placed alongside the best
of his hand, and that lesson I considered the best I had ever re-
ceived: the comparison was, I thought, enough, and if I had
vanity before I went, it left me all before my return. I must do

Stuart the justice to say that he gave me sound lectures and hope. I did not fail to profit by them. My native place being too small for giving scope to a painter, I removed to Philadelphia, where by an incessant practice of ten years, and constant employment, I have been enabled again to remove to my native place, with a decent competence, and a mind still urging on for further improvement, having but now, at this period of my life, just conceptions of the great difficulty of reaching the summit of the fine arts. I look forward with more zeal than ever.—It is a fire that will never quench; and I hazard nothing in saying that I fully believe that the freedom and happiness of the citizens of this free country will one day produce painters as great, if not greater than any that have embellished the palaces of Europe."

I copy from a letter of Sully's, his account of his first meeting with Mr. Eichholtz:

" When Governor Snyder was elected, I was employed by Mr. Binns to go on to Lancaster, and paint a portrait of the new chief magistrate of the state. Eichholtz was then employing all his leisure hours, stolen from the manufacturing of tinkettles and copper-pans, in painting: his attempts were hideous. He kindly offered me the use of his painting room, which I readily accepted, and gave him during my stay in Lancaster, all the professional information I could impart. When I saw his portraits a few years afterwards, (in the interim he had visited and copied Stuart,) I was much surprised and gratified. I have no doubt that Eichholtz would have made a first-rate painter had he begun early in life with the usual advantages."*

Eliab Metcalf, 1785–1834.

ELIAB METCALF—1809.

One of the many of our artists who sprung from the true nobility of America, the yeomanry of the land. He through life displayed the virtues which are derived from good early education—an education in the bosom of a family where order, morality and religion were the practice and joy of the inmates.

Eliab Metcalf was born in the town of Franklin and state of Massachusetts, on the 5th of February, 1785. His ances-

* In my intercourse with Mr Eichholtz, I have admired in him a man of frank, simple, unpretending manners, whose conversation marked his good sense, and whose conduct evinced that propriety which has led to his success and ultimate independence. Mr. T. B. Freeman informs me, that in 1821 he saw at Harrisburgh a portrait by Eichholtz, which excited his curiosity; and going to Lancaster, he called upon him, and invited him to Philadelphia, where the first portrait he painted was Freeman's, and soon afterwards Commodore Gale's.

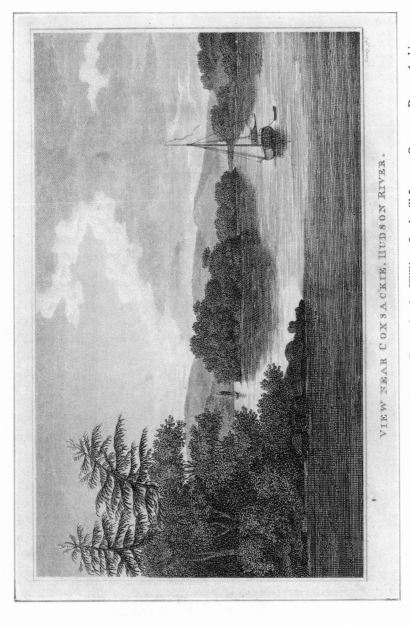

VIEW NEAR COXSACKIE. HUDSON RIVER.

201 View near Coxsackie, Hudson River. Engraving by William Satchwill Leney. *Courtesy Dover Archives.*

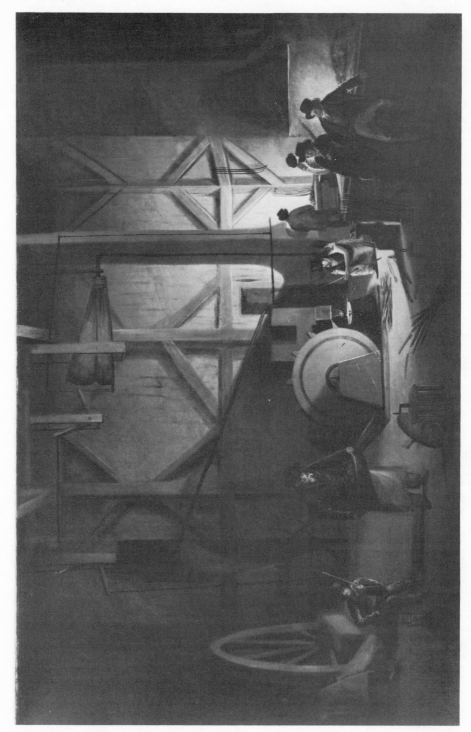

202 INTERIOR OF A SMITHY. Painting by Bass Otis. Courtesy The Pennsylvania Academy of the Fine Arts.

tors, from the time of the landing of the pilgrims at Plymouth had, in successive generations, occupied the same farm, and tilled it, prosperously serving their country, and ever bearing the character which led to the flight from European oppression. Eliab's father bore the same high character. His name was James. The mother of the painter was Abigail Harding, a near relative of Chester Harding, now one of our first portrait painters. Eliab was the third son of his parents, and was intended to succeed his father as an agriculturist; but it was written otherwise in the book of that law by which the universe is governed and is advancing to its perfection.

After a common school education, the youth was occupied in the labours of the farm, until the age of eighteen, when a cold affected his lungs and disabled him for the employment. This *cold* was the foundation of the disease which pursued him through life. At this time, 1807, he became acquainted with a youth of the name of Loviel, a native of Guadaloupe, who was receiving his education in the United States, and accepted his invitation to pass the winter with him in his native island, as a mean of restoring his health. This visit to Guadaloupe influenced his movements in after life. In the spring Metcalf returned home, but on the passage renewed *his cold,* and was confined under the care of my early friend Dr. Wright Post, for many weeks at New-York. To his care and skill Mr. Metcalf attributed his recovery from this attack. Less fitted than ever for agricultural labours, Metcalf, always partial to drawing, thought of painting as a profession better suited to his impaired health and debilitated frame. His friends opposed this wish, and by their advice he passed the succeeding winter in mercantile pursuits in the West Indies. He was unsuccessful in commerce, but returned home in the spring with renewed health, and his books filled with attempts at drawing. Fully determined to pursue painting as a profession, his father reluctantly consented, for the worthy yeoman could see no prospect of fortune in an occupation which appeared to him trifling. Young Metcalf now commenced painter of miniatures, without any knowledge of drawing, like a great many before and since. He was confined to his father's house under care of a physician, but improved himself in painting by copying pictures. Being sufficiently recovered, he travelled as a miniature painter for several years in the eastern states, Canada and Nova Scotia. Feeling his deficiencies, he came to New-York, and in that city, a perfect stranger, established himself as a painter, and studied drawing under John Rubens Smith,

whose instructions have forwarded many artists, although he never could paint decently himself.

In September, 1814, Mr. Metcalf married Ann Benton, the daughter of Captain Selah Benton, an officer of the revolution. In 1815, Metcalf made his first effort in oil painting, under the kind instruction of Messrs. Waldo & Jewett, who resided in his neighbourhood. They lent him pictures to copy, and directed his efforts. Business slowly but gradually increased with his increasing skill; but his health, which had been gradually failing, had, in 1819, become so poor that his physician recommended a journey to the south. He could not well take with him a wife and two children, and to leave them and his friends, and his increasing employment, was a hard trial to a man devoted to domestic quiet and the happiness of a husband and father. But even for the sake of those dear to him, the effort must be made; and with letters to influential persons in New-Orleans, he, in the autumn of 1819, arrived at that city. He was the only portrait painter in the place, and found abundant employment. His health improved. He gained many friends, prominent among whom was the late Rev. Mr. Larned, who introduced him to men of taste and literature, that could appreciate the artist and the man. Mr. Metcalf remained three years in New-Orleans, with the exception of one visit to New-York, travelling, by advice, on horseback through the western states. In the autumn of 1822, he visited the island of St. Thomas. His success, and the high estimation in which he was held there, has been mentioned to me by my young friend the Rev. Mr. Labagh, who is settled in that island, a native of New-York, and son to our worthy alderman of that name.

At the islands of St. Thomas and St. Croix Mr. Metcalf remained four years, fully employed in his profession. He painted the governors, and many of the principal men of both islands. Being invited by the men in authority at Porto Rico to paint the governor of that island for a stipulated sum, he consented to go thither for that purpose, and a government vessel was sent for him. He was treated with the greatest possible respect, and remained six months on the island fully employed.

Mr. Metcalf improved constantly in his profession, and the pictures he sent home and exhibited at Clinton Hall placed him on a permanent stand of high elevation among our portrait painters. After remaining four years among these islands, the artist thought his health sufficiently re-established to allow the indulgence of passing a winter with his beloved family, and perhaps to remain with them. The experiment failed—he

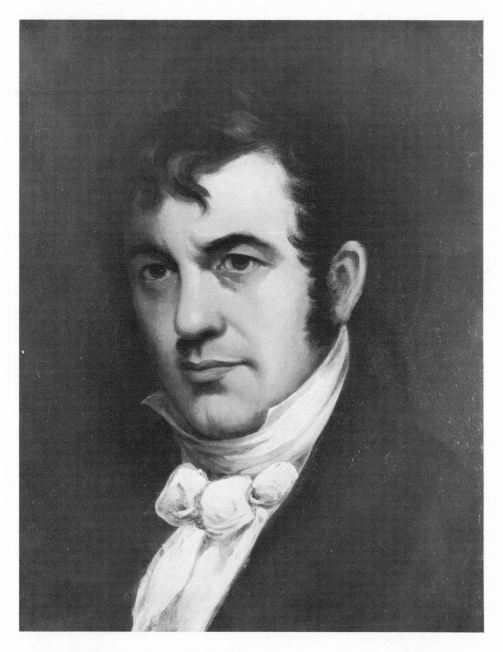

203 JOHN WESLEY JARVIS. Painting by Bass Otis. *Courtesy The New-York Historical Society.*

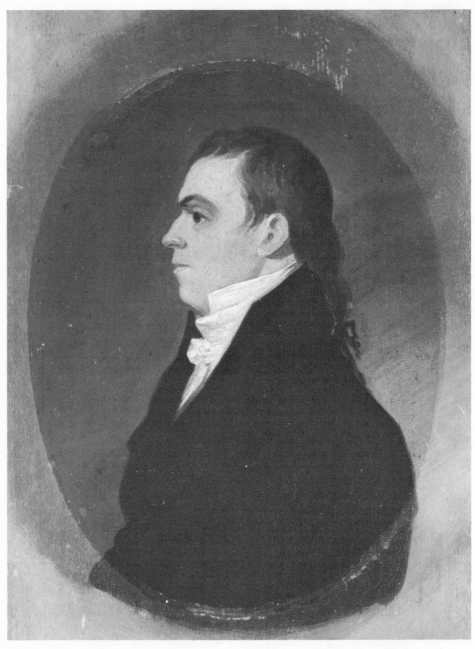

204 WILLIAM DARLINGTON. Painting by Jacob Eichholtz. *Courtesy The New-York Historical Society.*

was confined to his house most of the winter—his cough grew alarmingly worse, and in the autumn of 1824 he again took leave of his wife and children, now four in number, and sailed for the Havana. The Spaniards received him coldly, but for two years he found ample employment from Americans; his health improved, and for six more years he found a more general employment. During these eight years, he visited his family every summer. When the jealousy of the Spaniards was overcome, he had friends and employers of the first grade. The bishop, the governor, and other inhabitants of distinction, treated him with marked kindness; and his family particularly point out among his friends Wm. Picard, Esq. and Mr. Cleveland, the American vice consul.

In April, 1833, the cholera raged in Havana. Mr. Metcalf was seized with this disease, but recovered so far as to be pronounced out of danger. But he never touched pencil more. The pictures begun were left unfinished, yet such was the esteem in which their author was held, that in that state they were sought for, received, and at full price paid for.

The invalid recovered so far as to return to his family in June, but no effort could restore his wasted frame. Hope that the warm clime of the West Indies might yet restore him, led him to return to Havana accompanied by his second son, and his faithful servant Francis, who for the last eight years had scarcely left him for a moment, and to whose kindness and care the artist was indebted for a great portion of the comfort his feeble health had permitted him to enjoy.

The voyage was short, tempestuous, and cold. The sufferer was received with open arms by kind friends—lingered in growing debility until the 15th of January, 1834, and then closed his eyes in death as in sleep.

Mr. Metcalf was among the many amiable men I have known, and I always highly esteemed him. Those who were intimately acquainted with his virtues, speak of him as a model of purity, charity, and exalted piety. His moral character was never tarnished by a single stain, nor has calumny ever dared to affix a blot upon his fair fame.

JOHN CRAWLEY—1810.

John Crawley, 1784–?.

The father of Mr. Crawley was an Englishman, who emigrated to New-York and married a lady of the name of Van Zandt. He was successful as a merchant, and returned to his native country, where John was born in 1784. His parents, however, after a very few years, returned to America, bringing him with them when very young, and settled at Newark,

New-Jersey. John's love of painting, and desire to become a painter, was excited by the portraits of Sharpless; and after an education at a country school, he was sent to New-York for instruction in painting. He was placed with Savage soon after John Wesley Jarvis left him, and had as a fellow-student Charles B. King. From Mr. Archibald Robertson he obtained more than from Savage, and learned those rudiments of drawing, and the management of water colours, which has enabled him to be useful as a drawing master.

Mr. Crawley painted portraits in Philadelphia, and exhibited at the first opening of the Pennsylvania academy of fine arts. After marrying, he took up his abode at Norfolk, in Virginia, where he has continued to this time.

Previous to marriage, Mr. Crawley had made arrangements to go to London, and had visited the brother of Benjamin West on the old Springfield farm, and obtained a letter from him to the painter. He was stopped by the embargo which preceded our last war with England. Mr. Crawley has a son (likewise John Crawley) now in New-York, who has devoted himself to lithographic drawing, and is eminently successful.

THOMPSON—1810.

, Thompson. Cannot be identified among the many artists of this name.

A person of this name painted poor portraits in Norfolk, but managed to procure employment and make money enough to buy a farm in his native village "down east" and retire, independent of all but mother earth, and the rain and sunshine which fertilize her bosom and ripen her products.

JOHN LEWIS KRIMMEL—1810.

John Lewis Krimmel, 1789–1821.

This very extraordinary young man appears to me to have possessed a combination of talents with integrity, wit with kind feelings, genius with prudence, imagination with industry, that must have given him a distinguished station in society, if he had lived to the ordinary bounds of man's earthly sojourn, notwithstanding the impediments which the state of society in our country a few years back presented in the path of the man who devoted himself to the muses rather than to the powers who preside over dollars and cents. I do not recollect any foreigner, who has visited America, who had superior claims to admiration as an artist, and esteem as a man, to Mr. Krimmel.

J. L. Krimmel was born in the town of Edingen, in the duchy or principality of Wirtemberg, Germany, in the year 1787, and came to this country in company with his countryman Rider, in 1810. He had been well instructed in drawing

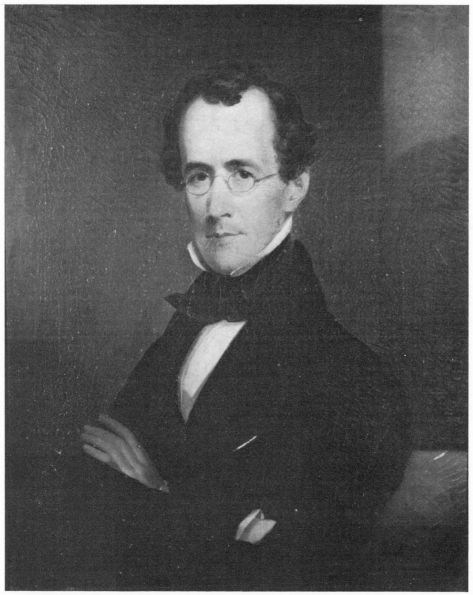

205 JOHN WILLIAMSON NEVIN. Painting by Jacob Eichholtz. *Courtesy John Nevin Sayre.*

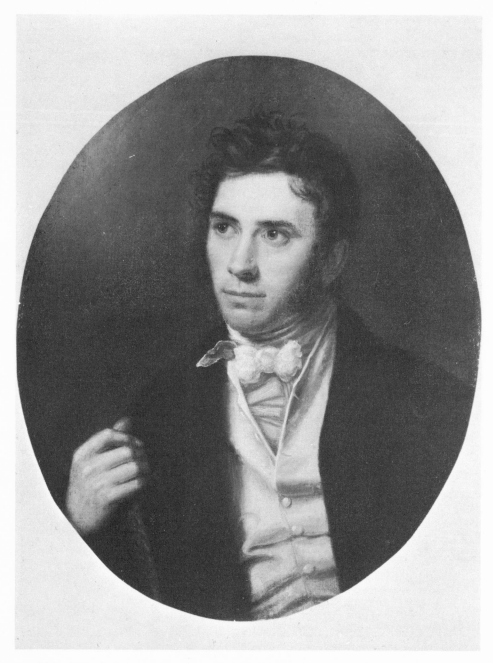

206 ASHER B. DURAND. Painting by Eliab Metcalf. *Courtesy The New-York Historical Society.*

and the management of colours. The brother of the young painter had preceded him in emigration, and having been some time in Philadelphia as a merchant, sent for the subject of our memoir to come over to him, his intention being to connect him with himself in commerce, but the young man preferred the pencil; and finding this difference of opinion made his situation onerous, he renounced trade and threw himself upon the resources of his own skill and genius.

He at first painted portraits, and those of the master and mistress of his boarding-house, and the boarders who were its inmates introduced others, until he found himself independent, or only dependent on his own exertions. I have reason to believe that these portraits were miniatures in oil, somewhat in size like those with which Mr. Trumbull commenced his career. He soon showed that the style in which Wilkie excelled, and the humour which had inspired the pencil of Hogarth, were his own; such scenes were his delight, and to display them on the canvas his sport. The first effort of this kind which attracted public attention to the young stranger was his "Pepper-pot Woman." Pepper-pot is an article of food known no where else in the United States but in Philadelphia—I presume introduced from the West Indies; and though it is, year after year, and day after day, cried in the streets, it is never seen at the house of a citizen by a stranger. The pepper-pot woman is an animal only known in the streets of Philadelphia.

About this time the print of Wilkie's Blind Fiddler came out, and Krimmel was so delighted with a composition congenial to his taste and feeling, that he made a picture in oil colours from it, of the same size, and in every respect truly admirable. His "Blind-man's-buff," an original picture of the same size, soon followed; this was likewise in oil and of great merit, but the sketch in water colours has even more. These were followed by the "Cut Finger," and others in the same style, which all elicited admiration. In 1811, the year after his arrival, he exhibited the "Pepper-pot Woman;" "Celadon and Amelia," "Aurora," and "Raspberry girls of the Alps of Wirtemberg," all marked in the catalogue *for sale.*

Small was his remuneration for these extraordinary efforts; and he, with his friend Rider, likewise an artist, became teachers of drawing. Such was Krimmel's strict economy, that at the end of a few years he found himself enabled to revisit his dear *fader-land.* He took passage for and landed in France, travelled to Vienna, visited other parts of Germany, particularly his native town of Edingen—the steeple of whose

church appeared much lower to him than when he had looked back upon it from Philadelphia, and probably many other things had diminished in the same proportion ; and after seeing many good pictures and good people, he appears to have been content to return to America as the land of his choice. The store of gold with which he left Pennsylvania was not great, yet, with honest pride, he threw a portion of it on his friend's table at his return, as a proof of his prudence, temperance and economy.

On returning to Philadelphia, Krimmel resumed his occupation of teacher of drawing. The principal portion of the emolument resulting from this source proceeded from a great boarding-school for young ladies. Krimmel, like an honest and conscientious man, was in the habit of teaching the girls what to do, how to do, and then leaving them to do it, under instruction. The consequence was, that his pupils did not produce, in a given time, such pretty pictures as were presented to their parents by the young ladies of a rival establishment, where the cunning and complaisant teacher put his lessons in practice by finishing the work his pupils were utterly incompetent to the production of, and thus cheating papas and mamas, and increasing the reputation of the school. Krimmel was told by the proprietor of the establishment that he must not only teach her scholars to draw and paint, but must draw and paint for them, or give up the school. The unbending Wirtemberger did not choose to be an agent in deceit, and chose the latter part of the conditions. Honesty, poverty, a clear conscience and independence were preferable, in his mind, to money, servility and falsehood.

My valued correspondent, John Neagle, Esq., says of Krimmel : " He confessed to me that he could not paint in a manner broad, and at the same time delicate enough to please himself. He could not paint hair well, arising perhaps, from his having too perfect a vision, which conveyed every minute particular. He could stand at a great distance and count the different courses of bricks in a building without a glimmer before the eyes. He was candid and honest to every one, very blunt to those who asked his opinion, but too kind of feeling to wish to wound. He was free to communicate any thing he knew, he had no secrets to sell. His acuteness of vision led him to the use of very small brushes, some no thicker than a common pin. After his death I purchased, at a sale of his effects, all his brushes, many were so small as to be useless to me, and I gave

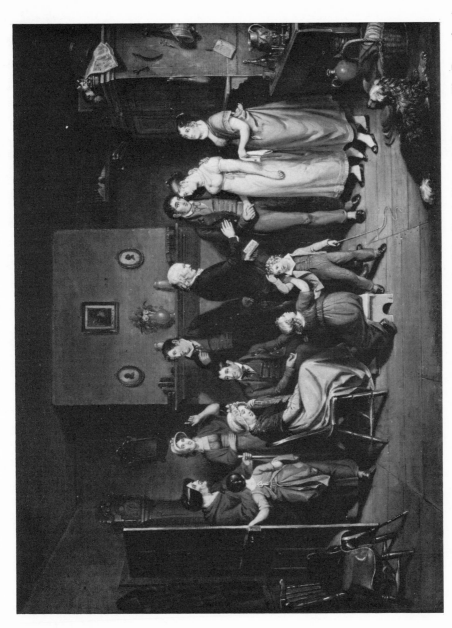

207 COUNTRY WEDDING; BISHOP WHITE OFFICIATING, c. 1814. Painting by John Lewis Krimmel. *Courtesy The Pennsylvania Academy of the Fine Arts.*

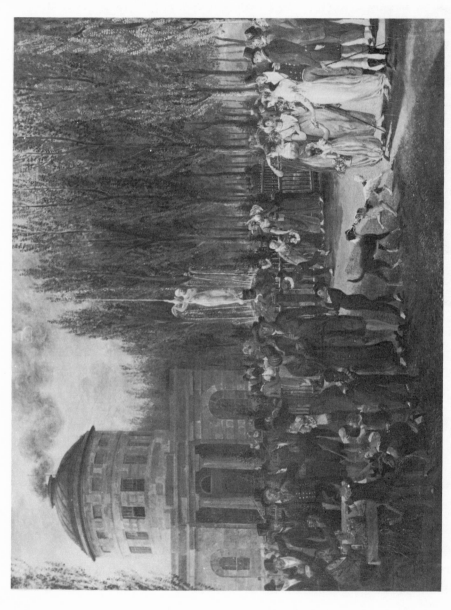

208 Fourth of July in Centre Square. Painting by John Lewis Krimmel. *Courtesy The Pennsylvania Academy of the Fine Arts.*

them to his friend Rider, who works with the same kind of tools."

In 1812 Mr. Krimmel exhibited in the Pennsylvania Academy of Fine Arts, a picture representing a crowd in the Centre Square, Philadelphia, which is said to rival Hogarth in truth, nature, and humour.

Notwithstanding his extraordinary talents, Krimmel received no commissions, and had little to do. He did not seek to paint portraits, and works of the species he delighted in were not sought after by the wealthy patrons of art. He wanted little—he called upon no one for aid or employment —he enjoyed the friendship of his brother artists—he studied, sketched, and occasionally painted.

The last work he finished is a great composition of several hundred figures in miniature oil, executed with a taste, truth, and feeling, both of pathos and humour, that rivals, in many respects, the best works of this description in either hemisphere. This picture I have seen. It is a Philadelphia election scene, in Chesnut-street, in front of the state house. It is filled with miniature portraits of the well known electioneering politicians of the day. It has a portrait of the venerable building within whose walls the independence of America was declared. The composition is masterly, the colouring good, every part of the picture carefully finished, and the figures, near or distant, beautifully drawn. This picture was either painted for, or purchased by, Mr. Alexander Lawson, who began to engrave it, but, for some reason to me incomprehensible, has been discouraged from proceeding with the work, after bestowing much time and labour on it. Surely the citizens of Philadelphia alone would amply remunerate him.

Mr. Lawson advised Krimmel to paint his favourite subjects without waiting for commissions, and take his chance for the sale. The advice was good, and one would suppose the employment would have been pleasant to him; but he was adverse to the plan, and continued to study and sketch. At length he was engaged to paint a picture of Penn's treaty with the Indians. But while preparing for this arduous task, he went to visit a friend in Germantown; and going with the children of the family to bathe in a neighbouring mill-pond, he strayed from his young companions, and they having finished their sport, waited for him a long time to accompany them home— as he did not return they sought him, but found only his corpse. In the prime of life, with increasing skill and accumulating knowledge, brilliant genius, and immoveable in love of the good and the true, this fine young man was lost to the world, probably

owing to the circumstance of choosing a solitary spot to bathe unobserved by his young companions, who might perhaps, when the cramp seized him, have afforded the necessary succour.

The moral character of Krimmel was faultless. His love of truth exemplary. His simplicity of manners endeared him to his friends, and his shrewd remarks made him at all times an entertaining companion. There was a downright bluntness in his conversation which, although justly appreciated by those intimate with him, did not serve to smooth his path in life, perhaps even retarded his progress.

My friend Francis B. Winthrop possesses several of Krimmel's pictures. He had corresponded with the artist, but had not seen him. One day a man entered and announced himself in a manner partly characteristic, and partly the effect of foreign education, "I am Krimmel." Mr. Winthrop was soon much pleased with his guest.

There is a pleasing mode of behaviour, evincing a wish to accommodate one's self to the wishes of others, which is serviceable to a man by gaining good will, even if it is only the product of education, and the habit formed in early good society; but when suavity of manner and the wish to oblige is perceived to be the result of a feeling, and a true sense of man's duty to man, it is irresistible in its effects, and attaches all hearts to its happy possessor. Such manners are the result of good feeling, united to an extensive knowledge of human nature, a cheerful disposition, and a true sense of our duty. Such manners are therefore rare.

Philip Thomas Coke Tilyard, 1785–1830.

TILYARD—1810.

An honest and unfortunate man of genius. He was born at Baltimore in 1787; and was taught the rudiments of art as a sign painter, which was his original occupation. He committed a fault in buying a lottery ticket, and was greviously punished by drawing a prize of $20,000. The possession of this wealth induced him to enter into commerce, and in a short time he broke—failing for more than he was worth. His sense of justice and propriety was so outraged, that he never recovered from the shock. He resumed his original business of sign painting. My friend Sully says of Mr. Tilyard, in 1810 " his attempts at portrait are admirable: he made great efforts to get on as a portrait painter, and I helped him all I could. Peter Hoffman told me that Tilyard, after his failure, visited him. He did not know him, as his business as a merchant had been transacted by his partner. Tilyard reminded

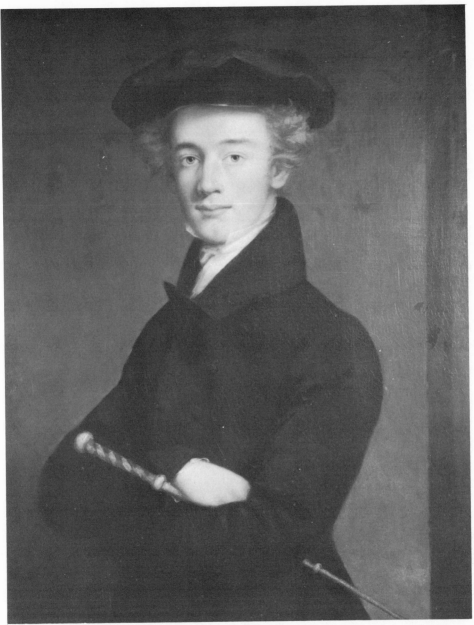

209 JOHN PENDLETON KENNEDY. Painting by Philip Thomas Coke Tilyard. *Courtesy Private Collector. Photograph Frick Art Reference Library*

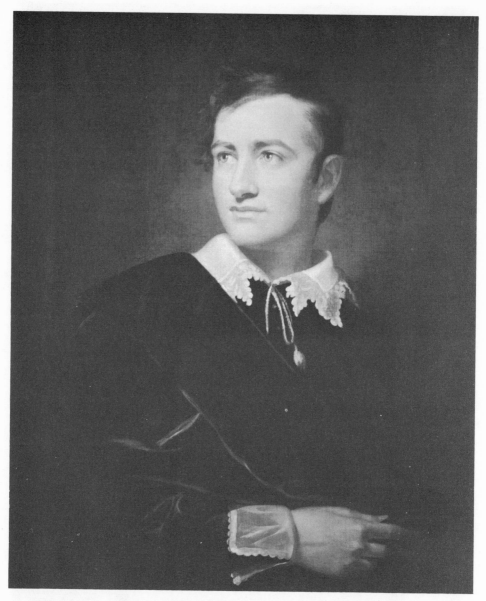

210 JOHN HOWARD PAYNE. Painting by Charles Robert Leslie. *Courtesy Museum of Fine Arts, Boston, gift of George Robert White and Howard Payne.*

Hoffman of the loss his failure had occasioned him, and said the object of his visit was to request Mr. Hoffman to permit him to paint portraits for him to the amount of the debt. He thus relieved his mind and made a friend of Hoffman, who employed him, and *paid him.* A few years before his death (which occurred in 1827, at the age of forty) he lost his reason." The worldling will say he was always mad.

My friend Robert Gilmor, Esq., of Baltimore, says of Tilyard, " He had a true genius, and taught himself to paint excellent portraits. He died mad. Had he been well educated, he would have been a distinguished artist." In another letter Mr. Gilmor says, " He attained considerable excellence as a portrait painter, but died poor and insane ; from dwelling too much on his situation, and the difficulty of supporting his family by his pencil."

CHAPTER XVII.

Leslie's parents Americans—They visit London, and he is born there—brought home in childhood—Encouraged by his father in drawing—Apprenticed to S. F. Bradford, the friend of Wilson the ornithologist—Bradford's liberality—Leslie's sketches of actors—instructed to use colours by Sully—Friends who enabled him to go to England—A room-mate with S. F. B. Morse—West, Allston, and C. B. King—First employment by Americans—West's fatherly attentions to him—"Saul and the Witch of Endor"—"Anne Page and Master Slender"—"Sir Roger de Coverly going to Church," painted for his friend James Dunlop—Marriage—Accepts an appointment at West Point, and returns to America, 1833—Sancho and the Duchess—The Earl of Egremont—West's theory and practice—Washington Irving and Leslie—Mr. Leslie returns with his family to London.

CHARLES ROBERT LESLIE—1811.

Charles Robert Leslie, 1794-1859.

T<small>HIS</small> gentleman's talents, and the taste with which he has exerted them, has placed him in the foremost rank of living artists. His father, Robert Leslie, and his mother, Lydia Baker, were both Americans. They visited England in 1793 or 4, and on the 19th of October, 1794, the subject of this sketch was born in London. Our cousins of Great Britain, who are very willing to cozen us out of any thing that might do us credit, have claimed Leslie as an Englishman, although his parents returned to their native country and carried the boy with them before he was five years old. We would ask an English ambassador residing at Pera, if he has sons born to him there, are they therefore Turks ? No : Charles Robert Leslie is an American, and received his first instruction as a painter

in America, and imbibed his taste and love for the art before he left the country to study systematically in Great Britain.

It has so happened that many of our eminent artists were born in England, and removed to this country by their English parents while infants or children. Sully, Jarvis, Cummings, and Cole, all born in England, all imbibed their love for the fine arts, and their love for the institutions of this country in childhood. Two of them have never been out of the country, since brought into it, and the others were good painters before they sought additional knowledge by returning to the land of their nativity.

The father of our painter was long established in Philadelphia as a watch-maker, and there are persons living who recollect him as a very ingenious man. He was himself fond of drawing, and had attained both accuracy and skill in the art. His drawings of ships and of machinery are spoken of as being beautifully executed. Such was his attachment to this art, that when he sent his boy to school in New Jersey, he stipulated that he should be permitted to draw. Great facility of hand had been acquired by young Leslie in the exercise of his pencil and water colours during his apprenticeship, and his propensity was never discouraged by the liberal gentleman to whom he was bound, nor by any of the Americans around him. His first lessons in painting were received in America, and Americans enabled the youth to seek in Europe for further instruction. He found it, but still he found in Americans, though in Europe, his most efficient advisers and instructors.

In the year 1811, happening to be in Philadelphia, my friends spoke to me of the cleverness of young Leslie, and I went with Mr. Sully to the house of Mrs. Leslie, the young painter's mother; but though introduced to her and her daughters, I did not see him. On the 16th of April I went with Mr. Trott to Mr. Edwin's, the engraver, for the purpose of viewing Leslie's drawings of Cooke, Jefferson, Blisset, and others, which he had made merely from seeing them on the stage in character; and which were to be published in the "Mirror of Taste." I thought them very extraordinary. Leslie was then in the book store of Messrs. Inskeep and Bradford, an apprentice. Two days after I saw him at the fish club on the Schuylkill, where he came with Bradford to sketch the scene, or some of the characters there assembled. I never saw him again till he called with his friend Morse to see me a day or two before he returned to England in April 1834.

On Mr. Leslie's arrival in this country in 1833, I addressed

a letter to him, requesting such information as would enable me to be accurate in my biographical sketch of him for this work : his prompt, frank, manly reply is before me, and it would be injustice to him and to the reader not to give his own words.

After mentioning the facts already given respecting his parents and his birth, he proceeds : "In 1799 my father returned to America with his family, consisting of himself, his wife, and sister, and five children. We lived for a short time in the state of New Jersey, close to the Delaware, and directly opposite Philadelphia ; and there I remember that, on being sent to school for the first time, a condition was made with the schoolmaster that I should be permitted to amuse myself with drawing on a slate, when not engaged in saying my lessons. My father, whose health had been long declining, died in 1804, in Philadelphia, where we then resided. Before this event, I had been sent to the university of Pennsylvania, where, under Dr. Rogers, professor of English grammar, history, &c., and Mr. Patterson, professor of mathematics, I received all the school education I ever had. Here, as well as at the little country school in Jersey, I was more attentive to drawing than to my other studies, though now obliged to practise it by stealth. In the year 1808, I was bound apprentice for seven years to Messrs. Bradford and Inskeep, booksellers, my mother being unable to give me the education of an artist. I had served nearly three years of my time when Mr. Bradford, who had acted more like a father than a master to me, became of opinion that I might succeed as a painter. He informed me that if I wished to devote myself to that art, he would cancel my indenture ; and as some theatrical sketches that I had made had been shown, by him and another excellent friend, (Mr. Joshua Clibborn,) to some of the principal gentlemen of Philadelphia, he had no doubt of raising a fund, by means of a subscription, that would enable me to study two years in England. As I had secretly resolved to commence artist that moment I should become my own master, it may be readily imagined how overjoyed I felt at this most kind and unexpected proposal.

"I know you object (and I think very properly) to the application of the title of *patron of the arts*"—still more to that of patron of the artist—" to the *mere* buyers of pictures ; but I think you will allow that Mr. Bradford and the other friends who enabled me to become a painter, were *patrons* to *me*. I believe the following is a correct list of their names : S. F. Bradford, Mrs. Eliza Powell, J. Clibborn, J. Head, Joseph

Hopkinson, J. S. Lewis, N. Baker, G. Clymer, E. Penning-
ton, William Kneass, Alexander Wilson, the ornithologist, G.
Murray, Engraver, and one hundred dollars was also voted
by the Pennsylvania Academy of Fine Arts. I went to Eng-
land in 1811 with Mr. John Inskeep, Mr. Bradford's partner,
who visited London on business; and after the sum subscribed
was exhausted, Mr. Bradford continued to supply me with
money until I could support myself. Just before my de-
parture, Mr. Sully, with his characteristic kindness, gave me
my first lesson in oil-painting. He copied a small picture in
my presence to instruct me in the process, and lent me his
memorandum books, filled with valuable remarks, the result
of his practice. He also gave me letters to Mr. West, Sir
William Beechy, Mr. King, (Charles B.) and other artists in
London. My earliest friends in England were Messrs. King,
Allston, and Morse. With the latter gentleman I shared a
common room for the first year, and we lived under the same
roof, until his return to America deprived me of the pleasure
of his society. From Mr. West, Mr. Allston, and Mr. King"
(all Americans) " I received the most valuable advice and as-
sistance ; and I had the advantage of studying for several
years at the Royal Academy under Fuseli, who was keeper.
I attempted original compositions, but received no money for
any thing, excepting portraits and copies of pictures, for seve-
ral years. My employers at that time were almost entirely
Americans, who visited or resided in London ; among whom
I may mention Mr. James Brown, the brother of Charles
Brockden Brown, (as I believe you know him.) (You will be
glad to hear that I saw this gentleman in good health on the
18th of September, 1833.)" Mr. James Brown is an estima-
ble friend of the writer's, whom he has not seen for many
years, and of whose welfare he is always rejoiced to hear.

I have now before me a portrait of my friend Doctor John
W. Francis, painted by Leslie in London among his earlier por-
traits, and that and the portrait of the painter's friend Mr.
Dunlop, are the only portrait heads I have seen by him. He
painted a most spirited group of children for Charles King,
Esq., when his family were in England : it is in a bold style,
and admirable for attitude and expression. While my mind
is occupied by the pictures of Leslie brought to New-York, I
will mention one which has always given me great delight—
it is a citizen's family enjoying the delights of the country,
and is in the possession of Mr. Donaldson.

In another letter Mr. Leslie writes : " I presented the letter
Mr. Sully had given me to Mr. West immediately on my ar-

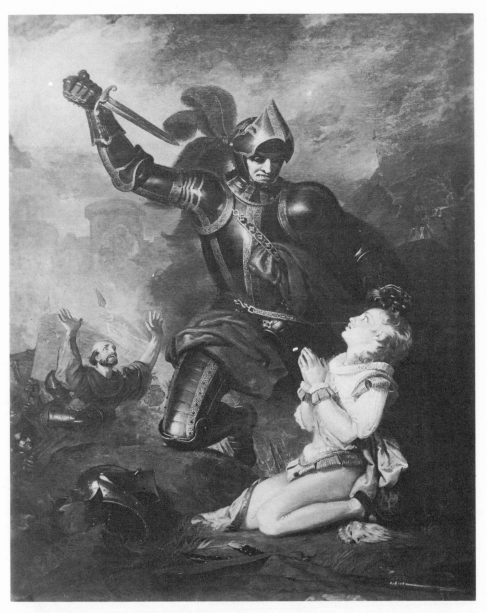

211 THE MURDER OF RUTLAND BY CLIFFORD, 1815. Painting by Charles Robert Leslie. *Courtesy The Pennsylvania Academy of the Fine Arts.*

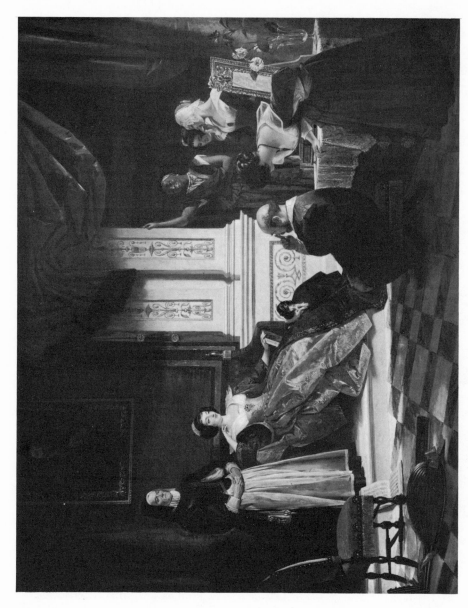

212 SANCHO PANZA IN THE APARTMENT OF THE DUCHESS. Painting by Charles Robert Leslie. *Courtesy Tate Gallery, London.*

rival, and he at once offered me all the assistance in his power in the prosecution of my studies. This offer was amply followed up by the most useful acts of kindness during the remainder of his life. He lent me his pictures to copy, allowed me to paint in his house, and spent a great deal of, what to him was of the greatest value, his time, in directing my studies. One of the first compositions I attempted was "Saul and the Witch of Endor." He came often to my room while I was engaged in it, and assisted me very greatly in the arrangement of the composition, effect, &c.* By his advice I sent it to the British institution for exhibition, but as it was too fresh to varnish, the directors thought it unfinished,† and turned it out. Feeling severely disappointed, I went to Mr. West for consolation, and I received it. He desired me to bring the picture to his house. I did so, and by his advice varnished it in his large painting room. He then told me he would show it to some of the directors of the institution, most of whom visited him frequently. In a few days I had the satisfaction to receive a note from him, telling me he had sold it for me to Sir John Leicester, one of these very directors."

In a periodical work called the Recorder, I find the following under the head of Master Leslie. The writer, after speaking of the interest taken by his friends in Philadelphia in his welfare, continues—

"That he has by his application and improvement justified the expectations of his friends, the writer a few days ago had ample proofs, by the examination of two pictures in oil, the first a copy from a Diana by our illustrious countryman West, the second an original composition of his own, the subject chosen from Scott's Marmion.

"In the first, Master Leslie has succeeded so perfectly, that it would require a connoisseur of more skill than I possess, to pronounce the picture a copy. It has the drawing, colouring, manner, and touch of Mr. West.

"The second, which is sent as a tribute of gratitude to a lady in Philadelphia, who interested herself in the young artist's fortunes, is a composition far above the level of mediocrity, and as it tested, so it proved, the talents of its author. The subject is Constance before her bigoted judges, and at-

* We may judge by this statement of Mr. Leslie's of the assistance Mr. West gave to those who painted their composition pictures altogether under his roof and his eye. In the pictures of such men, painted under such circumstances, we see all the knowledge, not of the painter, but the instructor displayed.

† This institution, like the American Academy of Fine Arts at New-York, is *not* composed of artists.

tended by the executioners of their cruelty. The disposition
and grouping are in a style of chaste simplicity, the figures of
the distance characteristic and well kept; an executioner in
the fore-ground is the most laboured and best figure in the
picture, and unfortunately the principal figure of the piece is
the worst.

"I write some time after having seen the picture, which
was immediately sent on to Philadelphia; but I fear not to
assert, that the friends of Master Leslie and the fine arts may
congratulate themselves upon proof to conviction, that his in-
dustry and talents have justified their efforts and their predic-
tion."

Leslie's picture of the murder of Clifford (now in the Penn-
sylvania Academy) was painted before October, 1816, and
had arrived in America. Allston spoke of it at the time as a
work that did him great honour. A branch of composition,
or rather a description of subjects more congenial to his taste
soon after occupied his pencil, and his success has proved that
such subjects are more to his mind than "battle and murder."

He had likewise, in 1816, painted the portraits of John
Quincy Adams and his wife; Adams being at that time our
ambassador at the Court of St. James's. It was in this same
year that Mr. James McMurtrie, of Philadelphia, being in
London, requested the favour of Mr. West to allow a copy of
the head of Christ by Guido, in Mr. West's possession, to be
made by some competent artist. The request was granted,
and Mr. Leslie pointed out as the painter the owner wished to
copy his picture. Of this picture, Mr. Allston says in a let-
ter to Mr. McMurtrie, "the copy is a very close one, and
would embellish any collection."

In 1818 Mr. Allston says that Leslie had just finished
his beautiful little picture of "Ann Page and Master Slender,"
and intended coming to America in the spring of 1819: but
in 1820 Leslie writes to a friend that the state of the arts in
London is not in the most flourishing condition, notwithstand-
ing, he says, "I have no other view for the present than that
of remaining where I am. I am now painting a picture of
"May day in the time of Queen Elizabeth, which, if I can do
any thing like justice to the subject, will, I think, be interest-
ing. I shall endeavour to give as close a representation of
the manners of the times as I can."

In 1825 an artist writes from London to his friend in Amer-
ica, "The best pictures in the present exhibition are of Wil-
kie, Leslie, Hilton, and Lawrence." Sully says of Leslie's
portrait of Sir Walter Scott, that is a "commanding work.

The expression natural, the effect forcible and true. The flesh colour has too much of light red in it—I think so—notwithstanding the complexion of the original, because I find Leslie has too great love of that colour and yellow oker."

I will now recur to Mr. Leslie's first letter, in which he gives a rapid account of the principal events of his life, to the period of his returning to America in 1833. " The first original composition that made me known was ' Sir Roger de Coverly going to church,' painted for James Dunlop, Esq. my warm and steady friend from that time to this. In the year 1821, I was elected an associate of the Royal Academy, and in 1826 an academician. In 1825 I married Miss Harriet Stone, of London, and in 1833 my brother, without my knowledge, asked and obtained for me the situation of teacher of drawing at the Military Academy of West Point. This induced me to remove to America with my wife and children, and we arrived here in the autumn of 1833.*

" Having given you an account of the patronage I met with before I left America, I feel it due to the country, where for twenty-two years I enjoyed the greatest advantages the world has now to offer to an artist, to mention one among many instances I could relate of the liberality of Englishmen. In the year 1823 I received a commission from the Earl of Egremont to paint him a picture, leaving the subject and price to my determination. I painted for him a scene between Sancho Panza and the Duchess, from Don Quixotte. While it was in the exhibition he called and asked me, if I had received any commission for a similar picture? I told him I had not. He then said, you may, if you please, paint me a companion to it, and if any body should take a fancy to it, let them have it, and paint me another. *I wish to keep you employed on such subjects instead of portraits.* Soon after I received other commissions, and Lord Egremont desired me to execute them, and

* On the arrival of Mr. Leslie and his family, I mentioned the circumstance in a letter to Mr. Allston, and in his next to me (November 4, 1833,) he says " I am glad to hear of the safe arrival of my friend Leslie and his family. He is a valuable acquisition to our country, for he is a good man as well as a great artist. Leslie, Irving, and Sir Thomas Lawrence were the last persons I shook hands with on leaving London. Irving and Leslie had accompanied me to the stage-office, and Sir Thomas, who was passing by on his morning ride, kindly stopped to offer me his good wishes. It is pleasant to have the last interview with those whom we wish to remember associated with kind feelings. I regret that the *res angusti domi* prevent my being one at the *dinner of welcome* which you propose giving to Leslie. Pray say for me that I bid him welcome from my heart; no one values him more, for no one better knows his value." Mr. Leslie declined the dinner proposed by the National Academy of Design, but he passed his last evening in America with them by invitation.

reserve the one he had given me until I should be in want of
employment. An offer was made to me before the picture of
Sancho and the Duchess was sent to him, from an engraver,
with great prospect of pecuniary advantage to me. I asked
Lord Egremont if he would permit an engraving to be made?
He wished to know how long the picture would be required.
I wrote to him (he was then at Petworth) to say two years,
and immediately received the following reply. 'It is a long
time, and I am afraid, at seventy-three, that I shall not live to
see the picture in my possession; but however you shall have
it.' The engraver, however, changed his mind, and begged
I would release him from his engagement, which I was not
sorry to do, and the picture went directly to Petworth. When
Lord Egremont heard of my intended departure from Eng-
land, he wrote to me in the kindest manner upon the subject,
and expressed his fears that I had not met with sufficient en-
couragement. He concluded his letter with these words : 'For
my own part I can only say, that I will gladly give a thousand
guineas for a companion picture to Sancho and the Duchess.'
As this was more than double the price I had received for that
picture, I replied that I should consider it a robbery to re-
ceive it for one of the same size, but that I should be most
happy to paint him a picture in America, if he would allow
me, on condition that the price should not exceed 500 guineas;
and this picture I am now to paint for him." But, alas! not
in America. Leslie has returned to London, and while I
am writing, may be painting for Lord Egremont, or some
other capable of appreciating his worth, in the metropo-
lis of Great Britain. The letter proceeds, "I have men-
tioned this last circumstance because a statement of it has ap-
peared in some of the newspapers, in which it is erroneously
said I refused the commission. Next to Sir George Beau-
mont, the Earl of Egremont was the first to appreciate Mr.
Allston's merit. Sir George employed Mr. Allston to paint a
large picture of the Angel delivering Saint Peter from prison,
which he presented to the church of Ashby de la Zouch; and
Lord Egremont purchased his 'Jacob's Dream,' and a small-
er picture of a female reading. Lord Egremont remarked to
me that the figures in 'Jacob's Dream' reminded him more of
Raphael, than any thing else he had seen by any modern
artist.

"I omitted to mention in its proper place, that in 1817 I
visited Paris, with Messrs. Allston and Collins. I spent three
months there, making studies from pictures in the Louvre, and
then returned to England through the Netherlands, in com-

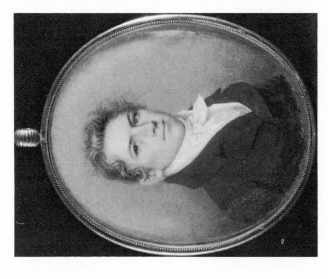

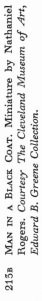

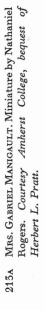

213A MRS. GABRIEL MANIGAULT. Miniature by Nathaniel Rogers. Courtesy Amherst College, bequest of Herbert L. Pratt.

213B MAN IN A BLACK COAT. Miniature by Nathaniel Rogers. Courtesy The Cleveland Museum of Art, Edward B. Greene Collection.

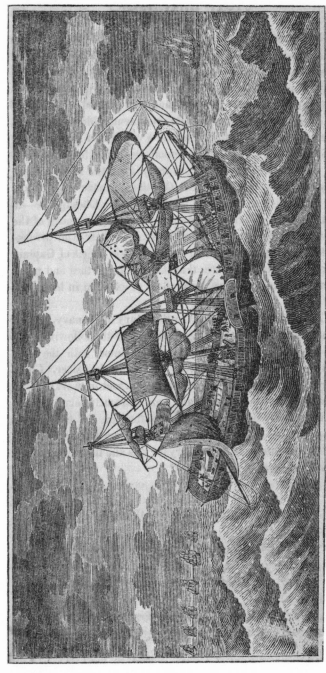

M. Corné, p.

A. Bowen, sc.

THE WASP BOARDING THE FROLIC.

214 THE WASP BOARDING THE FROLIC. Woodcut by Abel Bowen after the painting by Michel Felice Corné. Courtesy Dover Archives.

pany with Mr. Stuart Newton, whom I met in Paris on his
way to London from Italy."

From another letter of Mr. Leslie's, I will make an extract
showing the intimate terms he was on with his great master,
West, and some of the opinions of that profound artist.

" The simple expedients of an artist are sometimes instruc-
tive as well as amusing. I was one day in Mr. West's room,
while he was painting his great picture of ' our Saviour before
Pilate.' On remarking that the helmets of some of the Ro-
man soldiers were painted with a degree of truth that I thought
could only be obtained from models, he took up one of the
fire-irons, and pointing to a small ball of polished steel that
surmounted the handle, said, ' That was my helmet, sir.'*

" Mr. West often condensed a great deal of the most im-
portant instruction in a few words. In speaking of chiaro
scuro, he used to say, ' light and shadow stand still.' And
he frequently expressed by a single word, ' *continuity*,' the
great leading principle of composition, colours, and light and
shadow.

I have heard him say that among the old masters there were
but two that knew how to draw a tree—Titian and Annibal
Caracci.† In the same spirit Fuseli used to say, there had
existed but two poets—Shakspeare and Milton. Mr. West
was of opinion that the superiority of the Venetian painters in
colouring was in no respect owing to the materials they used.
He thought we had better colours and oils than were known
to Titian and Paul Veronese. I believe he was right, and
that the *Venetian secret*, as it is called, was not a chemical
secret. We must study nature, as they did, in the *fields* and
in the *streets*, to arrive at it. Most of us confine our obser-
vations too much to our painting rooms. In the arrangement
of colours in his pictures, Mr. West had adopted a theory
taken from the rainbow, which he considered an unerring
guide. I cannot help thinking that his too strict adherence
to this rule produced a sameness in his works during the latter
part of his life. He said Raffaelle was the only painter who
understood this theory, and that it was from the study of the
Cartoons he (Mr. West) had discovered it.‡ In a small copy

* The reader will be reminded of Mr. Sully's anecdote of the paroquet's wing,
which served for the genii, in " Love conquers all."

† It may be remarked, that the trees and foliage of West's Calypso and
Telamachus, are perfect contrasts in manner to those of his other pictures—yet,
all true to nature, and of great beauty.

‡ Those who recollect Sir Thomas Lawrence's picture of West, (which Law-
rence's biographers say he made a present to the American Academy, but for
which he received $2000 from gentlemen who subscribed the sum in New-York,)

of the ' Peter Martyr' of Titian, which I saw at his house, I observed that colours were arranged on a plan diametrically opposite to that of the rainbow. I asked him if he thought Titian was wrong, but he evaded the question by saying that Titian's eye was so fine that he could produce harmony by any arrangement.

" It is fortunate for the art, that many of Mr. West's best works were engraved under his own eye, and at a period when line engraving had reached its utmost perfection. The ' Lear,' by Sharpe, and the ' Death of Wolfe,' by Woollett, have never been surpassed—perhaps never equalled. Woollett left behind him a fine etching of West's, ' Telemachus and Mentor ship-wrecked on the island of Calypso ;' it has been well finished by Pye, within these few years, though it is not yet so well known to collectors of engravings as it deserves to be. This charming composition is alone sufficient to prove, that Mr. West felt the poetry of landscape. In colour, the picture is inferior to Claude—in every thing else the production of a kindred mind."

The following, from a periodical, expresses my opinion of Mr. Leslie so well, that I give it here :

" Leslie stands high in the rank of our painters of domestic scenes, on subjects connected with life and manners. He is all nature, not common, but select—all life, not muscular, but mental. He delights in delineating the social affections, in lending lineament and hue to the graceful duties of the fireside. No one sees with a truer eye the exact form which a subject should take, and no one surpasses him in the rare art of in-spiring it with sentiment and life. He is always easy, elegant and impressive ; he studies all his pictures with great care, and, perhaps, never puts a pencil to the canvas till he has painted the matter mentally, and can see it before him shaped out of air. He is full of quiet vigour; he approaches Wilkie in humour, Stothard in the delicacy of female loveliness, and has a tenderness and pathos altogether his own. His action is easy ; there is no straining; his men are strong in mind without seeming to know it, and his women have sometimes an alluring *naivete*, and unconscious loveliness of look, such as no other painter rivals.

" It is so easy to commit extravagance—to make men and women wave their arms like windmill-wings, and look with all their might—nay, we see this so frequently done by artists

will recall to mind the rainbow introduced in it and one of Raphael's cartoons, both explanatory of this theory of colours, the subject of that lecture which Law-rence represents him as in the act of delivering.

A View of Lemon Hill the Seat of Henry Pratt Esq.[r]

J.Exillous del & sculp.

215 A VIEW OF LEMON HILL. Engraving by John G. Exillous after his own painting. *Courtesy Dover Archives.*

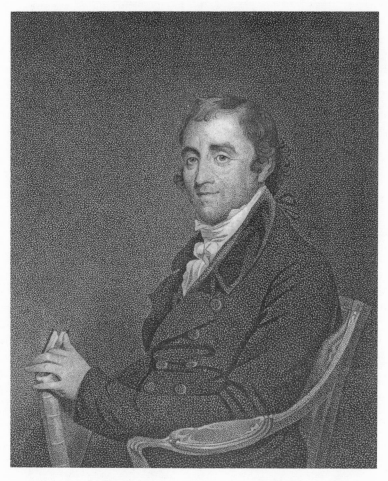

216 FISHER AMES. Engraving by John Boyd after the painting by Gilbert Stuart. *Courtesy Dover Archives.*

who believe, all the while, that they are marvellously strong in things mental—that we are glad to meet with a painter who lets nature work in a gentler way, and who has the sense to seé that violence is not dignity, nor extravagance loftiness of thought. We could instance many of the works of Leslie in confirmation of this; nor are his pictures which reflect the manners and feelings of his native America more natural or original than those which delineate the sentiments of his adopted land. We are inclined, indeed, to look upon some of Leslie's English pictures as superior even to those which the remembrance of his native land has awakened. Roger de Coverly going to church amid his parishioners—Uncle Toby looking into the dangerous eye of the pretty Widow Wadman, and sundry others, are all marked with the same nature and truth, and exquisite delicacy of feeling. He touches on the most perilous topics, but always carries them out of the region of vulgarity into the pure air of genius. It is in this fine sensibility that the strength of Wilkie and Leslie lies ; there is a true decorum of nature in all they do ; they never pursue an idea into extravagance, nor allow the characters which they introduce to overact their parts. In this Leslie differs from Fuseli, who, with true poetic perception of art, seldom or ever made a true poetic picture. Leslie goes the proper length, and not one step farther ; but Fuseli, in his poetic race, always ran far past the winning-post, and got into the regions of extravagance and absurdity. When Leslie painted Sancho Panza relating his adventures to the Duchess, he exhibited the sly humour and witty cunning of the Squire in his face, and added no action. When Fuseli painted the Wives of Windsor thrusting Falstaff into the bucking-basket, he represented Mrs. Ford and Mrs. Page as half-flying: the wild energy with which they do their mischievous ministering is quite out of character with nature, with Shakspeare, and with the decorum of the art.

"The pictures of Leslie are a proof of the fancy and poetry which lie hidden in ordinary things, till a man of genius finds them out. With much of a Burns-like spirit, he seeks subjects in scenes where they would never be seen by ordinary men. His judgment is equal to his genius. His colouring is lucid and harmonious ; and the character which he impresses is stronger still than his colouring. He tells his story without many figures ; there are no mobs in his composition ; he inserts nothing for the sake of effect ; all seems as natural to the scene as the leaf is to the tree. His pictures from Washington Irving are excellent. 'Ichabod Crane' haunts us ;

'Dutch Courtship' is ever present to our fancy; 'Anthony Van Corlear leaving his mistresses for the wars,' is both ludicrous and affecting; 'The Dutch Fireside,' with the negro telling a ghost-story, is capital; and 'Philip, the Indian Chief, deliberating,' is a figure worthy of Lysippus."

Washington Irving, Esq., has told me, that on arriving from the continent of Europe, where he had been some time, he found Newton and Leslie in the same house, and that while he was writing his Sketch Book, he saw every step they made in their art, and they saw every line of his writing. Here was a communion of mind that could not but lead to excellence. Irving's admiration of Leslie, both as a man and an artist, is extreme. A cultivated mind, purity of moral character, refined taste, indefatigable study, by which his knowledge of drawing and skill in composition were such, that having determined his manner of treating a subject, and drawn it in, no change or alteration took place: in this a perfect contrast to his friend Newton.

I have above said, that Mr. Leslie returned to London. In the only interview I had with him, which was in my sick chamber a day or two previous to his embarkation on his return, he did not express any feeling of disappointment. With the government of the United States he certainly had no cause of complaint. He was invited to West Point as *teacher* of drawing, with the same emoluments and accommodations which his predecessor had enjoyed. But his friends, anxious that he should be with them, had assured him that the teachership would be made a professorship, with additional advantages corresponding with the other professors, and that a painting room should be built for him. But in our representative government, this required an act of Congress, and the passage of the yearly appropriation bill. This act and appropriation were intended; but Mr. Leslie had taken post at West Point, at the commencement of winter, with his family, never before out of London. The winter is a trying season in a bleak situation on the Hudson—a situation at other times redundant with charms. Mrs. Leslie is a London lady, and her family remained occupants of the house left by the artist; her heart was naturally at home. Leslie, I am told, upon an answer from the Secretary at War, that he could not order a painting-room built until appropriation was made for it, gladly resigned the situation, and took his family to London again, no doubt happy to escape from the bleak promontory on which they had passed a discontented winter.

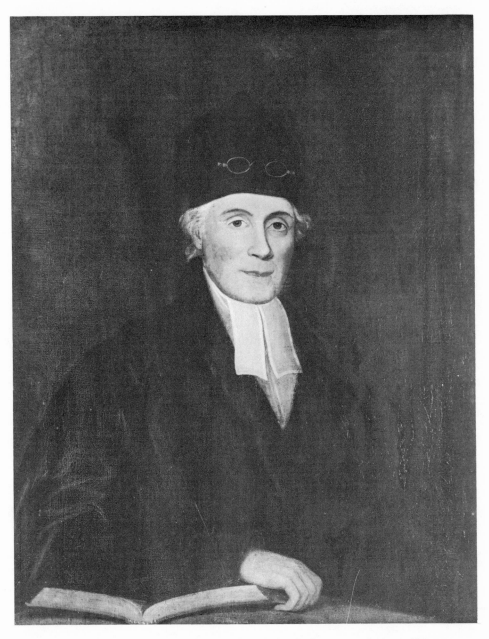

217 SAMUEL STANHOPE SMITH. Painting by Charles B. Lawrence. *Courtesy Princeton University.*

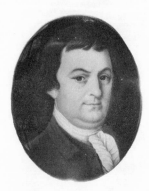

218A JAMES STANYARNE. Miniature by Pierre Henri.
*Courtesy Carolina Art Association. Photograph
Frick Art Reference Library.*

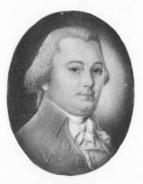

218B JOHN DEAS. Miniature by Pierre Henri. *Courtesy
Carolina Art Association. Photograph Frick Art
Reference Library.*

CHAPTER XVIII.

N. Rogers—Mysterious Brown—Bowen—Beet—Boyd—Exilius—Charles B. Law-
rence—P. Henri—T. Gimbrede—L. White—W. R. Jones—Wm. Jewett—
Throop—Ames- J. R. Smith—Titian Peale—Thomas Birch, a good landscape
painter and excellent painter of sea pieces—Stein—Pennyman—Charles B.
King; instructed by Savage; goes to England; friendship for Sully; they
room together; Sully's opinion of him; amiable and virtuous character—
T. Dowse—Williams—Volozon—Miller—Bishop---James Peale, jun.

NATHANIEL ROGERS—1811. Nathaniel Rogers, 1788-1844.

MR. ROGERS has long been of the first in rank among Ame-
rican miniature painters. He was born in Bridgehampton,
near Sag Harbour, east end of Long Island, in the year
1788. His father was John Y. Rogers, and Nathaniel has
the honour of springing from the same class of citizens that
gave birth to Benjamin West, Joseph Wright, John Vanderlyn,
Ashur B. Durand, Alvan Fisher, Joseph Wood, Francis
Alexander, William S. Mount, and a long list of artists; the
yeomanry of the country, commonly called farmers, because
they till the fields that support them; but in America, those
fields are the property of the man who ploughs them, and their
harvest *his alone.*

His mother's name was Brown; the daughter of the clergy-
man of the parish. This couple had the blessing of five sons,
and the father, though an independent yeoman, knew that
the territory, ample for one, would be a poor provision for five,
and destined his boys after a good common school education,
to be put apprentices to mechanic trades. Nathaniel was
placed with a ship carpenter at Hudson; but when sixteen
years of age, he accidentally received a cut on the knee, from
which he never perfectly recovered, but which seems to have
decided his fate for life. He had always had a desire to make
himself a draftsman, and now returned to the paternal dwelling,
and being disqualified for active life, he was indulged in the
intervals of pain with opportunities to gratify his love of the
art. He was threatened with amputation of the injured limb,
but by care, probably that of a mother, the leg was saved, and
though the knee was never perfectly restored to action, it has
increased in usefulness. Thus present evil, if not the consequence

of vice, is often the parent of future good. He read, copied prints, and even made essays at designing, during his confinement.

His physician, Dr. Samuel H. Rose, had a mind, education, and taste, that might have placed him among those who gain distinction in cities. Above all, he had a benevolent disposition ; and seeing the efforts of the suffering boy, he to alleviate them, and forward his love for the art, presented Nathaniel with a box of colours and pencils, and gave him some instructions as to their use. This decided young Rogers' fate. He copied two miniatures which were in the house, and attempted the likeness of some friends. His father, as soon as he could walk, thought of sending him to New-York for surgical advice—the son thought more of obtaining advice and instruction in painting. In the meantime he accepted the charge of a school, but his mind was more occupied by the children of his fancy, than by those of the rustic yeomanry intrusted to his care; and he soon relinquished a task which his youth, and extremely mild disposition, made him, as I should judge, very unfit for.

On a visit to Connecticut, having taking some ivory and his colours with him, he seems to have commenced miniature painter, like many others, without a knowledge of any portion of the art required. Those around him had never seen any thing so pretty. Encouraged by their praises, and wishing to relieve his father's anxiety, who could not believe that a living was to be made by colouring pieces of ivory, he persevered in painting at very low prices, until he accumulated sufficient to enable him to visit New-York. The family that first gave him a start as a painter, was that of captain Danforth Clark, of Saybrook. A man, from the painter's account, as amiable as himself.

In 1811, when Wood had separated from Jarvis, Rogers came to New-York and found him established, and full of employment, in Broadway. Rogers was received by Wood and instructed in his art. For his instructor he ever retained a strong attachment, and in the days of his adversity, proved a friend to him and his children. This the virtue and prudence of Rogers enabled him to do bountifully.

Mr. Rogers' father was long an unbeliever in the *profitability* of the choice his son had made of a profession ; but Nathaniel now set up for himself, and found increasing employment; and by way of proving to the old man that he was doing well, he sent a handsome sum in bank-notes to him, to remove his doubts, and dissipate his anxiety. This was a

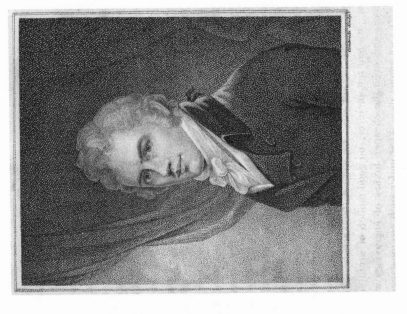

219B EDWARD GREENE MALBONE. Engraving by Thomas Gimbrede after the self-portrait. *Courtesy Dover Archives.*

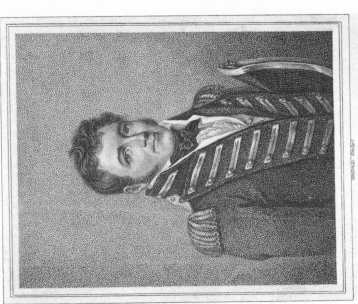

219A JOHNSTON BLAKELY. Engraving by Thomas Gimbrede. *Courtesy Dover Archives.*

James Inglis, D.D.

220B JOHN INGLIS. Engraving by John Peter Van Ness Throop after the painting by Joseph Wood. *Courtesy Dover Archives.*

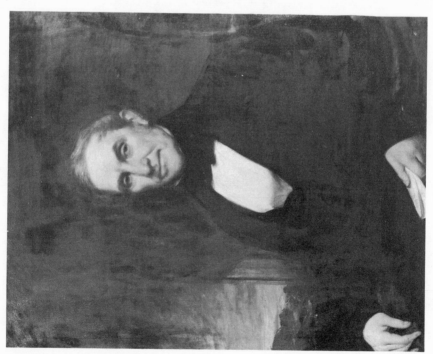

220A ANSON GREENE PHELPS, 1847. Painting by Samuel Lovett Waldo and William Jewett. *Courtesy The New-York Historical Society.*

proud moment for the young painter, when he could ask his father to invest his money as he saw proper, for his future benefit. Wood removed to Philadelphia, and left the field open to Rogers, who, from that time to this, has continued prosperously to maintain a large family honourably, educate his children to his wish, and accumulate property.

Mr. Rogers' first opportunity of deriving profit from painting when in New-York, was by Wood's employing him to work in the subordinate parts of his pictures ; which, after Rogers had been with him one year, he liberally paid for. His independent establishment was in 1811. He married in 1818 to Caroline Matilda, the daughter of captain Samuel Denison, of Sag Harbour ; and they have a family of five children. Brown the miniature painter, whom I have call *mysterious Brown*, was of great service to Mr. Rogers, for he could teach him much. They reciprocally served each the other ; for when Brown found his sight fail, he made use of Rogers' young eyes, and repaid him by instruction.

Mr. Rogers possessed a good constitution, but from his close application to his sedentary occupation, his health declined, and in 1825 he was near falling a victim to the demon who had destroyed Malbone : but by hard riding, and relaxing from business, he was happier than his amiable predecessor ; and has long been restored to health. For twenty-three years he has painted in New-York, and there alone. He now is independent, and contemplates relinquishing painting as a profession, though he never can as an amusement. He is a member of the National Academy of Design, and of several of our charitable and moral institutions. As a trustee of our public schools, he has devoted a large portion of his time to those foundations of our republican happiness. The life, conduct, and prosperity of this gentleman, are lessons for our younger artists.

MYSTERIOUS BROWN—1812.

"mysterious" Brown may be Uriah or Urial Brown, *fl. c.* 1805–c. 1808.

This gentleman was an Englishman, and had been thoroughly instructed in drawing with chalks and in miniature painting, as accomplishments. He came to America at the age of fifty, and by the elegance of his female portraits attracted and deserved employment. He was an amiable man, of genteel manners ; but in literature or any portion of knowledge beyond the chit-chat of the moment, he was ludicrously deficient. He resided in New-York about twelve years, and then returned home. I am convinced that Brown was an assumed name. He was always poor and always well dressed. He

would market for himself and cook for himself, sleeping and painting, and eating in the same room. With half his skill as a painter another man would have accumulated a fortune in this country ; but he was *shiftless* and imprudent, constantly in debt for paltry sums, and haunted by the image of an imaginary catch-pole. There was no quackery about him : he readily communicated his professional knowledge, and Mr. N. Rogers received much information from him, which he repaid by assisting him in various ways. He was as ignorant of the ways of the world as he was of history, mythology, or geography, and with superior talents as an artist, and an amiable disposition, lived in obscurity and returned poor to his family connexions in England, from whom he had been hidden for years under the name of Brown. He practised Sir Joshua Reynolds's method of using the ideas of others in the composition of his pictures, and kept carefully in his trunk a collection of prints, as assistants. He was not singular in this practice, which by inducing the student to rely on others, prevents that observation of nature, which can alone lead to perfection.

Abel Bowen, 1790–1850.

Cornelius De Breet, c. 1772–1840.

John Boyd, *fl. c.* 1810–c. 1825.

John G. Exillous, *fl. c.* 1810–c. 1814.

ABEL BOWEN, C. DE BEET, J. BOYD, EXILIUS—1812.

Mr. Bowen is an engraver on wood settled in Boston. He is said to be a gentleman of talent and a skilful artist. He was the instructer of Alonzo Hartwell in this art.

Cornelius De Beet painted landscapes in Baltimore in 1812, and likewise fruit and flower pieces.

J. Boyd was an engraver in Philadelphia in 1812.

J. G. Exilius exhibited landscapes in Philadelphia in 1812.

Charles B. Lawrence, *fl. c.* 1813–c. 1837.

CHARLES B. LAWRENCE—1812.

This gentleman was born near Bordentown, New-Jersey, and the indications he made of talent induced Judge Hopkinson to encourage his efforts. Rembrandt Peale has mentioned him as a pupil of his. He is said to have studied with Stuart, who said that Charles always had the start of him whenever he suggested any thing. For example, when Stuart, who was instructing him in portrait painting, would say he thought some light or shade or touch was necessary, the pupil would reply, " I was just going to do so." " You had better glaze down that spot." " I was just thinking of it." Stuart wishing to put an end to this, told him that he reminded him of the servant of a nobleman who, when asked why this, or that, was not done, would always reply that he was going to do it,

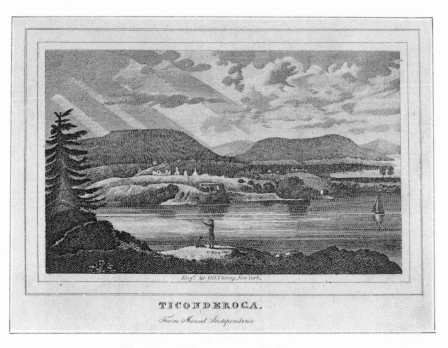

TICONDEROGA.

From Mount Independence

221 TICONDEROGA FROM MOUNT INDEPENDENCE. Engraving by
Orramel Hinckley Throop. *Courtesy Dover Archives.*

222b PHILIP VAN CORTLANDT. Painting by Ezra Ames. *Courtesy The Metropolitan Museum of Art, gift of Christian A. Zabriskie.*

222a GEORGE CLINTON, c. 1812. Painting by Ezra Ames. *Courtesy New York Historical Association, Cooperstown, New York.*

or thinking of it, until the master thought to stop this by ridicule, and said, "John, why the devil don't you *wash my books?*" "Just going to do it, my lord," said John, "I have got the water heating for the purpose."

Charles took the hint, and no longer teazed the painter with "just going to do it."

I remember several of Mr. Lawrence's landscapes without merit, and a portrait in the Pennsylvania Academy that Mr. Thackara, the keeper, told me was much admired. It was smooth, hard, and destitute of any good quality. Mr. Lawrence wisely relinquished painting, and has found employment in private life, where he is said to be very estimable.

PETER HENRI AND THOS. GIMBREDE—1812.

Pierre Henri (or Peter Henry), *fl. c.* 1788–*c.* 1818.

Thomas Gimbrede, 1781–1832.

Both by birth Frenchmen, and both at one period in their lives miniature painters. Henri painted in Richmond, Virginia, and afterwards in Philadelphia; his skill does not entitle him to notice: the same may be said of Gimbrede, but his indefatigable fund of animal spirits and his unwearied exertions made him a more conspicuous object. I have been told that he was first known in New-York as a dancing-master. I first knew him as a miniature painter without employment. He then tried engraving, and did some work for publishers of books, and had a work-shop of some extent and several apprentices. The prints he has published from drawings by himself show his utter want of skill or knowledge in the art, yet he was appointed teacher of drawing to the Military Academy at West Point. In this situation he continued until his death in December 1833.

It must have required uncommon talents, or what is called cleverness, to teach that which he did not know: but by placing before the pupils approved models and making himself acceptable, *he got on.* It adds to his celebrity, that the government, on his death, invited one of the best artists in existence to supply his place—no, not to supply his place, but to fill a situation to which he had proved incompetent. How he obtained the appointment which Leslie occupied and Weir now fills, is one of the mysteries never to be explained. He was an enthusiast in animal magnetism, and is said to have suffered from it.

L. WHITE AND WM. R. JONES—1812.

Lemuel White, *fl. c.* 1813–*c.* 1817.

William R. Jones, *fl. c.* 1810–*c.* 1824.

Both Americans, and both practised in Philadelphia. White was a pupil of Birch's. He copied very well and attained to

the painting of a tolerable portrait—but tolerable will not do in an egg or a picture. He became enamoured with the stage, but there again tolerable is not sufficient; he then turned his attention to teaching elocution, and has attained standing and reputation. Mr. Jones pursues another path, and is a designer for and engraver of bank-notes. This is inevitably a money-making business.

William Jewett, 1789 or 1790–1874.

WILLIAM JEWETT—1812.

This excellent artist and good man has long been so intimately associated with his friend Waldo, that he will be scarcely known alone—Waldo and Jewett have become one appellation—but William Jewett can stand alone both as a citizen and an artist. He sprung, like many other of our artists, from the honourable class of American yeomanry, but was deprived of his father at a very early age; and his mother with her infant children were received into the family of his father's father, where as soon as possible he was inured to the habits, hardships, and labours of an agricultural life. He was born in the town of East Haddam, Connecticut, February 14th, but in what year my informant is ignorant, I presume it was about 1795.

William worked on his grandfather's farm, sighing for the time when he might he *put out* to learn a trade, and the time came, *in good time.* His mother (oh, how much are we all indebted to our mothers!) taught him the lessons which are usually taught at country schools, and the lessons of morality and religion which have guided him through life.

At the age of sixteen, Jewett was placed with a relative, who was a coach-maker at New-London, and there for more than two years his employment was preparing paints and assisting in colouring carriages. Mr. Jewett has from nature an eye for colours, and as a boy he was delighted with the bright; and the occupation he was engaged in awakened a desire to do more with such pleasing materials than he had then an opportunity of essaying. He was a most useful assistant to the coach-maker, who treated him well, but as it proved shortly after, from selfish motives.

Mr. Waldo came to New-London and painted several portraits. This was the first opportunity Jewett had had of seeing any painting of this kind, and he became dissatisfied with daubing carriages. In order to obtain more easy and frequent admittance to the sight of these wonders of art, Jewett offered to grind colours for the painter, who gladly accepted the offer. Thus commenced the connection of Waldo and Jewett.

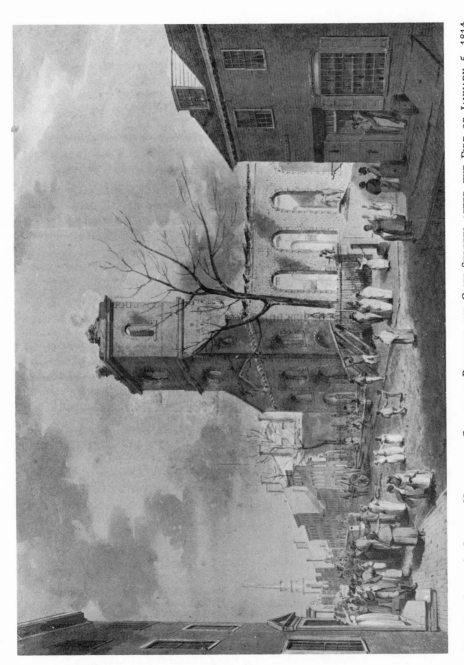

223 ST. GEORGE'S CHAPEL, NORTHWEST CORNER OF BEEKMAN AND CLIFF STREETS AFTER THE FIRE OF JANUARY 5, 1814.
Watercolor by John Rubens Smith. *Courtesy Museum of the City of New York.*

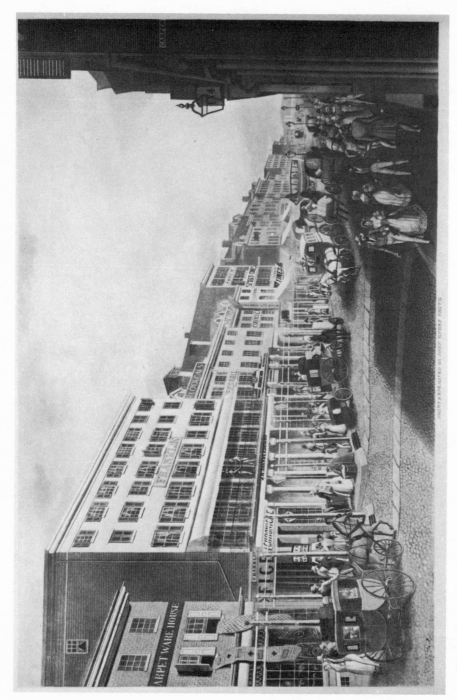

224 A SOUTH WEST VIEW OF SANDERSON'S FRANKLIN HOUSE, CHESTNUT STREET, PHILADELPHIA, c. 1835. Aquatint engraving by John Rubens Smith after his own drawing. *Courtesy Yale University Art Gallery, Mabel Brady Garvan Collection.*

About this time the future artist made his first attempt at painting a head, which, as is always the case, was much admired by the ignorant, however great a prodigy of deformity. Mr. Waldo, well pleased with his colour-grinder, invited him to accompany him to his place of permanent residence, New-York; and offered to take him into his family, instruct him, and give him a small salary for his assistance, sufficient to find him in clothing. This offer was made for the term of three years. Gladly Jewett accepted the friendly invitation; but the coach-maker interposed his veto, and although the youth was not bound to him, forbade the bans, on pain of severe punishment. The ship and packet masters were forbidden to take the youth off; but he knew that no just claims existed to hold him, and determined to pursue the path that had been opened to him. He dispatched his books and other articles that might encumber an elopement, by a vessel to New-York, and resolved to make his way on foot to the great city. The coach-maker seeing that he probably would lose his servant, thought best to offer him his liberty, provided he gave his note payable with interest for the sum at which he valued his time of service. Jewett agreed, and faithfully in seven years paid the bond. Borrowing two dollars to pay his passage in the steerage of a ship for New-York, and gaining credit for a "seven dollar coat," with a joyful heart, at the happy age of eighteen, the youth left all behind him that appeared cloudy in life, and looked forward to a world of brightness, beauty and roses. But the adventurer was aware that "evil communications corrupt good manners," and that temptations lay in his way, and he formed a few rules for his conduct which he religiously followed, when he entered amidst the vice and evil examples with which all large towns abound. The first was, not to profane the sabbath, and to attend worship at least once on that day. Secondly, to read every day at least twenty verses in the bible. Thirdly, to avoid all bad or questionable company. And lastly, to honour and faithfully serve his new master.

Mr. Jewett has said, "finding my home pleasant and my situation altogether agreeable, I had no inclination to change it for eighteen years." He studied drawing and passed much of his time at the receptacle of the antique casts, which were then deposited at the custom-house near the Bowling-green. After three years study in drawing he began to paint, making copies and paying great attention to colouring, and during another three, he assisted his instructor and improved himself by reading and other study. Painting from nature followed, and gave him still greater delight; his love for the art in-

creasing with his practice of it. He has said, that " the whole excellence of the art" at this time appeared to him to consist "in a bold and judicious opposition of light and shade, and a free light manner of handling the colour."

About this time, Jewett and his friend Waldo passed some months painting landscapes in the open air and fields, near the banks of the Hudson, with much pleasure as men and profit as artists. After being with Waldo ten years, he was offered a joint interest in his business of portrait painting, if he would devote himself entirely to that department of art, he accepted the offer, and the partnership of Waldo and Jewett has continued prosperously from that time to this.

With the practice of portrait painting grew the love of it, and a corresponding improvement. Mr. Jewett is altogether an an American painter, and seems to have considered the study of nature at home of more use to him as an artist than the study of old pictures abroad. On this subject others may differ. When I look at the works of some of our painters, and without meaning disrespect to others, I would instance those of William Sidney Mount, I am inclined to the same opinion, and it is strengthened when I contemplate the pictures of some travelled artists ; but when I see those of Sully, Morse, Weir, Leslie, Allston and many others, I wish that after the proper course of study and at a proper age, our artists may visit the schools and study the wonders of European art.

That several of our artists have already rivalled those of modern Europe in painting and engraving, is acknowledged : and I do not see any impediment to that progressive improvement, which shall in time place all our arts of design upon an equality at least with those of the best days of Greece and Italy.

THROOP AND AMES—1812.

Three Throop brothers were engravers at this time. John Peter Van Ness Throop, 1794–*c*. 1861. Orramel Hinckley Throop, 1793–?. Daniel Scrope Throop, 1800–?.

Ezra Ames, 1768–1836.

Of *Mr. Throop* I only know that he practised engraving on copper in Boston, and was a teacher of Alonzo Hartwell, who afterwards preferred wood engraving.

Mr. Ames was a coach painter in Albany ; but attempting portraiture, so far succeeded, that, in 1812, his portrait of Governor George Clinton was exhibited, much to the painter's credit, in the Pennsylvania Academy of Fine Arts. He, for many years, painted the portraits of most of the western members of the legislature, and of many others : and I have reason to believe, that in old age he enjoys the blessing of competency, derived from his enterprise and industry. He has a son who paints miniatures.

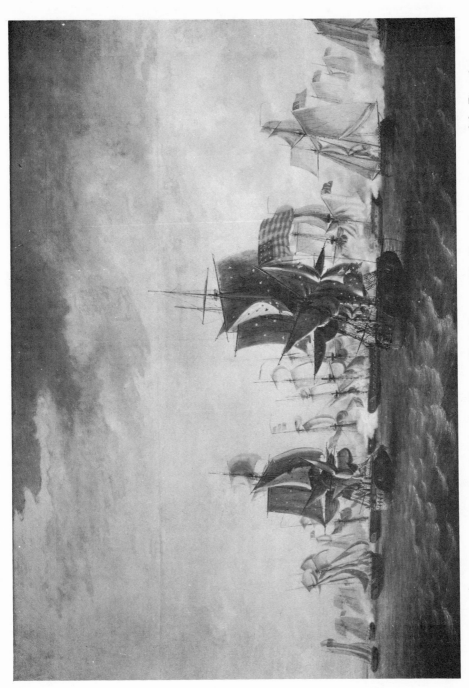

225 THE BATTLE OF LAKE ERIE. Painting by Thomas Birch. *Courtesy The Pennsylvania Academy of the Fine Arts.*

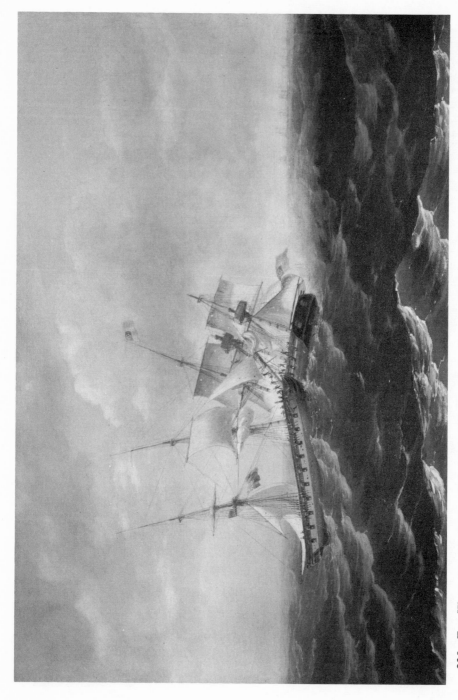

226 THE WASP AND THE FROLIC. Painting by Thomas Birch. *Courtesy Museum of Fine Arts, Boston, the M. & M. Karolik Collection.*

JOHN RUBENS SMITH. T. PEALE—1812.

John Rubens Smith, 1775–1849.

Titian Ramsay Peale,
1799–1885.

The first mentioned person is an Englishman, and the son of an English artist, who educated him for his profession. He painted portraits in water colours, in New-York, in 1812, (perhaps a little earlier) no way distinguished for their merit. I remember his attempting to copy one of Sully's portraits in oil, under his instructions, but it was a lamentable failure.

He removed to Boston and opened a drawing school, for which he was in many respects well qualified; but his manners, and utter want of every feeling necessary for society, rendered his residence there of short duration. He returned to New-York, and was a successful teacher of drawing. He likewise occasionally designed, and both etched and scraped in mezzotinto. His design and etching of George Frederick Cooke's monument, erected by Kean to the memory of his predecessor, in St. Paul's churchyard, New-York, with the figures of Kean and Dr. Francis, had some notoriety at the time, and more in England since Kean's death. He removed to Philadelphia, and, I believe, continues there, a successful teacher of drawing.

Titian Peale was born in Pennsylvania; the son of Charles Wilson Peale, a naturalist and draughtsman. He executed the drawings of the birds for the first volume of Chas. Lucien Bonaparte's American Ornithology, and part of those of the fourth volume.

THOS. BIRCH —1812.

Thomas Birch, 1779–1851.

This artist is the son of William Birch, the enamel painter above mentioned, and was brought to this country in 1794, when he was seven years of age. Like many others of our subjects, he is English by birth, but an American artist. He could from infancy (to use his own expression) " sketch a little." He of course had his father for an instructer : but, as he advanced in life and art, he preferred the instruction of nature, and studied on the banks of the Schuylkill, his father's place of residence being Philadelphia. He had for his companions, in sketching the beautiful scenes near the river, John Wesley Jarvis, Samuel Seymour, and sometimes Thomas Sully; but that could only have been after 1805, and when Birch was approaching manhood.

Mr. Birch is a good landscape painter, and a very fine painter of marine pieces. He has exhibited, at the gallery of the National Academy, Clinton-hall, New-York, many masterpieces in this branch of painting. Engravings from Vernet's

Seaports, and other marine subjects, first kindled in him the love of similar subjects. His first regular essays in this department were made at the commencement of the late war between his adopted and his native country. England was known as *his* country, but he felt as an American. The triumphs of the " bit of striped bunting" kindled his enthusiasm, and the desperate fights which could lower the flag and the pride of the boasted mistress of the ocean, were his chosen subjects.

His first picture of this description, painted to order, was the " Engagement of the Constitution and the Guerriere," for Mr. James Webster, a publisher, of Philadelphia. The next was the " Wasp and Frolic," for Nicholas Biddle, the present president of the United States Bank. The battles of the frigate United States with the Macedonian—those which resulted in Perry's victory on Lake Erie, and Mc Donough's on Lake Champlain, with a succession of similar subjects— furnished employment to his pencil in the path he had chosen, and in which he stands unrivalled in our country.

? Stein, *fl. c.* 1820*ff*.

STEIN—1812.

A portrait painter of this name was born in Washington, Virginia, but principally exercised his professional skill beyond the Alleghanies. He is said to have had talent.

In 1820 he painted portraits in Steubenville ; and the sight of his work, and his manner of working, kindled that latent spark in the mind of Thos. Cole, which has since burst into flame, and thrown a glow over the wilds of America and the plains of Italy. Mr. Stein died a young man.

John Ritto Penniman, 1783–?.

PENNYMAN—1812.

This is the name of an ornamental painter, who flourished in Boston about this time and after. He had more talent and skill than many who aspire to higher branches of the art. If he had had that education, or those feelings, which would have led him to aspire to the character and conduct of a gentleman, he would have been a good artist and a respectable citizen ; but he became a drunkard, and died despised or lamented, according to the feelings of those who were acquainted with his talents and his conduct. He had the honour of being the first teacher of Alvan Fisher.

Charles Bird King, 1785–1862.

CHARLES B. KING—1812.

This gentleman was born at Newport, Rhode Island, in the year 1785. What circumstances in early life led to the choice

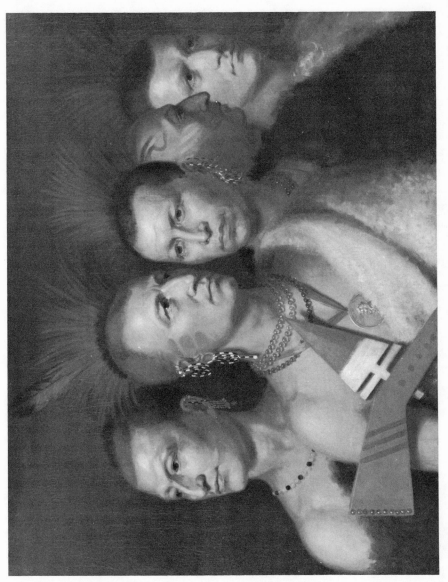

227 Young Omahaw, War Eagle, Little Missouri and Pawnees. Painting by Charles Bird King. *Courtesy National Collection of Fine Arts, Smithsonian Institution.*

228 VANITY OF THE ARTIST'S DREAM. Painting by Charles Bird King. *Courtesy Fogg
Art Museum, bequest of Grenville L. Winthrop.*

of painting as a profession I know not, but may presume the inclination to imitate pictures and the objects by which we are surrounded, led him (as we find in every instance of boys who have become painters or engravers) to mar his copy and ciphering books, and after a time to copy some print which elicited the admiration of admiring ignorance, and roused the ambition of the youth to become another West or Raphael. When I wrote my History of the American Theatre, I remarked that all my heroes, future Alexanders, Othellos, Richards, and Henries, began the career of glory by running away— not from the enemy, but their friends. The heroes of the palette and maul-stick are equally uniform in their commencement, which is almost always as above supposed for Mr. King.

His first instructer was Edward Savage, who had a mingled establishment, half painting gallery, half museum, from 1788 onwards, in New-York. John Crawley was a fellow-student with King, and John W. Jarvis had preceded them and set up for himself. I must date Mr. King's sojourn with Savage at about 1800 and on to 1805. I am obliged to guess, as he refuses to satisfy my curiosity by giving me any information. In 1805 he found his way to London, and remained in that city a most assiduous student for near seven years, enjoying the benefit of the academy and the instruction of the benevolent West. In 1809 Mr. Sully found King in the above situation, and they became room-mates and fast friends from that time to this. In 1811, when Charles R. Leslie went to London, he there found King, and acknowledges his obligations to his friendship.

The reader of this work will find in the biography of Thomas Sully many particulars relative to his friend C. B. King. Sully says of him, " I found him, as a fellow student, the most industrious person I ever met with. He limited his hours of sleep to four—was jealous of the least loss of time—his meals were dispatched in haste, even then (while eating) he read some instructive book. By this unremitting assiduity he has amassed a fund of useful knowledge." I presume that it is his industry in painting that has served him instead of genius, in which nature has stinted him. It appears that all he has acquired has been by very hard study; and Mr. King is an example of a man of very moderate genius who has acquired much in his profession, and commanded that employment which has made him independent in his circumstances, and an object of attention in society.

In the communication from which I have made the above extract, Mr. Sully continues thus: " He has much mechanical skill, and good taste in architecture. As a man, he is one of

the purest in morals and principle. Steady in his friendship, and tenderly affectionate. I have known him receive many injuries, but never knew him to resent one—generally returning good for evil when he had the opportunity: in short, without professing to belong to any *particular* set of christians, he is the best practical christian I ever was acquainted with."

Mr. King, as I have said, returned from England in 1812, and I remember with pleasure the picture of the girls and the cat which he brought with him, painted when he and Sully were together in London. He set up his esel in Philadelphia, but did not succeed to his wish, and removed to Washington City in the year 1816. Sully says, " He began the world at Washington with little other materials than his palette, pencils and books; and he has now amassed a secure independence— that is, with his moderate wants."

King has remained a bachelor. He built a house at Washington, and a good picture gallery. In his gallery he has exhibited several of my pictures, and his conduct has not only been honourable but friendly. In 1824 I visited Washington and found Mr. King full of business and a great favourite, assiduously employed in his painting room through the day, and in the evening attending the soirees, parties, and balls of the ambassadors, secretaries of the cabinet, president or other representatives and servants of the people, and justly esteemed every where.

He has contrived several mechanical machines for facilitating the labour of artists. He uses a slender rod of wire about a foot long, to ascertain the proportions of his picture, compared with the original. It is gauged with white paint, about an inch from the top, which is held upright at such distance from the subject as to effect one division—the face of a sitter for example. If the proportion of the arm to the face is wanted, hold it in the same position and place the nail of the thumb in the corresponding place of intersection of the arm on the rod. By applying this guage to the picture you may correct the proportions. But all mechanical aids are mischievous. The artist should depend alone on his eye.

Mr. King is ever ready to impart instruction. Mr. George Cook acknowledges with pleasure and gratitude that he was his first instructer, giving him precept and example without fee or reward.

In person and manners Mr. King is prepossessing. He has not the polish of a court, neither has he the duplicity of a courtier. A frankness and naiveté have attended him through life, seldom found in men who have mingled so much in society.

229A EDWARD COVERLY. Miniature by Henry Williams. *Courtesy The Metropolitan Museum of Art, Lazarus Fund.*

229B MARY C. NORCROSS. Miniature by Henry Williams. *Courtesy Worcester Art Museum, bequest of Grenville H. Norcross.*

230 GEORGE WASHINGTON. Painting by Denis A. Volozan. *Courtesy Delaware State Archives.*

DOWSE—WILLIAMS—D. A. VOLOZON—1813.

Thomas Dowse, 1772–1856.

Henry Williams, 1787–1830.

Denis A. Volozan,
fl. c. 1806–*c.* 1819.

Mr. Dowse is not an artist, but has encouraged the progress of art in America. He is the proprietor of a large number of drawings, and a still greater number of prints, coloured and uncoloured; fifty-two paintings in water-colours, invaluable for their correctness and beauty, and for the truth with which they represent the style, the composition, the drawing, and the colouring of those masters, whose works we rarely see on this side of the Atlantic.

Williams painted both in oil and miniature, at this period in Boston. He was likewise a professor of electricity; and in addition modelled in wax. He was a small, short, self-sufficient man; very dirty, and very forward and patronizing in his manner.

D. A. Volozon was a French artist, who painted for some years in Philadelphia, principally in crayons. His exhibited portraits are said to be indicative of patience and industry, as well as classical knowledge of his art. He likewise taught drawing, and was the early instructor of Mr. Paradise.

G. M. MILLER—T. BISHOP—J. PEALE jun.—1813.

George M. Miller, ?–1819.

Thomas Bishop, *c.* 1753–*c.* 1840.

James Peale, Jr., 1789–1876.

Miller was by birth a Scotchman. He would have been an artist of eminence, if he could have made bread enough to support himself and wife, by the profession of modelling. But he came to us before the time when merit could be appreciated, or the pretender known from the artist. His busts of C. W. Peale, Bishop White, Commodore Bainbridge, and Mrs. Jerome Bonaparte, are proofs of his talents. By these talents as an artist he could not live, and from necessity turned goldbeater. He died in the year 1818.

Bishop painted miniatures in Philadelphia. A lady of this name has exhibited some modelling in wax, probably the widow of Thomas Bishop, and sister-in-law to Miller, above mentioned.

James Peale, jun. painted and exhibited sea pieces in Philadelphia; probably the son of James Peale, and nephew of Charles Wilson Peale.

CHAPTER XIX.

Alvan Fisher—his letter—my recollection of his paintings and knowledge of his amiable character.—Lucius Munson.—John Frazee—his early struggles—apprenticed to a mason—tries stone-cutting—love of music—removal to New-York—first model—first bust in marble—great present success and employment.

Alvan Fisher, 1792–1863.

ALVAN FISHER—1814.

THE following extract from a letter written by this excellent artist and estimable man, in answer to my request for information respecting his career, is so honourable to him, that I publish it, rather than give its contents in my own words :

" I was born on the 9th of August 1792, in the town of Needham, county of Norfolk, state of Massachusetts. While young, I left that town for Dedham, where my connexions have resided, and some continue to reside to this day, therefore, I have always hailed from Dedham. Until past eighteen years of age I was engaged in a country store; and greatly against the wishes of my friends, (who intended that I should go into a mercantile counting-room in this place,) determined to be a painter—a fondness for which business the account books of the store in which I was engaged could most abundantly prove, could they be found : they probably would somewhat resemble the old illuminated manuscripts. In consequence of this determination to be an artist, I was placed with a Mr. Pennyman, who was an excellent ornamental painter, with him I remained upwards of two years. From him I acquired a style which required years to shake off—I mean a mechanical ornamental touch, and manner of colouring. In 1814 I commenced *being* artist, by painting portraits at a cheap rate. This I pursued until 1815. I then began painting a species of pictures which had not been practised much, if any, in this country, viz: barn-yard scenes and scenes belonging to rural life, winter pieces, portraits of animals, &c. This species of painting being novel in this part of the country, I found it a more lucrative, pleasant and distinguishing branch of the art than portrait painting, which I then pursued. I continued this course until 1819–20, when I gradually resumed portrait painting, which I have practised more or less to this time, so that at present my principal business is portraiture. It is seldom that I am without orders for painting other than portraits. April 1825 I visited Europe. During my absence I

231 GEORGE WASHINGTON. Miniature by Thomas Bishop after the painting by
Gilbert Stuart. *Courtesy The New-York Historical Society.*

232 MARINE WITH SHIPPING, 1859. Watercolor by James Peale Jr. Courtesy The Parrish Art Museum, gift of Mr. and Mrs. Alfred Corning Clark.

travelled in England, France, Switzerland and Italy, visiting all that an artist usually visits. My journey in Switzerland was made on foot, the only way a traveller can see that picturesque country. In Paris I studied drawing at a private life academy, and made copies from the old masters in the gallery of the Louvre. Previous to my going abroad I travelled and painted in many parts of this country; since my return I have made Boston my home, and generally resided there, and am, I suppose, permanently fixed there for life. I believe, sir, that you have not seen a class of my paintings, such for example as the " Escape of Sargeant Champ," " Mr. Dustin saving children from the savages," " The Freshet," " Lost Boy," &c. As these paintings and many of the like character were painted to order for gentlemen in this city, it is this class of pictures which have been as advantageous as any other to my reputation as an artist.

" I do not know that I have communicated any thing which can interest the public; my life has been without striking incidents; it has been what I apprehend to have been the life of most of the American artists, a life of toil, seeking the realization of a dream—of hope and disappointment—of cloud and sunshine, so that it is difficult, perhaps, to say whether I was wise or foolish in choosing a profession."

I have seen many of Mr. Fisher's early works in scenes belonging to rural life—cattle and landscapes; and remember them as promising that excellence to which I doubt not that his pencil has attained. He opened an exhibition in Boston last year (1833) in conjunction with Messrs. Doughty, Harding & Alexander, which I understand has added to the reputation of all concerned, and given ample remuneration for their labour. Mr. Fisher's uniform conduct through life has evinced an amiable disposition and perfect moral worth.

LUCIUS MUNSON—1815.

Lucius Munson, 1796–1823.

This ingenious and lamented young gentleman was born at New-Haven, Connecticut, in 1796. Always attached to drawing and painting, he had, however, as he approached manhood, determined to become an agriculturist, and was about purchasing a farm, but a friend, himself a good artist, encouraged him to follow the bent of his inclination and become a painter. He accordingly devoted himself to the study of drawing and painting. I remember him assiduously drawing in New-York in 1817 and 18.

He had commenced as a professional portrait painter in New-Haven in 1815. In 1820 he visited South Carolina,

professionally, and the next year sailed for Bermuda. His mind was bent on visiting Europe, and he painted incessantly for the purpose of accumulating the means necessary to a residence in London, and travelling on the Continent. From Bermuda he went to Turks' Island—took sick and died, I believe in 1822. An amiable man and promising artist cut off in the springtide of his hopes.

John Frazee, 1790–1852.

JOHN FRAZEE—1815.

The struggles of an individual, who appears to have every circumstance that attends his situation, from the earliest childhood, opposed to his well being, but who ultimately places himself in the rank of those honoured for genius and for moral conduct, must be looked upon with admiration by all; and such a one is raised, in my opinion, above the favourite of fortune, who attains equal eminence in the scale of society.

The ancestors of John Frazee were emigrants from Scotland, and landed at Perth Amboy among the early settlers of that place. The family name was Frazer, and was changed to Frazee by the grandfather of John. Our subject was born on the 18th of July, 1790, in the upper village of Rahway. His mother's name was Brookfield, and he was her tenth child. Shortly after his birth she was deserted by an unworthy husband, and left to struggle with the ills of poverty.

At the age of five John was taken to the protection of his grandmother, Brookfield, whose character was similar to that of her daughter; and from these worthy women the child derived the basis of his moral and religious education. The boy was the household drudge, as well as the out-door labourer, but cheerfully assisted his aged relatives; even milking the cow, churning, and working for his grandmother, and doing the field-work. Neither the school-boy instruction nor the school-boy sport, fell in due degree to John; and his principal amusement, when not at work, was to cut the forms of familiar objects out of boards or shingles, and to chalk figures upon the doors. His reward for these efforts was, to have his ears boxed, and the prediction that he would be a *limner*.

John was removed from his grandmother, and placed with a farmer of the name of De Camp, whose character and conduct were of the most deplorable kind. The boy remained in this habitation of vice, a slave to a brutal family, for two years. He had eluded the propositions made to bind him to De Camp, and escaped from this bondage at the age of thir-

233 MISHAP AT THE FORD. Painting by Alvan Fisher. Courtesy Corcoran Gallery of Art.

234 Harvard University Yard In 1821. Painting by Alvan Fisher. *Courtesy Fogg Art Museum, Harvard University.*

teen, to his mother and grand-parents, who joyfully received and protected him.

He was now strong enough to manage and work the little farm of old Brookfield, and his mother procured him the advantage of a little more schooling. Circumstances, however, removed him from the occupation of an agriculturist, and he was bound apprentice to a country bricklayer, of the name of Lawrence.

Another trial awaited young Frazee. The bricklayer took out a licence for tavern-keeping; and John, in addition to working on the farm, and laying bricks, had to become a tavern waiter. In the winter, when sleighing parties were frequent, many a night was passed in attending upon and supplying the reveller and the drunkard. But even here, with every temptation and example around him, the precepts of his mother and her mother preserved him. Besides, he had seen the evils of intemperance and gambling; and, at an early age, he resolved to eschew those vices, and kept his resolve firmly.

Sundays were his own, and he devoted them to teaching himself penmanship, and attempting to draw with his pen.

So far Frazee had proceeded in life's career without a knowledge of the instrument which was destined to open a brighter career for him—the chisel: but in the summer of 1808, Lawrence having contracted to build a bridge over Rahway river at Bridgetown, was ambitious enough to wish his name chiseled in a neat tablet of stone, with the date of the year the work was finished. Upwards of forty men were employed on the bridge, two or three of whom were stonecutters from New-York, but none would undertake to immortalize the bridge builder. John asked permission to try his hand with the chisel, and the master consenting, he prepared the tablet and engraved on it, "Built by William Lawrence, A. D. 1808." This was the first work with the chisel by the future sculptor. He was now eighteen years of age, active, strong and vigorous, and acknowledged as a skilful workman. From this period the chisel and mallet appeared to him the tools of his choice, and he aimed at becoming a stonecutter instead of a bricklayer.

Even before he was "out of his time" as an apprentice to the bricklayer, he was called upon to exercise his skill as a stonecutter upon a building his master was employed to erect for Peter De Wint Smith, near Haverstraw on the Hudson. He had acquired confidence in his skill, and having offered to undertake the ornamental stone-work of the building, his ambi-

tion was encouraged by Mr. Smith, and he succeeded to the satisfaction of all parties. I feel a pleasure in pointing out the first monuments of Frazee's progress towards the art he now excels in, and would willingly make a journey to see the tablet of Rahway bridge, and the ornamental work on the house at Haverstraw. I admire the energy of the youth who could thus rise above the depressing circumstances of his early condition ; and I see a lesson to all in the manner his efforts were seconded, and his moral character preserved and improved.

At this time Frazee felt the want of early instruction. Reading, writing, and the first rules of arithmetic were the whole of his learning. As he mingled in society, he felt his deficiencies. But yet he had to look for bread—notwithstanding which he pursued his study of arithmetic, and by the aid of Mr. Wilson of Fairfield, Connecticut, improved himself in useful knowledge. To this friend Mr. Frazee remains unalterably attached. The first years of his freedom passed in bricklaying in summer, making headstones in winter, and in the evenings teaching psalmody.

In the summer of 1813, Mr. Frazee married Jane, the daughter of Garret Probasco of Spotswood, in his native state. For this partner he had prepared a home by purchasing a small house in Rahway, and adding to it a workshop for his business of stone-cutting. In 1814 he entered into partnership with a former fellow-apprentice, and they established themselves as stonecutters at New Brunswick.

At what time Mr. Frazee made his way to New-York, my guide has left me uninformed. I remember him in partnership with his brother in Broadway as a stonecutter. What induced him to attempt modelling the human figure I know not. Mr. Durand tells me that his first attempt was to copy the bust of Franklin. He found himself in the path intended for him, and soon modelled a figure of one of his children eating a pie I remember the admiration I felt (when in one of our exhibitions of the National Academy, of which he became a student and a member,) at seeing a bust of his mother, modelled by him. I am told that as early as 1817 he executed a design representing fruit and flowers, even when he resided in Brunswick, New Jersey.

The first bust Mr. Frazee chiseled in marble was that of John Wells, Esq., 1824; this is in Grace church, New-York. It was executed from imperfect profiles, after his death. From this beginning he has progressed to a perfection which leaves him without a rival at present in the country. The bust of

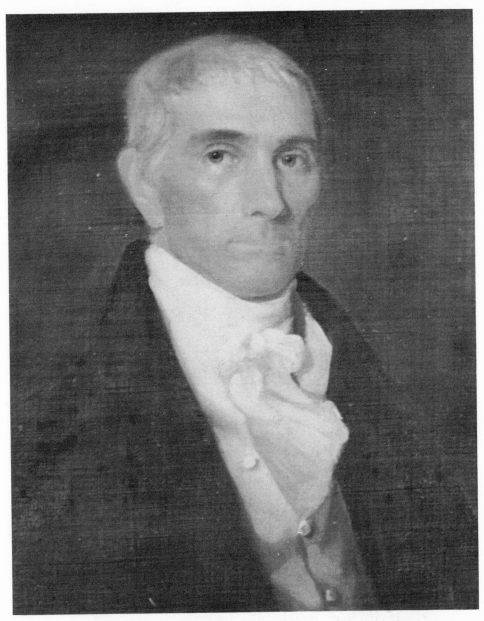

235 JOSEPHUS DARRELL. Painting by Lucius Munson. *Courtesy Bermuda Historical Monuments Trust.*

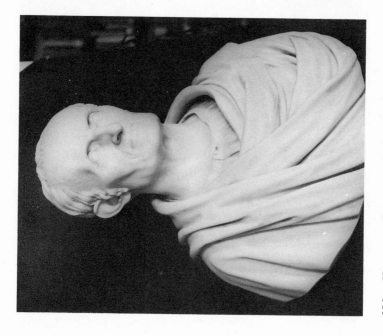

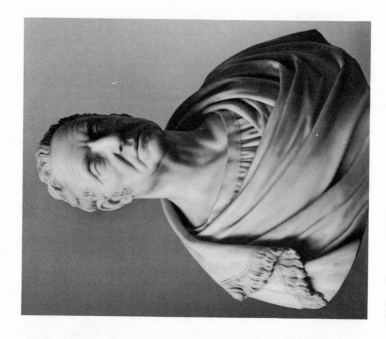

236A NATHANIEL BOWDITCH. Sculpture by John Frazee.
Courtesy Boston Athenaeum.

236B THOMAS H. PERKINS. Sculpture by John Frazee.
Courtesy Boston Athenaeum.

Mr. Wells was, as I believe, the first portrait in marble attempted in the United States.

At present Mr. Frazee is full of employment. He has executed (having been commissioned to proceed to Richmond, Virginia, for the purpose) a bust of Chief Justice Marshall. I have seen with admiration his bust of Daniel Webster, and with more that of Dr. Bowditch : both chiseled in marble with skill and taste. He has also recently executed, with great fidelity, a bust of N. Prime, Esq. of New-York. He has seven busts engaged for the Athenæum in Boston, to which city he has recently been to model the likenesses.

CHAPTER XX.

W. E. West---His picture of Lord Byron---Leslie's opinion of him---His portrait of William Beach Lawrence, Esq.---Charles Cromwell Ingham---His education in Dublin---comes to America---great merit in oil and miniature---great success ---George Munson---Hugh Bridport---Nelson---William James Bennett.

WILLIAM E. WEST—1815.

This gentleman is one of those able artists who do honour to our country, and raise its reputation for talent and virtue in Europe ; yet I have very imperfect information respecting him.

William Edward West, 1788–1857.

I suppose him to be the son of William West, the son of the rector of St. Paul's, Baltimore, who went to England and studied painting with B. West in 1789. My obliging and much-valued correspondent, J. R. Lambdin, Esq. upon whom full reliance can be placed, says, that " the father of Wm. E. West resided in Lexington, Kentucky, and was a man of uncommon mechanical talents." Of the son he says, " I know little of the early life of West : he painted miniatures several years before going to Philadelphia, where he studied with Sully," the friend and refuge of all who applied to him. " He practised several years at Natchez, where are many of his best pictures ; (meaning, of course, of that time). His great patron, and the person who was instrumental in sending him to Europe, was the late Mr. Evans, of that city." He left the United States in 1822 ; and shortly after gained considerable notoriety by his portrait of Lord Byron, painted at Leghorn. He is now (1833) in London."

In a letter to me, C. R. Leslie, Esq. says, " We have ano-

ther countryman in England, Mr. W. E. West, who is pro-
bably known to you by the engravings from his portraits of
Lord Byron and the Countess Guiccioli. In Moore's Life of
Byron you will find a very interesting account of the poet,
while sitting for his picture, written by Mr. West.

Moore says, " He sat for his picture to Mr. West, an
American artist, who has himself given the following account.

" On the day of appointment, I arrived at two o'clock, and
began the picture. I found him a bad sitter. He talked all
the time, and asked a multitude of questions about America
—how I liked Italy; what I thought of the Italians, &c.—
When he was silent he was a better sitter than before; for he
assumed a countenance that did not belong to him, as if he
was sitting for a frontispiece to Childe Harold." How he
could be a better sitter on this account I know not: perhaps
the little word "*not*" has been omitted in Harper's edition. "In
about an hour our first sitting terminated; and I returned to
Leghorn, scarcely able to persuade myself that this was the
haughty misanthrope whose character was always enveloped in
gloom and mystery—for I do not ever remember to have met
with manners more gentle and attractive. The next day I re-
turned, and had another sitting of an hour; during which he
seemed anxious to know what I should make of my under-
taking.

" While I was painting, the window from which I received
my light was suddenly darkened, and I heard a voice exclaim,
E troppo bello! * I turned and discovered a beautiful female
stooping down to look in, the ground on the outside being on
a level with the bottom of the window." This was Byron's
mistress, the Countess Guiccioli. The painter being intro-
duced to her, and the noble lord appearing very fond of her,
he became " a much better sitter."

" The next day," proceeds the painter, " I was pleased to
find the progress I had made in his likeness had given satis-
faction : for when we were alone he said, he had a particular
favour to request of me—would I grant it ? I said I should
be happy to oblige him; and he enjoined me to the flattering
task of painting the Countess Guiccioli's portrait for him."—

* As I copy this from Harpers' edition of Moore's Life of Byron, which has,
for a frontispiece, an American engraving, marked as from a painting by Wm. E.
West, I look in vain for the beauty attributed to the sitter or to the picture —
It would be better for the Harpers to save the expense of their *decorations*, for
they only deform their publications and do injustice to American art. I protest
against such specimens as this of West's Byron, the portrait of Benjamin West,
in Cunningham's Works ; that of Mrs. Siddons, and many others. Our arts are
not in so low a state as these paltry things would lead us to suppose.

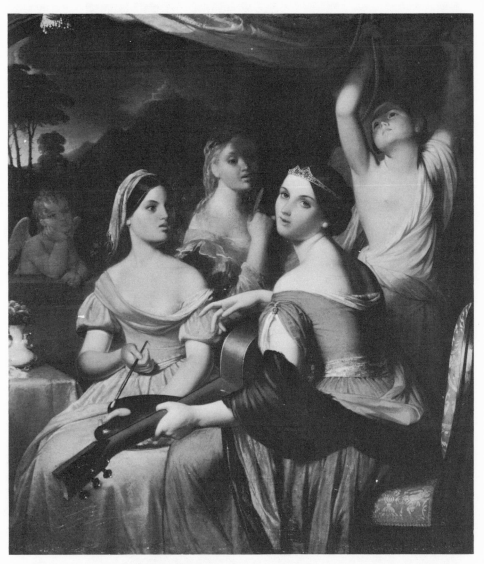

237 THE MUSES OF PAINTING, POETRY AND MUSIC. Painting by William Edward West. *Courtesy Corcoran Gallery of Art, gift of Elizabeth H. E. McNabb.*

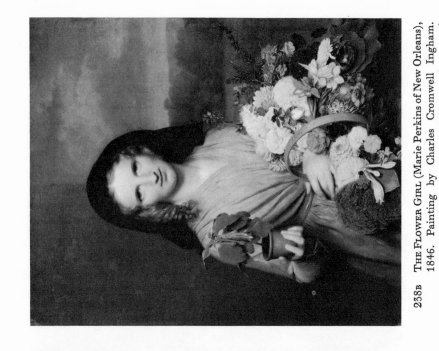

238B THE FLOWER GIRL (Marie Perkins of New Orleans), 1846. Painting by Charles Cromwell Ingham. *Courtesy The Metropolitan Museum of Art, gift of William Church Osborn.*

238A AMELIA PALMER, c. 1829. Painting by Charles Cromwell Ingham. *Courtesy The Metropolitan Museum of Art, gift of Courtlandt Palmer.*

This the painter did, and the noble lord told him the history of his " connexion with her."

This appears to me very much like " much ado about nothing," and I will spare my readers any more of the painter's account of this worthy pair. Leslie says :

" Mr. West is a modest man. His best pictures are from ' the Pride of the Village,' and ' Annette de l'Arbre.' The pathos and natural expression of the last attracted the admiration of Mr. Stothard and Mr. Rogers, two men whose good opinion is well worth having. His pictures have a merit not the most common in the art. The principal figures *are much the best.* Mr. West spent some years in Italy. If you meet with Washington Irving you will be able to obtain much more information than I can give you about him : Irving and he were very intimate."

Such is the testimony of C. R. Leslie : it is fully confirmed by Mr. Irving. West experienced some disappointment in respect to selling this portrait of Byron ; which he brought to London, thinking no price could be too high for John Bull to give for the acknowledgedly best likeness of the popular poet. He refused a very liberal offer, (I am afraid to say how much) and the public feeling fell and the value of Byron's head with it. I have seen but one of Mr. W. E. West's pictures, which is the portrait of William Beach Lawrence, Esq. late our chargés des affaires at the court of St. James's, London. This is a well painted portrait, and very fine likeness of the original.

CHARLES CROMWELL INGHAM—1816.

Charles Cromwell Ingham, 1796–1863.

Charles Cromwell Ingham was born in Dublin in the year 1796. Descended from a gentleman who came to Ireland as an officer in Cromwell's army, the great protector's name has been given regularly to one of the family of Ingham, until it reached our painter. We have seen that Gilbert Stuart's father had, in his veneration for the exiled Stuarts, who, by their bigotry, vice, and tyranny, had been driven from the throne of Great Britain, given to Gilbert the additional name of Charles, which the painter dropped on arriving at the years of maturity : so our young Irishman, feeling indignant at old Noll's usurpation of kingly power and abandonment of democracy, dropped the name of Cromwell since coming to man's estate ; but hesitates even now as to abandoning an appellation which is associated with so many and so great virtues.

Every artist remembers his juvenile propensity to deform every substance placed before him by the evidences of his imitative genius and love of the beautiful. Every form, na-

tural, artificial, or fanciful, is subjected to the growing desire of rivalling the works of nature and of art, and of fixing the evanescent, or even the imaginary, so as to be subjected to the physical eye. Ingham has said, in conversation, that his first attention to pictures originated in being himself, when a child in petticoats, made the subject for a painter's skill, and placed upon a pile of big books on a chair, to raise him to a level with the artist's eye, who had undertaken to portray him, as well as all the taller personages of the family. From that time he remembers the pleasure he took in examining the portraits at his grandfather's house, and particularly the sparkling gold lace of the old-fashioned habiliments and glittering splendour of the buttons; and soon the white-washed walls of the kitchen received proofs of his talents whenever he could seize on a piece of charcoal, and work unobserved by the cook.

This childish propensity to imitate persons and objects he saw attracted attention, and he was, of course, pleased with being the object of attention, and carried the proofs of his skill from the kitchen to the higher regions. Full of the animal spirits incident to his age, he was often made the object of amusement to the ladies connected with or visiting his father's family. On one occasion, full of glee and childish prattle, sitting at a table with several ladies, suddenly the door opened, and a very large woman, of remarkable appearance, entered. " Give me a pencil," cried the child ; " give me a pencil, and I will make her picture." The sister of Mr. Cuming, (afterwards his teacher) was present, and she gave him a set of her brother's brushes, to encourage his propensity for painting.

The praises bestowed upon his attempts, and the progress he made, encouraged him, and induced his friends to place him, at the age of thirteen, at the Dublin Institution ; where he drew for one year, and then was received as a pupil by Mr. William Cuming, the best painter of ladies' portraits ever in Dublin, and a thoroughly accomplished artist.

With Mr. Cuming young Ingham studied four years. Of his teacher he uniformly speaks as being an excellent artist, a liberal man, and a finished gentleman.

After " the Union," when the wealth of Ireland was drawn to England, there were but three portrait painters in Dublin, and they had not full employment. What a contrast does this afford to New-York ! Of miniature painters there were more and several painters of water-coloured views, but they relied principally upon teaching.

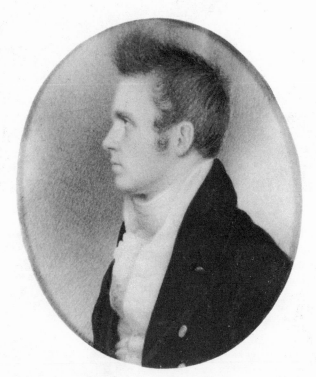

239 NATHANIEL JOCELYN. Miniature by George Munger. *Courtesy Yale University Art Gallery, Mable Brady Garvan Collection.*

240B STEPHEN VAN CORTLANDT. Watercolor by Hugh Bridport. *Courtesy The New-York Historical Society.*

240A GENERAL THOMAS MIFFLIN. Engraving by Hugh Bridport after the painting by Gilbert Stuart. *Courtesy Dover Archives.*

The young pupil of Cuming received a premium for a composition in oil colours, representing the " Death of Cleopatra," which, as I have seen, I can speak of as a wonderful specimen of skill, considered as the production of a boy.

Mr. Ingham came to New-York with his father's family in 1816, and his Cleopatra was exhibited at the gallery of the American Academy of the Fine Arts, at the first exhibition got up by that institution. The young painter was at that time twenty years of age, but with the appearance of sixteen. He soon attracted attention, and was established as a portrait painter; and has continued to paint in this city, from the time of his arrival to this day, with constant employment and uniform improvement. He has exercised his art generally in oil, but has occasionally painted miniatures in water colours, on ivory, with a truth of drawing, beauty of colouring, and exquisite finish, only rivaled by the best and first in the country. He never painted in that style, or with those materials, until he came to New-York. His last miniature, (and he says it *shall be his last*) a lady, half-length, will bear competition with any in that branch of the art, in all the qualities for which miniatures are valued.

The peculiar style of oil painting which this artist has adopted is (as it respects this country) emphatically his own. It may be designated as the style of exquisite finishing. His process is successive glazings; and he produces a transparency, richness, and harmony of colouring rarely seen in any country. It is my opinion, that no living artist can rival him in this mode of painting. His high finish, added to his knowledge of the more essential parts of his art, has made him principally the ladies' portrait painter.

This style is liable, when unskilfully attempted, to fall into hardness; and, instead of flesh, to represent polished ivory. Some of Mr. Ingham's earlier pictures, after he became an American painter, have this defect. But he has persevered in what he thought a manner suited to his powers, his taste, and his eye; and the public, as well as judges of the art, have rewarded him by applause almost universal and unqualified. His skill and his taste have appeared to be in a state of uniform and progressive improvement.

Besides portraits, Mr. Ingham has produced several compositions of figures in oil, of a size less than life, almost miniature. The most prominent of this is a scene from Byron's " Don Juan. His first very attractive portrait was a young girl laughing. His White Plume gained him great applause, but it has been followed by works that throw it in the shade.

With great frankness of manner, and some of the peculiarities of his country, Mr. Ingham is a most pleasant companion, and his virtues render him an inestimable friend. He is among that large class of our present artists who are looked up to, and sought for, in the most enlightened society. He has long been an Academician of the National Academy of Design, and an efficient member of the council.

GEORGE MUNGER, H. BRIDPORT, NELSON—1816.

Mr. Munger devoted himself in early life to miniature painting. He was born at Guilford, Connecticut, in the year 1783. After arriving at years of maturity, that loathsome disease, the small-pox, left him in a state that prevented his pursuing his studies for eleven years. In 1816 he painted miniatures of extraordinary merit, as I am informed by an artist well qualified to judge, and after practising his profession eight years, he died in 1824.

Mr. Bridport was born in London 1794, and emigrated to America in 1816, residing in Philadelphia principally, but occasionally exercising his art of miniature painting in other parts of the country. He studied at the Royal Academy and afterwares with C. Wilkin, miniature painter in London.

Mr. Bridport has forwarded the arts of design by teaching drawing and water-colour painting.

Nelson painted portraits in Pittsburgh in 1816, but where he came from or where he went I know not. Chester Harding took his first lesson from studying his portraits, which entitles him to a niche in my temple of immortality, not from any merit of his own, but from that of his pupil. He painted vilely, and required payment for communicating the art he did not possess.

WILLIAM JAMES BENNETT—1816.

Mr. Bennett's first appearance on the theatre of American arts was in 1816. He was born in London in 1787, and at a suitable age enjoyed the advantages of the Royal Academy. He was a pupil of Westall's, but seems to have had a greater taste for landscapes than for the species of composition for which is master is most known.

At the age of eighteen he had an appointment connected with the medical staff of the army, and was sent with the forces which Great Britain, in 1805, transported to Egypt. This voyage opened a fine field for the draughtsman and landscape painter, and he improved the opportunity for study. He saw a portion of that country of wonders, which sacred

241 Baltimore from Federal Hill, 1831 Engraving by William James Bennett after his own drawing. *Courtesy Library of Congress.*

242 NIAGARA FALLS. Aquatint engraving by William James Bennett after his own drawing. *Courtesy Library of Congress.*

and profane, ancient and modern history has made so familiar
to us. But Egypt is not a country to delight a landscape
painter—though a country of wonders, it is not in modern days
a country of beauties.

The forces amidst which the young painter was enrolled,
arrived only to be too late, and the next land submitted to his
pencil was Malta. History and the romance of history have
shed a lustre over this rocky isle, and the views which Mr. Ben-
nett's portfolio possesses of this frontier of christendom, when
the knights of the cross resisted the mighty power of the
infidel, are worthy of one who felt that he represented scenes
known to fame and dear to the imagination.

After returning home, the artist, still attached to the mili-
tary hospital, was sent with Sir James Craig a second time
into the Mediterranean. Craig is well remembered by the
writer when he was the captain of the light-infantry company
of the forty-seventh ; often the guest of my father, and occu-
pying a centre room in the barracks at Perth Amboy, whose
ruins mark the time when France and England fought their
battles in the woods of America. Under this commander Mr.
Bennett visited several parts of Italy in the routine of duty,
and Florence, Naples, and Rome with leave of absence.
This gave him further opportunity to cultivate the art he
loves, and to make drawings of scenes which nature and asso-
ciation render picturesque and interesting beyond most on our
globe.

Since his arrival in the United States, Mr. Bennett has
exercised the art of both painting and engraving, happily
multiplying by one the products of the other. The gallery
of the National Academy of Design at New-York (of which
institution he is a member, and the keeper, *in the sense that term
is understood in London*) is yearly decorated by his landscapes
and sea pieces, in water-colours, the latter altogether unri-
valled; and at the same time with prints from his engravings.

Within a few years this gentleman has, by taking a wife
from the daughters of the land, become an American.